The Aesthetic Relation

The Aesthetic Relation

Gérard Genette

TRANSLATED BY

G. M. Goshgarian

CORNELL UNIVERSITY PRESS

Ithaca and London

Cet ouvrage, publié dans le cadre d'un programme d'aide à la publication, bénéficie du soutien du Ministère des Affaires Etrangères et du Service Culturel de l'Ambassade de France aux Etats-Unis.

This work has received support, as part of a program of aid for publication, from the French Ministry of Foreign Affairs and the Cultural Services of the French Embassy in the United States

Copyright © 1999 by Cornell University

First published 1999 by Cornell University Press
First printing, Cornell Paperbacks, 1999

Printed in the United States of America

Library of Congress Cataloging-in-Publication Data
Genette, Gérard, 1930–
 [Relation esthétique. English]
 The aesthetic relation / Gérard Genette ; translated by G.M. Goshgarian.
 p. cm.
 Includes bibliographical references and index.
 ISBN)0-8014-3511-0 (hardcover). — ISBN 0-8014-8511-8 (pbk.)
 1. Aesthetics, Modern—20th century. 2. Art—Philosophy.
 I. Title.
 BH202.G4713 1999
 111'.85—dc21 99-31406

Cornell University Press strives to use environmentally responsible suppliers and materials to the fullest extent possible in the publishing of its books. Such materials include vegetable-based, low-VOC inks and acid-free papers that are recycled, totally chlorine-free, or partly composed of nonwood fibers. Books that bear the logo of the FSC (Forest Stewardship Council) use paper taken from forests that have been inspected and certified as meeting the highest standards for environmental and social responsibility. For further information, visit our website at www.cornellpress.cornell.edu.

Cloth printing 10 9 8 7 6 5 4 3 2 1
Paperback printing 10 9 8 7 6 5 4 3 2 1

FSC FSC Trademark © 1996 Forest Stewardship Council A.C.
 SW-COC-098

Contents

Translator's Note

My editorial practice has been as follows: (1) Words enclosed in brackets in the text are my interpolation when they represent a French equivalent. Words placed in brackets in the footnotes are my interpolation when they represent a French equivalent, explain a reference, or provide supplementary bibliographical information. All other bracketed material in the text or notes is Genette's. (2) Words or phrases followed by an asterisk are in English in the original text. (3) All ellipsis points are Genette's. (4) When Genette quotes from a work that has appeared in English, the English text has, when available, been quoted directly. (5) Titles of works of art are given in English, ordinary usage permitting. (6) Translations of French works quoted by Genette are mine unless otherwise indicated.

<div align="right">G. M. G.</div>

Author's Note

THIS BOOK IS A SEQUEL TO *THE WORK OF ART: IMMANENCE AND TRAN-SCENDENCE* (Cornell University Press, 1997). The subject of the earlier work is the modes of existence of works of art, a matter that contemporary aesthetics usually treats as a question of "ontological status," without distinguishing the two categories that give *The Work of Art* its subtitle. On the author's view, this confusion is the source of most of the problems and theoretical dead ends currently encountered in this field. *Immanence* is the way a work is identified with ("consists in") a physical object or event (such as a painting, sculpture, or dramatic or musical performance) or ideal object or event (such as a text or score). *Transcendence* is the set of all the ways a work exceeds this object of immanence.

The first part of *The Work of Art* accordingly deals with the immanence of works. Immanence is examined in its two characteristic regimes, whose names are borrowed from Nelson Goodman: the *autographic regime* is that of works which "immanate" either in a physical object, as works of painting or sculpture do, or in an event or act, like the work of dancers, actors, or performing musicians (works of "performance"). This physical object may be unique, as is usually the case in painting (the *Mona Lisa*) or carved sculpture (the *Venus of Milo*), or multiple (as when several objects are considered, by convention, to be identical), as in engraving or cast sculpture (Rodin's *Thinker*). Works of performance, for their part, have a composite status owing to their iterability: as a singular event, a performance is a physical object, but, insofar as it can be repeated in ways considered identical by convention, it acquires the status of an ideal entity.

That is more typically the status of *allographic* works, such as works of literature, scored music, or architecture based on building plans. In works of this kind, the objects or physical events that a receiver encounters (copies of texts or scores, recitations or musical performances) are occurrences of manifestation (tokens*, in Peirce's sense) which refer us to ideal *types* that receivers construct (more often than not unconsciously) by a process of *reduction* to their artistically pertinent features: for example, the linguistic features of a printed page, to the exclusion of its graphic features, which are either regarded as contingent or assigned to the province

of another art (typography); or the properly musical ("compositional") features of a symphonic performance, apart from those that pertain to the art of interpretation. Allographic works are thus divided into two categories: those with a purely mental immanence (the immanence of a singular ideality, or "ideal individual," in Husserl's sense), and those with physical manifestations that can be infinitely multiplied, using the most widely varied techniques.

The second part of *The Work of Art* deals with the transcendence of works, which proceeds from, basically, three modes:

1. The transcendence due to *plurality of immanence*. This is manifestly the case of works which have "replicas" or "versions" consisting in a number of material objects (Chardin's *Saying Graces*) or ideal objects (the versions of *The Song of Roland*, *The Temptation of St. Anthony*, or *Petrushka*) that are acknowledged to be nonidentical, yet nevertheless gathered up by cultural consensus into the unity of a single work, essentially that of a class (a "genre") regarded by convention as an individual.

2. The transcendence due to *partial immanence*. This characterizes works of which (definitively or for the time being) we encounter only fragments (the *Venus of Milo*, Livy's *History*), or indirect manifestations in the form of reproductions, copies, recordings, descriptions, or documents of various kinds, whether their object of immanence is accessible elsewhere, or, like Phidias's *Athena Parthenos*, has since disappeared. Indirect manifestations are partial, in the sense that they display only *certain* features of a work: thus the colors of a painting do not appear in a black-and-white photograph. In either case, our relationship to the work, though necessarily incomplete, is far from being nonexistent. This shows that a work can function *in absentia*, or by way of a lacunary presence.

3. The transcendence due to *plural reception*. In a celebrated tale, Borges has shown that the same text, produced on two separate occasions three centuries apart, cannot have the same meaning both times, but necessarily gives rise to two different works: Cervantes' *Don Quixote* and the (imaginary) *Don Quixote* by Pierre Ménard. His fable is a metaphor for the inevitable functional plurality of art works' objects of immanence. If a work is defined as an object of immanence *plus* an aesthetic function, then it must be granted that the same text, painting, score, or building, if accorded different receptions (interpretations) depending on period, culture, individual, or occasion, determines, in each new context, a different work. As everyone knows, cubism has "changed" Cézanne for us; Proust has changed Flaubert; Stravinsky has changed baroque music. Hence the examination of these phenomena of transcendence provides a transition between the descriptive study of the (onto)logical status of works and the

study of their properly aesthetic (or *artistic*) function. The latter is the subject of *The Aesthetic Relation*.

Long convinced that, because literature is (also) an art, poetics is a province of aesthetics, the author of *Palimpsests* here sets out to broaden his field of inquiry by moving to the (logically) next highest level. His sole aim is to gain a clearer vision of the subject and a better grasp on it, while communicating, if possible, such progress as he may have made in the comprehension of things literary and, more generally, artistic.

Introduction

THE PAGES THAT FOLLOW ARE ABOUT THE AESTHETIC RELATION to works of art, a relation I will also be calling, more succinctly and for reasons that will appear in due course, the *artistic function*—though I am not unaware that most works of art have a number of other functions as well, and that many objects which are not works of art can also trigger aesthetic responses, possibly more intense.[1] I say "trigger," but not *solicit*, because the specific and, therefore, defining feature of works of art is, as I see it, that they proceed from an aesthetic *intention*, and accordingly perform an aesthetic function, whereas other sorts of things can at best elicit a purely attentional aesthetic *effect*. A *defining* feature: that is precisely what the properties relative to art's modes of existence (which we have already discussed)[2] are not, because neither their regimes of immanence nor their modes of transcendence are characteristic of art alone. The humblest piece of workaday pottery, no less than the *View of Delft* or the *Winged Victory of Samothrace,* belongs to an autographic regime with a single exemplar; every last press photo and piece of cast sculpture belongs, like Rodin's *The*

1. To cite Mikel Dufrenne yet again, "a church can be beautiful although it has not been deconsecrated, a portrait, even if we have not yet forgotten who sat for it" (*Esthétique et philosophie,* vol. 1 [Paris: Klincksieck, 1980], p. 29).

2. Gérard Genette, *L'œuvre de l'art,* vol. 1: *Immanence et transcendance* (Paris: Seuil, 1994) [tr. *The Work of Art: Immanence and Transcendence,* trans. G. M. Goshgarian (Ithaca: Cornell University Press, 1997)]. As the present volume is the sequel to *The Work of Art,* I shall have to refer my readers to its predecessor from time to time. I would ask them not to take this as a sign of self-satisfaction; the fact is that my references to the earlier volume sometimes carry a touch—doubtless insufficient—of self-criticism.

Thinker or Dürer's *Melancholia*, to the autographic regime with multiple objects; the crudest prospectus belongs to the same allographic regime as the most beautiful literary or musical works. In their different ways, the processes of repetition or emendation, lacunary or indirect presentations, and the transformations worked by time also affect all kinds of objects, material or ideal, which lie wholly outside the province of art. The final mode of transcendence, that arising from functional plurality, might seem more specific to art, precisely because it involves the artistic function, and, thus, the fact that an object has the status of a work. Yet what might be called the *genetic effect*, or, after Borges, the *Ménard effect*—the fact that the meaning or value of an object varies with the source to which it is ascribed—is by no means confined to works of art alone: the meaning of the least little thing we do or say depends, to some extent, on who does or says it and the situation (historical, social, sexual, legal, etc.) he finds himself in. What is uniquely characteristic of works of art is their intentional aesthetic function, that is, their artistic function. To put it in more subjective terms, what endows an object with the status of an artwork in the eyes of its receiver is the impression, warranted or not, that it proceeds from an intention that was at least in part aesthetic. Of course, a work that is not received as such can produce the same kind of aesthetic effect as an "ordinary object"—or none at all, as when, going into a public building to attend to some administrative chore, I give no thought to when it was built or its architectural style.

In my estimation (we will have occasion to consider the opposite view), the real difference between that kind of intentional function and the merely attentional aesthetic relation we may have to other objects, natural or man-made, does not necessarily imply any difference in value, or even in intensity, between the effects they produce: contemplating a landscape can often yield pleasure as (or even more) intense,[3] and, if this adjective means anything, as "exalting" as that produced by looking at a painting or listening to a symphony. (Unlike Kant, I do not go so far as to maintain that only the appreciation of "the beauty of nature" accords with

3. "He walked past several pictures and was struck by the aridity and pointlessness of such an artificial kind of art, which was greatly inferior to the sunshine of a windswept Venetian palazzo, or of an ordinary house by the sea" (Marcel Proust, *La prisonnière*, in *A la recherche du temps perdu* [Paris: Pléiade, Gallimard, 1988], vol. 3, p. 692 [tr. *The Captive*, in *Remembrance of Things Past*, trans. C. K. Scott Moncrieff and Terence Kilmartin (New York: Random House, 1981), vol. 3, p. 185]). ["The sunshine of a windswept Venetian palazzo" is Moncrieff's and Kilmartin's translation of *les courants d'air et de soleil d'un palazzo de Venise*, literally, "currents of air and of sunshine of a Venetian palazzo." Genette makes the following comment on the French:] I grant that a current of air is not exactly an aesthetic object—but would we say the same about a *current of sunshine*?

"the moral feeling.")[4] The difference between the "ordinary" aesthetic relation and the artistic relation[5] turns, to repeat, on the presence or absence of an intentional factor and on the various effects that factor inevitably produces; these account for the complexity of the artistic relation. But "simple" aesthetic relations are not lacking in complexity either, though it is of a different order: the complexity of a relation doubtless depends on that of its object, multiplied, if I may put it this way, by that of its subject. This very quickly runs us up into fairly big numbers.

The idea that the artistic function is merely a special case of the aesthetic relation implies, it seems to me, that we should consider the latter in its generality before turning to the former in its particularity. The first two chapters of this book will accordingly be devoted to the aesthetic relation in general; we will be discussing two interrelated but distinct aspects of it, which I call *attention* and aesthetic judgment. This is not to say that the first two chapters will not mention works of art at all, but it *is* to say that they will not take the artwork's functional specificity into account. Thus I will consider, as the occasion offers, our relation to works of art, but only to the extent that it has something in common with our aesthetic relation to ordinary objects. Among these common points is, for example, the fact that we can appreciate both ordinary objects and art works aesthetically, even if artistic appreciation differs in many respects from ordinary aesthetic appreciation, as will appear in the third and final chapter: a piece by Webern does not appeal to me in the same way as the Matterhorn does, even if I like both (aesthetically speaking). These two kinds of pleasure must, then, have something in common, and it is perhaps best to begin with that. The reason for proceeding in this order is, obviously, not axiological, but logical and methodological.

I should doubtless note at this point that my discussion will proceed largely by way of an examination of positions held by writers before me, from Hume and Kant to Vivas, Beardsley, Goodman, Danto or Walton, and one or two others. My assessment of their works, now positive, now negative, and generally both at once, has enabled me to refine and articulate positions that, I feel sure, were no less mine, in some sense, before my

4. Immanuel Kant, *The Critique of Judgement*, in *Kant's Critique of Aesthetic Judgement*, trans. James C. Meredith (Oxford: Clarendon, 1911), §42, pp. 157–162.

5. In discussing works of art, I shall be using "function" and "relation" more or less interchangeably. The sole difference in meaning resides in the fact that the word "function" carries a strong connotation of intentionality. Thus we can speak indifferently of a work's aesthetic function or of the aesthetic relation we have to the work; that relation is necessarily artistic *if* we perceive the work's intention. However, it seems to me inappropriate to speak of the aesthetic *function* of a natural object, which does not *set out* to produce the effect it does.

various responses to these thinkers helped me become more fully aware of them. What Michael Baxandall has shown to hold for artistic "influences" is true of intellectual filiations as well:[6] each of us, in choosing his intellectual authorities and foils, reveals and indeed *discovers* his own underlying choices, which critical argument and the comments of others permit him to confirm and motivate, or, perhaps, devise rationalizations for, even if the subjects we will be dealing with here are more a matter of individual or collective opinion, as I see it, than of apodictic certitude and rational demonstration. I can already foresee the disadvantages of thus inching along from one reference to another, from approbation to refutation and hypothesis to counterargument. In any case, let me clearly state, if that were necessary, that my object is in no sense historical. To the extent that a fairly haphazard library permitted, I have taken from the literature of aesthetics and the theory of art whatever served to stimulate my own thinking, if only *a contrario;* but I have also turned to art history and criticism for accounts of the aesthetic response,[7] since such accounts are not as readily furnished by everyday reception, which is often mute or barely articulate. The massive or partial absences which leap to the eye in the pages that follow are not all "lacunas"; they are more often signs of selective, and frankly biased, attention. It will soon become evident that the selectivity at work here operates in favor of analytic contributions, in the Kantian or modern sense of the word; to my mind, they have the merit of putting forward propositions which, whether or not one agrees with them, are at least intelligible. The same selectivity has tended to filter out the ponderous tradition Schopenhauer calls "the metaphysics of the Beautiful," and Jean-Marie Schaeffer, aptly, the "speculative theory of art."[8] In this tradition, stretching from Novalis to Heidegger or Adorno, and, consequently, a bit beyond, I generally find nothing but unverifiable affirmations, rather heavily laced with the ideology of antimodernism, together with celebrations of art's revolutionary subversiveness or exalted glorifications of its power to make ontological revelations.[9] One can, perhaps, do art no greater disservice than to overestimate its role by counterposing it, in a

6. Michael Baxandall, *Patterns of Intention: On the Historical Explanation of Pictures* (New Haven: Yale University Press, 1985), pp. 59–60, previously cited in Genette, *L'œuvre de l'art*, p. 284 [*The Work of Art*, p. 254].

7. But nothing else. Unlike, for example, Monroe C. Beardsley, I by no means take aesthetics to be the "philosophy of [professional] criticism"; for me, it is the analysis of ordinary aesthetic reception. Cf. Beardsley, *Aesthetics: Problems in the Philosophy of Criticism*, 2d ed. (Indianapolis: Hackett, 1981).

8. Jean-Marie Schaeffer, *L'art de l'âge moderne: L'esthétique et la philosophie de l'art du XVIIIᶜ siècle à nos jours* (Paris: Gallimard, 1992).

9. It would be doing Hegel something of an injustice to reduce him to such formulas, which the grandeur of his thought transcends. The fact remains, however, that he grants

way smacking of obscurantism, to that of science or technology, and by unwarrantedly assimilating its message to philosophy's—even if the complementary and inverse complaints (which derive, negatively, from the same expectation, once it has been disappointed) about art's inability to "make" anything at all "happen,"[10] put right Auschwitz and Hiroshima, or make up for the death of a child seem to me a little naive and, all things considered, out of place—as if a cobbler were to apologize for being unable to bring about a solar eclipse. "Making things happen" is not art's function; anyone who wants materially to change the state of the world should proceed differently—at the risk, let us add, of failing differently, or of "making" something other than what he meant to "happen." As a branch of general anthropology, which it necessarily is, aesthetics (I will doubtless come back to this point) is not called upon either to justify or excoriate the aesthetic relation; its function is, if possible, to define, describe, and analyze it. It should be added that the pages that follow, even when taken together with those that precede, by no means pretend to cover the whole of the field designated by the term "aesthetic relation" or by the general title[11] of these two volumes.[12] I wish simply to explore, as best I can, what little I have grasped of the subject.

art an axiological privilege ("the beauty of art is *higher* than nature. . . [because] the beauty of art is beauty *born of the spirit*"), and also a logical monopoly (aesthetics, as Hegel defines it, "deals not with the beautiful as such but simply with the beauty of art") vis-à-vis (indeed, in opposition to) any other kind of aesthetic relation, which amounts to reducing the aesthetic to the artistic. These two positions seem to me equally untenable. See G. W. F. Hegel, *Aesthetics: Lectures on Fine Art*, trans. T. M. Knox (Oxford: Clarendon, 1975), vol. 1, pp. 9–10. As to the apparently far-fetched association of Heidegger's name with Adorno's, I believe it is warranted at this level by the symmetry between their two antithetical ways of overestimating the powers of art, although it is true that Adorno sometimes nuances what he has to say on the subject, because he is more sensitive to the fact that even the most "critical" works are "neutralized" as a result of their co-optation by society—"bourgeois society," of course. See, for example, Theodor W. Adorno, *Aesthetic Theory*, trans. C. Lenhardt, ed. Gretel Adorno and Rolf Tiedemann (London: Routledge and Kegan Paul, 1984), p. 325.

10. The sentence of Auden's tacitly evoked here reads, more precisely, "*poetry* makes nothing happen." See Arthur Danto's generally sound comments in chap. 1 of *The Philosophical Disenfranchisement of Art* (New York: Columbia University Press, 1986), pp. 1–21.

11. [Unlike the two volumes of the English translation, the two volumes of the original French work both bear the same title, *L'œuvre de l'art.*]

12. Its title notwithstanding, my essay, "La clé de Sancho," *Poétique* 101 (1995): 3–22, contains the whole of the present volume in embryo. After that essay was written, Jean-Marie Schaeffer published *Les célibataires de l'art: Pour une esthétique sans mythes* (Paris: Gallimard, 1996). I share a great many of the views expressed in Schaeffer's book, and will have more than one occasion—and reason—to cite it below.

CHAPTER I

Aesthetic Attention

ONE DAY, THE STORY GOES, IT SUDDENLY OCCURRED TO Courbet, as he was working on a landscape, that he had for some time been painting a distant object without knowing what it was.[1] He dispatched an assistant to go find out. The assistant came back and said, "You've been painting a pile of sticks." Courbet had, then, been painting an "unidentified" object; but he was not unduly troubled by the fact, because, as a painter, his business was not with the identity of the object ("what is it?")—and even less with its function ("what purpose does it serve?")—but rather with its outward appearance, its *aspect*—its contours and colors: "what does it look like?"

"Identity" is perhaps too broad a term for what this anecdote has Courbet neglecting, for the aspectual properties he focuses on can by themselves serve to identify the object in question, if only by contradistinguishing it from another object with a different aspect: that brown thing

1. Cézanne to J. Gasquet, cited in P. M. Doran, ed., *Conversations avec Cézanne* (Paris: Macula, 1978), p. 119. In another version of the story, the assistant identifies the object, not by going and looking at it, but by more attentively examining the detail of the picture in which the painter is supposed to have faithfully represented it without recognizing it. "I didn't need to know what it was," this version has Courbet say, "I painted what I saw without realizing what I was painting." Then, stepping back to survey his canvas, he adds, "Why, it really was a pile of sticks." Francis Wey, "Notre maître peintre Gustave Courbet," in Pierre Courthion, ed., *Courbet raconté par lui-même et par ses amis: Ses écrits, ses contemporains, sa postérité*, vol. 2 (Geneva: Pierre Cailler, 1950), pp. 190–191. For our purposes, the two versions of the story have the same moral: in certain cases, one can perceive and "faithfully" represent something without first identifying it.

over there, as distinct from that red thing right next to it. But I use the term "identity" in the narrower, stronger sense of generic identity, the sense it has in any number of ordinary classificatory systems, whether scientific or practical: this thing is a stick, that is, it belongs to the well-known class—which happens to be a class of practical objects—of sticks. An "unidentified flying object" is obviously unidentified in that specific sense: I can see it is something which flies and identify it as such, and also as, say, something round; I do not, however, know what technical category to put it in.

Again, I do not claim that every painter goes about things the way Courbet does in our anecdote—which is, indeed, somewhat suspect, since it obviously assimilates Courbet's style to one more characteristic of his "student" Whistler (who soon shook off his master's tutelage) or of his impressionist successors[2]—though this approach had already been described in a line attributed to Turner: "My business is to draw what I see, not what I know."[3] Moreover, if I bring up the anecdote, I do so not to illustrate an artistic practice, but rather because it is emblematic of a type of attention—perception without practical identification—characteristic of aesthetic experience, and, even, perhaps, somewhat more characteristic of our aesthetic relation to natural objects than to works of art.[4] I am of course not claiming that *every* aesthetic relation implies that we suspend our interest in identifying an object and neglect the means that can help us do so; I can contemplate (and appreciate) a tree from an aesthetic point of view without being unaware that it is a tree, or even a chestnut tree, or

2. Pierre Francastel, *Art et technique au 19ème et au 20ème siècles* (Paris: Minuit, 1956), p. 146, is inclined to use the anecdote that way: "This anecdote goes to show that the principle of the destruction of the object already informs the way Courbet sees, though it does not inform his style, inasmuch as he takes pains to provide the viewer perfectly legible objects. When this legibility is consistent with adding a patch of color to certain parts of the canvas so as to balance the painting, refrains from making the detail explicit, but he does not deduce a general aesthetic principle from this observation. His vision is more modern than his theory."

3. Marcel Proust, citing John Ruskin in the Preface to the French translation of Ruskin's *The Stones of Venice*, in *Contre Sainte-Beuve*, preceded by *Pastiches et mélanges* and followed by *Essais et articles* (Paris: Pléiade, Gallimard, 1971), p. 121. Proust describes, in much the same terms, "the effort made by Elstir to reproduce things not as he knew them to be but according to the optical illusions of which our first sight of them is composed," because "what one knows does not belong to oneself." *À l'ombre des jeunes filles en fleurs*, in *À la recherche du temps perdu* (Paris: Pléiade, Gallimard, 1987), vol. 2, pp. 194, 196 [tr. *Within a Budding Grove*, in *Remembrance of Things Past*, trans. C. K. Scott Moncrieff and Terence Kilmartin (New York: Random House, 1981), vol. 1, pp. 897, 898]. There is surely no need to recall how and to what degree Walter Gombrich's analyses in *Art and Illusion: A Study in the Psychology of Pictorial Representations*, 2d ed. (Princeton: Princeton University Press, 1969) encourage us to relativize this simplistic dichotomy.

4. I will come back to this distinction in the last chapter.

even the chestnut tree my grandfather planted back in 1925. Indeed, that is the most common state of affairs. All I wish to affirm is that the aesthetic relation *can*, in extreme cases, forego such generic, specific, or unique identification: "I do not know what it is, but it certainly is beautiful." Again, I am not claiming that the aesthetic relation is the only one that can do without such identification: if I want to drive in a nail, I can hastily grab the first object that comes to hand without knowing what it is. Yet how successful my act is will depend, at a minimum, on one or another nonvisual property (weight, hardness) of the object I happen to grab. This property, then, designates that object, and thus identifies it, in the practical sense, as something that will serve—as something belonging to the class of objects capable of serving—as a hammer: a potato will not turn the trick as readily as a rock that resembles it. On the other hand, when it comes to (modestly) decorating my mantelpiece or figuring in a still life, these two objects can be treated, at least for a while, as more or less equivalent. In this case, only their common aspect interests me.

I will therefore use the word "aspectual"[5] to refer both to the properties mobilized in this type of relation and to the kind of attention that mobilizes them. Our temporary recourse to this adjective is dictated by a consideration that will become clearer somewhat further on, but that I will, for now, describe as follows: this type of attention is necessary to establish an aesthetic relation, but not sufficient to define one. The example just given can serve to illustrate this insufficiency. If someone shows me the potato and rock in question and asks me if I can tell them apart just by looking, I will pay the same kind of attention to both (I will examine only their aspect); however, the relation this attention invests will not be aesthetic, but rather, let us say, purely cognitive. In my opinion, what prevents us from legitimately calling such attention aesthetic is the fact that it does not involve appreciation, and does not even propose to produce an appreciation. By appreciation, I mean the act of judgment a different type of question would doubtless solicit here: "Of these two objects, which would you rather see on your mantelpiece?" Should my rock and potato seem rather vulgar as examples go, here is a more elegant one. If I ask an expert to make an attribution of a painting without using any technical apparatus, such as X-ray equipment, he would have nothing to carry his in-

5. Rather than "formal"; although Kant uses this term, its connotations seem to me too narrow. Thus "formal" tends to make us think of, say, the shape of a visual object, although our aesthetic judgment of the object depends just as much on its color or what it is made of. "Perceptual" might appear to be the more appropriate term, but it is in fact too restrictive, for a different reason that we will discover in due course.

vestigation out with beyond his eyes, which may, moreover, suffice in certain cases, at least when it comes to making an approximate statement of the type, "if it's not a Corot, it's a good imitation." The expert would accord my painting the same kind of attention as would the ordinary art lover who was merely seeking pleasure, at least in the sense that his attention would be focused on the visual aspect of the object; yet this attention would be made to serve a different end. If I were now to ask him his opinion of the painting, all questions of attribution aside, the "same attention" would not, of course, change its object, but the end it was directed to *would* change. Thus aspectual attention, which I define by its choice of object (here, the visual aspect of this potato, rock, or painting), can determine, or enter into, at least two distinct types of relation, of which only one is aesthetic in the true sense. That is why I do not hasten to call aspectual attention as such aesthetic. Let us say for the moment that aspectual attention is a condition, necessary but not sufficient, of the aesthetic relation, which is established only if another condition is also fulfilled: that of aesthetic judgment—or perhaps, more precisely or more simply, the *question* of aesthetic judgment. It would follow that aesthetic attention should be defined as aspectual attention informed by, and oriented toward, a question of aesthetic judgment—or (but this comes to the same thing) should be defined as a question of aesthetic judgment ("Do I like this object . . .) posed on the basis of an act of aspectual attention (". . . because of its aspect?" and not because, say, ". . . it makes life easier?"). Needless to add, I will have occasion to return to this point: it is the very essence of what interests us here.

I have justified the use of the adjective ("aspectual") before that of the noun ("attention"), which, however, also needs to be justified, since it may have as many disadvantages as advantages. Its main disadvantage leaps to the eye: "attention" in the usual sense suggests intense, rigorous perceptual activity, whereas the kind of perception we are concerned with for the moment may be cursory, synthetic, or even distracted. An encounter with an object can give rise to aesthetic appreciation, or even, perhaps, very intense aesthetic appreciation, even if the object has not first been subjected to a particularly "attentive" examination—as when, for example, I am so taken by the form and finish of an antique that I buy it because I have foolishly "fallen in love with it," without so much as checking out its dimensions to see whether I can get it through my door. *Attention* as I use it here is symmetrical with *intention*. The production of an object—a work of art, for example—by a human being always proceeds from an intention in the usual (and strong) sense of the word; the reception of an object, even a natural object, which, in principle, is not intentional in

this first sense, proceeds from an activity that *can* be described as "intentional" in the Husserlian (and Searlian) sense.[6] This second sense, broader and therefore weaker than the first (albeit more technical), refers, in sum, to any deliberate "consideration" [*visée*] of an object (and not merely of a goal); it seems to me simultaneously to comprehend the two distinct phenomena we call the intentional (in the strong sense) activity of a producer, and the activity (intentional in the broad sense) of a receiver, whether or not the latter activity corresponds to a producer's intentions. In this sense, every perceptive or cognitive activity counts as intentional. In order to distinguish the two kinds of intentionality, and to mark the absence, in the latter, of any "intention" (in the strong sense) directed toward a goal to be attained, I suggest we use the word "attention" to designate this latter, weaker sense.[7] Unsurprisingly, I will call every activity of this kind, and every object such activity bears on, "attentional." "Aesthetic objects" are, first of all, attentional objects, that is, objects of attention; an object which is not (now) attentional for someone cannot (now) be "aesthetic." The all too familiar term "aesthetic object" must therefore be employed with caution: it has the doubtless considerable merit of extending the field of the "aesthetic" beyond that of works of art alone, but it too readily suggests that certain objects "are" aesthetic (i.e., possess the objective, permanent, and apparently positive property of "being aesthetic"), whereas others are not (do not possess this property). That idea, as I see it, is simply meaningless, unless one construes "object" to mean, by ellipsis or metonymy, "something that is (now) the object of aesthetic attention and judgment," in which case the adjective "aesthetic" is, here, not "dispositional," but re-

6. See John Searle, *Intentionality: An Essay in the Philosophy of Mind* (Cambridge: Cambridge University Press, 1983), especially chap. 1, "The Nature of Intentional States," pp. 1–36, which clearly distinguishes the two senses of the word. Searle uses "Intentionality" (with a capital *I*) to refer exclusively to the broad sense: "Intentionality is that property of many mental states and events by which they are directed at or about or of objects and states of affairs in the world" (p. 1); "intending to do something" is simply a special case of Intentionality. Jean-Marie Schaeffer takes the same position (see Schaeffer, *Les célibataires de l'art: Pour une esthétique sans mythes* [Paris: Gallimard, 1996], pp. 65–77). For Schaeffer, "Intentionality" in the broad sense is relevant to the definition of the work of art in a way it shall not be here; given the vantage point I have adopted, the word "attention" suffices to designate this broad sense. *A contrario*, I use "intention" and its derivatives, "intentional" and "intentionality," in the ordinary sense of subjective *end purpose*, objective, or design. An artist's *aesthetic intention*, a matter we will consider briefly in Chapter 3, consists essentially in making a bid for aesthetic attention (or reception).

7. In my *Fiction et diction* (Paris: Seuil, 1991) [tr. *Fiction and Diction*, trans. Catherine Porter (Ithaca: Cornell University Press, 1993)] and *L'œuvre de l'art*, vol. 1: *Immanence et transcendance* (Paris: Seuil, 1994) [tr. *The Work of Art: Immanence and Transcendence*, trans. G. M. Goshgarian (Ithaca: Cornell University Press, 1997)], I made use of this term and its derivatives without further ado. "Attention" is employed in both books in the same or in closely

sultative—it is not the object that makes the relation aesthetic, but the relation that makes the object aesthetic. The object that I am *now* contemplating (or thinking of) from an aesthetic point of view is *now*, and *in that sense*, an aesthetic object; in that sense and no other, unless, perhaps, the object is not a work of art, and one considers works of art (alone) to have the privilege of being permanently, constitutively, and even in the absence of all attention—aesthetic objects. That can doubtless be argued, but I am not certain it is necessary; I would be rather more inclined to say that works of art are permanently (etc.) *works of art*. But even that is very much open to discussion. In any event, we are not there yet.

Thus what the story about Courbet's pile of sticks is meant to illustrate here is the fact that attention can be superficial and indifferent (even if only temporarily) to the practical function, generic identity, or formal details of an object, while still sufficing to provide a basis for aesthetic appreciation. In a word, I do not believe that aesthetic appreciation presupposes exhaustive and, as they say, "thoroughgoing" examination of an object, for such judgment can be brought to bear, and quite intensely at that, on the most cursory and immediate sort of consideration, which, by definition, suffices to provide it with *an* object, even if this (attentional) object is only one aspect, and an indistinctly perceived one at that, of the thing in question. An exchange like the following: "Do you like this object?" "I don't know yet, I haven't examined it closely enough"—seems to me highly improbable, because it is contrary to the very nature of the aesthetic relation; however rapidly and superficially I may have examined an object, the act of examining it provides me with an object of appreciation, or, if you prefer, I judge what I have already examined, without waiting to examine it more attentively. That subsequent examination, if it takes place, may modify my appraisal by modifying its object, or even contradict it outright; but my initial appraisal, based on, and relative to, my initial examination, was, in this relation, just as legitimate as the subsequent one(s). Thus the sincere answer to the question posed above is either "yes," "no," or, perhaps, a noncommittal evaluation like "it leaves me neither hot nor cold"; the prudent answer would be something like "yes," "no," or "it leaves me neither hot nor cold . . . *at the moment*." Appreciation may be provisional and often is; it is sometimes even consciously so; but it may not be suspended in the sense of being *deferred*. My feeling can change, but it is fully, at every moment, my feeling of the moment. I do

related senses; they are, luckily, compatible with the one I assign it here. (In *Fiction et diction*, p. 131 [*Fiction and Diction*, p. 121], "attentional" is counterposed to "constitutive" and treated for all intents and purposes as a synonym of "conditional.")

not wait to find out if I will or will not like something, whatever it is, to-morrow, in order to like it or not today.

Beschaffenheit

What I call aesthetic attention (aspectual attention oriented toward aesthetic appreciation) is defined or, at any rate, described by Kant under a more general rubric, which he sometimes refers to as "aesthetic judgement," but more frequently calls "the judgement of taste" (*Geschmacksurteil*).[8] I say that this category is "more general," because, in the *Critique of Judgement*, the concept of "judgment" covers both the act of appreciation and the perceptual activity leading up to it,[9] although the accent is put, if only through the use of the term judgment, on the act of appreciation. It would perhaps be fairer to say that I am responsible for introducing, with the notion of attention, a distinction that is not made, or called for, in Kant's own analysis. However that may be, at least one of the traits examined in the "Analytic of the Beautiful" pertains, from our standpoint, to aesthetic attention. It is one of the two traits elucidated in the "First Moment" of the "Analytic of the Beautiful," entitled "Of the Judgement of Taste: Moment of Quality." It might seem odd to speak of two traits here, since, traditionally, commentators single out only one, i.e., that "the delight which determines the judgement of taste is independent of all interest" (*ohne alles Interesse*), or, more briefly, "disinterested." But there is another; it is the subject of the whole first subsection, and seems to me altogether essential. I mean the proposition that "the judgement of taste is aesthetic" (this is the heading of the subsection).

Since Kant, as is well known, uses the term "judgement of taste" to refer to what we call aesthetic judgment or appreciation, this formula might seem totally redundant or superfluous. But it is not. Kant is here using "aesthetic" to describe the purely subjective nature of appreciation, which judgments of taste fully share with judgments of "pleasure," or

8. This is the more precise term—but I am still simplifying matters, for the apparatus of the third *Critique* is decidedly no model of coherence (Immanuel Kant, *The Critique of Judgement*, §1–60, in *Kant's Critique of Aesthetic Judgement*, trans. James C. Meredith [Oxford: Clarendon, 1911], p. 40). "Aesthetic judgement" is the term used in the title of Part I and in those of its two sections ("Analytic" and "Dialectic"), while the term "judgement of taste" is used in the titles of two of the four "moments" of the "Analytic" as well as in the headings of their individual subsections.

9. See Jean-Marie Schaeffer, *L'art de l'âge moderne: L'esthétique et la philosophie de l'art du XVIIIᵉ siècle à nos jours* (Paris: Gallimard, 1992), p. 384, as well as the whole first chapter, "Prolégomènes kantiens," pp. 1–84, and the "Conclusion," pp. 341–387.

physical satisfaction—for example, the pleasure one takes in savoring a glass of Canary wine. Because this first trait, involving "quality," has (in my view) more to do with appreciation, I will leave it aside for now, although we will, of course, encounter it again. What is of concern to us here is the trait which fundamentally differentiates aesthetic judgment from the judgment of pleasure: namely, the second trait (the topic of subsections 2 through 5)—the disinterested nature of what Kant calls delight, and what I call aesthetic attention. Kant's use of the term "disinterested" has often been contested, in part because everyone knows that aesthetic appreciation of an object creates a certain "interest" in it, leading, often enough, to a desire to own it. Kant does not concern himself in the least with this last point, perhaps because his inquiry bears mainly, or typically, on our relation to natural "aesthetic objects," which less often excite a desire for ownership, if only because of the often manifest impossibility of realizing it (no one can hope to "own" the heavenly vault).[10] For Kant, however, "disinterested" quite obviously means "which is not determined by any" rather than "which determines no" interest,[11] and the interests that aesthetic appreciation may engender do not have any bearing whatsoever on his analysis. The main difficulty has to do with the fact that Kant seems (if only by virtue of the title of §2), to ascribe the "disinterestedness" in question to the *satisfaction* procured by the object (and to the "judgment" that articulates it), not to the way one considers the object. This ascription is consistent with the tradition the third *Critique* belongs to, an essentially English tradition that harks back to Shaftesbury (and, by way of Shaftesbury, to Plato). For Shaftesbury, aesthetic pleasure is distinguished from the other kinds in virtue of a paradoxical feature: it is a pleasure in which no personal interest is involved.[12] Kant somewhat mechanically borrows this notion and the term that is its vehicle (as he will later borrow from Burke the notion of the sublime, reshaping it to his own ends), but the de-

10. Although works of performance, or works with an ideal object of immanence (literary or musical works, for instance) do not accommodate a desire for ownership any more readily; in the best of cases, one can own more or less indirect manifestations of them. Incidentally, the value one confers upon these indirect manifestations can be independent of the value of the works in question (consider the case of the bibliophile, the record collector, etc.).

11. A note to §2, pp. 43–44, would appear to confirm this; it spells out that "a judgement upon an object of our delight may be wholly *disinterested* but withal very *interesting*." But this note is not distinguished by its clarity. The phrase that precedes the sentence just cited seems to apply to moral judgments; as for judgments of taste, they can "set up an interest," but the interest involved is the advantage that redounds to someone "in society" who "has good taste."

12. See Anthony Shaftesbury, *Characteristics of Men, Manners, Opinions, Times,* ed. J. M. Robertson (Indianapolis: Bobbs-Merrill, 1964). See also Jeremy Stolnitz, "On the Significance of Shaftesbury in Modern Aesthetic Theory," *Philosophical Quarterly* 11 (1961): 97–113, and "On the Origins of 'Aesthetic Disinterestedness,'" *Journal of Aesthetics and Art Criticism* 20 (1961): 131–143.

tail of his analysis shows, to a certain extent against his own intentions, that what is disinterested is not the nature of the pleasure (or displeasure) that an object gives rise to, but rather the nature of the attention bestowed upon it in the aesthetic relation. The crucial point is that we remain indifferent to the real existence of the object—to the question whether "we, or anyone else, are, or even could be, concerned in it"—and content ourselves with merely contemplating it. "If anyone asks me whether I consider that the palace I see before me is beautiful . . . , all one wants to know is whether the mere representation of the object is to my liking, no matter how indifferent I may be to the real existence of the object of this representation." Plainly, it is this "mere representation"—not the pleasure (or displeasure) it causes—that can be described as "contemplative," the adjective which is applied somewhat further on to the judgment of taste (in the twofold sense of the word I mentioned a moment ago): "contemplative" in that "it is a judgement which is indifferent as to the existence of an object, and only decides how its character [*Beschaffenheit*] stands with the feeling of pleasure and displeasure."[13]

What Kant calls *Beschaffenheit* obviously corresponds to what I call aspect, while the attention directed to *Beschaffenheit* is my "aspectual attention." Such attention is "indifferent as to the existence of its object" and "without reference to the faculty of desire," in the sense that it can just as easily be brought to bear on fictitious objects, like fictional characters or worlds; "virtual" objects, like the holographic images in "The Invention of Morel"; mirror images (Narcissus seduced by his own reflection in the water); icons (Tamino enamored of Pamino after gazing at her portrait);[14] or even pure illusions: after several days of wandering in the desert, the mirage of a lush green oasis doubtless provides me no physical satisfaction, but the aesthetic pleasure I might take in contemplating it (assuming I can find the time) will not be a whit diminished by my knowing that it is a hallucination. For an object to sustain, by its own action, physical pleasure (I do not say physical desire), it is absolutely necessary that that object exist; but the mere appearance of an object suffices to sustain aesthetic pleasure,

13. Kant, *Critique of Judgement*, §5, p. 48.

14. In each of these three examples, obviously chosen to make a point, I am interested only in the aesthetic aspect ("seduction") of an amorous attraction—which, to be sure, goes on to provoke a sometimes dangerous *desire* for the "real existence" of its object. The historical or fictional theme of the man who sees a portrait and promptly falls head over heels in love—generally at first sight*—is, of course, universal. Thus Richard II is supposed to have fallen in love with the portrait of Isabelle of France, Charles VI with that of Isabella of Bavaria, and Philip the Good with that of a Portuguese princess (see Johan Huizinga, *The Waning of the Middle Ages: A Study of the Forms of Life, Thought, and Art in France and the Netherlands in the XIVth and XVth Centuries*, trans. F. Hopman [Garden City, N.Y.: Doubleday, 1954], p. 235). In such cases, however, the situation is very similar to that in which one picks out a woman, to matrimonial or other ends, after flipping through an illustrated catalogue.

because aesthetic judgment bears solely on appearance. This circumstance is illustrated, *a contrario*, by the obviously intentional humor of Mark Twain's one-liner—"I have been told that Wagner's music is better [*plus beau*] than it sounds"—inasmuch as being beautiful is nothing other than looking or sounding beautiful. And, incidentally, it is this circumstance, and this circumstance alone, which differentiates aesthetic judgments from judgments of pleasure (whose "aesthetic," that is, purely subjective, nature they share), and which, consequently, rounds off the definition of aesthetic judgment: it is "aesthetic" (subjective), like the judgment of pleasure, but, at the same time, "disinterested" or "contemplative." These two traits suffice to define it in terms of the *genus proximum* (subjectivity) and *differentia specifica* (the fact that it is contemplative), to use Scholastic terms.

But I am proceeding a bit too hastily, for this definition takes into account only the "First Moment" of the "Analytic of the Beautiful"; there are three others. My justification for this haste is that the first moment is, in the terms (traditional since Aristotle) of Kant's Analytic, that of *quality*, which one might well hold to be essential to a definition.[15] The following moments, "quantity," "relation," and "modality," are here, perhaps, accessory or redundant. We will meet the second and the fourth again in connection with Kant's discussion of aesthetic judgment. Their function, on my view, is to rectify the first trait of the first moment (subjectivity); in other words, to allow Kant to exempt it from what is, for him, an unwelcome consequence, the *relative nature* of the judgment of taste. A great deal of ink has been spilled over this third moment; I will not spill much more. Kant here discusses, let us recall, the " 'relation' of the ends brought under review in judgements [of taste],"[16] and thus the status of "finality" in the aesthetic relation. The answer to the question as to the status of aesthetic finality, as everyone knows, is that the finality perceived in the aesthetic relation is a "finality without a purpose"—or, to quote the "definition derived from this third moment" literally, the fact that "*beauty* is the form of *finality* of an object, so far as perceived in it *apart from the representation of a* [determinate] *end*." This is not an overly limpid formulation (whence the ink spilled over it, which has hardly made it clearer). More-

15. Be it recalled that the definition "derived from the first moment" leaves aside the trait of "subjectivity," and also that it is put forward as a definition of the *beautiful*. However, the definition is cast in the following very subjectivizing terms: "The object of such a delight is called *beautiful*." The emphasis on "beautiful" is Kant's. "Called" should be emphasized as well; it is, I would argue, this word that makes the definition subjectivist. The crucial consideration is that the delight in question here be disinterested; beautiful is simply the predicate that *is attributed* (by whom? the aesthetic subject? the philosopher himself?) to its object. I will take this point up again in the next chapter.

16. The inverted commas in the title of the "third moment" (a sign of embarrassment?) are provided by Kant himself.

over, the six subsections it forms the conclusion to are something of a hotch-potch: one has the impression that Kant feels he must at all costs say something about the moment of "relation," and that he acquits himself of the task as best he can, just as, not so long ago, the *agrégatif* slogged through this or that part of his three-part exam essay, for better or worse. (There are four parts in the present instance.)[17] But I am doubtless exaggerating: the most significant statement in this section is to be found, it seems to me, in §15, where Kant emphatically declares that "the judgement of taste is entirely independent of the concept of perfection." Indeed, taking a subjective purpose into account would obviously contravene the "disinterestedness" of aesthetic attention. As to objective finality, it can be either external—which gives us the *utility* of the object (I find it hard to see how "utility" differs from the preceding term)—or internal—this is what is known as its formal *perfection*, which is based on a definable relation. In either case, finality "can only be cognized by means of a reference of the manifold to a definite end, and hence only through a concept."[18] But this would run counter to the subjective liberty (the "free play of the mental powers") which defines the judgment of taste as "aesthetic," in both senses of the word in this instance. The "finality" perceived in the object of such a judgment can therefore only be a finality *without a definite end*, however that is to be understood.[19] As far as I can tell, then, this third moment does nothing more than draw out the consequences of the first as applied to the "relation of the ends," which Kant feels duty bound to treat. The first moment thus contains the crux of the matter. We will come upon the lesson it has to teach again.

The Aesthetic Attitude: Pro and Con

The "contemplative" character that Kant, to repeat, attributes to the judgment of taste in general has been rediscovered in our time under various names (distance, attitude, point of view, situation, state of mind, experi-

17. [An *agrégatif* is someone preparing for or taking the *agrégation*, the highest competitive French teacher's examination. The traditional French student essay has a standardized three-part dialectical structure.]

18. Kant, *Critique of Judgement*, §15, p. 69.

19. In any event, "without a definite end" does not mean "without a *known* end." A prehistoric tool whose external finality (use) we do not know, although we do know it had one, cannot, according to Kant, "be described as beautiful," that is, there can be "no immediate delight whatever in [its] contemplation." (See the last note to §17, p. 80.) I shall not, incidentally, follow Kant on this point.

ence). Common to all these terms is the fact that they suggest—with the possible exception of "experience"[20]—that Kant's "contemplativity" presupposes a distinction, explicit or not, between the act of contemplating an object and that of appreciating it on the basis of this contemplation. The reader already knows that I too advocate making such a distinction, and that I call the first of the two acts in question "attention." It therefore seems to me worthwhile to pass some of these proposals in rapid review, along with the critiques they have sparked.

THE EARLIEST STATEMENT OF THIS POSITION MAY WELL BE THAT put forward in 1912 by Edward Bullough,[21] who regards "psychical distance" as the defining feature of the aesthetic relation, whether to natural objects or works of art. Bullough's point of departure is the experience of sailing through a fog at sea*, a situation one can experience aesthetically only by dint of a "distancing" that consists in watching this spectacle as if one were safely on shore (*suave, mari magno* . . .). Turning from this observation to art, Bullough discusses the various reactions *Othello* can call up in a spectator, who may be insufficiently distanced from the tragedy (underdistancing*), and therefore inclined to relate the story to, say, his own marital situation; at an excessive distance from it (overdistancing*), and thus interested only in the "technical details of the performance"; or at the aesthetically "right" distance, and therefore disposed to "attend to the action of the play as such"—to, I would add, the action viewed as fictitious. Let me illustrate the first of these three possibilities by analogy to Don Quixote's reaction to Master Peter's little theater: the underdistanced spectator would leap onstage to bump off (the actor playing) Iago, or to prevent (the actor playing) Othello from bumping off (the actress playing) Desdemona:

> Last year (August 1822) a soldier who was standing guard in the theatre in Baltimore, upon seeing Othello, in the fifth act of the tragedy of that name, about to kill Desdemona, cried out: "It will never be said that in my presence a damned nigger killed a white woman." At the same moment the soldier shot at the actor who was playing Othello and broke his arm. Not one year passes but what the newspapers report similar incidents. Now

20. "Experience" is sometimes taken in a broad sense that includes aesthetic judgment (by, for example, Monroe Beardsley, whom we will meet again), and sometimes (as in Vivas) in the limited sense we are concerned with here.

21. Edward Bullough, " 'Psychical Distance' as a Factor in Art and an Aesthetic Principle," in M. Levich, ed., *Aesthetics and Philosophy of Criticism* (New York: Random House, 1963), pp. 233–254. On psychical distance, see Sheila Dawson, " 'Distancing' as an Aesthetic Principle," *Australasian Journal of Philosophy* 39 (1961): 155–174.

that soldier was entertaining an *illusion*: he believed in the reality of what was happening on the stage.[22]

In real life, Bullough says, aesthetic distancing consists in *acting as if* one were not concerned; in art, it consists in *understanding* that one is not. It is easy to see where this overhasty transition from "life" to "art" (art in general) goes awry: what is at issue in the second of these two cases is not merely art as such, but also fiction; and what Stendhal here calls "illusion" (or, more precisely, the "perfect illusion"[23] which one never goes to the theater looking for, and which one only finds in fleeting "delicious moments," "for example, half a second, or a quarter of a second") consists in taking fiction for reality. But a work of art is not necessarily fiction: one's relation to a cathedral, abstract painting, or piece of music would be unlikely to engender the sort of confusion evoked a moment ago.[24] The feature that consists in "not being concerned" is hardly relevant to the contemplation, however "aesthetic," of a work of this kind. Doubtless what is involved here is rather a *different way* of being concerned; this nuance also holds, all things considered, for one's relation to natural objects or scenes. The patch of fog that I contemplate from a safe spot (at the "right distance"), as the Turneresque esthete would, can "concern" me quite as nearly as the fog I confront, all eyes, at the helm of my frail bark; but, of course, it concerns me *differently*. The verb *to concern* is simply not germane to the distinction involved here. "Distance" is no doubt closer to the mark, though fairly metaphorical—but what word is not in this realm? The example of theatrical performance at least has the merit (apparently unintended) of showing that the aesthetic object has not *one* aspect, but several, possibly situated at different levels, or at differing degrees of distance. A performance of *Othello* is plainly a complex aesthetic object (one that also happens to be artistic) which elicits the "imperfect illusion" from an attention focused on various matters: on the fictional action, as Bul-

22. Stendhal, *Racine et Shakespeare* (Paris: Garnier-Flammarion, 1970), p. 58 [tr. *Racine and Shakespeare*, trans. Guy Daniels (New York: Crowell-Collier, 1962), p. 22].

23. "It is impossible for you not to agree that the illusion one seeks at the theatre is not a complete illusion. *Complete* illusion is the kind experienced by the soldier standing guard in the theatre in Baltimore. It is impossible for you not to agree that the spectators know very well that they are in a theatre and watching a work of art, not a real event. Who would think of denying that? Then you grant that there is *imperfect illusion?*" Ibid., p. 23.

24. Closer to the theatrical experience, though still lacking the fictional dimension, is the situation created by a musical performance: a listener who does not like a symphony, and is confused about who is responsible for what, could vent his wrath on a conductor who simply conducts the orchestra in conformity with the score.

lough would have it, but also on the production, stage business, décor and costumes, he lighting, etc., all part of the (autographic) work which this performance is. Noticing that the actress playing Desdemona doesn't know her lines, or even that she has "a tooth missing," like the actress who, to Henry Brulard's delight,[25] plays the Carolina of *Matrimonio Segreto* in Ivrea, cannot be dismissed as irrelevant in principle. And even if one wishes to limit oneself to Shakespeare's work properly speaking, that is, to the *text* of the play,[26] one's attention is still focused on a number of different levels: for example, language, style, and what the formalists call the "fable" (what we call the subject or plot), or what they call the "subject," that is, the way the play is constructed—to say nothing of the pretextual (even prelinguistic) level that, for a spectator or reader who knows no English, would be comprised by a purely phonetic or graphic contemplation of, say, a page of *Othello* treated as a merely auditory or visual object. The "stratified" character that Roman Ingarden finds in (precisely) literary works[27] can certainly also be found in the arts Étienne Souriau terms "representative,"[28] such as painting or sculpture, and doubtless even, *mutatis mutandis*, in all the arts in general; one does not have to ascribe an expressive function to a movement of a symphony in order to discern various levels of aesthetic functioning in it—instrumental color, harmonic flavor, rhythmic structure, "formal" organization, and so forth. We will have other occasions to consider, from various vantage points, this question of the plurality of aspects and levels of attention, which is complex in its turn.

25. Stendhal, *Vie de Henry Brulard*, in *Œuvres intimes*, vol. 2 (Paris: Pléiade, Gallimard, 1982), p. 951 [tr. *The Life of Henry Brulard*, trans. Jean Stewart and B. C. J. G. Knight (Chicago: University of Chicago Press, 1986), p. 340].

26. I assume that text and play are identical so as to bring my argument into line with what I presume to be Bullough's position, but I very much doubt that one can legitimately reduce a play by an author like Shakespeare to a text, ignoring the fact that it is meant to be performed. Moreover, to speak of *the* text of *Othello*, in the singular, is to display a certain naiveté about an *œuvre* (Shakespeare's *œuvre* in general) that is typically pluritextual. On this subject, see Margreta de Grazia and Peter Stallybrass, "La matérialité du texte shakespearien," *Genesis* 7 (1995): 9–27.

27. Roman Ingarden, *The Literary Work of Art: An Investigation on the Borderlines of Ontology, Logic, and Theory of Literature*, trans. George G. Grabowicz (Evanston, Ill.: Northwestern University Press, 1973). Cf. René Wellek and Austin Warren, "The Mode of Existence of a Literary Work of Art," chap. 12 of *Theory of Literature*, 3d ed. (New York: Harcourt, Brace and World, 1956), pp. 142–157.

28. See Étienne Souriau, *La correspondance des arts: Éléments d'esthétique comparée* (Paris: Flammarion, 1947). See also Schaeffer, *Les célibataires de l'art*, chap. 4, pp. 249–344, which links this stratification to the semiotic status of works that proceed from a "derived Intentionality."

ELISEO VIVAS USES, ALTERNATELY, THE TERMS "AESTHETIC EXPE-
rience" and "aesthetic transaction";[29] but the definition he gives in 1937 of
the first, one which obviously applies to the second as well, shows that his
subject is less appreciation than attention. Indeed, a literal reading of his
definition would seem to indicate that he neglects the appreciative and
emotive components of the aesthetic relation altogether, reducing it to at-
tention alone:[30] "The aesthetic experience is an experience of intransitive,
rapt attention on any object which may elicit interest." On the same page,
Vivas spells out what he means as follows: the aesthetic experience "is an
experience of rapt attention which involves the intransitive apprehension
of an object's immanent meanings in their full presentational immediacy."
He confirms his use of these terms in a 1959 essay "Contextualism Recon-
sidered," in which he recalls his "definition of the aesthetic experience as
intransitive attention." The crucial word is plainly the adjective "intransi-
tive," which Vivas defends by sharply counterposing aesthetic to moral,
scientific, and religious experience. In the case of the last three, he says,
"we transcend the object, in search of relationships to which it points, but
does not embody in itself. . . . And I would suggest that it is here, in *the
transitive character* of these three modes of experience, that we shall find
what distinguishes them from the aesthetic mode. For in the aesthetic
mode, in contrast, we look at the object in order to see it, listen to it in
order to hear it, touch or taste it in order to feel it; we fasten our percep-
tive attention on it, arrest it within it, in such a way that we do not wander
from it, but rest within it attentively."[31] In the aesthetic relation, meanings
are "incarnated" in the object, because they are "immanent" or "reflexive,"
not "transcendent," as they are in the other modes of our relation to the
world. These formulations, whose Kantian resonance is unmistakable (to
the best of my knowledge, Vivas never cites Kant, though he does call the

29. Eliseo Vivas, "Contextualism Reconsidered," *Journal of Aesthetics and Art Criticism*
18 (1959): 222–240, "A Definition of Aesthetic Experience," *Journal of Philosophy* 34 (1937):
628–634, and "A Natural History of the Aesthetic Transaction," in Yervant H. Krikorian, ed.,
Naturalism and the Human Spirit (New York: Columbia University Press, 1944), pp. 96–120.

30. That Vivas pays scant notice to the evaluative or emotional aspects of aesthetic re-
sponse, like, as we shall see, Nelson Goodman, is shown by the following passage, which
dates from 1944: "whether the value of the aesthetic experience depends upon the presence
or the absence of emotion, its character depends on neither. Our definition of the aesthetic
experience, therefore, will not include emotion as one of its traits." Vivas, "A Natural His-
tory of the Aesthetic Transaction," p. 103. "Emotion" is perhaps too strong a word to serve as
a general term for the feeling of pleasure or displeasure that goes to make up appreciation,
but the fact remains that Vivas blithely tosses the baby out with the bathwater, like Goodman
after him.

31. Vivas, "A Natural History of the Aesthetic Transaction," pp. 99–100, and "Contex-
tualism Reconsidered," p. 233.

aesthetic relation "disinterested" at least once),[32] may for the moment seem more insistent than persuasive, but we will discover at least the beginnings of a justification for them later, in Nelson Goodman. Before taking leave of Vivas, let me add that he attempts, in most un-Kantian fashion this time, to single out a number of traits capable of eliciting intransitive attention; they would make it possible to define the aesthetic character one ascribes to certain objects but refuses to ascribe to others. It seems to me that, for Vivas, there are basically two such traits. The first, "freshness," is less objective than he would like, inasmuch as what is fresh for one person is not necessarily such for another. The second trait, standard at least since Thomas Aquinas, and one that Vivas would, moreover, appear to attribute exclusively to works of art, is *unity*, though unity (what Kant calls "the unity of the manifold") seems to me less a distinctive feature of certain objects than a precondition for any perceptual activity whatever. But it is too early to consider the arguments for objectivism in aesthetics, the more so as we will find much sharper illustrations of them in other authors.[33]

MORE OF A KANTIAN IN THIS RESPECT, JEROME STOLNITZ (WHO has, incidentally, published two essays on the evolution of the idea of "aesthetic disinterestedness" from Shaftesbury to Kant)[34] does not posit any objective conditions for what he calls the "aesthetic attitude," which he defines as "the disinterested (with no ulterior purpose) and sympathetic attention to and contemplation of any object of awareness whatever, for its own sake alone." For Stolnitz, an attitude "organizes and orients our awareness of the world," and, accordingly, our attention as well, in consequence of the various objectives that motivate us. For him too, the aesthetic attitude sets itself apart from the more common practical attitude by its disinterested (absence of utilitarian considerations) and sympathetic nature. Stolnitz seems not to notice that the second feature is more characteristic of a positive appraisal (it is difficult to maintain that one regards

32. Vivas, "A Natural History of the Aesthetic Transaction," p. 116.

33. For his part, Vivas makes his criteria a good deal less objective by acknowledging that reciprocal determination plays a role in the aesthetic *transaction*: "the characters of an object to which power of sustaining intransitive attention can be ascribed are objective relatively, not absolutely; they are objective *for a subject*." Ibid., p. 106; my emphasis. Putting a slight accent on the *for* (in the sense "in the eyes of") suffices to transform the last sentence into a description of what I will later call *objectification*.

34. Jerome Stolnitz, "The Aesthetic Attitude," in *Aesthetics and the Philosophy of Art Criticism* (Boston: Houghton Mifflin, 1960), pp. 32–42. The two essays on the history of aesthetic disinterestedness are "On the Origins of 'Aesthetic Disinterestedness' " and "On the Significance of Shaftesbury in Modern Aesthetic Theory."

an object with "sympathy" if one has made a negative appraisal of it), so that it does not apply to aesthetic attention in general—unless we so dilute the meaning of the term "aesthetic" as to make it a superfluous synonym for "disinterested." Stolnitz underscores the often active nature of this form of attention, which the widely used term "contemplation" should not be allowed to occult, and also emphasizes its "discerning" and thus analytic nature. This is an important point, in my opinion, but it pertains rather to what I shall call *secondary* aesthetic attention, which characterizes our relation to works of art above all: it does not seem to me exact to treat it as a feature of all aesthetic attention, let alone a condition for any kind of appreciation whatever. "We usually," Stolnitz says, "have to walk round all sides of a sculpture, or through a cathedral, before we can appreciate it."[35] I indicated earlier why I think such an affirmation is mistaken: appreciation is brought to bear on an object initially provided it by attention, and can thus very easily be based on a vague act of attention not marked by a serious effort to be discerning—even if this sometimes means that the appreciation in question has to be reconsidered after a more thoroughgoing examination. That the first attitude is not the most commendable, especially when it comes to works of art, does not mean it does not exist, and it is surely not sound methodology to include in a definition a trait characteristic of only the "best" members of the class it defines: just as a "bad citizen" is still a citizen, so a hasty appreciation is still an appreciation. Doubtless we need to walk around in a cathedral for a long time in order to perceive all the details of its construction, and thus to appreciate it knowledgeably; but our first impression does not fail to provide the basis for an initial appraisal—concerning which I shall be careful not to say, or to deny, that it was the "right" one.

THE POSITION J. O. URMSON TAKES IN HIS 1957 DEBATE WITH David Pole, entitled "What Makes a Situation Aesthetic?" seems to me closer to my own. On Urmson's view, what differentiates an *aesthetic* response, satisfaction, appreciation, or judgment from other kinds of responses, satisfactions, etc.—moral, intellectual, or economic, for example—is not so much a particular quality inherent in it, as the ground*, or *fundamentum divisionis*, which provides the specific occasion for it. At the limit, there is nothing about aesthetic satisfaction to distinguish it, psychologically speaking, from other kinds: the difference resides entirely in its cause, that is, a difference in attentional choice. The determining factor in aesthetic satisfaction is "the way the object appraised looks (shape and

35. Stolnitz, "The Aesthetic Attitude," p. 37.

color), the way it sounds, smells, tastes, or feels. . . . What makes appreci-
ation aesthetic is that it is concerned with a thing's looking somehow
without concern for whether it really is like that; beauty we may say, to
emphasize the point, is not even skin-deep."

Here, of course, we are very close to Kant's *Beschaffenheit*, as Pole po-
litely points out in his reply: "[Urmson] himself, indeed, reaches the emi-
nently traditional conclusion, which Kant reaches in his own critical way,
that aesthetic pleasure is pleasure in the formal qualities of objects; for
though Urmson may bring a new hoe, here and there it turns up an old
root." Fortunately, an idea is not necessarily false simply because it is "tra-
ditional." The basic objection to this sort of neo-Kantian formalism lies in
the fact that one can appreciate more than just pure form aesthetically: for
example, a philosophical concept put forward by a character in a literary
work. Doubtless one could stretch the notion of form to include such ob-
jects; but then, Pole says, it is very much to be feared that "form" will be
defined as "whatever can be made the object of an aesthetic response"[36]—
which (even if Pole is too discreet to point this out) leads us straight back
to a circle, if I may put it that way: aesthetic appreciation is defined as that
which bears on form, and form is defined as that which solicits aesthetic
appreciation.

This objection is perhaps not as powerful as it seems, or, rather, the
problem it raises is not quite the one it points to. It is true enough that aes-
thetic appreciation, whether positive, negative, or neutral, is closely re-
lated to "formal" (to use my own terms, aspectual) attention, since this is
the ground* that distinguishes it as such from other kinds of appreciation.
Everyone can grasp the difference between the gustatory and the aesthetic
appreciation of a piece of fruit; the ground for this distinction has to do
with the difference that distinguishes two ways of dealing with a piece of
fruit, known respectively as eating it and looking at it (I am not unaware
of the aesthetic component of gustatory appreciation; I will return to this
point). Again, everyone can see the difference between a moral and an aes-
thetic judgment of an act or opinion, which can be condemned at one level
and simultaneously admired at another. But this close relation is not recip-
rocal: if aesthetic appreciation depends on aspectual attention, aspectual
attention does not depend on aesthetic appreciation, since it can, as we
have seen, be harnessed to nonaesthetic, purely cognitive ends in certain
circumstances (the expert's appraising glance). Attention is not, then, de-
fined by appreciation (which may or may not result from it), and the

36. J. O. Urmson and David Pole, "What Makes a Situation Aesthetic?" *Proceedings of
the Aristotelian Society*, supp. vol. 31 (1957): 96, 99.

"circle" Pole points to consists only in the erroneous notion that it *is* so defined, a notion that is by no means an intrinsic part of the theory in question. The problem resides rather in the incontestable fact that an "idea" (whether philosophical or of some other kind), "character," plot, and so on, can elicit aesthetic appreciation, which in this case seems not to derive from an act of aspectual attention, since the attention involved is directed toward an element, not of form, but of "content." The answer to this objection is that anything whatsoever can be considered with regard to its aspect, and, in that sense, be a function of aspectual attention—elements of content included.

Intentionally or not, Panofsky has illustrated how relative the notion of form is by showing that what we ordinarily call a "formal description" of a painting, one which, for instance, notes that it depicts "a man" or "a boulder," but does not inquire into the historical identity of the man or the geological identity of the rock, in fact already presupposes a semiotic reading, and, in consequence, requires us to identify the contents described. A "purely formal" description, in contrast, "would essentially have to limit itself to colors, to the many different contrasts among them and the way they shade off into one another, making possible the infinite variety of their nuances"[37]—to content itself, in other words, with considering in a nonfigurative way, in terms of lines and dabs of color, a painting whose intention is manifestly (this is Panofsky's operating hypothesis here) figurative. As is well known, Panofsky rejects approaches of this kind, suggesting instead that iconological analysis be brought to bear on a whole set of objects defined by a "signified content" which is determined by supplementary information drawn from historical, literary, and religious sources, among others. But the hesitation he begins by invoking clearly shows that any level can be defined as "formal" with respect to the next-highest level: this splotch of color is identified as a human being, that human being as a Roman soldier, and so forth, with the result that each content may be perceived as a "form" designating a more specific content; analysis thus progresses from form to content, and regresses from content to form. Obviously, this phenomenon is particularly characteristic of works of art, and, to repeat, more specifically characteristic of "figurative" works, inasmuch as only objects falling into that category exhibit, in manifest and, as it were, institutionalized fashion, signifying forms and signi-

37. Erwin Panofsky, "Zum Problem der Beschreibung und Inhaltsdeutung von Werken der bildenden Kunst," *Logos* 21 (1932): 104–105. [My English translation is tailored to the loose French translation Genette cites.]

fied contents.[38] In such works, it is the signifying form alone (the verbal texture of a poem, the design and colors of a picture) which initially seems capable of appealing to formal attention, and, therefore, of giving rise, under certain circumstances, to aesthetic appreciation. Yet the fact is that any of its "stratified" levels can perform the same function with equal ease: the emotions expressed in a poem or the scene depicted in a painting are just as capable of sustaining a formal examination that fastens on what might be called, in Hjelmslevian terms, "the form of the content." To belabor an oft cited remark of Aristotle's,[39] the basic structure of the story of Oedipus arouses interest independently of its mode of representation (whether it is presented in a narrative or as a play). But the interest it arouses is also independent of its psychological content for anyone who chooses to ignore the theme of mother-son incest or patricide and concentrate instead on the causal schema of the *fatal precaution*, a schema it shares with other stories which have different psychological themes and both comic and tragic endings.[40] To approach the story from this vantage point is plainly, in a certain sense, to consider its content by way of its formal aspect; the decision to take this tack may of course bring down a charge of, precisely, "formalism," but this reproach itself shows clearly that aspectual attention can attach itself to several different levels of a work, each of which can be considered intransitively, independently of its denotational function, with regard to what we will later be calling, after Goodman, its "exemplificational value." Moreover, I am not certain that the thematic content of this story ("the Oedipus complex," in the Freudian sense) cannot itself sometimes be treated as an aesthetic object. What is generally

38. However, Panofsky elsewhere analyzes, in similar terms, the interpretive stratification that subtends our everyday perception of the outside world, when we make the transition from the (relatively) elementary observation "something is moving in front of me" to the *primary* or (*natural*) signification, "it's a gentleman removing his hat," and thence to the *secondary* (or *conventional*) signification, "the lifting of the hat stands for a greeting." For Panofsky, the primary/secondary dichotomy, which we will meet again, applies, as does the stratification of forms and contents, to all aspects of our interpretive behavior. See Erwin Panofsky, *Studies in Iconology* (New York: Harper and Row, 1967), pp. 3–4.

39. Aristotle, *De Poetica* (*Poetics*), trans. Ingram Bywater, in Richard McKeon, ed., *The Basic Works of Aristotle* (New York: Random House, 1941), 1453b, pp. 1467–1468.

40. A good example of the comic ending is provided, not by the *Barber of Seville*, where the precaution is merely "futile," as the subtitle indicates, but by *The School for Wives* (even if the ending is hardly comic from the hero's point of view); here the hapless graybeard is clearly *foiled* by his own precautions, like Laius and Jocasta. The effect of self-fulfilling prophecy*, which Karl Popper christens, precisely, the "Oedipus effect," might thus also be dubbed the "Arnolphe effect." See Popper, *The Poverty of Historicism* (Boston: Beacon Press, 1957), p. 13.

called "aestheticism" consists precisely in considering (and valorizing) the aesthetic aspect of what should rather be considered and evaluated (like the "beautiful crime" dear to some) for its ethical content and social consequences, and in privileging the most subjective aesthetic appreciation over moral responsibility.[41] In short, aestheticism comes down to relativizing, or, more exactly, *dialecticizing* the notion of aspect—an operation which is assuredly necessary if aesthetic attention is not to be reduced to surface effects alone, as it has been, in art criticism, by critics like Clement Greenberg. This relativization does not necessarily lead to the circle Pole points to, which would have us moving endlessly from form to appreciation and from appreciation back to form. Whatever level of the object aspectual attention latches onto, it determines and defines, nonreciprocally, aesthetic judgment, which is merely one of its effects—even if, obviously, the effect is here more important than its cause: an act of attention that fails to culminate in appreciation is the affair of, at best, a few specialists, whose purely cognitive activity and motivation would seem to have little to do with everyday aesthetic experience, the subject to hand. Nietzsche more or less says, although I don't know where, that the artist is a man who sees a form where the common run of mortals sees a content; this is well and truly the attitude our emblematic Courbet takes toward his pile of sticks. But this transfer typifies, more generally and from the outset, all aesthetic attention.

THE CONCEPT OF AESTHETIC EXPERIENCE, DENOUNCED AS A "phantom state,"[42] was attacked as early as 1924 by I. A. Richards; he was reacting to the Kantian tradition and the theories of Clive Bell, the leading English aesthetician of the early twentieth century.[43] Richards takes issue above all with the idea that one of the features of aesthetic experience is a "mental activity" *sui generis*. We have seen that such a feature is by no means essential to the definition of aesthetic experience, which derives rather from the specificity of its object. We could, then, simply dismiss this critique as irrelevant; but it marshals, in passing, an argument worth attending to: Richards affirms that it is impossible to conceive of anything aesthetic pleasure and displeasure have in common. One could doubtless

41. This is (at least) one of the aspects of the attitude Proust condemns in Ruskin; he calls it "idolatry": "The doctrines that he professed were moral, not aesthetic, and yet he chose them for their beauty. And as he did not want to present them as beautiful, but as true, he had to lie to himself about the nature of the reasons that had led him to adopt them." Proust, Preface to the *Stones of Venice*, p. 130.
42. I. A. Richards, "The Phantom Aesthetic State," chap. 2 of *Principles of Literary Criticism* (London: Routledge and Kegan Paul, 1924), pp. 11–18.
43. Clive Bell, *Art* (New York: Capricorn Books, 1958).

reply that what these two feelings share is precisely the *aesthetic* character which that adjective designates, just as the common element in economic recession and economic growth is the fact that both are economic. This response, however, runs the risk of sounding like empty wordplay: that the common element actually exists remains to be demonstrated. It seems to me that its existence follows precisely from the fact that aesthetic attention, as it was defined a moment ago and will be more fully defined later, can constitute any object whatever as an aesthetic object (of attention), capable, as such, of giving rise to a feeling of pleasure or displeasure. This causal *ground**, to use Urmson's term, is the element these antithetical emotions have in common both with each other and, secondarily, with the intermediate or neutral state of aesthetic indifference, by no means exceptional. As Urmson rightly points out, a reaction of aesthetic indifference (his term is "mere toleration")—"I find this object neither beautiful nor ugly"—is in no sense an absence of aesthetic relation; an aesthetic relation fails to come about only if we do not consider the object "in an aesthetic light." To grab a tool one needs without paying any attention to its aesthetic aspect is plainly not equivalent to saying in response to a question about that aspect, after reflection, "it leaves me neither hot nor cold." We will return to this point in connection with appreciation, but it is not surprising that it should come up here: the common feature between John's aesthetic pleasure and Harry's aesthetic displeasure in the face of the same object is very clearly the fact that both John and Harry regard the object from an aesthetic point of view. In other circumstances, John could take intense aesthetic pleasure in the contemplation of a piece of fruit (for example a quince) that would cause Harry marked gustatory displeasure if he bit into it. I do not, incidentally, believe that we should say that these two experiences have *nothing at all* in common: any pleasure of a certain kind and any displeasure of some other kind have in common, if nothing else, the fact that they can both be defined as "emotions." It might be objected (by Richards, for example?) that this common element is of a logical rather than psychological order, but this objection seems to me hardly worth pausing over. I am, I must confess, as little interested in as I am capable of defining aesthetic experience in terms of psychological (or, for that matter, physiological) properties, even if I do not think that Kant is wrong when he says, rather unpredictably evoking Epicurus, that aesthetic pleasure must surely have some physical effect, since it would not be a pleasure if it did not.[44] The safest way to proceed seems to me to define

44. This is a rather cavalier paraphrase of a passage in Kant, *The Critique of Judgement*, §29, p. 131. The pivotal sentence in the passage reads, "We must even admit that, as Epicurus

aesthetic experience in terms of its cause, which is not its object in the ordinary sense of the word, since any object can, in this sense, give rise to it, but is rather the manner in which the object is regarded—a manner that is in its turn defined by what aesthetic experience chooses to contemplate in the object. That choice, once made, constitutes its attentional object.

BUT THE CHIEF CRITIC OF THE NOTION OF AESTHETIC ATTENTION is George Dickie, whose argument is explicitly directed against Bullough, Vivas, and Stolnitz.[45] I shall leave to one side his refutation of Bullough, since Bullough's analysis is itself not particularly pertinent. As to Dickie's critique of the position Vivas and Stolnitz both defend—that is, the notion of "intransitive" or "disinterested attention"—it seems to me somewhat sophistic. On the one hand, Dickie says that it makes no sense to speak of disinterested attention, quite simply because, *a contrario,* it is not possible to listen to music, for example, "in an interested manner." On the other hand, he affirms that a critic who attends a concert *with an eye to* reviewing it[46] (a critic who, in this sense, attends the concert in a transitive and interested way) nonetheless listens to it aesthetically. These two contradictory arguments seem to me to be equally invalid. The first reduces the aesthetic relation in general to the more specific relation to works of art, in which "disinterested" attention is as it were required, or at least strongly suggested, by the nature of the object. Vis-à-vis a work of art (especially music), an "interested" attitude of a purely practical kind is obviously quite rare: when one listens to a symphony, the most natural or common question is certainly not "What purpose does that serve?"—although this by no means implies that that question can simply be ruled out.[47] A literary, or, a fortiori, architectural work is doubtless more likely

maintained, gratification and pain. . . are always in the last resort corporeal." But, for Kant, such matters are of small interest; he relegates them to the realm of what he disdainfully calls, in a discussion of Burke, "empirical anthropology" (ibid., p. 131).

45. George Dickie, "The Myth of the Aesthetic Attitude," *American Philosophical Quarterly* 1 (1964): 56–65. "The Aesthetic Attitude," chap. 5 of *Aesthetics: An Introduction,* ibid., rehearses the same basic arguments Dickie put forward in 1964 under the more polemical title. A third text, "Beardsley's Phantom Aesthetic Experience," *Journal of Philosophy* 52 (1965): 129–136, refers explicitly, by way of its title, to Richards's *Principles of Literary Criticism,* but treats of the "aesthetic experience" in Beardsley's broad sense of the term; it thus has more to do with appreciation.

46. [Dickie actually refers to a student listening to a piece of music in preparation for an examination.]

47. One might, for example, wonder whether such-and-such a piece of music was appropriate for such-and-such a ceremony. Another kind of nonaesthetic attention to a work of art consists in treating it as if it were a historical document on, for example, a language's state

to solicit such a question; a utilitarian object is still more likely to, for in this case one must make a deliberate decision, conscious or unconscious, to *adopt* an attitude of intransitive attention. The example Dickie chooses is thus too narrowly *ad hoc* to be pertinent. As for the critic who has been assigned to write a review, it is true enough that his attention, if he is serious, will be of an aesthetic (or, more precisely, artistic) kind, but it is false that it will be "interested" vis-à-vis the work in question. He will certainly not ask about it, "What purpose does that serve?"; rather, he will ask himself, like any other "disinterested" listener, *what it is like* and *what he thinks of it*, and then set out to communicate to his readers his observations and his appraisal, which will make up the substance of his review. It is that review, not the piece of music, which he treats instrumentally and transitively—as, for example, a means of educating the public, or else bringing home the bacon—unless he produces even the review in a disinterested manner, "for the fun of it." But in any case (one can certainly imagine others), the function assigned the review is by no means assigned to the symphony itself, so that it cannot be maintained that the critic's attention *to the same object* is simultaneously aesthetic and transitive. Let us note in passing that these two arguments proceed from a shift, which is *not* made explicit, from the aesthetic to the artistic relation; moreover, the second argument even shifts its focus from aesthetic attention in general to professional critical attention. This shift, and the distortion it gives rise to, are typical of contemporary analytic aesthetics, which likes to think of itself as a theory of critical practice and discourse, as Kantian aesthetics is not—as if this practice and discourse were the domain par excellence of the aesthetic relation.[48] We find the same feature in Beardsley, among others; it is clearly thematized in the title of his principle work, *Aesthetics: Problems in the Philosophy of Criticism*.

Dickie also takes issue with a thesis put forward by Vincent Tomas, who defines the aesthetic attitude (in painting) as involving "looking at a picture and attending closely to how it looks."[49] Dickie describes this attitude as "vacuous." To me, it seems merely insufficient, since it defines aspectual attention alone; plainly, it is not at all oriented toward appreciation. Doubtless Champollion attended very closely indeed to the way the

of development, which might be revealed by a poem, or, in the case of a building, the level of development of building techniques. These three instances, among many others, show that specifying that attention is intransitive is not as superfluous as Dickie claims, even when what is involved is art.

48. This reservation does not apply to, at least, Goodman and Danto; neither typifies the approach of analytic aesthetics, if for different reasons.

49. Vincent Tomas, "Aesthetic Vision," *Philosophical Review* 68 (1959): 63.

Rossetta Stone looked, but his attention was evidently directed to something other than an appreciation in terms of pleasure or displeasure; we might say, anticipating Goodman's categories, that such attention subjects the properties exemplified by its object to intense scrutiny, but with the specific intention of establishing its denotational function—which in itself determines a selection from among those properties, so that attention is concentrated exclusively on graphic features, ignoring the characteristics of the stone that serves as their support. Again, there can be little doubt that Sherlock Holmes will go over the scene of a crime with a fine-toothed comb, without deciding in advance what might or might not be a clue. Yet he is no less in search of a clue for that, and, of course, as soon as he finds his clue, his investigation ends. For Holmes as for the Goodmanian esthete, "every detail counts," but only until the relevant detail is discovered; once it has been, all the others are relegated to insignificance. Close attention to the appearance of an object does not, then, *constitute* aesthetic attention; it does, however, contribute to it, and mentioning it is therefore not as "vacuous" as might be supposed. That said, I do not claim there is anything very novel about it.

The most pertinent of Dickie's criticisms, it seems to me, bears on the idea that there are several *species* of attention, representing so many distinct kinds of mental activity. But I doubt that any of the proponents of the "aesthetic attitude" subscribes to this proposition, which is probably unverifiable. What differentiates the various types of attention is, to repeat, their choice of object and their aim. Dickie is right to emphasizes this point: "So although it is easy enough to see what it means to have different motives, it is not so easy to see how having different motives affects the nature of attention. Different motives may direct attention to different objects, but the activity of attention itself remains the same."[50] But this objection by no means invalidates the thesis Dickie wishes to refute, which, in most cases, already takes the objection into account. This does not mean I would claim that what has been said so far provides a fully satisfactory definition of aesthetic attention. I do, however, submit that the Goodmanian theory of "symptoms of the aesthetic"[51] will bring us a few steps closer to such a definition.

50. Dickie, *Aesthetics*, pp. 54–55.

51. Nelson Goodman, *Languages of Art: An Approach to a Theory of Symbols* (Indianapolis: Bobbs-Merrill, 1968), chap. 6, §5, pp. 252–255; "When Is Art?" in *Ways of Worldmaking* (Indianapolis: Hackett, 1978), pp. 57–70; and "On Symptoms of the Aesthetic," in *Of Mind and Other Matters* (Cambridge: Harvard University Press, 1984), pp. 135–138.

Symptoms of Aesthetic Attention

It might seem odd to turn, at this point, to Goodman, who consistently refers in rather sarcastic terms to the notion of "attitude," which, for him, is rather too redolent of inertia and contemplative passivity. He forcefully, and very pertinently, counterposes to it the more dynamic notion of "action";[52] indulging his penchant for caricature, he does not hesitate to illustrate the aesthetic attitude with the idea that "the appropriate aesthetic attitude toward a poem amounts to gazing at the printed page without reading it," although he himself rightly holds that one must read, not only poems, but also paintings (as Poussin had already said).[53] He is, incidentally, even more hostile to the notion of aesthetic *pleasure*, which he assails in the name of a purely cognitivist conception of the aesthetic relation (but we are getting ahead of ourselves). Above all, he by no means presents his "symptoms" as relative to a particular (subjective) mode of reception; rather, they have to do with the properties of certain objects, especially (but not exclusively) works of art. But this position is not really tenable, in my opinion. I think that the Goodmanian aesthetic (a term he rejects)[54] is, on this point, more subjectivist than Goodman would wish; or, more precisely, that it lends itself more readily than he would wish to a subjectivist reading.[55] Indeed, I contend that it admits of no other kind of reading, since Goodman's "symptoms" cannot be anything other than symptoms of aesthetic *attention*.

52. Goodman, *Languages of Art*, chap. 6, §3, pp. 241–244. We might note in passing that Dickie makes no mention of Goodman in the chapter of his *Aesthetics* devoted to the "aesthetic attitude," although Dickie's book appeared three years after Goodman's, which was published in 1968. Dickie probably assumes that the notion of "aesthetic attitude" has no relevance for Goodman, who is certainly of the same mind. Schaeffer, for his part, speaks of an aesthetic "mode of behavior" [*conduite esthétique*]; this is perhaps the most appropriate term in French.

53. Goodman, *Languages of Art*, p. 241.

54. See the Introduction to *Languages of Art*, pp. xi–xiii, in which Goodman defends his rejection of the term "aesthetics" by pointing out that he makes no judgments of aesthetic value and offers no canons of criticism. Elsewhere ("On Symptoms of the Aesthetic," p. 198, and Goodman and Catherine Elgin, "Changing the Subject," in Richard Shusterman, ed., *Analytic Aesthetics* [Oxford: Blackwell, 1989], p. 190), he takes his distance from "traditional aesthetics," which is always based, in his view, on a theory of "standards of Beauty." It is to be hoped that he does not situate Kant in that tradition.

55. For Goodman (see Goodman and Elgin, "Changing the Subject," p. 191), subjectivism "threatens." The word seems to me revelatory: a more radically objectivist theory would not be "threatened" by subjectivism. Goodman's formulation reads, literally, that the "symptoms" are symptoms "of aesthetic *function*" ("On Symptoms of the Aesthetic," p. 138). This too is ambiguous.

Goodman's two major discussions of this question situate the analysis of these "symptoms" in the context of an inquiry into the status of the work of art; they thus seem to subordinate analysis of the symptoms to an account of the status of the artwork.[56] In *Languages of Art*, the aim is to replace the criteria of "traditional aesthetics," taxed with putting undue emphasis on pleasure and emotion, with a description of the effects art produces. In "When Is Art?" the aim is to respond in functional terms to the question posed in the title; that a "when?" takes the place of the usual "what?" clearly illustrates Goodman's anti-essentialist stance. Moreover, this text proceeds rather elliptically, inasmuch as it appears to answer a question about the *artistic* by way of the *aesthetic*: there is art, according to Goodman, whenever (only and on every occasion when) an object exhibits the symptoms of the aesthetic.[57] It would follow that every "aesthetic object" (every object *when* it functions aesthetically) is a work of art. I am not certain that Goodman's position is as cut-and-dry as this sequence of statements implies, but I will reserve judgment on that point; for the moment, we are considering the Goodmanian symptoms only insofar as they are aesthetically relevant, without looking into the possible connection between the realms of art and the aesthetic.

In line with his resolutely semiotic[58] conception of art, and, indeed, of intellectual activity in general, Goodman approaches[59] the definition of the aesthetic phenomenon by way of a series of "symptoms," that is, clues capable of pointing back to this phenomenon as to their probable cause: where (certain of) these symptoms are present, there the aesthetic must also be. A symbolic function underlies all these symptoms: an object is aesthetic (artistic?) when it functions symbolically, in a particular manner specified by these symptoms. In 1968 there were four of them; they were joined by a fifth in 1977. All five have their roots in the very special system constituted by Goodmanian semiotics, which does not apply only to aes-

56. In a third text on the subject, "On Symptoms of the Aesthetic," Goodman responds to certain questions and comments (Alan Nagel, "Or as a Blanket: Some Comments and Questions on Exemplification," *Journal of Aesthetics and Art Criticism* 39 [1981]: 264–266) by reiterating rather than explaining his position, as is his wont.

57. Clearly, the word "aesthetic" is used here, not as a noun designating a discipline (aesthetics), but as an adjective: "symptoms of the aesthetic" thus means (to formulate it neutrally) symptoms of the aesthetic *phenomenon* [*fait*].

58. Goodman does not use this term, although he says that his objective is to construct a "theory of symbols."

59. Merely *approaches*, for he displays considerable methodological caution here: "These symptoms provide no definition, much less a full-blooded description. . . . Symptoms, after all, are but clues" ("When Is Art?", p. 68); "a symptom is neither a necessary nor a sufficient condition" (*Languages of Art*, p. 252); "choice of the symptoms perhaps belongs to an early stage in a search for a definition" ("On Symptoms of the Aesthetic," p. 135).

thetic objects. This system is elaborated in terms of a theory of notation (and ways of expressing measurements) laid out in chapters 4 and 5 of *Languages of Art*—which explains why the symptoms can seem out of place in the context of aesthetic theory.

The first of these symptoms is *syntactic density*,[60] that is, the fact that the smallest imaginable difference between two states of the signifier—for example, the slightest movement of one of the hands on an analogic timepiece—is fully significant. (The opposite of syntactic density is syntactic differentiation, or articulation, where the signifying states are discontinuous, as in the case of a digital clock.) This property counterposes sketches*, which are syntactically dense, to scripts* written in natural languages, as well as musical, choreographic, or other scores*, all of which are syntactically articulated: there is no intermediate state between two phonemes, two letters, or, in standard musical notation, two consecutive notes in the scale.

The second symptom is *semantic density*, that is, the continuous character of the signifier: the passage of time as symbolized by the hands of an analogic clock, the spatial continuum of an object represented by a drawing, or the way in which the verbal signifieds (concepts) of natural language mesh, overlap, or shade off into one another. Here, both texts and drawings are counterposed to notations, which are articulated not only syntactically, but also semantically: in a classical score, we cannot note an A that would subsume all possible As, whatever their pitch or duration, as we can in discursive language (indeed, I just did). Similarly, there is no note in the tempered tonal system between A and $A\#$, in the sense in which there *is* always a shade of red between two other reds, even if we cannot always find a name for it.

The third symptom, which Goodman seems to confine to syntactically dense systems,[61] is *relative syntactic repleteness*, that is, the fact that relatively many syntactical features are semantically relevant. There is a difference between a scientific diagram, whether economic (stock market quotations) or medical (a fever chart, an electrocardiogram), and a formally identical drawing, such as a Hokusai representing a mountain range. This difference, which is not perceptual and immanent but contextual (relative to the object's symbolic status), hinges on the following: in the diagram, all that counts is the position of points with respect to the abscissa

60. "Continental" readers will save themselves a good deal of trouble if they take Goodman's "syntactic" to mean "pertaining to the signifier," and "semantic," "pertaining to the signified."

61. It is not entirely certain that Goodman intends to make such a restriction: he does so in *Languages of Art*, p. 253, but not in "When Is Art?"

and ordinate axis. (Indeed, often enough a "curve" is just a broken line whose segments only serve to connect one significant point to the next; their details are insignificant. This, if I am not mistaken, means that diagrams are not syntactically "dense.")[62] In the Hokusai drawing, in contrast, every "syntactical" (aspectual) detail counts: its absolute size, the shades of color, thickness of the lines, hesitations, alterations, runs and smears, the nature of the support, and so on.[63] Obviously, one can object to examples of this kind on the grounds that a diagram and a drawing are highly unlikely to coincide so perfectly as to be perceptually identical; but we need only imagine that we have before us a *single* line, and do not *know* whether it occurs in a drawing or a diagram. During World War I, Italian customs officers detained Stravinsky because he was carrying a cubist portrait of himself done by Picasso; they refused to let him cross the border because they were convinced that the portrait was a map, possibly of strategic importance.[64] Depending on the hypothesis used to identify it, the same line not only took on different referents, but inspired two very different *modes of reading*. These differences are differences of degree, in part because it is always possible to increase the number of pertinent features a diagram has: in a graph charting daily stock market quotations, the volume of transactions could be symbolized by the thickness of the line or by variations in its color. Incidentally, this shows, it seems to me, that an articulated schema can itself be more or less replete, and, consequently, that the opposition *repleteness-attenuation* is not only characteristic of syntactically dense systems. Conversely, repleteness does not imply that *all* properties are pertinent. For example, the *weight* of a painting is not considered significant; at any rate, let us say that, for the ordinary observer, it usually is not (it can become significant during an expert appraisal).

THE FOURTH SYMPTOM IS *EXEMPLIFICATION*, OR, MORE PRE-cisely, symbolization in the exemplificational mode. An object that exemplifies refers to properties it possesses, as a sample refers to one or more of its own properties (a swatch of red woolen velour refers to the three properties *velour*, *wool*, *red*, which it has in common with the bolt of cloth it can

62. A curve is not "dense" unless the line that represents it is pertinently continuous, like the line traced by the recording pen on a thermograph.

63. This hypothetical example is adduced, not in chap. 6, section 5 of *Languages of Art*, but in section 1, in which the difference between repleteness and "attenuation" (the opposite of repleteness) does not yet function as an aesthetic symptom, as it will in "When Is Art?" I will come back to this point.

64. Pierre Cabanne, *Le siècle de Picasso* (Paris: Folio-Essais, Gallimard, 1992), vol. 2, p. 484 [partially translated as *Pablo Picasso: His Life and Times*, trans. Harold J. Salemson (New York: Morrow, 1977), p. 187].

be used to order). An aesthetic object (one received as such) can function in the denotational mode, like the Hokusai drawing that represents a mountain range, or else not (an abstract painting or a piece of music is not generally supposed to denote anything at all), but it also (and sometimes exclusively) functions in the exemplificational mode, in the sense that it designates certain predicates by belonging to their membership-class, while, reciprocally, these predicates denote it, literally or metaphorically. (Goodman christens metaphorical exemplification "expression"; expression is, of course, a special case of exemplification.) Thus a tondo may exemplify roundness (among other things) and express sweetness (among other things); a symphony may exemplify the key of C major (among other things) and express majesty (among other things); a church may exemplify Romanesque art and express rustic naivety, early Christian simplicity, and so on.[65]

The ticklish point, as far as this fourth symptom is concerned, resides, as I see it, in that "among other things"; I will come back to this. Here, however, we need to note that this fourth feature, exemplification, is counterposed to the preceding three, all of which are tied in with the denotational mode: articulation or density, attenuation or repleteness are characteristics that are (absolutely or relatively) opposed within denotational systems, and they serve, among other things, to differentiate between strict systems of notation (classical scores provide the illustration par excellence) and simple verbal or graphic denotations. It might thus seem that the criteria of aestheticity are defined, *a contrario*, by those of notation,[66] and that, after discovering that the conditions required for a notational system constituted the distinguishing criterion of the allographic regime, Goodman belatedly grasped that the aesthetic function was by its nature bound up with the necessary conditions of the opposite regime. The antithesis between diagrams and drawings might be taken to corroborate this assumption: a diagram is simultaneously an allographic, "attenuated," and scientific object, while a drawing is simultaneously autographic, replete, and artistic. Even if this antithesis is meant to illustrate nothing more than the opposition between two types of "density," it is hard not to read it as a symbol, à la Danto, of the opposition between a

65. This "and so on" could be extended to include, *inter alia*, the deliberately paradoxical interpretation Jean Giono puts forward in *Voyage en Italie*, in *Journal, Poèmes, Essais* (Paris: Pléiade, Gallimard, 1995), p. 553: "How much pride there is in Romanesque humility!" Expressive values are open-ended, and reversible *ad libitum*.

66. "Three are properties required to be absent from what I have defined as a notation, and the other two would be extraneous and usually troublesome in a notation." Goodman, "On Symptoms of the Aesthetic," p. 137.

nonartistic object and another (physically indiscernible), artistic object,[67] which seems to lead on to the assumption that the symptoms of the aesthetic coincide with the criteria of the autographic. It would follow—however flexible and easily applicable the "symptoms" are—that works of visual and plastic art, being naturally dense and replete, are, so to speak, more fully (or more readily) marked by the stamp of the aesthetic than are literary texts, whose medium (language) is syntactically articulated, or musical compositions, whose notations are fully articulated. But this is of course not true, for a number of reasons. Music cannot be reduced to the fact that (some) musical scores (though not musical performances) are notational. Literary works cannot be reduced to the denotational system of language and/or writing. Conversely, a painting could function as a symbol in a rudimentary, but perfectly well articulated, system, in which, by convention, displaying the *Mona Lisa* would mean "war has been declared," while displaying the *Venus of Urbino* would mean "negotiations are still in progress." (I am confident that professional and, above all, amateur analysts will find, *ex post facto*, motivations for these two arbitrary signs—as Lévi-Strauss amuses himself, somewhere, by motivating and then countermotivating the colors of traffic lights.) But we do not, of course, need to make up examples of this sort; there already exist functions that are quite as conventional, and, for that very reason, of equally low "density." We need only think of (or try to avoid thinking of) the monuments to the war dead found in every French town and village. Who pays any attention to their iconographic details, instead of contenting himself with noting their global signified—"sons of this community (see below for a list of their names) laid down their lives for the fatherland"? It transpires that the reduction (to pertinent features) which opposes "attenuated" to "replete" symbols is not identical with, but, as it were, parallel to the reduction characteristic of the allographic regime: allographic reduction consists in bracketing features of manifestation so as to retain only features of immanence (for instance, ignoring the typographical peculiarities of an edition of a book in order to concentrate on the ideality constituted by its text). As to the kind of reduction peculiar to attenuated symbols, it consists in bracketing as irrelevant certain features of immanence, such as the thickness of the lines in a diagram, their color, or—I would for my part add, changing fields of reference (but not the subject)—the stylistic peculiari-

67. Indeed, Danto (Arthur C. Danto, *The Transfiguration of the Commonplace: A Philosophy of Art* [Cambridge: Harvard University Press, 1981], pp. 142ff.) cites this example of indiscernibility in support of his position, and then substitutes for it a similar instance taken from real life: Lichtenstein's *Portrait de Madame Cézanne*, painted after Erle Loran's diagram of the painting.

ties of an agenda. The (antithetical) symptom of repletion is, then, wholly independent of the regime of immanence[68]—although it must of course be added that autographic objects do not allow of any other kind of reduction, a circumstance which eliminates all risk of confusion (for us).

Furthermore, Goodman emphasizes the fact that the "presence or absence of one or more of [the symptoms] does not qualify or disqualify anything as aesthetic; nor does the extent to which those features are present measure the extent to which an object or an experience is aesthetic. That poetry, for example, which is not syntactically dense, is less art or less likely to be art than painting that exhibits all four symptoms thus does not at all follow. Some aesthetic symbols may have fewer of the symptoms than some nonaesthetic symbols. This is sometimes misunderstood."[69] The apotropaic function of this footnote is clear enough, and by no means superfluous. Indeed, skeptics might be beginning to wonder if these much vaunted symptoms, which have to be handled with so much care, are really dependable and useful. I believe that they are, perhaps even more so than their inventor suggests; but we need to examine them at somewhat greater length to show that this is so.[70]

The first three symptoms, as we have seen, have to do with the way that objects which are taken as denotational symbols function. Thus they involve, for the most part, arts that have a denotational function, such as literature or figurative painting. It should, however, be borne in mind that anything can denote anything else by convention—and that an already denotational object can be used to denote something quite different, like my *Mona Lisa* and *Venus of Urbino* of a moment ago. A melody, which is (in principle) a nondenotational object (work), can perfectly well be assigned a precise denotational value if the need should arise, as occurs, if I recall correctly, in Hitchcock's *Lady Vanishes*. In both this example and the previous one, the symbol is highly "attenuated syntactically," because it need only be identified globally in order to serve its purpose; the details don't matter. This clearly holds for bugle calls, as well as a host of other audible signals. One could, however, set out to make the melodic signifier even more "replete" by making certain variations in rhythm or key represent nuances of meaning. Thus it would not be hard to symbolize the "curve"

68. See Genette, *L'œuvre de l'art* [*The Work of Art*]. Be it recalled that the notions of immanence, regime, reduction, and ideality are not to be found in (though they are, in my estimation, compatible with) Goodman's theory.

69. Goodman, "When Is Art?" p. 68. (The last three sentences constitute a footnote.)

70. I am not forgetting the fifth symptom; it is highly likely that I will devote more space to this (for me) crucial symptom than does Goodman, who never allots it more than three or four laconic pages, qualified, in each case, as merely exploratory.

representing a patient's morning and evening temperatures with a melody sung or whistled (or, a fortiori, noted on a musical staff—but this is really getting too easy) in a certain key; one could apply the same method to the other eleven patients in the ward, assigning each one his or her distinctive key. Variations in rhythm or timbre could be used to extend the capacity of the system even further; this would require only that one have properly trained, and—I insist—decently paid staff. I by no means claim (nor, indeed, is it my wish) that these examples cast doubt upon the long tradition of musical "formalism" stretching from Hanslick to Stravinsky (and beyond). I simply want to specify, in passing, the limits within which the thesis that music does not signify anything holds good. A musical object, like any other, can always signify anything one likes, by denotational convention; what music does not have, or, at any rate, has less than other arts, is a means of denoting things that is *motivated*, and, in particular, mimetically motivated. To be sure, it can still avail itself of a whole gamut (that is certainly the right word here) of borrowed connotative or "allusive" possibilities (a phrase or chord can sound bluesy*, jazzy*, flamenco, Brazilian, Oriental, etc.), along with a few scraps of partial but relatively stable conventions, like the well-known (and rather overrated) emotional values of major and minor that the ancient Greeks assigned their musical modes (Dorian = serious, Phrygian = martial, Lydian = sad, Aeolian = happy); or like, again, the emotional values some people attribute to our keys (F major = pastoral). There is doubtless no need to recall, while we are on the subject of global, and largely arbitrary, symbolic values, the Wagnerian leitmotifs, which are sometimes actually inventoried in official glossaries for the benefit of untutored exegetes.

Syntactical and semantic density and relative syntactical repleteness are, then, clues relative to the denotational function; they can, however, have an incidence on any symbolic system, and therefore on any artistic practice (and other kinds of practices as well). Nevertheless, I believe that the status of the first two differs from that of the third, relative syntactical repleteness, which, consequently, has much more to do with the fourth (exemplification). Whether a system is syntactically or semantically dense or articulated is a stable, objective fact that is established at the outset by convention; it does not depend on how one considers an object. Thus whether the perpendicular line segments in a diagram are or are not relevant to its denotational function does not depend on my attentional attitude; I must rather be informed of this in advance if I am to interpret the diagram correctly. Otherwise, I might come to the conclusion that, for example, my patient's temperature had risen steadily from 37.2 degrees Celsius in the morning to 38.7 degrees in the evening, whereas, in reality, no

observation had been made in the interval, so that the line between the two temperatures was semantically insignificant. The line would cease to be insignificant if each of the points on it corresponded to the patient's temperature as taken at five-minute intervals, which would doubtless produce a wigglier line—and more bother for the patient. To take another example, everybody knows that the indications of tempo in classical musical notation (adagio, allegro, presto, etc.) are dense (and therefore non-notational), in the sense that their value has not been precisely defined, so that one can always shift from one tempo to the next without being able to say where the line between them lies (hence the relative freedom accorded performers). This is not true of metronomic indications (quarter note = 90, quarter note = 91), which are thus syntactically (and semantically) articulated. However, nothing prevents a composer from defining his tempos in terms of metronomic values, while maintaining the classic nomenclature (allegro = x, adagio = y, etc.); these tempos would thus be marked off as discrete units, making absolute distinctions between compliant and noncompliant performances possible. In these two examples, then (and in countless others), one needs to know from the outset what convention one is dealing with—what objective (that is, here, *instituted*) convention the receiver's attention is not at liberty to modify. Plainly, the effects of denotational repleteness that I imagined earlier can only function on the basis of the same kind of conventional rule: if the thickness or the variable colors of a line in a diagram or the variable pitch and timbre of a melodic signal are assigned denotational values, all those using them for purposes of semiotic communication must know what these values are. In contrast, the effects of repleteness that Goodman attributed to the Hokusai drawing do not arise from similar requirements, because they do not necessarily fulfil the same function: this or that (virtually) imperceptible ripple does not automatically "represent" a bump in the profile of the mountain. It may have no denotative function, and yet carry considerable—let us call it artistic—meaning for the sensitive, attentive art lover. (The assumption is that an identical ripple on the scientific diagram has *no* meaning whatsoever.) In sum, repleteness can result either from an objective convention, when features are explicitly assigned denotational functions, or from a completely different symbolic mode, when such a convention and function are wanting. This other mode is, of course, what Goodman terms "exemplification." It therefore seems to me that "syntactic repleteness" can be, depending on the circumstances, an instrument at the service of denotation or a factor in exemplification—and that it counts as an aesthetic symptom only in the second case. Naturally, I am going to pursue the point a bit.

I have said that the ripple in the Hokusai drawing *might* not have any representative function, which is to say that it *can* have an exemplificational function, and that nothing here allows us to decide whether it does or not: either the ripple represents an unevenness [*accident*] in the landscape, or else it represents an accident [*accident*] that affected the drawing of the picture, and I do not know how to take it. If what is involved is not a ripple in the line but a small ink stain, it is easier to arrive at a verdict: the graphic detail, which can hardly correspond to a detail in the subject of the drawing, can therefore only be a property, accidental or deliberate, of the drawing considered as an artistic object. In either case, and whether I am certain or not, I cease to regard the drawing as a simple, transitive means of representation, and begin to consider it for its own sake, with the properties which it exhibits—which, I shall perhaps conclude, it exemplifies.

I shall leave this "perhaps" in abeyance in order to consider one or two more examples. Take this sentence from the old French penal code, which has already been worked very hard (too hard, in every respect): "Every person condemned to death shall have his head cut off." It is possible to consider the sentence solely with a view to its denotational function, which is to say, in the reductive mode (the mode of "attenuation"), in which the syntax is reduced to its pertinent semantic features alone: that is evidently how the courts would proceed, without pausing over the length of the sentence or the play of sounds in it. It is also possible to consider it with an eye to its form, as Stendhal does: to note that it is terse, count its twelve approximate feet, criticize, as a good Malherbian should, the cacophony of *hedcutoff*, etc.; one might even label these formal features "expressive" and relate them to the harsh treatment the sentence calls for. In that case, one's attention will be focused, either exclusively or additionally, on the properties of the object of the sentence—I mean, of course, its ideal object, because I am assuming that the reduction which leads from graphic manifestation to textual immanence has already been carried out.[71] Once again, I am faced with a choice between paying "denotational" or "exemplificational" attention to the same object; only the second invites me to saturate its "syntax," that is, to consider as many details as possible.[72] The Hokusai drawing, let us recall, is an autographic object; the sentence from

71. I could, of course, treat the graphic—for instance, the typographical—properties in isolation from the others, but I would, in that case, no longer be dealing with the same object.

72. Goodman notes, using more objectivist language, that "exemplification is often the most striking feature distinguishing literary from nonliterary texts" ("On Symptoms of the Aesthetic," p. 135). Needless to say, exemplification can in my view serve only to distinguish two types of reading (two types of "reception").

the penal code is an allographic object. Let me now mention a third object, one that may with equal ease be regarded as belonging to either regime. Imagine that, as I am driving home, I see a (European) road sign indicating "no entry." The kind of attention one normally bestows upon such a sign is denotational and transitive: I see the sign, understand I can't drive down the road, stop or turn off. But I can just as well, under certain special circumstances (I don't know what the sign means, someone invites me to "appreciate" it, a detail suddenly strikes me as so interesting that I linger over it, etc.), bracket its denotational function and lose myself in contemplation of it: I observe, for its "own sake," the big red circle cut in two by the broad, white horizontal bar, I consider the features of *this particular*, more or less scratched-up sign, or the features of this particular type of sign (that is, I treat it as autographic or allographic), depending on whether I am asked, say, to give my opinion of the individual sign ("Should this sign be replaced because it is dilapidated?") or the type ("Should this symbol be changed?"). Let us observe that, so far, none of these attentional decisions in favor of exemplification is necessarily of an aesthetic order, in the ordinary sense of the word: I can consider, as expert, historian, or ethnographer, the "technique" of the drawing attributed to Hokusai, I can study the sentence from the penal code as a linguist would, I can examine the road sign from an engineer's point of view: for example, I might wonder whether the sign would not be easier to see for someone looking at it sideways if it had a curved surface, as such signs usually do in Norway (and perhaps elsewhere). In all these cases, and in order to introduce into this (loose) commentary on Goodman the qualification I made earlier, my attention can be aspectual without, for all that, being aesthetic. Even if aspectual attention is a necessary condition for aesthetic attention, it seems to me obvious—as it does to Goodman—that it is not a sufficient condition.

The Symptom Par Excellence

"Syntactic repleteness," then, operates sometimes in the denotational mode (on the basis of explicit conventions), and at other times in the exemplificational mode. In the second case, I believe, it can be a symptom of the aesthetic relation. For exemplification is, at least to my mind, the aesthetic symptom par excellence, while repleteness, owing to its characteristic ambiguity, serves in some sort as a transition between the two symbolic modes. But it does not follow that the second of these modes by itself pro-

vides an infallible index of the aesthetic relation. A sample is a typical exemplificational symbol, although it is clear that there is nothing specifically aesthetic about the way it functions: it is a symbol as functional and practical as any other denotational sign, and, under ordinary circumstances, we use it quite as unproblematically, the imaginary miscarriages Goodman mentions notwithstanding[73]—for such malfunctioning presupposes a healthy dose of stupidity or bad faith on the part of the users. The reason samples work so well is that their use (like that of other everyday "examples") is governed by semiotic rules, explicit or implicit, which both participants in the transaction are familiar with. When I choose a type of cloth after looking at a sample, I know that the swatch exemplifies the quality of the cloth I am buying, not its length and width; when I choose a certain paint for my kitchen, I know the wall will be painted the color I saw on the display, not covered with the kind of plastic the display is mounted on; when I give my listeners an example, I do so, not in a vacuum, but in a context which indicates how the example is to be applied. An example is always an example of something (it always exemplifies a class), even if the object in question belongs to any number of classes that it could satisfactorily exemplify. "Serving as an example" is a typically relational property that needs to be specified straightaway: if, all at once, I point to an object (among others) sitting on my desk, and, without providing any context, say, "There's a good example," my interlocutor will inevitably ask me, with some irritation, "An example of what?" For the object could exemplify its color, form, function, provenance, age, etc.—to say nothing of the clever reply (since we've descended to the level of guessing games), "An example of an object that's currently sitting on my desk." In other words, exemplification does not function smoothly and efficiently (is not "workable") unless accompanied by specifications. To be sure, these specifications need only discriminate among an object's many membership-classes: the paper clip I had in mind a moment ago cannot exemplify the class of portable computers, and my green sweater, which can perfectly well exemplify the class of clothes in general, cannot exemplify the class of socks or red clothes.

From this obvious restriction, Goodman draws the conclusion that symbols which exemplify are more strictly determined than those which denote—since the arbitrary nature of conventional signs holds sway in the denotative realm ("When I blow on the horn, you shall drink this poi-

73. Goodman, "When Is Art?" pp. 63–64. For example, the material a customer ordered is delivered to her, but arrives cut up into little rectangles of the same size as the samples she picked out, because she had said "the material must be exactly like the sample."

son"), whereas something can only exemplify a class it belongs to, or—but this comes to the same thing—a property it possesses itself.[74] This proposition seems to me both accurate, for the reason stated above, and inaccurate, for the following reason: once a denotational symbol has been adopted by convention, its denotational function cannot be modified unless a new convention is explicitly adopted. I cannot decide on my own, like Hermogenes in the *Cratylus*, that "horse" refers to "a man," just as Hernani cannot claim, without breaking the pact, that the sounding horn is an invitation to run off with Doña Sol. Conversely, as I have argued at too great length, we can never know a priori which of its properties an object exemplifies. In other words, denotational values are unrestricted only *before* the adoption of a convention, and exemplificational values are determined only *after* specification. But since Goodman models his entire theory of exemplification on a situation involving samples whose meaning has been duly specified (if only by long practice), he ends up assuming that the same kind of specification characterizes all kinds of exemplification—including, it seems, exemplification in the aesthetic sphere, which is, precisely, something else again.

The question this throws up, crucial to the present discussion, was raised by (among others) Monroe Beardsley, in a 1978 essay published in the journal *Erkenntnis* along with Goodman's reply.[75] That the properties exemplified by a work, Beardsley says, in sum, must necessarily be "possessed" by the work does not tell us *which* properties are exemplified; hence the distinction between "possession" and "exemplification" is largely inapplicable, and a work of art may simply be said to exemplify all its properties. Goodman's general response to this objection is that it is no easier to determine with certainty a work's denotational values, and that the philosopher's role is not to determine symbolic values but to analyze how they work in actual practice. More specifically, he says that a property possessed by a work is exemplified when the work calls attention to it, refers to it, conveys it, exhibits it, thrusts it to the fore, etc.[76] These anthropomorphic metaphors do not seem to me to provide a real response to the question, inasmuch as someone must still decide which properties a work (or, in general, an object) does or does not single out for attention. That there are x measures in a symphony, that a painting measures x by y inches,

74. Goodman, *Languages of Art*, pp. 52–54, 59.

75. Monroe C. Beardsley, "*Languages of Art* and Art Criticism," *Erkenntnis* 12 (1978): 95–118; Goodman, "Reference in Art," in *Of Mind and Other Matters*, pp. 80–86. See also Joseph Margolis, *Art and Philosophy* (New York: Harvester, 1978), p. 99.

76. Goodman, *Languages of Art*, pp. 93–94, 239–240; *Of Mind and Other Matters*, pp. 80–86, esp. pp. 83–84.

that a novel contains *x* words—these are all undeniable (objective) features of the works; but whether or not these works refer to (and therefore exemplify) the features mentioned is not of the order of the cognizable, unless we conclude with Beardsley (I shall come back to this) that all of a work's perceptible properties, and only those properties, are exemplified by it. Some of a work's features are indeed "singled out for attention," by the author of the work or another more or less authoritative or influential person, by means of the title (Symphony in C Major, *Still Life with Fruit Bowl, Saturnine Poems*) or some other paratextual mark (*Madame Bovary* with a puce cover, *Salammbô* with a cover in purple). But the fact is that most of the features singled out for attention are singled out *ad libitum* by the receiver of the work, who can, as he chooses, privilege certain of the features that are present and more or less "discernible" in an object: whether *Tristan and Isolde* is a morbid celebration of passion or a first attempt to break down the traditional tonal system, whether the *View of Delft* constitutes a "cavalcade of theorems" or a precious container for a famous little patch of yellow wall[77]—these are rather obviously questions of "vision," that is, of "attention." As Roger Pouivet says, "We impoverish the exemplificational function if we reduce it to those instances in which codification has become conventional as a result of social practice."[78]

I do not know if this warning is intended for Goodman, or even if it would be appropriate to issue him such a warning, but what seems to me certain is that it applies absolutely to one and all: an object's exemplificational values can be reduced to those prescribed by social or interindividual convention only in the domain to which the convention applies ("this object is an example of a corkscrew"). Beyond its limits, the object, or, more precisely, the person using it, is again free to interpret as he chooses: the object can exemplify any of the classes to which it belongs, whose predicates, in turn, can denote it. To acknowledge this interpretive freedom is not to adopt a lax attitude, or to advocate semiotic (or logical) anarchy, for it is still assumed that an object can exemplify only those properties which it possesses, and that the list of these properties does not depend on the sheer whim of its receiver: confronted by a square green object, I am free to activate the property "green" or "square," but not the

77. Marcel Proust, *La prisonnière*, in *A la recherche du temps perdu* (Paris: Pléiade, Gallimard, 1988), vol. 3, p. 692 [tr. *The Captive*, in *Remembrance of Things Past,* trans. C. K. Scott Moncrieff and Terence Kilmartin (New York: Random House, 1981), vol. 3, p. 185]; Paul Claudel, *Introduction à la peinture hollandaise*, in *Œuvres en prose* (Paris: Pléiade, Gallimard, 1965), p. 182. Cf. Genette, *L'œuvre de l'art*, p. 283 [*The Work of Art*, p. 252].

78. Roger Pouivet, ed., *Lire Goodman: Les voies de la référence* (Combas: Éclat, 1992), p. 36.

properties red or circular, unless I can justify these paradoxical choices.[79] Given that they proceed from an authorial intention that is sometimes openly announced, works of art can bear the weight of this intention in a way that restricts, or, at a minimum, orients, their receivers' interpretive choices; yet it is never impossible to go beyond this restriction, and it is even easier to get around it. The fact that Prokofiev entitled his first symphony, opus 21, *Classical* Symphony does not prevent me from finding modernist touches in it; nothing *compels* me to take the mythological subject of *The Fall of Icarus* into account; the "Dostoyevskian" strand in Madame de Sévigné was certainly not intended by the exquisite Marquise; and, if Proust had defended his commentary on her with the argument that her letters "call attention to," "exhibit," and "foreground" this strange consanguinity, by themselves and independently of anybody's interpretation, we would all understand that he was using a series of metaphors to ascribe to an inert (in this sense) object an aesthetic intention retrospectively imposed on it. The exemplificational capacities of works of art are no more strictly determined than those of, say, natural objects; in a sense, they are even less strictly determined, because the History that contains them never ceases to modify the horizon within which they are perceived. As Catherine Elgin aptly says, "The features an object exemplifies are a function of the categories that subsume it. So opportunities for exemplification expand as new categories are contrived. Some are the benefits of hindsight. When his works were first exhibited, it was, for obvious reasons, impossible to see Cézanne as a harbinger of cubism. Now his paintings practically cry out for such a reading, so plainly do they exemplify the shape of things to come."[80]

The last sentence has, again, an anthropomorphic turn that may work to obscure the spectator's interpretive role, but the fact Elgin here refers to is plain enough: today, Cézanne's paintings exemplify for us, in striking fashion, a feature they could not have exemplified either for Cézanne's contemporaries or for Cézanne himself, namely, the fact that they "herald cubism"—just as, according to Proust, Madame de Sévigné "heralded" Dostoyevsky by virtue of the subjective quality of her writing, and, above all (I would say), "heralded" Proust himself. I will come back to the implications of these categorical effects characteristic of artworks; but it was im-

79. "Paradoxical" does not necessarily mean "absurd." Something green can be, metaphorically speaking, red, in the way in which Éluard's orange is blue, or Audiberti's milk secretly black: they are such, surely, by antiphrasis, irony, or *coincidentia oppositorum*.

80. Catherine Elgin, "Understanding: Art and Science," *Midwest Studies in Philosophy* 16 (1991): 198–199. It should be borne in mind that Elgin is a faithful disciple of Nelson Goodman's (and occasionally co-authors his texts).

portant that I first underscore the twofold point that these effects are linked primarily to the exemplificational function, and that artistic exemplifications are just as (if not more) open-ended than the other kinds of aesthetic exemplification, which is another way of saying that they are in large measure attentional.

Contrary, then, to the exemplification characteristic of the functioning of samples, which is restricted by convention, aesthetic exemplification is essentially open-ended because it is indeterminate. It is this indeterminacy that grounds the principle of repleteness. "Every detail counts" in the sense that every detail (every property "possessed" by an object) can, at one time or another, be activated or "mobilized" by the attention of a receiver,[81] who applies the predicate connected with that detail to the object he is considering. Depending on whether that predicate is literal ("this is a Romanesque church," "this prelude is in B minor") or figurative ("this church is modest," "this prelude is sad"), the property singled out is exemplificational, in a literal sense, or else in a figurative sense which is usually metaphorical (be it recalled that Goodman has christened the latter symbolic mode "expression"), but which may also be metonymical,[82] as when one says that a line by Baudelaire is Racinean, or, again, that a sentence by Madame de Sévigné is Dostoyevskian. To the indeterminacy of generic ascription, we must therefore add that of transposition to the figurative level: not only can several different properties be predicated of the same object (an object always belongs to several classes), so that the object can exemplify all of them, but, again, each of these predicates can be interpreted, metaphorically or metonymically, in several different senses, so that the object "expresses" or "evokes" them indirectly: a musical composition can, depending on the attentional disposition of those listening to it, exemplify its "form," "mode," "key," "orchestration," "tempo," "style," and so on. Each of these properties, in turn, can express, more or less legitimately, very different emotions, depending on who is listening when and under what circumstances; after all, nothing obliges us to find a prelude in B minor "sad" or an overture in C major "majestic." Moreover, I am not certain that the categories used to classify tropes are as stable and impermeable as classical rhetoric assumed, and I am even less certain that the distinctions among them matter much, especially here. The distinction between literal and figurative predicates seems to me to matter even less,

81. "I do not claim . . . that a work's properties change when its receivers do; the work is what it is, but the receivers do not all 'mobilize' the same properties." Schaeffer, *L'art de l'âge moderne*, p. 385.
82. See Genette, *Fiction et diction*, p. 120 [*Fiction and Diction*, p. 110].

especially as predicates are subject to the erosion attendant upon linguistic development: to say that a color is "cold" is a metaphor only in historical retrospect; the expression "pale" chord[83] will some day, perhaps, be as technically and objectively literal as the designation of certain notes of the Afro-American scale as blues notes* already is; and it seems to me as difficult as it is pointless to distinguish between the phrases "this lied expresses Romanticism" and "this lied exemplifies Romanticism." Today's "expressions" are, perhaps, tomorrow's "exemplifications"—and the other way around.

The exemplificational function is not, to repeat, an infallible index of, or a sufficient condition for, the aesthetic relation. When I stop paying attention to what a "no entry" sign signifies in order to contemplate its aspectual properties, the transition from the denotational to the exemplificational mode by no means indicates that I am now in the aesthetic regime, as was noted earlier; this is indicated even less by the fact that I suddenly notice that one of the men on a chessboard belongs to a different set than all the others, so that, for a moment, I lose sight of its functional value in order to make a simple generic ascription of the sort "this white knight doesn't belong to the same set as the other chessmen." I am not sure that we can define an act of aspectual attention as aesthetic without appealing to another factor, which Goodman categorically refuses to take into account, but which we shall in short order examine without him. In any event, it seems to me that the two criteria of exemplification and syntactic repleteness should be closely associated here. We have seen that Goodman's analysis does not make room for the category "semantic repleteness," and I am not sure I should do so in his stead. "Semantic repleteness" could be taken to refer to something like the indeterminacy of meaning (the "plural meaning" hermeneutics emphasizes), which we will perhaps encounter again along with the fifth symptom. Syntactic repleteness, in contrast, is obviously closely bound up with exemplification, because it facilitates (or reveals) a sudden shift in attention from the denotational (or, more generally, the functional) to the exemplificational, or, in other words, to aspectual properties—from the purpose an object serves to what it is, or, rather, what one "finds" in it. The surest symptom of aesthetic attention would thus be something like *replete* exemplification (or exemplification of the sort that *tends to make* exemplification replete). This means, to repeat, the kind of exemplification whose semiotic function remains open ended and indeterminate.

83. I believe I owe this lovely term, whose metaphorical meaning remains a bit mysterious for me, to the musicologist Marc Vignal. I have lost the reference.

SUCH AN INTERPRETATION IS, PERHAPS, VULNERABLE TO THE criticism that Pole addresses to Urmson; he accuses him of "turning up old roots with a new hoe," in particular, of simply resuscitating our friend Immanuel's good old "disinterested contemplation of an object's *Beschaffenheit*," or Vivas's intransitivity, redefined (or simply rechristened) in terms of a post-Peircian semiotics. I am not certain that this criticism is absolutely decisive: after all, if the old roots are still being turned up by the new hoes, this goes to show, perhaps, that the old roots are good roots, and still serve a purpose.

Goodman himself seems to have anticipated this objection, which he attempts to meet as follows: "Counting such exemplificationality as aesthetic may seem a concession to the tradition that associates the aesthetic with the immediate and nontransparent and so insists that the aesthetic object be taken for what it is in itself rather than as signifying anything else. But exemplification, like denotation, relates a symbol to a referent, and the distance from a symbol to what applies to or is exemplified by it is no less than the distance to what it applies to or denotes."[84]

Exemplification is clearly as much a mode of reference as denotation, even if it proceeds in the opposite sense (from the object to the predicate or property, not from the predicate to the object). Thus one cannot define it theoretically as annulling the movement toward the symbolic; rather, it *reverses* this movement. Accordingly, works that lack all denotational function, like, generally speaking, music, architecture, or nonrepresentational painting, are, in this sense, quite as "symbolic" as any other: "Not only representational works are symbolic. An abstract painting that represents nothing and is not representational at all may express, and so symbolize, a feeling or other quality, or an emotion or idea,"[85] and even natural objects, when they operate (that is, are received) as aesthetic objects, also fulfil this symbolic function—albeit in a (more) purely attentional mode, since their expressive values cannot be defined with reference to the intentions of a human agent. But this straightforward reversal is, spontaneously and in actual practice, perceived by the aesthetic subject as a veritable suspension of the movement toward the symbolic or the referent; it discourages him, at least momentarily, from looking through the object for (or to the benefit of) its function, whether symbolic or of some other kind, and inclines him to consider it in a disinterested manner—in Stolnitz's words, "for its own sake alone."

84. Goodman, *Languages of Art*, p. 253.
85. Goodman, "When Is Art?" p. 61.

Thus the aesthetic relation is just as transitively semiotic as our usual relation to objects we receive as practical or (merely) denotational. However, the reversal of direction it operates, and the saturating attention to the object it calls for, cause us to perceive it as intransitive and purely contemplative, as if this contemplation did not bring out any meaning. In fact, it brings out just as much meaning (to contemplate means precisely to look for and to find values of exemplification or expression—"this tulip is purple," "this church is Romanesque," "this music is joyful"—and these *are* meanings). However, the meaning it brings out is of a different order, and it brings it out in a different way, one which creates the impression that this meaning is immanent in the object, or, as Sartre says, that it is a "transcendence that has fallen into immanence."[86] Indeed, Goodman acknowledges this effect: thus he points out that aesthetic properties "tend to reduce transparency [and] to require concentration upon the symbol." "Where exemplification occurs," he affirms, "we have to inhibit our habit of passing at once from symbol to what is denoted."[87]

> These properties tend to focus attention on the symbol rather than, or at least along with, what it refers to. . . . We cannot merely look through the symbol to what it refers to as we do in obeying traffic lights or reading scientific texts, but must attend constantly to the symbol itself. . . . This emphasis upon the nontransparency of a work of art, upon the primacy of the work over what it refers to, far from involving denial or disregard of symbolic functions, derives from certain characteristics of a work as a symbol. This is another version of the dictum that the purist is all right and all wrong.[88]

This deliberately ambiguous formulation finds an echo in Danto's assertion that works of art (I would say, "aesthetic objects" in general) are "semi-opaque objects."[89] They are, moreover, semiopaque in at least two

86. Jean-Paul Sartre, *Saint Genet comédien et martyre* (Paris: Gallimard, 1952), p. 283 [tr. *Saint Genet: Actor and Martyr*, trans. Bernard Frechtman (New York: George Braziller, 1963), p. 304]. The function of this expression in Sartre is to distinguish "meaning" from "signification"; the distinction is very similar to the one Goodman draws between exemplification and denotation.

87. Goodman, "On Symptoms of the Aesthetic," p. 137.

88. Goodman, "When Is Art?" p. 69 (the last sentence constitutes a footnote). By "purist," Goodman here means a formalist who holds that symbolic functions are aesthetically irrelevant.

89. Arthur Danto, *The Philosophical Disenfranchisement of Art* (New York: Columbia University Press, 1986), p. 79. Cf. Jean-Marie Schaeffer's Preface to Claude Hary-Schaeffer's French translation of Danto's *The Transfiguration of the Commonplace*, *La transfiguration du banal* (Paris: Seuil, 1989), pp. 7–18.

senses. The first is the one we have just seen (exemplification does not interrupt the movement from symbol to referent in quite the way it seems to). The second is that exemplificational values do not efface denotational values (when there are any), but rather take their place alongside them. To concern oneself with the "sounds" of a poem or the composition of a figurative painting does not mean that one has to become deaf or blind to their meaning, any more than perceiving the color of a pane of tinted glass, if I may be allowed this simplistic comparison, prevents one from perceiving what, taking on the color of the glass, can be seen through it—and vice versa. The same holds, *mutatis mutandis*, for the practical functions of an object (if it has any), which are not necessarily occulted by attention to its properties as such. If "a church can be beautiful even if it has not been deconsecrated," conversely, admiring a church from an aesthetic point of view does not necessarily prevent us from attending mass in it, any more than appreciating the shape of a cloud prevents us from opening an umbrella, or admiring the contours of a landscape, from "inquiring into the rent it brings in," like Charles Bovary at la Vaubyessard.[90]

This notion of "semiobscurity" can, it seems to me, resolve the contradiction between partisans of two extreme views of aesthetics that are wrongly regarded as mutually exclusive. One of them might be termed formalist, the other (if we stretch the usual meaning of the word) "functionalist." I just said that admiring a church from an aesthetic point of view does not prevent us from attending mass in it, but this is apparently not the opinion or experience of Étienne Gilson, who confesses that, at Venice, the paintings by Veronese in the Church of San Sebastiano made him "forget the mass while [he] was looking at them."[91] And my view of the matter accords even less with that of Jean Hamson of Port-Royal, who recommended that monks "close their eyes while praying in a church that was too beautiful," or that of dear Mother Angélique, who had all the decorations removed from the chapel of the convent in Paris, dutifully declaring, "I love *all that is ugly.* Art is but falsehood and vanity. *To give to the senses is to take from God.*"[92] We could trace this tradition back to, at least, St. Bernard's campaign against the opulence of the monasteries at Cluny. Such an attitude implies that a church cannot be judged beautiful without, as it were, "deconsecrating" itself by renouncing all its religious functions; or, again, that it is not possible to be a believer and an art lover at the same time. But

90. Gustave Flaubert, *Madame Bovary*, ed. Jean Pommier and Gabrielle Leleu (Paris: José Corti, 1949), p. 217.
91. Étienne Gilson, *Introduction aux arts du beau* (Paris: Vrin, 1963), p. 196.
92. Cited in Louis Réau, *Histoire du vandalisme: Les monuments détruits de l'art français*, 2d ed. (Paris: Robert Laffont, 1994).

the opposite attitude implies that no one can appreciate a work without fully endorsing its function and/or "message." This was the opinion of, for example, Ruskin, for whom "the architectural form can never be well delighted in, unless in some sympathy with the spiritual imagination out of which it arose."[93] Proust, in a note to his translation of *The Bible of Amiens*, cites, in counterpoint to Ruskin's remark, the "contrary"—that is, formalist—idea, which he finds articulated in these terms in Léon Brunschvicg:

> In order to experience an aesthetic joy, to appreciate the edifice, no longer as well built but as truly beautiful, one must . . . feel it in harmony, no longer with some external purpose, but with the intimate state of actual consciousness. That is why the ancient monuments that no longer serve the purpose for which they were built or whose purpose fades more quickly from our memory lend themselves so easily and so completely to aesthetic contemplation. A cathedral is a work of art when one no longer sees in it the instrument of salvation, the center of social life in a city; for the believer who sees it another way, it is something else.[94]

Proust, who rightly sees in this passage "the very opposite of *The Bible of Amiens* and, more generally, of all the studies of Ruskin on religious art in general," here refrains from joining in this fictitious debate (even if, elsewhere, he condemns the deconsecration of churches as acts of pure vandalism that will cause them "to die").[95] It seems to me that he does well to abstain. Although the aesthetic function is plainly distinct from practical functions, it neither depends on them nor rules them out. It accommodates not only continued or renewed "sympathy with" the "imagination," spiritual or not, that governed the production of a work of art, but also, equally well, indifference to it (even if that indifference stems from ignorance), or "protracted hesitation" between belief and indifference; it requires neither absolute acceptance of, nor total indifference to, that which "our fathers [or our distant cousins] have told us," as Ruskin puts it. What is certain is that, as Malraux says, "works of art are restored to life in our world of art, not in their own," and that we hear "what they tell *us*."[96]

93. John Ruskin, *The Bible of Amiens*, in *The Works of John Ruskin*, ed. E. T. Cook and Alexander Wedderburn, vol. 33 (London: George Allen, 1908), p. 124.

94. Léon Brunschvicg, *Introduction à la vie de l'esprit* (Paris: Félix Alcan, 1900), p. 97, cited in Marcel Proust, "On Reading Ruskin: Preface to *La Bible d'Amiens*," in *On Reading Ruskin: Preface to* La Bible d'Amiens *and* Sésame et les Lys, ed. and trans. Jean Autret et al. (New Haven: Yale University Press, 1987), p. 84.

95. Proust, *Preface to* La Bible d'Amiens, p. 85, translation slightly modified.

96. André Malraux, *Le musée imaginaire* (Paris: Idées-Art, Gallimard, 1965), pp. 234, 239 [tr. *Museum without Walls*, trans. Stuart Gilbert and Francis Price (Garden City, N.Y.: Doubleday, 1967), pp. 234, 239].

Their world is not, however, *necessarily* different from ours; what they tell us is not necessarily different from "what they have told us"—nor is it necessarily the same; and nothing ensures that the original message was meant to be extra-aesthetic, or that the current message is exclusively aesthetic by definition. In short, subscribing to the symbolic "message" of an object, or putting it to practical use, is doubtless neither a necessary condition for, nor an insuperable obstacle to, the aesthetic relation, which invests whatever it wants, whenever it wants.

A DESCRIPTION OF AESTHETIC ATTENTION LIKE THE FOREGOING will unfailingly recall the descriptions of "poetic language" or the "poetic function" offered by writers like Richards, Valéry, Sartre, or Jakobson, all of whom underscore the relative intransitivity of messages that emphasize the "perceptibility" of their form and consequently become "untranslatable," that is, incapable of "effacing themselves" before their meaning or of being replaced by another message with the same meaning. I am not here going to recite the litany of these statements, which have become almost proverbial;[97] I will only cite one, which seems to me to come very close to the view sketched above: "The poetic attitude . . . considers words as things and not as signs. For the ambiguity of the sign implies that one can penetrate it at will like a pane of glass and pursue the thing signified, or turn one's gaze toward its *reality* and consider it as an object."[98] I will spare the reader the generalizing paraphrase that forcibly suggests itself here, but I would like to emphasize, one last time, that exemplifying attention reverses (or deflects) the movement from object to referent, rather than simply blocking it: to regard a sign (or anything at all) "as an object" is not to dismiss all meaning, but rather to "pursue" another meaning that takes

97. See, inter alia, Paul Valéry, "Poésie et pensée abstraite," *Œuvres*, vol. 1 (Paris: Gallimard, 1957), pp. 1314–1339 [tr. "Poetry and Abstract Thought," *Collected Works*, vol. 7, trans. Denise Folliot (New York: Pantheon, 1958), pp. 52–81] and "Propos sur la poésie," *Œuvres*, vol. 1 (Paris: Gallimard, 1957), pp. 1361–1378 [tr. "Remarks on Poetry," *Collected Works*, vol. 7, trans. Denise Folliot (New York: Pantheon, 1958), pp. 196–215]; Roman Jakobson, "Linguistics and Poetics," in *The Structuralists from Marx to Lévi-Strauss*, ed. Richard DeGeorge and Fernande DeGeorge (Garden City, N.Y.: Doubleday, 1960), p. 111. Cf. Gérard Genette, *Mimologiques* (Paris: Seuil, 1976), esp. chap. 6 [tr. *Mimologics*, trans. Thais E. Morgan (Lincoln, Nebraska: University of Nebraska Press, 1995)].

98. Jean-Paul Sartre, *Situations II* (Paris: Gallimard, 1947), p. 64 [tr. *"What Is Literature?" and Other Essays*, trans. Bernard Frechtman et al. (Cambridge: Harvard University Press, 1988), p. 29]. Thomas Aquinas observes that "the act by which we establish a relation to an image is of one of two kinds, depending on whether the image is taken as a particular object or the image of something else. The difference between these two movements is that the first has as its object the thing itself, which represents something else, while the second bears, by way of the first, on what the image represents." *Summa Theologica*, III, 2, 3.

its place alongside the first and adapts to it more or less successfully. To "consider" that a given line of verse is an alexandrine is an act as heavily charged with semiotic activity (though of another order) as to "consider" that it treats of love. Valéry doubtless exaggerated when he said that certain words "act on us without teaching us much of anything"; but he immediately corrected himself by adding: "What they teach us, perhaps, is that they have nothing to teach—that, employing the same means that usually teach us something, they perform an entirely different function." This "action" and this "function" are by no means devoid of *meaning*, and to teach us *that* is certainly not to teach us nothing. To signify insignificance is, after all, to signify, and the meaning involved is far from trivial.

A Final Symptom?

The fifth and last of Goodman's symptoms, discovered ("added") after the publication of the second edition of *Languages of Art*, involves "multiple and complex reference, by which a symbol performs several integrated and interacting referential functions, some direct and some mediated through other symbols." A footnote spells out that these symbolic functions have to be performed simultaneously; this excludes "ordinary ambiguity, where a term has two or more quite independent denotations at quite different times and in quite different contexts."[99] The distinction made here differentiates, then, between ordinary *polysemy*—for instance, that of the French word *pêche*,[100] whose two referents are, in theory, disjunctive alternatives (in ordinary usage, this word rarely designates both a sport and a fruit)— and *ambiguity*, dear to the theoreticians of poetic language, in which the two referents coexist, or, at the very least, remain undecidable (a possibility that could, moreover, be realized by a deliberately ambiguous statement like *l'été est la saison de la pêche*).[101] Since Goodman does not say anything more precise than this, it seems to me that we may call the fifth

99. Goodman, *Languages of Art*, p. 68. Cf. Goodman, "Routes of Reference," in *Of Mind and Other Matters*, pp. 55–71.

100. [*Pêche* means both "peach" and "fishing."]

101. [Summer is peach season/fishing season.] Consider also the following nice example of non-contextual, sentence-level ambiguity, in which three out of five words can have different meanings and function as different parts of speech (at least in written form; oral intonation would almost certainly differentiate among the various possibilities): *La petite brise la glace* [This means both "the little girl breaks the ice" and "the little breeze chills her to the bone"]. Cited in Jacques Moeschler and Anne Reboul, *Dictionnaire encyclopédique de pragmatique* (Paris: Seuil, 1994), pp. 146–147.

symptom itself "multiple and complex," in that it brings together under one head two distinct modes of semantic plurality: ambiguity, where several denotations coexist at the same level, and figurative transnotation,[102] where something denoted denotes in its turn, as when the word "flame" designates a material phenomenon that, by analogy, symbolizes a feeling. This endows "flame" with an indirect denotational function, and lends it the status of a figure of speech, here metaphor; but any other figure of speech, such as the synecdoche "sail" for "ship," or the antiphrasis "brilliant" for "stupid," is equally transnotational.

It seems clear that Goodman's laconic formulation is intended to encompass all these aspects of denotation, which, moreover, are by no means negligible or relevant to verbal expression alone (a drawing like Jastrow's duck-rabbit is undecidable in the absence of contextual indications; a graphic symbol like the cross refers to a religion *by way of* an instrument of torture); and they are indeed characteristic, though not exclusively so, of situations of an aesthetic kind. We accept an ambiguous statement like *l'été est la saison de la pêche* more readily in a humorous context than in a communication with a practical purpose, where the ambiguity would be unwelcome. But nothing prevents us from illustrating the criterion of multiple reference with relations of *multiple exemplification*, which may, in their turn, be specified by the way a work is presented (a title like *Symphonie Fantastique* or *Optimistic Tragedy* simultaneously establishes a generic attribution and a thematic coloring), or left open to the predicative activity of the receiver. This obviously brings us back to the criterion of open-ended exemplification that has already been advanced here, with or without Goodman's imprimatur. As for *complex exemplification*, it is, quite simply, constitutive of this symbolic mode, since an object always simultaneously exemplifies (again, *among other things*, unless the contrary is expressly stated) one of the classes it belongs to, one of the classes that class belongs to, and so forth: this corkscrew is a bacchanalian instrument, an instrument, a material object, an object of attention; the Parthenon is a Dorian temple, a Greek temple, a temple, a building, a work of art, etc. Goodman himself uses a work of art to illustrate this fact, observing that a painting can "be in," and therefore exemplify, Picasso's style, Picasso's Blue Period style, the twentieth-century style, and so on.[103]

102. I first proposed this term in Genette, *L'œuvre de l'art*, p. 278 [*The Work of Art*, p. 248].

103. Goodman, "On Being in Style," in *Of Mind and Other Matters*, p. 131.

ALL IN ALL, THIS FIFTH SYMPTOM, A LATECOMER,[104] SEEMS TO ME
to correspond rather well to the category of semantic repleteness that we
sought in vain a moment ago. It has the double reference (to both denota-
tion and exemplification) that attaches to any kind of repleteness, and has
the effect of functional intransitivity that repleteness always gives rise to:
"ambiguity," as Jakobson says, "is an intrinsic, inalienable character of any
self-focused message, briefly a corollary feature of poetry. Let us repeat
with Empson: 'The machinations of ambiguity are among the very roots
of poetry.'"[105] Perhaps one should put it the other way around, and say that
ambiguity (and figurative indirection) *tend to* accentuate the message. But
this symptom, which, like the other four, is more necessary than sufficient,
does not take us beyond the limits of a purely semiotic, and therefore
purely cognitive definition of the aesthetic relation. The aspects of this re-
lation that Goodmanian theory elucidates and describes seem to me
hardly open to question; nevertheless, I do not believe that this descrip-
tion is complete, or, consequently, that it provides us with a definition. In-
deed, we have seen that Goodman by no means claims to provide one. At
the risk of seeming to make that claim myself, I shall say that what is most
obviously missing from Goodman's theory (*what* it misses most, and most
deliberately—I shall come back later to the reasons Goodman gives for
this) is something without which no description of the aesthetic relation
can be at all faithful to what it describes: its *emotional* dimension, that is,
the appreciation that is part and parcel of it. It is perhaps time to discuss
this.

104. In "On Symptoms of the Aesthetic," p. 137, Goodman discusses and then rejects
two other "symptoms" that are sometimes evoked: "fictiveness," which, he argues, is always
produced by exemplification, by expression, or through a referential chain, and thus can be
reduced to previously identified symptoms (I am not so sure it can be, but I think that this
property is too narrowly confined to certain arts, in particular literature, to function as a fea-
ture of aestheticity in general), and "figurativeness," which he does not consider sufficiently
characteristic of the aesthetic: we find metaphors in various stages of decay in all sorts of texts
wholly wanting in aesthetic value. I am of Goodman's opinion; moreover, it seems to me
that figurative language is, typically, a matter of indirect reference.

105. Jakobson, "Linguistics and Poetics," p. 111. Cf. William Empson, *Seven Types of Am-
biguity* (Cleveland: Meridian, 1955).

Aesthetic Appreciation

It is with good reason, says Sancho to the squire with the great nose, that I pretend to have a judgment in wine: This is a quality hereditary in our family. Two of my kinsmen were once called to give their opinion of a hogshead, which was supposed to be excellent, being old and of a good vintage. One of them tastes it; considers it; and after mature reflection pronounces the wine to be good, were it not for a small taste of leather, which he perceived in it. The other, after using the same precautions, gives also his verdict in favour of the wine; but with the reserve of a taste of iron, which he could easily distinguish. You cannot imagine how much they were both ridiculed for their judgment. But who laughed in the end? On emptying the hogshead, there was found in it at the bottom, an old key with a leathern thong tied to it.

In his famous essay "Of the Standard of Taste,"[1] David Hume cites this episode of *Don Quixote*[2] to illustrate how relativism—or, to use the more pejorative expression he prefers at this stage in the development of his thought,[3] "scepticism"—can be avoided in the field of what we today

1. David Hume, "On the Standard of Taste," in Ernest C. Mossner, ed., *An Enquiry Concerning Human Understanding and Other Essays* (New York: Washington Square Press, 1963), p. 253.

2. Miguel de Cervantes, *Don Quixote*, bk. 2, chap. 13. I quote Hume's loose, abridged version.

3. Hume's position evolved, to say the least, after the publication of early essays like *The Sceptic* (1742), in which he puts forward, apparently without reservations, the subjectivist position he here condemns without admitting he once held it (ibid., pp. 249–250). On this

call aesthetic judgment. That relativism is presumed to be a danger may be inferred from an observation Hume makes at the beginning of the same essay, to the effect that tastes vary with individuals, nationality, historical period, generation, or age. Hume is in fact among the first to have made this observation.[4] The centuries before him had been dominated by a philosophy whose cardinal principal, from Plato's *Symposium* to Thomas Aquinas and beyond, was that Beauty is an objective property possessed by certain objects, living creatures, and works of art,[5] a property whose individual components had been more or less clearly established, and which was so patent that it must needs be recognized by everyone. I will not go into the details of the Humean inquiry into the "variety of taste," a variety which is today commonly acknowledged, even if its consequences may not be. The controversy begins beyond this point. Hume's way of settling it, which sounds rather like a retraction, is still representative of certain contemporary positions; rather disarmingly simple, it runs as follows: judgments of taste are, to be sure, diverse, and often even contradictory, but this diversity arises from the simple fact that some people are better judges than others—as Sancho Panza's kinsmen, who are able to detect the taste of a key and a leather thong in a sip of wine, are better judges than those who failed to detect it. The dullness of the palates of those in the second group is comparable, to borrow another famous comparison from the same text, to the blindness of those incapable of making the distinction— objective and even measurable—between the altitude of Mt. Tenerife and that of a mole-hill, or between the surface area of a pond and the sea.[6]

The flaw in this parable leaps to the eye: the diagnosis made by Sancho's oenologist kinsmen ("a small taste of leather and iron") is confirmed by an objective test, namely, the discovery, at the bottom of the cask, of the key responsible for this parasitic flavor. A diagnosis, however, is not an appreciation, and, when it comes to judgments of taste, that is, appreciations, objective proof is rather harder to come by. But it is doubtless worth pausing a bit longer over the situation evoked in this little story.

The discovery of the key seems to prove, incontestably, the accuracy

point, see, inter alia, Renée Bouveresse, Introduction to David Hume, *Essais esthétiques: Art et psychologie* (Paris: Vrin, 1974), pp. 7–63, esp. pp. 23–32, and Theodore A. Gracyk, "Rethinking Hume's Standard of Taste," *Journal of Aesthetics and Art Criticism* 52 (1994): 169–182.

4. The celebrated (and resolutely relativist) entry "Beautiful, beauty" in Voltaire's *Dictionnaire philosophique* [tr. *The Philosophical Dictionary*, trans. and ed. H. I. Wolf (New York: Knopf, 1924), http://history.hanover.edu/texts/voltaire/volbeaut.htm] dates, of course, from 1764.

5. I include works of art in this list so as to take in the whole field today covered by aesthetics, although for Plato, at least, beauty has very little to do with art.

6. Hume, "On the Standard of Taste," p. 250.

of the taste of our two oenologists—if we ignore the fact, recently pointed out by George Dickie,[7] that one of the two detects only the taste of the iron, and the other, only the taste of the leather, which makes each of them no more than a semi-expert. But, after all, the presence of the key and the taste of iron and leather stand in a relation of probable, not certain cause, like, for example, the relation between the anomaly that showed up in Le Verrier's calculations one day in 1846, and the existence of the planet Neptune, observed only afterwards. Moreover, Sancho's two kinsmen do not diagnose the presence of a key, exactly, but only discern a taste of iron and leather, which might have a very different, or even unascertainable cause. *A contrario*, if it had been discovered that there was no key, this would by no means have disqualified their palates. It would only have cheated them of an easy victory, based on an induction more spectacular than solid: a wine can taste of iron and leather without containing anything even remotely resembling a key, or, indeed, anything at all made of iron and leather. Conversely, an object made of iron and leather might very well be found in the wine without affecting its flavor in the least. Dickie imagines a third expert who claims that the wine has a slightly coppery taste, though no objective discovery comes along to confirm this. More simply, and closer to real experience, when an oenologist detects an aroma of violets or a taste of raspberries in his glass, he does not expect his diagnosis to be confirmed by any objective proof; indeed, he does not make a diagnosis in the proper sense of the word, does not, that is, interpret one state of affairs as an index, or "symptom," of another, which it would point back to as to its cause.[8] In ordinary situations, as well as in the case Cervantes evokes, the oenologist's judgment is a simple observation that makes no claim to being an inductive inference: the taste of iron, or raspberries, is a fact in itself, and does not point back to any cause. Indeed, I doubt that it can always be said *where*, in a given wine, the flavor of one or another fruit comes from; the question is perhaps idle. This being so, if another oenologist, invited to give a second expert opinion, maintains that the wine does not in the least taste of raspberries, but so obviously tastes of apricots that a five-year-old child would notice, no objective test could determine which of the two conflicting opinions is correct, not even if one were to send for the five-year-old in question, à la Groucho Marx. The real experience that most closely resembles the fictitious test described in *Don Quixote* is to be found, of course, in those wine-tasting competitions in which experts are supposed to guess the origins, vineyard and vintage included, of a ran-

7. George Dickie, *Evaluating Art* (Philadelphia: Temple University Press, 1988), p. 143.
 8. Ibid., p. 144.

domly chosen bottle of wine whose label has been covered up. The expert who calls out "Château-Lafite, 1976" will have his diagnosis (this time the word is entirely appropriate) and expertise confirmed if the label that is then uncovered turns out to be that of a genuine Château-Lafite bottled in 1976. Nevertheless, in this case as in the one mentioned a moment ago, such confirmation does not always proceed from an indisputable inference, like the one I have perhaps naively assumed the mechanics of the universe provides. A Margaux 1974 might just happen to have the same flavor as our Lafite, which might in its turn exactly resemble that of a Rothschild 1982, and so on, leaving room for what I shall call a "judicious error," that is, one which involves knowledgeably erring by correctly detecting in one object a property that is more commonly present in another[9] — just as, conversely, one can be "on the mark" without good reason, like the blind man in Plato who takes the right road by accident; or for the wrong reasons, like the second-rate expert who does not attribute a good imitation of Vermeer to that painter, not because he detects the "forgery," but because he does not even recognize Vermeer's style in the fake, thus triumphing through sheer incompetence.

But the essential point, it seems to me, is that in Sancho's little speech the diagnosis appears as a justification for, and thus as an integral part of, an aesthetic judgment (a "verdict"), because the presence of a slight taste of leather or iron is treated as something that diminishes the quality of the wine. However, this argument presupposes the always problematic link between fact and value that Hume wished, precisely, to deduce from it; for, everything else aside, it has still to be established that the slight taste of iron or leather is such as to *detract from* (or improve) the flavor of the wine. Two oenologists can be in perfect agreement about the presence of a flavor "to the tongue," and differ as to its gustatory value; leaving iron or leather aside, the famous "slight taste of flint" that lovers of Sauvignon value so highly is not necessarily to everyone's taste. The discovery of the key with the leather thong may prove what Hume calls the "delicacy" of Sancho's kinsmen's taste, that is, the accuracy of their perception, but it in

9. "Gustatory impressions can transgress official boundaries. Thus one is sometimes absolutely certain, when tasting a wine of the highest quality, the quintessence of a particular variety of grape, that one is drinking the juice of another, which enjoys higher standing in the hierarchy of the period. We recall, for example, that once, in the Nantes region . . . we discerned traces of Sauvignon in some old muscatels that were not to be had on the market (they had been distilled from the Melon of Burgundy) — and, among the best flavors of Sauvignon . . . certain flavors of the best Chardonnays. As for the red wines of this sort, they included, one within the next, like Russian dolls, traces of Gamay, Cabernet Franc, and Pinot Noir, in ascending order." Jean-Yves Nau, "Dis-moi quel est ton nom," *Le Monde*, 13 August 1994.

no wise proves the accuracy of the "judgment" or appreciation they wish to attach to it. A good part of the sophistry here is due to the ambiguity, observable in most European languages, of the word "taste" (and also of the word "judgment"): it sometimes designates a capacity for factual discernment (the ability to detect the presence of a flavor, or, more generally, a property), and sometimes refers to the capacity, in my view suspect, or even downright unthinkable, to bring to bear on this property what some do not hesitate to call "correct judgment." In view of this ambiguity, which confuses fact and value, let us—at the price of watering down still further a formula that has already lost a good deal of its punch—say that oenology, as Sancho conceives it, is not and never can be an exact science, or even a science tout court.

The same goes for aesthetics,[10] whatever Hume may have thought, or, rather, have wished, without, perhaps, too many illusions. Before turning back to aesthetics, however, I would like to draw one for the road from Sancho's cask (as they used to say before the alcohol test was invented). Like the flavor of iron and leather, the flavor of raspberries or flint is supposed to be something one observes, however difficult it is to verify the observation. But, after all, when an ordinary mortal raises a wine glass to his lips, it is not usually in order to divine the origins of the wine in it, nor even to analyze its bouquet and flavor by tasting it, but simply, as the song has it,[11] to see if it is "good"—that is, if he likes it—just as I generally look at a picture, not as an expert (which I am not) intent upon attributing it to a painter, but to see if it is "beautiful"—that is, if I like it. What is at stake here is no longer the identification of a fact, and even less an attempt to infer its cause, as in the process of attribution, but rather what is called *appreciation;* and this time it would *not* be appropriate to turn to specialists for an expert opinion, for nothing is more absurd or less pertinent than to look to others for what should depend on personal taste: "Pray sir," says Stendhal, in a stab at the conformism of the French, "am I amused?"[12] Even if everyone at the party should die laughing at my "bad taste," I have

10. It is perhaps time to spell out that the use of this term here (in conformity with ordinary usage) to designate a field of study ignores, to all intents and purposes, another sense of the term (also current, albeit derivative), in which it designates an artistic doctrine or tendency ("Classical aesthetics"), or, more broadly, a deliberate choice or particular preference in matters of taste ("this interior decoration is evidence of a rather kitschy aesthetic"). By way of example, *The Critique of the Faculty of Judgement* clearly illustrates these two senses of the word (I am being outrageously schematic) with its subjectivist theoretical aesthetic and pre-Romantic taste—which are, moreover, not unrelated. Again, Hegel's *Aesthetics* (same proviso) illustrates an "historicist essentialism" (Schaeffer) and a taste that runs to Classicism.

11. [The reference is to the traditional drinking song "Chevaliers de la table ronde."]

12. Stendhal, *Vie de Rossini* (Paris: Le Divan, 1929), vol. 1, p. 99 [tr. *Life of Rossini*, trans. Richard N. Coe (London: Calder and Boyars, 1970), p. 71].

a perfect right to prefer Ripple to Canary wine, or Sully Prudhomme to Baudelaire (Ogilby to Milton, says Hume), and nobody can force a genuine preference on me. Adopting the connoisseurs' opinions is nothing but a sign of insincerity, and will in no sense alter my taste, but only what I hypocritically say about it, or, perhaps, the opinion I contritely give of it under other people's influence ("I prefer Ripple, but I must be wrong"). A "taste" for this or that is a psychological phenomenon, not a phenomenon that can *truly* be influenced from the outside, by coercion or logical argument: aesthetic judgment is "without appeal," that is, autonomous and sovereign. Only inward change, the result, for example, of growing older, or of what is widely known as education, can alter it; and it would perhaps be still better to say that it alters itself. But, at the present moment, here and now, it is not in anyone's power, my own not excepted, to alter my judgment in the true sense, that is, authentically. This has to do with the strictly *subjective* nature of aesthetic appreciation. It is precisely this feature of appreciation which Immanuel Kant—whose reappearance here, on the heels of Hume and after my allusion to Canary wine, will surprise no one—calls *aesthetic*.

The Aesthetic of Judgment

The first subsection of *The Critique of Judgement* bears the title—which sounds rather odd to modern ears—"the judgement of taste is aesthetic." Since Kant uses the term "judgement of taste" (*Geschmacksurteil*) to refer to what we usually call "aesthetic judgment" today, this initial proposition, as I noted earlier, might seem to be a purely tautological statement to the effect that aesthetic judgment is . . . aesthetic. In fact, the word "aesthetic" has two very distinct meanings for Kant. What *we* call aesthetic judgment has, for example, to do (I put it summarily, and inaccurately), with the "beauty" or "ugliness" of things; this is what Kant generally calls a "judgement of taste." He borrows the term and the concept, along with a great deal else, from an earlier tradition, to which Hume of course also belonged. Again, when Kant calls a judgment "aesthetic," he means that it "is not a cognitive judgment, and so [is] not logical, but aesthetic—which means that it is one whose determining ground cannot be other than subjective."[13] This determining principle is a feeling of pleasure or displeasure, and an aesthetic

13. Immanuel Kant, *The Critique of Judgement,* § 1–60, in *Kant's Critique of Aesthetic Judgement,* trans. James C. Meredith (Oxford: Clarendon, 1911), pp. 40–41.

judgment of the type "this object is beautiful" does absolutely nothing other than to express this feeling, on which no argument, no demonstration, and no objective "proof," if one were to be had, can exercise a real influence, as is true of all feelings. No key, with or without a leather thong, can distinguish "good" judges from "bad" in matters of taste, or genuinely persuade anyone that his feeling is "wrong"—for that is quite simply a meaningless statement.[14] Neither the opinions of other people nor the evocation of general rules can compel inner agreement from anyone:

> Of course he may affect to be pleased with it, so as not to be considered as wanting in taste. He may even begin to harbour doubts as to whether he has formed his taste upon an acquaintance with a sufficient number of objects of a particular kind. . . . But, for all that, he clearly perceives that the approval of others affords no valid proof, available for the estimate of beauty. . . . This would appear to be one of the chief reasons why this faculty of aesthetic judgement has been given the name of taste. For a man may recount to me all the ingredients of a dish, and observe of each and every one of them that it is just what I like. . . yet I am deaf to all these arguments. I try the dish with *my own* tongue and palate, and I pass judgement according to their verdict (not according to universal principles).[15]

Thus the Kantian aesthetic is diametrically opposed—not, on my view, to Hume's, which is in fact a bit more uncertain or vacillating than it would wish to be—but to those which would take the story of the key with the leathern thong, as interpreted by Sancho, as a good illustration of their position; that is, as proof not only of "delicate" perception, but also of good judgment. It is opposed, in other words, to those who lay down or postulate, or even simply seek, what Hume calls a "standard of taste," a criterion of Beauty, or an objective foundation for aesthetic appreciation. I would say, in more modern terms, "those who seek to avoid relativism in aesthetics"—if it were not that Kant, to complicate things a bit, himself strives to steer clear of this relativism. But we are not there yet.

So far the analysis of the kind of judgment we call aesthetic boils down to the observation that it is "aesthetic" in nature, i.e., purely subjective. As we have seen, aesthetic appreciation has this characteristic in common with what Kant calls the "judgement of agreeableness," which is a judgment that expresses physical pleasure, or pleasure of the senses: the pleasure one has, let us say, since this prim example is decidedly Kant's, in savoring a glass of Canary wine. The feature "subjectivity," which is peculiar

14. "All sentiment is right," says Hume ("On the Standard of Taste," p. 249), in his generally accurate summary of the "sceptical philosophy" he goes on to repudiate.

15. Kant, *Critique of Judgement*, pp. 139–140.

to both, and differentiates both from, for example, cognitive judgment, or "practical" and moral judgment—based, for their part, on concepts of objective properties or principles of higher interest—is therefore not sufficient to define aesthetic judgment in its specificity. What defines it—that is, what distinguishes it from judgments of agreeableness, this distinction being sufficient to define it—is, as we have seen (I will not go over this point again) the fact that it is "disinterested," in the special sense Kant assigns this term: not based on an interest in the real existence of the object under consideration, for the simple reason that aesthetic judgment bears solely on the object's *Beschaffenheit*.

It would not be entirely false to claim that once Kant's aesthetic has thus defined aesthetic judgment by what it has in common with judgments of agreeableness (subjectivity) and what differentiates it from them (an exclusive interest in form), it has said, in ten pages, everything (worthwhile) it has to say, and that all that follows is only a kind of optional appendix, somewhat repetitious, and, at times, sophistic. Indeed, Kant's essential argument is condensed in two sentences that make up the conclusion to the "First Moment" of the *Critique*: "*Taste* is the faculty of estimating an object or a mode of representation by means of a delight or aversion *apart from any interest*. The object of such a delight is called *beautiful*."[16] We may note in passing how what was for centuries at the heart of reflection on the aesthetic (Beauty) is here relegated to a secondary, derivative, and, in some sense, marginal position. Beauty is now nothing more than "the object of such a delight"; it is no longer beauty which defines aesthetic satisfaction, but aesthetic satisfaction which defines beauty, as was already rather barefacedly announced in the first note to this text: "Taste . . . is the faculty of estimating the beautiful. But the discovery of what is required for calling an object beautiful must be reserved for the analysis of judgements of taste."[17] Here as elsewhere, Kantian philosophy proceeds to carry out what its author, without false modesty and, all things considered, without exaggeration, called a "Copernican revolution"—although this revolution proceeds in the opposite sense, inasmuch as the center of gravity shifts from the object toward the subject: if beauty is nothing other than the contents of subjective appreciation, aesthetics cannot be what it was hitherto conceived as, a science of the beautiful, for we cannot study that which has no objective existence, much less found a science of it. There exist objects that some find beautiful, and these objects can be studied as objects, but not as beautiful. There can be, indeed there

16. Ibid., p. 50. The formulation "is called beautiful" is in fact ambiguous (who is doing the calling?). I will come back to this point.
17. Ibid., p. 41.

is, a science of flowers, stars, and cathedrals, but not one of the beauty of flowers, cathedrals, or "the heavenly vault" (which, typically, is an object only from an aesthetic point of view, because, from a scientific point of view, the sky has nothing of a vault about it). Thus aesthetics as a study, or even, possibly, as a "science," can only be a "meta-aesthetic,"[18] that is, can only be a study of aesthetic appreciation itself.

Such an affirmation may seem contradictory, because it posits that appreciation is subjective and, at the same time, that it can be an object of study, whereas I have just denied that "that which has no objective existence" can constitute such an object. The answer to this objection is that it is the *contents* of an act of appreciation (the "beauty," "ugliness," etc. of the object evaluated) which has no objective existence, because it results from an erroneous objectification of the act of appreciation itself. That act, however (the act of judging the object to be "beautiful" or "ugly") is a fact, obviously "subjective," yet quite real *qua* psychological event, and observable, at least indirectly, by way of its various manifestations, especially verbal. As such, it is a valid, legitimate object of study. For my own part (I absolve Kant of all responsibility for this radical formulation), I would say that aesthetic appreciation is a real, subjective phenomenon whose objectified contents (that which is predicated by the act of appreciation) is, as such, illusory. Thus the only phenomenon that lends itself to study here, whether theoretical (general) or empirical (case by case), is the act of appreciation itself, the object of a meta-aesthetic analysis that we shall continue to call "aesthetic" simply so as not to overburden our vocabulary. But, after all (*before* all), Baumgarten, in his *Aesthetica* (1750), defined this new "science" precisely as the study of certain forms of cognitive behavior. The term "aesthetics" is, then, legitimate, on the express condition that we never seek in aesthetics an illusory "science of the beautiful." Our business is with objects of (aesthetic) attention, and it is also with the act ("judgement of taste") that consists in ascribing "aesthetic qualities" to them; but it is never, for good reason, with these "qualities" themselves, except (as Kant more or less says) by way of the analysis of the judgment of taste, considered as a content. As the proverb Hume cites and then rejects has it, "Beauty is in the eye of the beholder."[19]

We have to do, then, with two conceptions of aesthetic appreciation. One is symbolized by Sancho's key; the other, on my view, results from the Kantian revolution. It requires no great effort on my part to describe the first as objectivist and the second as subjectivist, or to confirm that I

18. Jean-Marie Schaeffer, *L'art de l'âge moderne: L'esthétique et la philosophie de l'art du XVIII^e siècle à nos jours* (Paris: Gallimard, 1992), p. 73.
19. Hume, "On the Standard of Taste," p. 249.

fully endorse the second, in part because of the fact, duly acknowledged by Hume, that appreciations vary widely, but also because of the fact, which he signals against his will and, as it were, *a contrario*, that no key of any kind can decide which of the two contradictory appreciations is right, as it can when the choice is between mere diagnoses. This motivation for the subjectivist position is known, of course, as the *relativity* of aesthetic appreciations. It finds crucial warrant in Kantian subjectivism; but, as I have already said, it would be going too far to put Kant himself in this camp, because the balance of the third *Critique* shows that he is, rather, at pains to avoid drawing this consequence. His aesthetic is typically subjectivist, but, to the extent that it can, it carefully sidesteps relativism, or, rather, denies that it subscribes to the relativism which seems to follow from this position. As is known, its way of warding off such relativism is to locate in aesthetic appreciation what Kant calls a "rightful claim" to universality, that is, to unanimity in judgments of taste. This somewhat contradictory notion of a *rightful claim* has two obviously distinct aspects whose interrelation is by no means assured. The one is the claim itself, in other words, the fact that, when I form an aesthetic judgment, I claim that everyone should share it; the other is the validity of this claim, that is, whether or not there are concrete grounds for it. In principle, the presumption that such a claim exists is a matter of simple observation: according to Kant, any aesthetic judgment includes a demand that everyone assent to it, this demand being one of the features that distinguishes it from a judgment of physical agreeableness. Here is what he says:

> As regards the *agreeable* every one concedes that his judgement, which he bases on a private feeling, and in which he declares that an object pleases him, is restricted merely to himself personally. Thus he does not take it amiss if, when he says that Canary-wine is agreeable, another corrects the expression and reminds him that he ought to say: It is agreeable *to me*. . . . With the agreeable, therefore, the axiom holds good: *Every one has his own taste*. . . . The beautiful stands on quite a different footing. It would, on the contrary, be ridiculous if any one who plumed himself on his taste were to think of justifying himself by saying: This object . . . is beautiful *for me*. For . . . when . . . he . . . calls [a thing] beautiful, he demands the same delight from others. He judges not merely for himself, but for all men, and then speaks of beauty as if it were a property of things.[20]

I will come back to this last phrase, which seems to me crucial. For the moment, let us note only that the "as if" (*als ob*) which occurs in it con-

20. Kant, *Critique of Judgement*, pp. 51–52.

tinues to present the universality of judgment as a mere claim, lacking solid grounds; the paradoxical nature of this claim is, moreover, underscored by the reminder that judgments of taste (this is the consequence, or, rather, the definition of its "aesthetic character") *are not based on any concept*. Two things constitute the grounds for the validity that Kant will go on to accord such judgments: one is of a logical kind, the other is a pure, *ad hoc* hypothesis. The first is a chain of reasoning imputed to the aesthetic subject and treated as obviously valid: because my aesthetic judgment, contrary to other types of judgment, is "disinterested," that is, not determined by any personal interest, whether physical or moral, it is, as I see it, necessarily shared by everyone, and therefore universal. It is somewhat surprising to see such abstract reasoning figuring in a context which is, in principle, dominated by a pure feeling (of pleasure or displeasure), and even more surprising to see the philosopher validate so weak or summary an argument, since the only thing he treats as capable of rendering a judgment of taste idiosyncratic, and therefore not universal, is interest. To proceed in this fashion is obviously to forget all the empirical grounds for disagreement that Hume elucidates, grounds that have to do, for example, with the natural or acquired diversity, not of interests, but of individual *sensibilities*. Kant does not explicitly acknowledge this flaw in his argument, but he soon comes up with other grounds for the validity of the claim to universality; he discusses them later in the third *Critique*, in connection with a second "claim" put forward by the judgment of taste, one which, it must be said, is barely distinguishable from the first—the claim of *necessity*. The backup basis for the claim of universality is the hypothesis of what Kant calls the *sensus communis*, or aesthetic common sense. Invoking this hypothesis, which, again, flies in the face of the most commonplace observation, the individual aesthetic subject postulates a community of "feeling" (of sensibility) that embraces all human beings, as a result of which their judgments of taste are said to be in natural agreement. Kant carefully avoids saying whether he himself considers this assumption to be founded or not: he contents himself with postulating that it is required to justify the validity of the claim, and merely ascribes it to the aesthetic subject, as, earlier, he ascribed to that subject the argument about disinterested pleasure.

With this, then, we have two reasons to believe that aesthetic judgments are universal and necessary. Neither one calls its subjective nature into question; neither one, that is, postulates an objective criterion of beauty. Making judgments in a disinterested manner, everyone deems that what pleases him is beautiful (and that what displeases him is ugly), and demands universal assent, invoking, first, his inner certainty as to the

disinterested nature of his judgment, and, second, the reassuring hypothesis that there exists a community of taste among all human beings. On this double basis, which is doubly fragile, Kant, going well beyond anything it authorizes, draws a double conclusion in, for once, an extremely dogmatic manner: "The *beautiful* is that which, apart from a concept, pleases universally," and "The beautiful is that which, apart from a concept, is cognized as object of a *necessary* delight."[21] It is not hard to combine these two propositions in the following apocryphal, synthetic form: "The *beautiful* is that which, apart from a concept, pleases in a universal and necessary manner." It is also not hard to see that the conclusion exceeds the premises. What Kant has actually shown is, at best, that aesthetic judgments lay claim to being necessary and universal. The validity of this twofold claim, however, remains to be demonstrated. I doubt that it is demonstrable; I doubt that the course Kant charts is the surest way of arriving at a demonstration of it; and I doubt even more strongly that these claims are consistent with his point of departure, which seems to me, for its part, incontestable: namely, the radical subjectivity of aesthetic judgments as simple objectifying expressions of a feeling of pleasure or displeasure. It seems to me, once again, that this whole rather specious argument is nothing but a desperate attempt to elude the inevitable consequences of the initial observation, which is, to repeat, the relative nature of aesthetic judgment.

Objectification

But let me come back to the phrase left in abeyance a moment ago. It seems to me to be the crucial point in Kant's analysis, according to which someone who makes a judgment of taste "judges not merely for himself, but for all men, and then speaks of beauty *as if* it were a property of things." Again, the "as if" clearly confirms that Kant is convinced, as, incidentally, I am too, that the beauty in question *is not* a property of the object, but rather that affirming its existence is merely the aesthetic subject's way of expressing his favorable judgment of the object. Somewhat further on, Kant, referring to the problematic of the *Critique of Pure Reason*, attempts to show that aesthetic judgments are synthetic a priori judgments. He then offers the following description of them, which is, to my mind, very suggestive: when one makes an aesthetic judgment, one links to a

21. Ibid., pp. 60, 85.

perception the feeling of pleasure or displeasure that accompanies a representation of the object, and "serv[es] it instead of a predicate."[22] These two propositions coincide insofar as the aesthetic subject *ascribes* to the object, in the form of a predicate, a property that is supposed to be the objective cause of his own pleasure or displeasure; he calls it the object's "beauty"—or identifies it as some other aesthetic "quality." Again, it seems to me that the "and" in the sentence that interests us ("he judges not merely for himself, but for all men, *and* then speaks of beauty as if it were a property of things") contains and occults a more powerful relationship, which is not one of simple coordination, but of causal subordination. I would say, for my part, that the aesthetic subject believes he can judge for everyone, *because* he makes beauty a property (implicitly, and by definition—an *objective* property) of the object he appreciates. When I say that the causal relation is occulted in this sentence, I mean that I think Kant himself misses it, that he passes it by without taking it into account, doubtless because he does not wish to. For, if the only grounds, the true grounds, for the claim to universality reside in the belief, which Kant himself obviously regards as false, that there exist objective aesthetic properties like beauty or ugliness, then this claim is ipso facto invalidated and branded as illegitimate: it becomes nothing more than an illusion, like the belief it is based on, and we are again driven back into the relativism that Kant and many others so fear. Hence this reason, as such, is occulted or obscured, and the two others I discussed earlier are put forward with a great deal of strain: the proof based on disinterestedness and the hypothesis of an aesthetic consensus.

Yet it seems to me that the phenomenon which Kant, here as elsewhere, points to without recognizing (wanting to recognize) its full import, is wholly constitutive of aesthetic judgment. This phenomenon, which belongs to the domain of empirical psychology but is very widely observable, if not, indeed, universal, consists in what might be called the *objectification* of judgment: the natural tendency to ascribe to an object, as one of its objective properties, the "value" that derives from the way one feels about it. I am not, incidentally, certain that such objectification is characteristic of aesthetic appreciation alone, for it seems to me that, in many cases, judgments of agreeableness (of physical pleasure) are also accompanied by projections of this sort: contrary to what Kant affirms, we very frequently find ourselves saying that a wine, whether from the Canaries or elsewhere, is "good," without considering it necessary or relevant to relativize matters by adding a proviso like "at least as far as I am

22. Ibid., p. 144.

concerned"; and it often happens that we, like Sancho's kinsmen (and their opponents in the debate), even forget the principle *de gustibus non disputandum* and therefore contest the taste of people who do not share our own, as if they had failed to recognize the objective property which, in our eyes, warrants our appreciation. As Gombrich says, with exemplary simplicity and common sense: "Man is a social animal and he is in need of approval,"[23] at whatever level. But I leave aside this secondary question, which has to do with what I consider Kant's somewhat forced distinction between aesthetic and physical appreciation. That the grounds for this distinction is obvious, and that it is in fact the one that Kant points to (namely, that aesthetic appreciation has more to do with the outward aspect of things, and physical appreciation with their real existence) does not necessarily imply that they function differently at every level; it seems to me that we have here a case in which they converge. The reasons for this convergence are, moreover, plain enough: in the case of both physical agreeableness and aesthetic appreciation (and perhaps others as well), objectification is in some sense natural, and constitutes an integral part of the sentiments involved. As to the objectivism characteristic of a great many aesthetic theories, though not Kant's, it is, when all is said and done, the spontaneous philosophy, or "indigenous" theory, of this natural reaction. One cannot love or hate something or someone, at whatever level, without assuming that something has given rise to one's emotion, which is assuredly the case, and that this cause is wholly contained in the thing or person hated or loved, which is much less assuredly the case. The cause is contained in the object in a sense, but only partially, insofar as the relationship between this object and the subject presupposes, in the one as in the other, reciprocal determination. If I like Canary wine, it is not because Canary wine is "good" in and of itself (it certainly is not "good" for all species of animals, probably not even for a six-month-old baby), but, at the same time, it is not "good" for reasons having nothing at all to do with Canary wine; if I like Canary wine, it is because there exists between its (objective) properties and my (subjective) taste an affinity that explains my pleasure—a pleasure which another wine would not give me, and which

23. Ernst Gombrich, *Reflections on the History of Art: Views and Reviews* (Berkeley: University of California Press, 1987), p. 100. Often what is at stake is not merely a need for approval, but a little more: a desire for communion with others by way of appreciation of the same object. As John Irving puts it: "How we love to have other people love things through our eyes" (John Irving, *The Cider House Rules* [London: Transworld Publications, Black Swan Books, 1986], p. 666). But some people, Stendhal among them, claim they are content to make an aesthetic appraisal all their own (an "egotistical" appraisal) with no regard whatsoever for that of others.

this wine would not give someone else. In short, as Montaigne said in another (but closely related) context, "because it is he, because it is I."

Aesthetic appreciation is based on a relation of the same kind. If I find a flower "beautiful," whereas my neighbor finds its "ugly," or simply uninteresting, it is because of the harmonious relationship that is established between this flower and me (between its objective properties and my own sensibility), one which is not established between the flower and my neighbor. The reason for aesthetic feelings lies in these phenomena of affinity, which, like all phenomena involving relationships, themselves have a twofold cause, located in the object and the subject. The process of objectification which Kant observes fleetingly and obliquely, but which merits closer attention, consists in unilaterally attributing to the object the entire responsibility for this bilateral relationship, *as if* it depended wholly on the object—and as if this object, consequently, must needs give rise to such a relationship between itself and all other subjects. This projection is one instance among many others of the subjective miscognition that marks, as Proust very nicely shows, the whole set of our relations to the world. Yet George Santayana is not wrong, in my opinion, to treat such projection as the most characteristic feature of the aesthetic relation, in a passage from which we will here cite only the following sentence, quoted more often than it is well understood, and sometimes unjustly ridiculed:[24] "Beauty is pleasure objectified*."[25] This does not mean what it is sometimes construed to, namely, that the *beautiful object* is an "objectified pleasure" (since, for Santayana as for Kant, there are no objects that are beautiful in themselves, but only objects in which the subject takes aesthetic pleasure), but rather that *this* (subjective) *value* of pleasure is attributed by the subject to the object as if it were one of its properties—an objective property, like any other. Let us note that this attribution goes well beyond the simple fact of identifying one or another property in the object as *the grounds* for my appreciation of it: to say that an object has aesthetic value for me, whether positive or negative, because it exhibits such-and-such a property ("I like this tulip because it is red") is a simple inference, which may or may not be right,[26] from a subjective effect back to its objective

24. For example, by Nelson Goodman, *Languages of Art: An Approach to a Theory of Symbols* (Indianapolis: Bobbs-Merrill, 1968), p. 243.

25. George Santayana, *The Sense of Beauty* (New York: Dover Publications, 1955), p. 33. The idea finds its clearest expression in ibid., p. 31: "Beauty is pleasure regarded as the quality of a thing."

26. It is not always easy to answer this question, nor even to measure its theoretical import: I can doubtless err in good faith about the reasons for my aesthetic pleasure, as I can err about the reasons for any other state of mind, and believe, for example, that I like a tulip for its color, whereas I in fact like it (for reasons that escape me) for its form. At the same

cause. The aesthetic illusion consists in objectifying *this value itself* ("this red tulip is beautiful"); objectification treats the effect (the value) as if it were a property of the object, and, consequently, the subjective appraisal as if it were an objective "evaluation." The putative aesthetic evaluation is, as I see it, merely an objectified appreciation. Indeed, evaluation, in the proper, legitimate sense of the word, is a judgment based on objective criteria, as when an expert evaluates an object in light of its condition and prevailing market rates. Aesthetic appreciation, for its part, takes itself for, and gives itself out as, the evaluation that it is not and cannot be, as soon as (and to the extent that) it illusorily objectifies its causes, transforming them into criteria.

THE REASON FOR THIS ERROR DOUBTLESS HAS TO DO WITH THE intense *presence* of the object of the aesthetic relation, which is in many respects a relation of fascination in which the subject tends to forget himself and therefore to ascribe everything to the object, his own act of valorization included. Santayana comes rather close to the mark, I think, when he says that the main difference between physical and aesthetic pleasure is the fact that the former is more precisely localized, or focalized, when brought into relation with the perceiving, and, if I may put it this way, operative organ, whereas, in the latter, the sensuous organ, the eye or the ear, for example, is as it were transparent.[27] One can of course say (and judge) that a color is agreeable to the eye, or a sound to the ear, but what is involved in that case is an instance of what Kant calls the (physical) pleasure of agreeableness: seeing a painting or hearing a symphony, and a fortiori, perhaps, reading a poem or a novel, give rise to a more generalized sort of pleasure, which is in large measure intellectual, and which we do not as spontaneously bring into relation with a sense organ, which the transitive nature of its activity helps us forget. This sensorial transparency to the object fosters the objectivist illusion. A counterexample drawn from everyday experience seems to me to confirm this explanation. It is true that we spontaneously say, in the (even if only imaginary) presence of a painting we like, "this painting is beautiful," and that we need to make a conscious effort to correct this objectifying assertion (if we correct it at all), transforming it into "this painting pleases me" or "I like this painting." However, we just as spontaneously (and, in my opinion, more accurately) say, when we are appraising a larger or more generic group of works, "I like Vermeer," or

time, the difference between "thinking that one likes" something and "truly liking it" seems to me very difficult to gauge.

27. Ibid., pp. 23–24.

"I like Mozart," or, a fortiori, "I like painting" or "I like music." In such a situation, the intense presence of the singular object disappears; this allows for a more accurate assessment of the subjective nature of the valorizing act. The relation to singular objects, in contrast, gives rise to a "judgmental"[28] activity in which cognitive exploration, no matter how synthetic or even rudimentary, is combined with emotional appreciation in the attribution, even if only tacit, of what Kant aptly terms "predicates." We shall return to this key point.

In fine, it seems to me that Kant is right to say that aesthetic judgments make a certain claim to universality. However, he exaggerates both the importance and the specificity of this claim, and misunderstands or, perhaps, partially obscures its real cause for the purposes of his argument, which sets out to validate this claim as the sole means of avoiding the relativism that an acknowledgment of the subjective nature of aesthetic valorization engenders (inevitably, in my view). Yet I do not deny the empirical existence—though it is, frankly, intermittent in the extreme, even erratic—of the famous *sensus communis*: it goes without saying that two individuals *can* concur in an aesthetic evaluation, and if two can, then why not three, four, or several million; but what is involved here is, at best, something Kant calls a *general* and purely empirical agreement, not, by any means, a universal a priori agreement, which alone could provide the assurance that there exists an objective basis for Kant's *sensus communis*. Chance, and, above all, acculturation have a great deal to do with the existence of such agreement; moreover, even in the case of two individuals whose cultural backgrounds are as similar as possible, I doubt that one can find instances of such convergence that embrace the whole aesthetic universe of both. In a word, the Kantian revolution opens a door to relativism that all Kant's subsequent efforts fail to close again. Contemporary antirelativists like Monroe Beardsley, George Dickie, Frank Sibley, and various others have understood this very well; their frequent differences of emphasis and minor disagreements notwithstanding, they concur in rejecting subjectivism in much the same manner, and attempt to renew with the tradition of pre-Kantian objectivism. In many respects, the question of aesthetic appreciation is, today, the locus of a debate between the two, on my view, irreconcilable parties here represented by the names Hume and Kant—between, that is, objectivism and subjectivism.

28. Schaeffer, *L'art de l'âge moderne*, p. 384.

An Objectivist Aesthetics

Typical of the Anglo-American analytic method, for which philosophy is above all an inquiry, not into the world, but into "the ways we conceive and speak about it,"[29] the aesthetics of Monroe Beardsley presents itself as a metacritique: "There would be no problems of aesthetics, in the sense in which I propose to mark out this field of study, if no one ever talked about works of art. So long as we enjoy a movie, a story, or a song in silence— except perhaps for occasional grunts or groans, murmurs of annoyance or satisfaction—there is no call for philosophy. But as soon as we utter a statement about the work, various sorts of question can arise."[30]

Such are the opening sentences of this book of more than six hundred pages, far and away the most monumental work of analytic aesthetics. To frame matters as Beardsley does here is obviously to take as one's object, not the aesthetic relation in itself, which, Beardsley suggests, is recalcitrant to any kind of study as long as it remains mute, but rather the discourse in which it sometimes finds expression. This initial restriction is reinforced by a second, clearly indicated in the subtitle of the book: "Problems in the Philosophy of Criticism." This shift from simple, everyday aesthetic com- mentary to professional critical discourse indirectly signals a shift from the aesthetic object to the artwork, since there exists no aesthetic "criticism" of everyday objects, and even less of natural objects.[31] And, indeed, Beards- ley's study deals for the most part with our relation to works of art, which Beardsley regards, because of their "specialized function," as "richer sources of aesthetic value [that] provide it in a higher order"[32] (this is the Hegelian position, which inverts Kant's). But Beardsley does not ulti- mately contest the principle that natural objects, at least, can also serve as the objects of an aesthetic relation (he says, typically, that "nature has aes- thetic value, often to a great extent"). Later we will have occasion to ob-

29. Arthur C. Danto, *Narration and Knowledge* (New York: Columbia University Press, 1985), p. xv.

30. Monroe C. Beardsley, *Aesthetics: Problems in the Philosophy of Criticism,* 2d ed. (In- dianapolis: Hackett, 1981), p. 1.

31. This point is contested by Michael Hancher, "Poems versus Trees: The Aesthetics of Monroe Beardsley," *Journal of Aesthetics and Art Criticism* 31 (1972): 181–191. In a discus- sion of Beardsley's theory, Hancher cites Thoreau's *Walden* as an example of "nature criti- cism*." This is to extend the notion of criticism to all sorts of descriptions of the landscape, or things in general. But the activity of criticism obviously includes something besides sim- ple descriptions, even if they are accompanied by appreciations; and this something extra presupposes the intentional nature of the thing considered. I shall return to this point.

32. Beardsley, *Aesthetics,* p. xx.

serve that certain aspects of his theory make it hard to apply even to our relation to works of art—owing to which, paradoxically, and very much against his wishes, Beardsley's aesthetics rejoins Kant's. It therefore seems to me that we can, its author's avowed intentions notwithstanding, treat Beardsley's metacritique as a meta-aesthetic, especially that part of it which interests us at the moment, the Beardsleyan theory of "Critical Evaluation" and "Aesthetic Value." These are the titles of chapters 10 and 11 of Beardsley's *Aesthetics;* they may be regarded as constituting a whole.[33] The formal division of this whole into two chapters seems to me to have more disadvantages than advantages, bringing, as it does, certain conceptual disjunctions in its wake.

Aesthetic evaluation[34] can, according to Beardsley, appeal to three different kinds of justification: genetic, affective, and objective. Genetic justifications, which have to do with the origins of a work and, especially, the intentions of its creator (or the intentions one imputes to its creator), are not valid, because they make the value of a work depend on matters extrinsic to it, some of which, moreover, we are not aware of. "The intentional fallacy"[35] is a special case of the "genetic fallacy," which assumes that one can interpret and evaluate an object by examining what gave rise to it. Affective justifications are not valid either, since to affirm the existence of an emotion is not to state the reason for that emotion. Thus, to say "this object has value because I like it" is obviously not to explain why I like the

33. The overall structure of the book is comprised of an initial chapter on "Aesthetic Objects," which we shall discuss below, followed by four chapters (II to V) on the descriptive aspect of criticism in the visual arts, literature, and music, followed by four chapters (VI to IX) on its interpretive aspect, and three (X to XII) on critical evaluation. Chapter IX in fact deals with the value of art in the life of man; it does not concern us here. Be it said in passing that chapters II to IX, which treat of concrete artistic practices, especially music, seem to me to be more convincing than the theoretical chapters I intend to discuss.

34. Like most English-speaking aestheticians, Beardsley uses the word "evaluation" to designate what I call *appréciation* [here usually translated as "appreciation," despite what Genette says in this note, but also as "judgment," "evaluation," or "appraisal," depending on the context]. There is a linguistic reason for this: unlike the French *appréciation*, the English "appreciation" is almost always used in a positive sense, which tends to exclude neutral use of the word; *évaluation* is therefore employed in this neutral sense. I indicated above the distinction I make between the two French nouns, which, in theory, are both neutral (though this is not always the case for the verb *apprécier*): *évaluation* is an objective *appréciation*, which aesthetic appreciation does not always manage to be (even if it thinks it does). In my discussion of Beardsley, I shall, to avoid annoying cross-linguistic interference, keep the word "evaluation," Gallicizing it by replacing the *e* with an *é*.

35. This is the title of a renowned essay by Monroe C. Beardsley and William K. Wimsatt ("The Intentional Fallacy," chap. 1 of *The Verbal Icon: Studies in the Meaning of Poetry* [Lexington: University of Kentucky Press, 1954], pp. 1–18). The essay was one of the theoretical manifestoes of American formalism, a movement exemplified, in literary studies, by the New Criticism.

object, and, a fortiori, why it has value. Such a statement can *constitute* a judgment of value, but not justify it. The only valid justifications are objective ones, that is, those based on the object's observable properties. There are three such properties, which are at once objective and positively valorized: unity, complexity, and intensity.[36] A work which exhibits these three qualities has intrinsic aesthetic value, and determining that it does therefore plainly constitutes a justification for making a (positive) evaluation of it. Of course, Beardsley is not unaware of the objection that can be made to this line of reasoning; he formulates it himself, acknowledging that the argument "this object is unified, and therefore beautiful" is a non sequitur, because it takes for granted the implicit major premise "everything that is unified is beautiful," which we are not logically required to accept. I will come back to this crucially important question, which, for the moment, will serve us only as an introduction to three theories of critical method that are all rejected by Beardsley: the "emotive" theory, according to which aesthetic judgment is nothing more than the expression of an emotion;[37] the "performatory" theory, for which an aesthetic judgment is not a genuine statement, but rather (what one calls, since Searle) a "declaration," which *confers* value rather than taking note of existing value;[38] and the "relativistic" theory, which maintains that judgments depend on the preferences of the individuals or groups who make them — and, consequently, have no objective validity. The emotive theory is naturally subject to the same criticism as affective justifications of aesthetic value, which it approves of. The performatory theory goes astray because it fails to see that aesthetic "verdicts," like other verdicts, depend on empirical evidence. Just as we award someone a medal only when we consider him deserving of it, so we "confer" value on an object only when we deem it worthy, so that such "declarations" have nothing in common with true

36. These three criteria plainly recall the three conditions of Beauty defined by Thomas Aquinas: *integritas*, *consonantia*, and *claritas* (*Summa Theologica*, I, 39, 8) as well as Hutcheson's twofold criterion: "uniformity in variety." However, St. Thomas's *integritas* has to do with an objet's wholeness ("since those things which are impaired [*diminutum*] are by that very fact ugly"). *Summa Theologica*, tr. Fathers of the English Dominican Province (1947; hypertext version, New Advent, Inc., 1996), http://www.newadvent.org/summa/103908.htm.

37. According to Charles L. Stevenson, *Ethics and Language* (New Haven: Yale University Press, 1944), this is what applying the theory of ethical judgment to aesthetics yields. See also Stevenson, "Interpretation and Evaluation in Aesthetics," in Max Black, ed., *Philosophical Analysis* (Englewood Cliffs, N.J.: Prentice Hall, 1963), pp. 310–358.

38. This time Beardsley is applying the theory of pragmatics introduced by Austin. See Margaret Macdonald, "Some Distinctive Features of Arguments Used in Criticism of the Arts," *Proceedings of the Aristotelian Society*, supp. vol. 23 (1949): 190. "To affirm that a work is good is more like bestowing a medal than pointing to one of its properties. . . . Verdicts and awards are not true or false."

performatives, which are acts performed by people authorized to do so ("I hereby declare you man and wife").[39] These declarations are "verdicts" only in a highly metaphorical sense, which depends on the "authority" certain critics enjoy, that is, the influence they have over the general public ("if Greenberg said so . . ."). We will meet these declarations again, but they are, in fact, plainly statements, which, as such, must be based on factual arguments—if I allow my own voice to mingle with Beardsley's here, it is because I am of his opinion on this point.

But what is crucial for us is, of course, Beardsley's critique of the "relativistic theory" (to which, as I see it, the so-called "emotive theory" can be reduced). This theory, Beardsley says, is based on the "variability" of aesthetic judgments. Yet the fact that two contrary judgments exist by no means proves it is impossible to find objective criteria enabling us (Beardsley here takes up Hume's argument, although he does not say so) to determine that one is true and the other false:

> So this is then our main problem in the following chapter [chap. 11]: we want to know whether the adoption of such standards as unity, complexity, and intensity can be justified. . . . The central question is whether there is any conclusive proof that there are certain reasons for critical judgments which would be given or accepted by one group of critics but which another group of critics would consider completely beside the point, *and* that there is in principle no rational method of persuading either group that it is mistaken. I don't see that the Relativist can present such a proof. But it may be said that the burden is rather on the Non-relativist to show that there is such a rational method. And it is this burden that must be taken up in the following chapter.[40]

Thus described, the relativistic theory is purely negative: it posits an impossibility it obviously cannot prove. On the other hand, it would be refuted ipso facto, together with the other two theories,[41] if a nonrelativist

39. It is true that the verdict delivered by a court (*vere dictum*) articulates, not only a decision ("I sentence you to two years' imprisonment without possibility of parole"—the correct designation for such a verdict is, in such cases, "sentence"), but also, and primarily, an opinion: "I find you guilty." In the one case as in the other, however, the verdict rests on an authority delegated by the body politic. No aesthetic judgment can boast as much. What comes closest to this in the artistic realm are court decisions which, in certain doubtful cases, "declare," not the *value* of a work, but the fact that it *is* a work of art: for example, that a text is poetic, not pornographic, that something is a sculpture, not an industrial artifact subject to different tax laws. We might recall here the decision handed down in favor of Brancusi's *Bird in Space*, which had been impounded by customs officials.

40. Beardsley, *Aesthetics*, pp. 486–487, 488.

41. This is so because the existence of objective criteria would show that the "emotion" of the emotive theory and the "verdict" of the performative theory are in fact based on these criteria, although both theories deny their existence or relevance.

(in fact, an objectivist) theory provided proof of the contrary. This is what Beardsley, speaking in his own name, graciously undertakes to provide: proof of the existence of objective criteria. He apparently forgets that, in the previous paragraph, he has already mentioned three such criteria, which I discussed a moment ago and which we will soon see again, though put to a different use.

But the demonstration announced here takes, in the following chapter, a rather oblique turn: Beardsley rejects the objectivist theory we were expecting him to defend, along with its subjectivist antithesis, in order ultimately to propose what he puts forward as a third way—something, to my mind, that his theory is not and cannot be. As we risk losing our bearings while following all these twists and turns, I prefer to say straightaway that this "third way" is, as I see it, simply an ill-disguised objectivist theory—and that it is, on my view, untenable. Let us examine the matter more closely.

AS PROPER PHILOSOPHICAL DEBATE DEMANDS, BEARDSLEY FIRST sums up the two competing theories of aesthetic value, then dismisses both. The first is the objectivist theory, which he christens, not unreasonably, the "beauty theory." This theory, which we have already encountered, maintains that beauty is an objective property of certain objects, and incontestably establishes their aesthetic value. The first flaw in such a theory is empirical: the theory makes it impossible to account for the oft invoked diversity of taste (Beardsley apparently refuses, for the moment at least, to fall back on Hume's counterargument about "bad judges"). The other flaw is logical: it is the well-known impossibility, already mentioned, of deducing a value judgment from a (or from several) judgment(s) of fact: "It is usually held that normative statements . . . cannot be deduced from nonnormative statements, no matter how many. Thus in a deductive argument with a normative conclusion, at least one of the premises must be normative. In effect we took account of this, without saying so, in the preceding chapter when we said that from 'This is unified' (nonnormative) it does not directly follow that 'This is good' (normative); we need the help of another premise, a normative one."[42] Furthermore, to say "normative" is to say *itself containing an evaluation* (for example, "now, everything that is unified is good") whose objective grounds must, once again, be established, and so on to infinity. Exit the "beauty theory," at least in principle.

Its subjectivist antithesis is here described as "psychological defini-

42. Beardsley, *Aesthetics*, p. 511.

tions"—in the plural, because, says Beardsley, there are two versions of this theory, the personal and the impersonal. The personal theory defines aesthetic value not only in a "psychological" (subjective) manner, but also with reference to the subject making the judgment. On this version, a statement such as "this object is beautiful" simply means "I like this object," or, in a more collective form, "the group of people I belong to likes this object." The impersonal version affirms, from the outside, that the statement "this object is beautiful" means, for example, "young people like this object," or "the Bororos like it," or, again, "the most qualified critics[43] like it."[44] The weakness of this theory lies, for Beardsley, in its "relativism," that is, in its incapacity, in cases where there is no agreement, to choose between contrary judgments. As this incapacity is, by definition, inadmissible, exit the subjectivist theory, and enter the "instrumentalist" theory that Beardsley will be defending from now on. This theory has been well received by other American aestheticians, for example George Dickie, who has delighted in complicating it,[45] to no particular advantage, as far as I can tell. Doubtless we would do better to consider it at the source.

Aesthetic objects (whether works of art or not) can be treated as if they were functional objects, whose function (intended or not) is to produce aesthetic experiences. Just as a good wrench is one that does a good job of turning nuts, so a good aesthetic object is one that produces good aesthetic experiences. Three traits characterize a good aesthetic experience. We are already familiar with them: *unity*, *complexity*, and *intensity*. Their convergence may be termed *magnitude*. The aesthetic value of an object depends on the magnitude of aesthetic experience which it produces—or, more precisely, on its *capacity* to produce such experience. Capacity, but no more, because the receiver has in his turn to possess a capacity for reception, if only physical or technical: the deaf cannot receive a musical work (in its audible manifestation), nor the blind a picture, and, to receive a literary work, one needs both to be literate and to know the language it is written in. This capacity for reception can, again, be psychological in nature, and depend on whether one possesses a certain degree of cultivation or maturity: there is one age or educational level for appreciating Tchaikovsky, another for Haydn; one for Rockwell, another for Cézanne; one for Graham Greene, another for Shakespeare (I have scrupulously preserved Beardsley's examples; I have small desire to stick my own nose

43. [Beardsley actually says "is regarded with favor by *most qualified critics*."]
44. Ibid., p. 513. I will come back to the oddity that consists in presenting this kind of statement as subjectivist: to speak of "qualified" judges obviously presupposes, as in Hume, a qualifying criterion that can only be objective.
45. Dickie, *Evaluating Art*.

into the machinery responsible for churning out this axiological progression). Beardsley makes an even blunter argument: a painting nobody has yet seen can possess, or fail to possess, aesthetic capacity of this sort, "meaning that if it were seen, under suitable conditions, it would produce an aesthetic experience." Beardsley therefore calls the term "capacity" "dispositional" (as an adjective like "nutritious" is dispositional: a very nutritious kind of food will not nourish someone who does not eat it, although this does not prevent it from being potentially more nutritious than another kind; similarly, an object possessing aesthetic value only has this value for someone in a position to receive and appreciate it); and he calls his own definition of value "non-relativist."

THAT IS, INDEED, THE VERY LEAST THAT CAN BE SAID ABOUT IT. I am going to comment on Beardsley's reasoning here in three stages. The first, very short stage will consist simply in approving of the—on my view decisive—critique that Beardsley makes of the (explicitly) objectivist theory. So much for the first stage. I shall next attempt to show that Beardsley's "instrumentalist" theory is in fact objectivist, and therefore cannot stand up under his own critique of objectivist theories. Finally, I shall come back to the subjectivist theory, of which, it seems to me, Beardsley offers a distorted description. On my view, this theory remains, as the reader hardly need be told, the only correct one, on condition that it is correctly defined.

What Beardsley calls "aesthetic experience" is quite different from what I have called aesthetic "attention" and what others call an aesthetic "attitude." At issue here is not the adoption, conscious or not, of the sort of viewpoint that constitutes an object as aesthetic, which (logically at least) is prerequisite to appreciating that object aesthetically. Rather, Beardsley has in mind this appreciation itself, approached as an overall mental experience; it is similar to what is usually called aesthetic "pleasure" or "satisfaction." Curiously, Beardsley does not allow for negative appreciation (Kant's "displeasure"), or for neutral appreciation, which, as we saw earlier with Urmson, is by no means equivalent to the absence of appreciation. For Beardsley, "badness in art is simply a low, perhaps very low, grade, or absence, of aesthetic value." The reason for this rejection of the notion of negative or neutral appreciation lies in the very definition of aesthetic experience, said to be characterized by intensity, complexity, and unity:

> If intensity of human regional qualities is a ground for positive valuation, there is no corresponding ground for negative valuation, since the bottom end of the scale is just the absence of such qualities. If complexity is also a

ground, again there is no corresponding negative, for the bottom of the scale is zero complexity, or absence of any heterogeneity. If unity is a ground, it might be said that opposed to unity is disunity; but every discriminable part of the perceptual field has some degree of unity, and disunity is only a low grade of unity—though perhaps a grade that is immediately unpleasant.[46]

If there are no negative states, it plainly follows that there are no neutral states either: there are only greater or lesser degrees of "magnitude" of positive aesthetic experience.[47] This experience, as we have just seen, is defined by those features of unity, complexity, and intensity which, be it recalled, were earlier attributed to the aesthetic object itself. Transferring them to the *experience* this object produces (without its being made very clear whether the object has now been divested of them, or whether it has them in common with its own psychological effect) is the move by which "instrumentalist" theory sets itself apart from banal objectivist theories. Unfortunately, I am not at all sure that this transfer makes much sense. I can more or less see why one should speak of the unity and complexity of an object, and even, perhaps, of its intensity (doubtless in the rather superficial sense in which we say that such-and-such a painting by Caravaggio or de Soutine is more intense than a picture of Whistler's, if only because its colors are more vivid; or that *Rites of Spring* is more intense than *The Childhood of Jesus* because of its more varied dynamics; or that Céline is more intense than Proust because of the vigor of his style; I am not certain that these differences constitute obvious criteria of superiority, but that is not our concern at the moment. I readily see why one would want to speak of the intensity of a mental state—but I fail to understand in what sense that feature is specific to aesthetic experience: a powerful emotion or physical sensation, pleasant or unpleasant, clearly constitutes an intense experience, but that does not necessarily imply that this intensity has something aesthetic about it. As to the unity and complexity of an experience, I do not really understand what this means, if not, again, a metonymic transfer of the characteristics of an object to the experience it produces. There is nothing illegitimate about such a transfer when it occurs in ordinary aesthetic discourse, but it seems to me ill-suited to a theoretical discourse that, in principle, aims to explain matters as clearly and literally as possible. In fact, this transfer seems to me to stem, here, from

46. Beardsley, *Aesthetics*, p. 501.
47. Like those that seismologists measure on the well-known Richter scale, which, of course, has no negative values.

a desire to refine the ordinary objectivist position (whose weakness, as we have seen, Beardsley is well aware of) and make it more subtle, with a view to arming it against a critique that Beardsley himself has formulated. To put it more bluntly, this "instrumentalist" theory seems to me to constitute a screen for objectivism (although Beardsley doubtless advances it in perfect good faith). Let me be more precise: that is its function in its Beardsleyan version; but one could just as easily give it a very different twist, which would make it a variant of subjectivism, for this "third way" cannot avoid, despite its claims, having to choose between the other two.

INDEED, THE (NEUTRAL) FORMULATION WHICH HAS IT THAT "the aesthetic value of an object is proportional to the intensity of the experience it produces" can only be construed to mean either that *(a)* "Everybody *attributes* a positive or negative aesthetic value to whatever produces a positive or negative aesthetic experience for him" (this is the subjectivist interpretation), or *(b)* "Only objects endowed with aesthetic value *are capable of producing* a positive aesthetic experience (unified, complex, and intense)"—this is Beardsley's interpretation, and I do not see how we can avoid labeling it "objectivist." The crucial notion in this debate is one we have already encountered, that of *dispositional capacity*, whose implications Beardsley does not seem to be aware of, though they appear obvious to me: if aesthetic value is contained in the object like a capacity that merely awaits an encounter with a qualified receiver in order to reveal itself and come into play—if it is present even in an object that nobody has yet perceived—I defy anyone to tell me whether what is in question here can be anything other than an objective property, like the taste of iron and leather in Sancho's cask, waiting for a "competent judge" capable of perceiving it.[48] Moreover, I take a rather skeptical view of the idea that aesthetic predicates of any kind whatever can describe a mental experience, as opposed to the object of that experience. It seems to me that aesthetic judgments expressed in terms of aesthetic predicates always and inevitably are judgments about an object which propose to justify the positive or negative emotion that object inspires. If I like an object, what I like is not my liking for it, but the object itself, and, rightly or wrongly, I ascribe *to the object* the "qualities" that, in my opinion, justify how I feel about it. Perhaps I can, subsequently, and, as it were, secondarily, appreciate this feeling in its own right, as well as the "experience" it colors, but

48. In addition to the statements already quoted, I mention the following: "To say that an object has aesthetic value is (a) to say that it has the capacity to produce an aesthetic effect, and (b) to say that the aesthetic effect itself has value" (Beardsley, *Aesthetics*, p. 533).

I doubt very much that this appreciation would in its turn qualify as aesthetic: it is hard for an aesthetic emotion to become an aesthetic object,[49] so that it is scarcely possible for this emotion to be the object of an aesthetic judgment. It is more likely, perhaps, to be the object of a judgment of psychological agreeableness that is, doubtless, partly physical. Kant concedes this to Epicurus, as I noted earlier: such-and-such an object pleases me; but the pleasure I take in it does not "please me" (aesthetically), it makes me happy. Indeed, the (nonaesthetic) appreciation elicited by an act of aesthetic appreciation can be, in terms of value, at opposite poles from it. If I like an object, my feeling about it is positive, yet my feeling about this feeling can be negative ("I'm a bit ashamed of liking that"); conversely, I can be glad that I don't like it, or satisfied with myself because I don't ("I'm not one of the yokels who go for that").

The very idea that the aesthetic relation can be "instrumentalized" seems to me to be fundamentally at odds with the reality of aesthetic experience, which is, to be sure, "attentional," and thus intentional in the broad sense, but not in the strong sense presupposed by the instrumentalization of anything whatever. The aesthetic relation does not grow out of any preexisting intention on the part of the receiver. What *can* be intentional, and, consequently, can treat the (still only hypothetical) aesthetic object as the instrument of a (projected) experience, is the kind of behavior that consists in *seeking out* an aesthetic relation: for example, the behavior that consists in traveling about in quest of beautiful landscapes, or going to a concert or an exhibition, or, again, buying a book one hopes will be pleasurable, without any guarantee that it will. (This type of behavior hardly allows for the anticipation of a negative experience, even if we can deliberately expose ourselves to negative experiences to purely cognitive ends: I do not like, say, Bacon, but I go to an exhibition of his work out of a sense of professional obligation, or in order to confirm that my disliking for him has not changed, and, possibly, to discover the reasons for it.) But, quite obviously, while these preliminary efforts can lead to an aesthetic relation, they do not in any way *constitute* it. The relation itself is entirely causal (I will come back to this); the hoped-for cause may fail to materialize, and, plainly, no intention can take its place.

Having thus made the aesthetic object into an "instrument" of the aes-

49. This possibility can doubtless not be wholly excluded, because anything can be taken as an object of aesthetic attention, and, therefore, appreciation; but it requires, as we have seen, establishing a perceptual "distance" that is difficult to attain when what is involved are subjective phenomena. Above all, the movement of objectification inherent in aesthetic appreciation makes it too "transparent" to constitute itself as an object, as Santayana says in so many words.

thetic experience, and defined that experience in terms (of unity, complexity, and intensity) that do not yet include their own valorization, Beardsley has no choice but to "instrumentalize" the aesthetic experience in its turn, by assigning it a positive role in human existence which, the claim is, gives it its value. This comes down to asking what ends the aesthetic experience itself serves, and what it is worth. I do not say that such an inquiry is absolutely futile, and the questions it throws up (pertaining, for instance, to cases of conflict between aesthetic satisfaction and moral obligation) are certainly not trivial.[50] Simply, it seems to me, to repeat, that such matters are beyond the remit of aesthetics, and that, as far as aesthetic experience itself is concerned, a definition of that experience in terms of pleasure/displeasure makes transcendental justifications superfluous. As Santayana says, aesthetic pleasure, like all pleasure, is its own end; it contains its own object within itself, and is not an instrument in the service of some ultimate objective. In this sense, "every genuine pleasure is disinterested":[51] it can only be "interested" in its own perpetuation or repetition, as displeasure can only be "interested" in its own cessation. While it may make some sense to define the aesthetic value of an object in "instrumental" terms, which the aesthetic subject measures concretely in terms of aesthetic appreciation, it really makes no sense at all to define, in the same terms, the appreciation itself, which is not in the service of anything besides itself.

I must now come back to what Beardsley calls the "psychological definition" of aesthetic value. It seems to me that his "impersonal" variant is an idle hypothesis: nobody ever puts forward a definition of the type "the statement 'this object is beautiful' means that such-and-such a class of receivers likes this object," unless he includes the subject of the utterance in the class in question—for example, "when a Bororo says 'this object is beautiful,' it means that he himself, and, possibly, other Bororos, like the object." But then this is nothing more than an observation of the diversity of tastes, an observation which in no wise constitutes a theory of value, since it has yet to be said whether that diversity is considered legitimate (this is "relativism," which holds that everyone, or every group, considers beautiful whatever he or it likes, and that everyone or every group has the right to do so), or whether it is to be criticized in the name of an objective criterion à la Hume, one capable of "discriminating" among tastes, by

50. See Monroe C. Beardsley, "Aesthetic Experience Regained," *Journal of Aesthetics and Art Criticism* 28 (1969): 3–11, and "The Aesthetic Point of View," in John W. Bender and H. Gene Blocker, eds., *Contemporary Philosophy of Art: Readings in Analytic Aesthetics* (Englewood Cliffs, N.J.: Prentice Hall, 1993), pp. 384–396.

51. Santayana, *The Sense of Beauty*, p. 25. Cf. Schaeffer, *L'art de l'âge moderne*, p. 380.

specifying, for example, that the Bororos are good judges or bad (are right or wrong to like the object). As to the definition on which "It's beautiful" means "Competent judges like it," which we have already encountered as an example of (according to Beardsley) the "impersonal psychological definition," it seems to me to be, in fact, typically objectivist, because it subordinates appreciation, as I have said, to a descriptive criterion that can be objective only from the standpoint of the person producing it.

The one definition left, then, is the "personal psychological," or properly subjectivist definition, on which "It's beautiful" simply means "I like it." Naturally, I range myself with those who subscribe to this kind of proposition, because I do in fact think that, when someone declares that an object is beautiful, this simply means that he likes it. However, I do not believe that I can describe this statement as a "subjectivist definition of aesthetic value," because, quite simply, I do not think that such a statement is compatible with the idea of "aesthetic value." This amounts to saying that I consider the very idea of "aesthetic value" illusory, at least in the sense in which it is intended here (and almost everywhere else), and, therefore, that I regard the very idea of a "subjectivist definition of aesthetic value" as self-contradictory. It seems to me that the subjectivist position is inherently inimical to the notion of aesthetic value, which is, by definition, an objectivist idea, inasmuch as value of any sort is always attributed to an object. It will immediately be objected that this is what we do every time we appreciate something from an aesthetic point of view. I am happy to confirm the factual observation, which, indeed, I take for granted; but I do not believe that this fact constitutes an objection. Doubtless I need to explain what I mean.

Toward a Subjectivist Aesthetics

The subjectivist proposition to the effect that "to say 'It's beautiful' means 'I like it'" is *not* a definition of the beautiful, which subjectivism rightly regards as undefinable.[52] It is a definition of aesthetic appreciation which treats the objectivist judgment "It's beautiful" as illusory, and substitutes for it what it considers to be the real meaning of this judgment (which it

52. It is thus rather futile to demonstrate at length, as Paul Souriau once did in a work devoted to defending and illustrating "rational aesthetics," that subjectivism cannot be defined—since the subjectivism in question affirms, precisely, that it would be absurd to try to define it. See Souriau, *La beauté rationnelle* (Paris: Félix Alcan, 1904), vol. 1, chap. 4.

expresses): "I like it." But we must first agree about what the expression "the real meaning" means: it does not mean that when the aesthetic subject says, "It's beautiful," he "only means* by that," or only *wants to say* [*veut seulement dire*], "I like it." He does not *want* to say that, because he does not think it, or, more precisely, he does not think that his judgment "It's beautiful" means only that he "likes it." He says, "It's beautiful" because he thinks it's beautiful. *I* am the one who, along with a (very) few others, "mean by that," as a subjectivist meta-aesthetician, only that *he* likes the object. *I* am the one who gives this meaning to *his* statement "It's beautiful"; I give it this meaning *from the outside*, and I believe that this (objective) description of his act of appreciation is accurate, but I by no means claim that it accounts for the (subjective) way in which he experiences and thinks that act himself, because I know very well that, for him, the object is quite simply and objectively beautiful. In other words, the subjectivist theory that I defend maintains that aesthetic appreciation is objectivist by constitutive illusion. It is, then, anything but an indigenous, spontaneous theory, because it describes its object (appreciation), from the outside, as essentially illusory. The corollary is that this theory must necessarily treat as illusory any theory which aspires to remain—and, a fortiori, succeeds in remaining—faithful to the subjective experience of appreciation. If appreciation is objectivist, the objectivist theory of appreciation is its spontaneous theory: whence its success. But I do not believe that an indigenous theory is, here (and elsewhere as well, perhaps) a theory worthy of the name; the role of a theory is not to *give expression to* a phenomenon, but to account for and explain it.

I said a moment ago that aesthetic appreciation was *constitutively* objectivist. This phrase might seem exaggerated, or unnecessarily provocative. But I do not intend it that way. In my opinion, aesthetic judgment is constitutively objectivist because it cannot give up its corollary, objectification, without disqualifying itself as an appreciation: if I consider an object beautiful, I cannot *at the same time* (in one and the same act) assent to the subjectivist, typically *reductive,* proposition "You consider it beautiful, but that simply means you like it." One cannot simultaneously like an object and not think that that object is objectively likeable: liking *consists* in this objectivist belief. And it obviously follows that the subjectivist (meta-)aesthetician—the aesthetician who says, from the outside and in principle, with Kant, that "the beautiful is simply the object of such satisfaction" (this means, of course, "is defined only by that satisfaction")—can never "apply" his own (true) theory to himself (to his own appreciations) while he is in the act of appreciating something. However justifiably con-

vinced he may be, in theory, that appreciation in general is purely subjectivist, he cannot in fact (any more than anyone else can) live his aesthetic life in the reductive mode of this theory; the relationship between the subjectivist theory and the objectivist act of appreciation is of the well-known type, "I know, but still. . . ." What holds for the other "Copernican revolution" holds for this one too: it is not enough to *know* that the earth revolves on its own axis in order to stop *seeing* the sun revolving around the earth. Thus Beardsley's critique, which claims that the subjectivist theory forecloses a legitimate question such as "I like this, but is it truly beautiful?"[53] seems to me quite wrongheaded, for such a question cannot accompany a true aesthetic appreciation *in actu*, since aesthetic appreciation does not consist in thinking "I like that," but in liking it and in thinking this emotional response in the form "That is beautiful." It is thus not the subjectivist theory which forecloses this question,[54] but the act of appreciation itself. An appreciation that calls itself into doubt in these terms, that is, which calls its own objective basis into doubt (I do not deny that there are such cases), is not a true appreciation; it is an observation by a taste that hesitates to "judge," that is, to objectify itself. Appreciation is like *belief* as described by Arthur Danto:

> When a person believes that *s*, he believes that *s* is true. This would be reflected in linguistic practice through the fact that people do not ordinarily say they believe that *s*; they simply act as though *s* were true. . . . [Whence] the well-known asymmetry between the avowal and the ascription of belief that such an analysis might support. I cannot say without contradiction that I believe that *s* but *s* is false, but I can say of another person that he believes that *s* but it is false. When I refer to another man's beliefs I am referring to him, whereas he, when expressing his beliefs, is not referring to himself but to the world. The beliefs in question are transparent to the believer; he reads the world through them without reading them. . . . My beliefs in this respect are invisible to me until something makes them visible and I can see them from the outside. And this usually happens when the belief itself fails to fit the way the world is.[55]

One has merely to transpose this analysis to obtain a faithful description of aesthetic appreciation and its spontaneous tendency toward objec-

53. Beardsley, *Aesthetics*, pp. 518ff.
54. It is, however, true that it considers the question meaningless, because it holds that nothing is "beautiful" or "ugly" apart from a relation of aesthetic appreciation.
55. Arthur C. Danto, *The Transfiguration of the Commonplace: A Philosophy of Art* (Cambridge: Harvard University Press, 1981), p. 319. This argument is developed from another vantage point (that of historical relativism), in Danto, *Narration and Knowledge*, pp. 329–330.

tification, which is inseparable from its attentional character. Appreciation, like firm belief,[56] excludes doubt, and even self-consciousness: it is aware of nothing but its object and the "value" it ascribes to it, as if this "value" were one of the object's properties. Stanley Fish, who himself defends this position in the field of literary criticism, has nicely described its consequences for the psychological status of the subjectivist, or relativist, position:

> Relativism is a position one can entertain, it is not a position one can occupy. No one can *be* a relativist, because no one can achieve the distance from his own beliefs and assumptions which would result in their being no more authoritative *for him* than the beliefs and assumptions held by others, or, for that matter, the beliefs and assumptions he himself used to hold. The fear that in a world of indifferently authorized norms and values the individual is without a basis for action is groundless because no one is indifferent to the norms and values that enable his consciousness. It is in the name of personally held (in fact they are doing the holding) norms and values that the individual acts and argues, and he does so with the full confidence that attends belief. When his beliefs change, the norms and values to which he once gave unthinking assent will have been demoted to the status of opinions and become the objects of an analytical and critical attention; but that attention will itself be enabled by a new set of norms and values that are, for the time being, as unexamined and undoubted as those they displace. The point is that there is never a moment when one believes nothing, when consciousness is innocent of any and all categories of thought, and whatever categories of thought are operative at a given moment will serve as an undoubted ground.[57]

I spoke a moment ago of the "psychological status" of subjectivism, but what I really meant to say was that its psychological status consists in not having one, because (or in the sense that) it cannot be psychologically experienced, only theoretically *thought*.

Ultimately, I am not certain that stating the matter in terms of "meaning" or semantic equivalence ("to say 'It is beautiful' means . . .") makes for the clearest possible exposition of a theory of appreciation. I might

56. Many beliefs, of course, are not firm, but coexist with a degree of doubt they repress as best they can. As Paul Veyne has stressed, this often seems to hold for ideological or religious commitments, which are of the order of "wanting to believe" and bad faith. Here, however, I (like Danto) mean by belief the simplest of psychological states founded on inward conviction (regardless of whether the conviction is justified); for instance, Ptolemy's belief in his geocentric system.

57. Stanley Fish, *Is There a Text in This Class?* (Cambridge: Harvard University Press, 1980), pp. 319–320.

note, moreover, that the nominalist definitions in general circulation (those one finds in the dictionaries) are, as a rule, ambiguous, of the sort "Beautiful (adj.): that which produces aesthetic pleasure."[58] One is left wondering how this is to be understood: whether in the subjectivist mode, i.e., "something is called beautiful if it produces aesthetic pleasure (for you)," or in the Beardsleyan (that is, "dispositional," and thus objectivist) manner, i.e., "something is beautiful if it possesses the property of producing aesthetic pleasure (for everyone, barring infirmity or incompetence)." This ambiguity, be it recalled, marks the formulation of the "definition derived from the first moment" of Kant's *Critique*: "the object of such a [disinterested] delight is called *beautiful*." Here the implied subject of the passive construction "is called" can be either the subject of the aesthetic relation, who calls beautiful something which pleases him in a disinterested manner, or the subject of theoretical knowledge, who means to state the objective truth. The philosopher himself would be one of those privy to this theoretical knowledge ("I call beautiful what [in general] pleases in a disinterested manner").[59] A similar formulation occurs much earlier, in Thomas Aquinas: "Beautiful are those things which please when seen."[60] This is why it seems to me that the most accurate formulation, the only one which, despite or perhaps because of its crudity, is clear and unambiguous, is one stated in terms, not of "meaning," but of causal rela-

58. For example, "the forms or proportions of which are pleasing; that which gives rise to a feeling of delight" (*Larousse*, 1972). [Another authoritative French dictionary,] the *Petit Robert*, defines beautiful as "that which gives rise to aesthetic emotion"; it fails even to restrict the definition to positive appraisals. It follows that I should call a chromo which sends me running off in horror "beautiful."

59. [Genette's note comments on the difference between Kant's German text and the French translation Genette cites, which reads, *On appelle beau l'objet d'une telle satisfaction [désintéressée]*. Commenting on the *on appelle*, Genette observes that] "this impersonal construction does not occur in the German text, which reads *heißt schön*. A more literal translation of *heißt schön* would give us *s'appelle beau* [literally, calls itself beautiful, i.e., is called beautiful], as one says that the donkey "is called" Martin, or that the star "is called" Sirius. But the "beautiful" does not "call itself" one thing or another any more than the donkey or star does. We have to call it beautiful, which brings us back to our ambiguity. The formulation that concludes the second moment ("the beautiful *is* that which, apart from a concept, pleases universally"—p. 60, my emphasis) tips the scales even further toward objectivism.

60. *Summa Theologica*, 100504.htm. *Pulchra dicuntur quae visa placent* (I, 5, 4). [Genette punctuates his French translation as follows: "*On* [?] *appelle beau tout ce qui plaît à voir.*" *On appelle* means "one calls"; thus the interpolated question mark again raises the question as to who is judging the "beautiful" beautiful.] What comes next (*Unde pulchrum in debita proportione consistit* ["beauty consists in due proportion," ibid.]) shows that an objectivist interpretation is the correct one here; so do the three criteria mentioned in note 36 above, and also this sentence from "On the Names of God," cited in Edgar De Bruyne, *Études d'esthétique médiévale* (Bruges: De Tempel, 1946), vol. 3, p. 282: "Something is not beautiful because we like it; we like it because it is beautiful and good."

tion: "the aesthetic subject likes an object *because* it is beautiful" (the objectivist theory) or "the aesthetic subject *deems* the object beautiful *because* he likes it, and believes he likes it because it *is* beautiful"—there we have the (my) subjectivist theory.

I am very much aware that such a statement of the question does not settle it, and even that it throws up a problem the objectivist theory does not run into (but we know that the objectivist theory runs into another problem). This theory maintains, in full harmony with what I call the objectivist illusion, whose theoretical emanation it is, that one likes an object because it is beautiful; once this is granted, the objectivist position has, as it were, already successfully pleaded its cause,[61] so that the only remaining (to my mind, impossible) task is objectively to define "beauty." The subjectivist position, by inverting the proposition, Coperniciously, at least temporarily deprives itself of an explanation that is plainly necessary: it is not enough to say "I consider this beautiful because I like it," one must also (try to) say why one likes it. In other words, the observation that appreciation is subjective does not explain anything, and may, indeed, be nothing more than a truism: surely nobody would deny that the fact that one likes something (aesthetically or otherwise) is "psychological." The real question arises a bit further on, when one is required to say what explains this fact, if not the reasons named by the objectivist theory of aesthetic value, which, whether it likes it or not, can only be an objectivist theory of Beauty (and Ugliness). But it is quite *literally* further on that we will encounter this question again, because I must first clear up another matter, to the extent that it can be cleared up: the phenomenon called "objectification," about which I have said, after Santayana (and Kant, whatever Kant's intentions), that it is at the heart of aesthetic appreciation. "At the heart of" is, however, too weak a statement of the matter: I think that objectification *constitutes* aesthetic appreciation.

Aesthetic Predicates

The model, as it were, for the kind of aesthetic appreciation I have been describing is what is sometimes called, to a certain extent inappropriately, an aesthetic *verdict*. The term may be regarded as inappropriate for reasons

61. [*La cause est entendue*, an idiom whose literal meaning is "the cause is heard"; here a pun suggesting something like "the cause for one's liking the object has already been stated."]

glimpsed in our discussion of the "performatory" theory: aesthetic "judgments" are not pronounced in the name of an authority which invests them with "the force of law." However competent and influential the person who makes a judgment, he never does anything more than articulate a feeling, individual or collective. That the metaphorical use of the term "verdict" is nevertheless legitimate is due to the undifferentiated character (which has so far barely been described, and argued even less) of pronouncements like "It's beautiful" or "It's ugly." Such pronouncements are, in essence, merely statements of one's positive or negative opinion, without further ado. When we make such judgments—however "objective" we might imagine them to be—we are, in some sort, very close to making emotional statements of the "I like it/I don't like it" variety; indeed, such judgments almost literally come down to saying "I like it" or "I don't," with the sheerest objectivist facade and virtually no attempt to defend one's opinion. However, in most cases, as I have said, aesthetic evaluation consists in a "judgmental" operation in which the cognitive exploration of an object is combined with emotional appreciation, leading to an ascription, even if it is not articulated, of what Kant aptly terms "predicates." Frank Sibley has examined this crucial point in a discussion of what he calls—the term is manifestly objectivist—"aesthetic qualities," as opposed to "nonaesthetic qualities."[62] Implicitly, this distinction is grafted onto one previously made by Beardsley (we shall encounter it again in another context). In every object, and especially in works of art, Beardsley differentiates "physical" qualities, including those which are not ordinarily perceptible (for instance, the weight or age of a painting), from "perceptual" qualities, the only ones that may be aesthetically relevant (such as the shapes and colors of the same painting).[63] For Beardsley, perceptual qualities (and perceptual qualities alone) are, as it were, unfailingly aesthetic. Sibley argues that we need to draw finer distinctions among perceptual qualities, since not all of them produce aesthetic effects. Simple "nonaesthetic features" are objective characteristics which, according to Sibley, are obvious to the normal observer; for example, whether a drawing or design

62. Frank Sibley, "Aesthetic and Non-Aesthetic," *Philosophical Review* 74 (1965): 135–159; "Aesthetic Concepts," *Philosophical Review* 68 (1959): 421–450; "Aesthetic Concepts: A Rejoinder," *Philosophical Review* 72 (1963): 79–83; and "Objectivity and Aesthetics," *Proceedings of the Aristotelian Society*, supp. vol. 42 (1968): 31–54. The existing French translations of Sibley imitate his spelling of "nonaesthetic" (without the hyphen). I have adopted the spelling *non-esthétique*, even when citing these translations, because writing the word with the hyphen seems to me to be both more faithful to the original and less likely to cause misunderstanding. The "nonaesthetic" [*non-esthétique*] is by no means irrelevant to the aesthetic. Quite the contrary: it is an aesthetically neutral perceptual quality that provides the supporting ground for aesthetic predicates, which are, in my opinion, evaluative.

63. Beardsley, *Aesthetics*, pp. 29–34.

is angular or flowing. Aesthetic qualities, in contrast, are features which can only be perceived by an observer who also possesses a special faculty of discernment Sibley calls "taste" or "aesthetic sensitivity": for example, the ability to perceive that a flowing design is (or is not) *delicate*.[64] Delicacy is here an "emergent" property;[65] this means, in sum, that delicacy is *underdetermined* by the nonaesthetic feature "flowing," which is a necessary but not sufficient condition for delicacy. Such, at any rate, is the case if we simplify matters by assuming that an angular design cannot be delicate (or that such a design would be, at the limit, delicate *despite* its angularity), and that a flowing design is only perceived as delicate (whenever it *is* so perceived) by an aesthetically sensitive observer.

I am not convinced by the idea that such properties are just as objective[66] as nonaesthetic properties, even if one needs to be perceptually more sensitive to notice them. In my opinion, the difference between the two sets of properties depends on the axiological charge carried by what I will rechristen aesthetic *predicates*.[67] The list of such predicates (graceful, elegant, dull, vulgar, powerful, heavy, light, pretty, deep, superficial, noble, stilted, charming, classical, academic, subtle, crude, moving, sentimental, uniform, monotonous, sublime,[68] grotesque, etc.) is, needless to say, endless, and it would be pointless to try to list them all (Danto assumes that they are so wide ranging "that there can hardly be an adjective of the language that cannot be pressed into the service of aesthetic utterance."[69] To stick with the example suggested by Sibley and simplified by myself, it is

64. *Gracieux*, my French translation of "delicate," puts a slightly different accent on Sibley's example (a design that is "delicate because of its pastel shades and curving lines") (Sibley, "Aesthetic Concepts," p. 66).

65. Sibley, "Aesthetic and Non-Aesthetic," p. 151.

66. Initially, Sibley explicitly avoids this word, which is, however, forcibly suggested by his overall analysis.

67. Responding to a remark of H. R. G. Schwyzer's, Sibley explicitly takes issue with such an interpretation. As he sees it, his "aesthetic qualities" are *not* evaluative; that is what differentiates them from what he terms, precisely, "verdicts" (the term can already be found in the 1959 essay on "Aesthetic Concepts" (see n. 3). If it were not that Sibley prefers to avoid the "evaluative-descriptive" dichotomy, he would call them "descriptive" ("Aesthetic Concepts: A Rejoinder," pp. 79–80). One finds the same remarks in "Aesthetic and Non-Aesthetic," along with this rather clumsy denial: "Nor shall I raise any other questions about evaluation: about how verdicts are made or supported, or whether the judgements I am dealing with carry evaluative implications." Yet he has just given, as examples of aesthetic judgments, "It's not pale enough" and "There are too many characters." If those are not evaluations . . .

68. I deliberately include in this list of examples a predicate whose fortune and rank have, of course, been assured by Kant, in the wake of "Longinus" and Burke. The word seems to me to have come in for inordinate attention. To my mind, "sublime" is just one aesthetic predicate among many others. I note in passing that Kant has rather accurately described what goes to make up sublimity (grandeur, power, etc.).

69. Danto, *The Transfiguration of the Commonplace*, p. 154.

clear enough that "delicate" includes a descriptive "seme" that applies to an objective property—let us assume it to be the flowing line—plus a "seme" that signals appreciation. To call a design delicate is both to describe it as flowing and to evaluate it positively, within the limited range of positive evaluations underdetermined by the feature "flowing" (the aesthetic predicate "austere," for example, lies outside this range). A negative appraisal of the same design would perhaps characterize it as "sentimental" or "mannered," whereas an angular design might elicit positive predicates, such as "vigorous," or negative ones, like "rigid." It is owing, precisely, to this axiological ambiguity of "nonaesthetic" (objective) properties that they underdetermine appreciations, which they motivate but cannot logically ground. But the "aesthetic" adjectives, which, as it were, smuggle their axiological character past us under a descriptive cover, constitute very powerful tools of objectification. An undifferentiated appreciation such as "It's beautiful" or "It's ugly" shows more plainly that it is a subjective "verdict" (this was, be it recalled, Hume's term, borrowed from Cervantes). In the phrase "It's graceful" or "It's powerful," the appreciation is made more precise and, at the same time, motivated by way of a descriptive specification, which may enable it to function as a justification, as is expected of a verdict: an argument like "This drawing is beautiful because it is graceful" seems (contrary to logical principle) legitimately to found a value judgment ("beautiful") on a factual judgment ("graceful"), whereas, in reality, the factual judgment already carries a value judgment; it does so, however, surreptitiously, and, for that very reason, more persuasively. The argument "This drawing is beautiful because it has a flowing line" would generate greater resistance, because the implicit, and questionable, major premise, "Everything that is flowing is beautiful,"[70] makes itself felt more strongly there. A value judgment does not follow from a factual judgment like "This painting is square-shaped," "This symphony is in C major," or "This church is Romanesque," but it can create the illusion that it does by putting forward as a descriptive term a predicate carrying a degree of positive or negative appreciation: "This painting is balanced (or immobile)," "This symphony is majestic (or pompous)," "This church is austere (or indigent[71])." That is what our aesthetic predicates help us do (I hesitate to say, more forthrightly, that that is what they are *for*); they work somewhat

70. Yet this is William Hogarth's central thesis in *The Analysis of Beauty* (London: Scolar Press, 1969). Hogarth calls the "waving-line" the "line of beauty"; he goes on to distinguish it, however, from the "line of grace," which, he says, is the "serpentine line." The nuance is lost on me.

71. Spotted in an advertisement for *La nuit des temps*, a series of books published by Zodiaque, this cleverly ambivalent adjective occurs in a description of one or another Norman church, said to be marked by "an austerity bordering on indigence."

like the statements of an ethical kind that Charles Stevenson calls "persuasive definitions."[72] Aesthetic, semidescriptive, or semijudgmental predicates, by means of which one judges under cover of describing, are also, in the domain they operate in, persuasive or valorizing descriptions that bridge the abyss between fact and value without becoming too conspicuous.[73]

Always audacious, Danto argues, for his part (without referring to Sibley), that "we cannot characterize works of art without in the same breath evaluating them. The language of aesthetic description and the language of aesthetic appreciation are of a piece."[74] This is obviously an exaggeration if the phrase "language of aesthetic description" is taken in the broad sense, so as to include purely descriptive predicates like "rectangular," "octosyllabic," or "in C major." If, however, we accept Sibley's distinction, these terms are plainly "nonaesthetic," while the terms that, on his view, are "aesthetic" in the proper sense are then inevitably "evaluative," as Danto says—and as Sibley denies. This question of terminology seems to me of small importance, but, for the sake of clarity, it would doubtless be preferable to sort aesthetic predicates in general, to the extent one can, into those that are purely descriptive (Sibley's "nonaesthetic" properties), those that are purely evaluative (Sibley's "verdicts"), and, *between the two*, Sibley's "aesthetic concepts," which are on my view compound predicates, effective (persuasive) precisely because they are compound.[75] But I do not claim that these are the only possible categories:

72. See Stevenson, "Persuasive Definitions," *Mind* 47 (1938): 331–350, and *Ethics and Language*. In "Interpretation and Evaluation in Aesthetics," Stevenson shows that value judgments always have two parts: one is descriptive (cognitive), while the other consists in a "decision" that is based on the descriptive part but cannot be reduced to it. "Criticism is more than science" (ibid., p. 341); in other words, it is knowledge *plus* something else.

73. "There are no aesthetic merit-conferring *properties*, with non-evaluative names . . . [However,] there exist. . . characteristics whose names are not non-evaluative, but already incorporate an evaluative judgment." Peter F. Strawson, "Aesthetic Appraisal and Works of Art," in *Freedom and Resentment and Other Essays* (London: Methuen, 1974), pp. 186–187. Strawson takes "witty," "delicate," and "economical" as his examples.

74. Danto, *The Transfiguration of the Commonplace*, p. 156.

75. This is nicely pinpointed in chap. 6 of Richard Shusterman, *The Object of Literary Criticism* [Schriften zur Philosophie und ihrer Problemgeschichte 29] (Amsterdam: Rodopi, 1984). "Many descriptive terms are also strongly evaluative (e.g. 'rich,' 'powerful,' 'moving,' 'insincere,' 'superficial,' 'incoherent'). In many of the critic's evaluative judgments it is these rather than the purely evaluative predicates which [indicate aesthetic value]" (p. 174). "Many allegedly objective evaluations may readily be seen as disguised subjective judgements" (p. 176; on p. 182, Shusterman speaks of "semi-descriptive evaluative terms"—such as "'graceful,' 'well-constructed,' etc."). This chapter is essentially intended as a descriptive analysis of "the logic of evaluation," i.e., an impartial (or "pluralistic") account of the major positions on the question. However, Shusterman accepts, in passing (p. 178), the idea that there exist "evaluative facts"; for instance, that "the *Divine Comedy* is a masterpiece." This is, in my view, a clear instance of objectivism, or of what Shusterman calls "absolutism."

predicates (of a more specifically artistic kind), such as "banal" or "original," belong to still other categories, which obviously involve more than an object's immanent properties (an object is not banal or original *in itself*). We will encounter these categories again.

In speaking here of persuasiveness, I am proceeding as if this kind of judgment were always an object of explicit argument, as is in fact the case in critical discourse. However, it seems to me that even our most silent or solitary aesthetic experience includes similar processes of inarticulated self-persuasion, the effect of which I call the objectivist illusion. This illusion is reflected on the theoretical plane by a discourse like Sibley's; Sibley has clearly perceived the existence and specificity of judgments of this type, but he deliberately occults their evaluative, and therefore subjective, nature.[76] It is in ways like these, I believe, that pleasure (or displeasure) is objectified into "value," and, as Kant so well says, "serv[es] . . . instead of a predicate."

THUS THE SUBJECTIVIST THEORY THAT I AM DEFENDING HERE seems to me inseparable from the phenomenon of objectification, which, in my opinion, not only accompanies aesthetic appreciation, but also *defines* it, since there can be no aesthetic appreciation without objectification. An "appreciation" that is not objectified, such as "I like this piece of music," is merely the expression of a feeling that does not seek to motivate itself in objective terms; it is not, in a word, a judgment. A motivation such as "I like this piece of music because it is in A major" is obviously ineffective, unless one completes it with ". . . and A major is a likeable key," which is a motivation that presents itself as (and believes it is) objective, but is in fact merely (self-)objectifying. Yet it is a true aesthetic appreciation which attributes its cause to the object (or, at least, to one of its properties), and which thereby denies the subject any causal role: if I like an object because it is objectively likeable, *I* am in no way the cause of my liking it. The other way of completing the phrase just mentioned is ". . . and I like A major." This remains within the realm of the subjective, merely displacing the question: "Why do you like A major?" etc. It is obviously this

76. In "Objectivity and Aesthetics," Sibley reinforces this objectivism to the point of caricature, attacking "skeptics," like Hume, and using the same arguments: those who deny the objectivity of aesthetic properties are compared to people who perceive colors incorrectly because they are colorblind or have the yellow jaundice. Just as one ignores their opinions, so one can ignore the aesthetic opinions of those who do not belong to an "elite" (p. 42) group of connoisseurs: "Some people, even if in a minority, *do* manage to use aesthetic terms as objective" (p. 45). Michael Tanner rightly responds that "when evaluation comes into the picture . . . objectivity goes out." (Tanner, "Objectivity and Aesthetics," *Proceedings of the Aristotelian Society*, supp. vol. 42 [1968]: 68).

situation, in which the questions can be multiplied to infinity, that makes the subjectivist position psychologically unacceptable, excluding it from any real aesthetic relation. We can, and, on my view, *must* be subjectivists "in theory," that is, whenever describing aesthetic appreciations from the outside; but we cannot be subjectivists in practice, that is, when we our- selves are involved in the act of appreciation, which is by definition objec- tivist.

It does not, however, follow that aesthetic appreciations are ab- solutely inexplicable. The fact is that they do not aim to explain themselves to themselves, but attempt, rather, to motivate (justify) themselves, which is almost the exact opposite: intentional (and, in the present instance, at- tentional) behavior rarely seeks an explanation, it seeks justification. Ex- planation can only come from the outside—which means, not necessarily from outside the subject, but from outside the behavior itself. Here and now, I like this painting, and I "judge" it beautiful; that is the reason I give for liking it. When I take a certain distance, so that my situation is no longer that of someone making an aesthetic appreciation, I may adopt an objective attitude vis-à-vis my judgment, asking myself what my reasons for forming it were. By "reasons," I here mean, of course, not the reasons I invoke to justify my judgment (giving those reasons in fact wholly con- stitutes it), but the causes that determine it, somewhat the way Swann, after he is "cured" of his love for Odette, wonders how he could have loved a woman who . . . etc. I am not forgetting that Swann never dis- covers the answer, but this is perhaps because he does not look long or hard enough, or, more likely, because he is not the person in the best po- sition to discover it; a sharp-sighted, uncompromising friend like Charlus would doubtless succeed more easily, if, for example, he could induce Swann to talk a bit (about something else), which would lead him insen- sibly, and dangerously, toward the couch. I do not claim that every aes- thetic appreciation, or, more generally, every aesthetic subject, must sub- mit to this sort, or any other sort, of investigation, since what is at stake here is perhaps not of the utmost importance. I merely claim that this is in principle possible, as long as one is no longer caught up in the act of ap- preciation itself, which, by definition, states its reasons, not its causes, which it does not know. I claim further that the principle such an investi- gation should be based on is obviously the subjectivist theory itself.

Doubtless the whole of what precedes can be summed up in a few words, which, I hope, will not seem too sophistic by now. With respect to the act of aesthetic judgment, *the objectivist theory of appreciation is subjective* (it inheres in and conforms to the act of appreciation) [*(est) inhérente et ad- hérente à l'acte d'appréciation*]. On the other hand, *the subjectivist theory is ob-*

jective, that is, it is extrinsic to the act of appreciation, adopting an attitude that we were only recently still calling an attitude of "suspicion," in other words, a refusal to take at face value the way a given mode of behavior announces, defines, and justifies itself. This attitude should not be any more surprising than the one from which "human sciences" such as psychology (especially, of course, psychoanalysis) or sociology arose (indeed, it is the *same* attitude). To repeat, the role of a science or theory is not to "espouse" its object but to describe it correctly, which implies a degree of divorce, even if by mutual consent: if so-and-so judges such-and-such an object beautiful (or ugly), and I share his view, the matter is highly likely to come to an end right there, since, by definition, I would also share his belief in the objectivity of this (of our) judgment. If I do not share any of that, I can either try to bring him to adopt *my* judgment (and my belief in its objectivity), by, say, showing him the object in another light; the result would be an aesthetic debate of the kind we engage in all the time. But I can also adopt a position of "scientific" neutrality, and attempt to discover (objectively) the (subjective) reasons for which the properties of this object elicit his appreciation, whether positive or negative. I may not discover them, but it cannot be said that such a search is meaningless (it is without interest, perhaps, but that is another story): for there must *always* be a reason for the fact that a given subject likes a given object.

From Subjectivism to Relativism

I have not been trying to do anything more from the outset of this chapter than accurately present a thesis which seems to me somewhat deformed in the incorrect version of it given by its opponents, such as Beardsley, and which was (earlier) abandoned en route by its most eminent proponent, loath to pursue it to its logical conclusion, aesthetic relativism. In principle, the next step would be to *justify* this theory, that is, to prove that it is correct, or, at a minimum, to disprove the contrary hypothesis. I am afraid that neither of these operations is possible, or, more precisely, I think that they are both pointless. To say so is doubtless to expose myself to the charge of being rather too flippant. Let me try to refute it by justifying at least the last of the propositions I just advanced. I think it is pointless to offer a positive justification of the subjectivist theory because, viewed from the present standpoint, it consists in an observation that is simply self-evident, namely, that aesthetic appreciation is subjective, or, in Kant's sense, "aesthetic": whenever an object pleases or displeases me, it

goes without saying that this pleasure or displeasure is a "psychological" phenomenon and, as such, subjective; if the subject is collective, as when an entire cultural group appreciates the same object the same way, this judgment is no less subjective for being collectively—socially—so. Subjectivity is not a matter of numbers, and a collective appreciation counts as an appreciation only if it includes concurring individual appreciations, even if they are the result of conformism or collective hysteria. Moreover, no theory, not even the most "absolutist," contests this fact, nicely brought out by Durkheim:

> Because a certain condition is found in a large number of people, it is not for that reason objective. Simply because there are many people who like something in a certain way, it does not follow that that appreciation has been imposed upon them by some external reality. This phenomenon of unanimity may be entirely due to subjective causes, notably a sufficient homogeneity of individual temperaments. Between "I like this" and "a certain number of us like this" there is no essential difference.[77]

The objections begin to pile up when one sets out to determine the cause or causes of this appreciation. At the risk of seeming to oversimplify, I will present this debate as follows: a subject's evaluative response to an object can, in principle and a priori, depend on:

— either the subject alone, in the absence of any determination by the object; this solipsistic variant of the subjectivist theory is obviously neither my own nor Kant's, and, indeed, I doubt that it has ever been seriously defended by anyone. If I mention it nonetheless, it is in order to avoid all misunderstanding, and also because it can apply, at the limit, to certain artificial experiments in which a subject, under the effect of a drug, for example, aesthetically "appreciates" an object that he perceives in a wholly distorted or purely hallucinatory manner. Moreover, it should be possible to reduce such a situation to a more basic one by saying that the subject is responding, in this instance, to the object "as he perceives it, or thinks he perceives it." This brings us back to the ordinary relation: we all respond to objects as we perceive them, or think we perceive them, and the "accuracy" of our perception is not always verifiable;

77. Émile Durkheim, "Jugements de valeur et jugements de réalité," *Revue de métaphysique et de morale* 19 (1911): 440 [tr. "Value Judgments and Judgments of Reality," in *Sociology and Philosophy*, trans. D. F. Pocock (Glencoe, Ill.: Free Press, 1953), p. 83]. At the beginning of this essay, Durkheim notes that "I like that" is not a value judgment, but rather a (subjective) judgment of reality: true value judgments are of the kind "this is beautiful" (or good, etc.). But a value judgment can be collectively subjective, as can the feeling that it objectifies.

— or on the object alone, in the absence of any determination by the subject. Taken literally, this position would obviously be untenable, as it would entail negating the subjective phenomenon of appreciation, which is precisely what is to be explained; but, in fact, it subtends the "absolutist" objectivism illustrated by the Humean interpretation of Sancho's story about the key. There are good and bad judges; the bad ones are simply prevented, by illness, stupidity, immaturity, or some other handicap, from correctly perceiving the object's properties, while the good ones, that is, those who do correctly perceive the object, cannot but appraise it correctly. Thus there is no difference in appreciation among them which could be chalked up to the diversity of their individual dispositions. The existence of "standards of taste," that is, of objective criteria for determining aesthetic quality, effectively rules out all subjective determination: beauty becomes *index sui*, and a correct appraisal, which obviously cannot be made in the absence of a subject, does not depend on the dispositions of that subject, who is, so to speak, neutral and transparent, purged of all sensibility other than pure receptiveness to what is objectively beautiful (or ugly);

— or, again, on a doubly determined relation of aesthetic affinity or discord between the properties of the object and the psychological and/or physiological dispositions of the subject. One and the same property, x, pleases subject y because he has such-and-such a disposition, and displeases z because he has the opposite, or a different, disposition. This is a description of the genuinely subjectivist position:[78] when Kant says that the principle informing a judgment of taste "cannot be other than subjective," he does not mean that that judgment is independent of all consideration of the object, but rather that it merely gives expression to the feeling of the subject "as he is affected by the representation"—of the object, of course.

If one accepts this formulation of the two positions still in the running (the first position, as we have seen, disqualifies itself), then there subsist, it seems to me, only two factual questions. The first is directed toward the objectivist position: do there or do there not exist, in the final analysis, objective properties such that they compel all "correct" receivers to make the same appraisal, as anyone who knows how to use the appropriate instruments is compelled to arrive at the same results in measuring the dimensions of a rectangle, weight of a package, or temperature of a room? (Let

78. Which obviously simplifies matters, if only because different individuals do not always perceive, or, to use Schaeffer's term, "mobilize," the same properties of an object. A situation in which we can be certain that two individuals are evaluating *the same property* differently (for example, the circular form of a tondo) can, in all probability, only be created artificially.

us note in passing that even these measurable data do not determine the same "appreciation" on the part of all subjects: depending on the subjects and circumstances, a surface that measures two by three yards is "big" or "little," something that weighs twenty-five pounds is "heavy" or "light," sixty-five degrees is "hot" or "cold.") Be it recalled that Beardsley takes up the challenge of proving this on behalf of objectivism, then ducks the obligation by adopting the ostensible third way of "instrumentalist" theory; he acknowledges, at several points in his argument, the logical difficulty involved in deducing a value judgment from factual premises. But Beardsley, we recall, initially chose three criteria as his candidates, before transferring them from the object to the "aesthetic experience" itself: unity, complexity, and intensity. These criteria represent a (very slight) revision of proposals put forward earlier by Thomas Aquinas and Hutcheson, as if the objectivist theory had not been able to come up with anything more in the several centuries it has been in operation. I would be rather hard put to advise it of other criteria it might adopt; of course, any one of the three might suffice, but I will surprise no one by saying that none of them seems to me adequate to the task. The first two stand in a fairly antithetical relation to each other, one which makes them inversely proportional: an object is the more unified the less diversity it contains, and vice versa. If these two criteria are of equal pertinence, it follows that we cannot augment the one without diminishing the other. This makes them, in some sense, optional: one object is beautiful because it is unified, and another because it is varied, which apparently gives us two different types of aesthetic value. This does not trouble me in the least, but it is hardly appropriate for a theory that claims to avoid relativism. If, alternatively, we revert to Hutcheson's synthetic criterion,[79] the goal should be to strike the right balance between unity and diversity; but this seems to me difficult to define, and rather likely to encourage banality—unless we dilute the idea to the point of making it, as I have already said, merely a condition ("unity of the manifold") of all perception, irrespective of aesthetic value. In any event, the shift in artistic taste (and, doubtless as a reaction, in aesthetic taste in general) has gradually alienated us from this kind of criterion, so that today we appreciate works which a classical taste would consider either unbearably unstructured, like certain of Pollock's drippings* or Coltrane's improvisations, or unbearably homogeneous, like Reinhardt's or Klein's monochromatic paintings—if not both at once, like Monet's *Nymphéas*, to mention no more recent work. Moreover, modern

79. George Dickie, *Evaluating Art*, p. 100, rightly observes that Beardsley's three criteria, all of which are positive, recall Hutcheson's, just as Sibley's open-ended list of predicates recalls Hume's.

attention to the "detail," obviously related to techniques for the photographic reproduction of paintings, has cast doubt on the validity of the criterion of unity or *integritas*, a development I, for one, consider positive in the extreme. How many works initially valued for the overarching structure of the whole reveal, when photographers or maquettistes make certain choices, an unsuspected capacity to break down into diverse fragments that are just as seductive (and structured) as the whole, if not more so? And how many poems survive only in the form of a stanza, or even a single line? The practice of putting together anthologies, "expanded" or not, has for centuries been yielding "fictitious" works, to use Malraux's term. Some of these anthologies are frankly superior to the real works they are extracted from—with often justified disregard for the unity of the works they "dismember." Many mutilated statues, or monuments in ruins, awaken no regrets in us for what we know is missing and yet do not miss: we do not, for example, wish to see them gaily painted again. Many "parts" are not only "more valuable" than the whole they are taken from, but also constitute very convincing "wholes" in their own right, thus revealing the often illusory character of the notion of unity. And it is common knowledge that certain great works, like the Mass in B Minor, *The Human Comedy*, or *The Legend of the Centuries*, were "unified" late in the day, and, as Proust says about the last two, "retroactively."[80]

Thus it seems to me that Beardsley's first two criteria show that he grants a certain privilege to classical taste, which is certainly not to be criticized in itself, but is still only one sort of taste (an "aesthetics") among others. In evoking the evolution of taste, I do not have in mind a continuous, linear progression. Classicism was the successor to (and unreservedly rejected, or unashamedly relegated to the shadows) forms of art similar to those we accept and promote today: consider its rejection of "Gothic" or "baroque" art as too composite and unbalanced, or the fact that it prudishly "forgot" the "formulaic," repetitive style of Homeric epic. But we will take up questions of this sort again a bit later. As to the last of Beardsley's criteria (intensity), it seems to me to be suspended between

80. Marcel Proust, *La prisonnière*, in *A la recherche du temps perdu* (Paris: Pléiade, Gallimard, 1988), vol. 3, pp. 666–667 [tr. *The Captive*, in *Remembrance of Things Past*, trans. C. K. Scott Moncrieff and Terence Kilmartin (New York: Random House, 1981), vol. 3, p. 158]. Proust's position is in fact more ambiguous, for he judges this kind of unity "not factitious, perhaps indeed all the more real for being ulterior, for being born of a moment of enthusiasm when it is discovered to exist among fragments which need only to be joined together; a unity that was unaware of itself, hence vital and not logical, that did not prohibit variety, dampen invention." Be it noted that Proust unjustifiably extends the category to include Wagner, who "perceiv[ed] all of a sudden [?] that he had written a tetralogy" (ibid., pp. 157–158).

meaninglessness, if one stretches it to the point of requiring merely that an object be perceptible, and irrelevance, if one postulates that an object has more aesthetic value the more intense it is: this is to privilege vivid colors and *fortissimos* and to devalue discretion—unless the concept is dialecticized until it encompasses its opposite, when its opposite is taken in the figurative sense, so that one can say that Debussy or Twombly are "in their way" aesthetically more intense than Wagner or Caravaggio. But this brings us full circle, from the *definiens* to the *definiendum*: now the aesthetic value of an object is not measured by its intensity; rather, its intensity is measured by the value one ascribes to the object. What is involved here is rather like what Beardsley does when he shifts his criteria from the object to the "experience" it produces—a shift whose disadvantages we have already noted. Ultimately, these supposedly objective criteria, which, it is said, do not deserve to be called objective because they are too hard to define,[81] seem to me to belong to the same category as Sibley's "aesthetic qualities": they are aesthetic predicates among others, which present themselves as fully objective, but are merely semidescriptive and semijudgmental. Depending on tastes and contexts, "unified" is automatically revalued as "monotonous," "varied" as "composite," "intense" as "garish"; and, once again, the value judgment one set out to provide objective grounds for is included, while being more or less successfully concealed, in what is supposed to ground it.

The second factual question, inherent in the subjectivist position, is the one Kant wished to settle by appealing, not to empirical data, but to a priori principle: that of the *sensus communis*, or the identity of the aesthetic disposition in all mankind. Posing this question in the framework of an empirical investigation would obviously not square with Kant's intentions, since what Kant had in mind was the absolute universality of aesthetic judgment. I will not reconsider the problems this poses, nor the insuperable obstacle it comes up against in the form of the rather stubborn fact that the tastes of individuals and cultures differ. I must, however, reconsider the no less obvious fact that there does exist a partial community of taste; this seems to me to constitute the complement, even the indispensable corollary, to the subjectivist theory. This fact, although it is of an empirical kind, and thus can only ground a mere "general" (not universal) consensus, rests on a simple principle. If an appreciation depends on an encounter between such-and-such a property (or properties) of the object and such-and-such a disposition (or dispositions) of the subject, it is

81. This means, doubtless, too hard to measure, in the sense in which we measure an object to discover whether it complies with the "golden section" (but who still applies that criterion?).

enough for two subjects to possess the same dispositions, even if this is sheer happenstance, for the same object to elicit the same appreciation from both; and if, as I have already noted, two, three, one hundred, or ten million subjects all individually appreciate the same object the same way, their common appreciation can be considered a collectively subjective appreciation, as Durkheim basically argues. I just said "even if this is sheer happenstance," but it goes without saying that most communities of judgment owe very little to happenstance, and a great deal to common determinations, mutual influence, or acculturation. I will not here belabor facts as obvious as these, which anthropology and sociology treat at great length and in great detail, with a competence and tools that I obviously do not have. I simply wish to underscore the following two facts, which are often misunderstood (or, at any rate, which subjectivism is often assumed not to understand): that *subjective* does not necessarily mean *individual*, and that the autonomy of true aesthetic judgment (I mean by this authentic appreciation that is not adulterated through imitation or conformism) does not exclude all possibility of modification. Fish's description, which I quoted earlier, provides a good explanation in subjectivist terms for the fact that personal tastes evolve, a circumstance which is often used as an argument against subjectivism, and which Kant chose to ignore. The autonomy of aesthetic judgment, which follows from its radically subjective nature, does not rule out evolution, but merely the possibility that an appreciation should be authentically modified under the impact of an external argument or influence, except in cases where a new "set of standards and values" has been *internalized* and integrated into a personality, itself profoundly modified as a result. I will come back to this last point, which grounds the possibility of *aesthetic education*, to adopt Schiller's term (if not his concept). The Kantian hypothesis that there exists a *sensus communis* which is universal, and therefore capable of justifying the (all too) famous claim about the universality of the judgment of taste, is certainly unwarranted, and, moreover, unnecessary once it has been understood that the judgment of taste does in fact lay claim to objectivity. However, one can (and must) observe, in more empirical fashion, that there exists considerable *convergence* in the aesthetic sphere, more or less broad and more or less stable, with regard to certain objects or certain properties. One must, consequently, admit that these objects or properties have greater "dispositional" capacity than others, in conformity with various physical, psychological, cultural, and historical conditions. I am not going to catalogue them, for that is an enterprise condemned in advance to banality, obsolescence, and, inevitably, ridicule. Suffice it to say that subjectivity by no means rules out such convergence (it would do so only if we adopted

the absurd principle that it is a priori *impossible* for the human race to agree
about an appreciation), and that, conversely, such convergence in no way
contradicts subjectivity: even if *all* human beings of all ages, countries, and
periods appreciated the same object the same way (but how could we
make sure of this?), that would not prevent their unanimous appreciation
from being subjective, both collectively and also in each individual case,
and it would not make the object "objectively beautiful."[82] I must confess
that a still more universal appreciation, which encompassed, in a single,
duly attested aesthetic frisson, all animal species—and why not all plant
species as well, since they say that certain plants have a preference (aes-
thetic or physical?) for certain pieces of music as opposed to others—
would trouble me a bit more, but things have not reached that pass yet.
And, if they ever do, it would still remain to extend the inquiry beyond the
pinched limits of our old planet: would E.T.'s preferences run to Cézanne
or Norman Rockwell?

THAT QUESTION, IDLE OR NOT, ECHOES A TWOFOLD ARGUMENT
often advanced by partisans of the objectivist position: I will call it the ar-
gument by *posterity* and *maturity* (we shall soon see what these two no-
tions have in common). The argument by posterity[83] is the older, for it can
be traced back at least to Classical doctrine. It states that (historical) time
itself works to separate the wheat from the chaff, and that, once superficial
fads and moments of temporary incomprehension due to departures from
old habit have passed, the genuinely (and, therefore, objectively) beautiful
works end up carrying the day, with the result that those which have with-
stood "the test of time" emerge from this trial bearing an incontestable,
definitive label of quality.

The Classicists (Boileau, Dryden, Johnson, etc.) generally used this ar-
gument negatively, as proof of the fragility of false values and overblown
reputations, like those of preceding periods, for example, the Gothic and
the baroque: it was not long, they said, before the "extravagant excesses"
of these periods, highly esteemed for a brief moment, began to inspire dis-
gust. Fashions come and go, true values endure. I do not, of course, deny
that fashion, and, a fortiori, today's commercial advertising and media
hype, can artificially transport to the heights works "one" will later judge
not to have deserved so much glory. Nothing, however, guarantees that
this reversal of aesthetic fortunes is not itself yet another consequence of

82. See Jean-Marie Schaeffer, *Les célibataires de l'art: Pour une esthétique sans mythes*
(Paris: Gallimard, 1996), pp. 215 and (on Kant's *sensus communis*) 225.
83. Invoked by, for example, Sibley, "Objectivity and Aesthetics," pp. 49–51.

fashion, which replaces one sudden and artificial enthusiasm with a countermovement just as artificial. What is noxious about "fashion" is the facile (and easily reversible) grievance one fashion or taste can lodge against another; anyone wishing to bury his competitor can accuse him of being in fashion today, or, better, of having been in fashion yesterday. The artistic "revolutions" of the modern period have, more than anything else, contributed to accrediting the positive variant of this argument, which says that the public needs some time to recognize the value of works that are, like Cézanne's or Stravinsky's, initially difficult or disturbing, but that always end up attaining the status of enduring "classics." According to Proust, works of genius, like Beethoven's last quartets, are by definition too original to find immediate acceptance; a work in this category must first educate its public "by fertilising the rare minds capable of understanding it," so as to "make them increase and multiply." How this "fertilization" comes about remains something of a mystery, but it is responsible for the fact that such a work "create[s] its own posterity."[84] On the face of it, we are likely to find the second variant more convincing than the first, but I doubt that this is because it is a more valid test of the objective superiority, and therefore the superiority tout court, of a work initially considered "difficult." Indeed, Proust himself relates how Bergotte's work, once assimilated, became so utterly "limpid" that it lost much of the value it had had in Marcel's eyes when he discovered a "new writer" whose turns of style led him to perceive fresh "relations among things." Thus "a man's work seldom becomes completely understood and successful before that of another writer, still obscure, has begun, among a few more exigent spirits, to substitute a fresh cult for the one that has almost ceased to command observance."[85] In other words, one "cult" drives out the last; none is able to hold sway forever. Above all, it seems to me that this variant—in which "posterity" acts not as ultimate arbiter but as witness to a late and

84. Marcel Proust, *A l'ombre des jeunes filles en fleurs*, in *A la recherche du temps perdu* (Paris: Pléiade, Gallimard, 1987), vol. 1, p. 522 [tr. *Within a Budding Grove*, in *Remembrance of Things Past*, trans. C. K. Scott Moncrieff and Terence Kilmartin (New York: Random House, 1981), vol. 1, p. 572]. In Valéry, this idea takes the form of "an important distinction: the distinction between works *which are in a way created by their audience* (whose expectation they fulfill, so that they might almost be said to be determined by an awareness of this expectation) and those which, on the contrary, *tend to create their audience*." Paul Valéry, "L'enseignement de la poétique au Collège de France," in *Œuvres*, vol. 1 (Paris: Gallimard, 1957), p. 1442 [tr. "On the Teaching of *Poetics* at the Collège de France," in *Collected Works*, vol. 13, trans. Ralph Mannheim (New York: Pantheon, 1964), p. 87].
85. Marcel Proust, *Le côté de Guermantes*, Part II, in *A la recherche du temps perdu* (Paris: Pléiade, Gallimard, 1987), vol. 2, p. 622 [tr. *The Guermantes Way*, in *Remembrance of Things Past*, trans. C. K. Scott Moncrieff and Terence Kilmartin (New York: Random House, 1981), vol. 2, p. 337].

possibly ephemeral influence—is entirely consonant with the "set of standards and values" that is (today) the dominant aesthetic paradigm: the "tradition of the new," in Harold Rosenberg's words. Adorno suggests the more complex idea that the true "merits" of a work—I would say, in more neutral terms, its most essential properties—do not become apparent until the effects that were the most striking when it first appeared have lost their novelty: "Appreciating Beethoven as a composer may have been made possible by somebody like Berlioz who outstripped Beethoven's titanic posture to which audiences first responded favorably. Also, the superiority of the great impressionists over Gauguin became obvious only later, when it turned out that his innovations were trivial when compared with later ones."[86]

This remark of Adorno's is actually rather unfair to Berlioz and Gauguin, but it seems to me to highlight a noteworthy fact. The effect of the oft invoked phenomenon of historical "distance" is frequently to free our judgment from a concentration on aspects of a work that are thrown into relief by their first, "spontaneous" reception: for example, features of contrast or similarity that automatically disappear from view once the context has been forgotten or reinterpreted. Baudelaire's "shamelessness" or Picasso's "deformations" are no longer the features of their work that command our attention, and the comparison between Racine and Pradon that mattered so much in 1677 no longer affects our judgment of *Phèdre;* it will perhaps come to the fore again someday, unless, in the interim, Racine himself sinks below the horizon, definitively or not. We will take up questions of this sort again later; they obviously have special relevance to works of art.

I am not ignoring the existence of such historical evolutions and revolutions, and, of course, I, like everyone else, subscribe to the common wisdom that makes much of them, but I am much less certain when it comes to the universal validity of the appreciations that historical change brings with it. I do not see, for example, how the fact that we need a certain period of reflection or adaptation before we can appreciate a work guarantees that our appreciation of it will be definitive: the "difficulty" of a Marino or a Gongora did not protect them from a long period of unpopularity in the Classical age, and the fact that they have more recently come back into favor carries with it no guarantee of enduring fame. French romanticism was first "revolutionary"; then, in its way, classic, that is, in harmony with the "values" of an age; and, still later (today) a bit on

86. Theodor W. Adorno, *Aesthetic Theory*, trans. C. Lenhardt, ed. Gretel Adorno and Rolf Tiedemann (London: Routledge and Kegan Paul, 1984), p. 279.

the corny side in the estimation of many. The historical fluctuations in the evolution of taste are not as linear and cumulative as the advocates of its successive paradigms suppose: the fact is that taste changes in every which way, with moments of rejection, oblivion, or rediscovery that one would have been hard put to predict a decade or two in advance. The Classicists of the seventeenth and eighteenth centuries, satisfied that they had buried their predecessors and confident in the "judgment of posterity," would doubtless be very surprised indeed to learn about the less than gratifying fate currently meted out to their works, which are being kept alive artificially with transfusions provided by the schools and the Academy; they would be quite as surprised to witness the return to grace of baroque art (poetry included), underway for a good fifty years now, and of Gothic and Romanesque art, whose return to favor has held good for two centuries. It should of course be said that nothing rules out the possibility that this reversal will be reversed some day, and so on and so forth: I am by no means attacking the aesthetic of classicism, but rather the naive dogmatism that it shares with other aesthetics—what it is entirely appropriate to call, for once, its "absolutism." The truth is simply that "posterity," in the sense classicism gave the word, is nothing but a consoling myth, like the immortality of the soul, the resurrection of the body, and (more recently) the infallibility, in the long run, of public opinion (Lincoln: "You can fool some of the people some of the time . . .").[87] "We are told that Time is the great judge. This is a statement which can neither be confirmed nor denied, but from the vantage point of today both these artists [Piero and Vermeer] have been neglected for longer than they have been admired. Nor can it be assumed that once a painter has been recovered from oblivion he cannot, as it were, be lost again."[88] Haskell errs, if at all, by excessive moderation: it seems to me that his work, especially the text from which I have taken this warning, brilliantly refutes the idea that the "supreme arbiter" in question has the virtues some ascribe to it. There is not—and cannot be—an arbiter in this matter.[89]

87. Besides, I am not certain that democracy is based on the infallibility of the people's *opinion*, which is fairly suspect both in the long and the short run. Rather, it probably rests on the sovereign character of the people's *will* and decisions: a people enjoying universal suffrage can perfectly well err, and, indeed, rarely misses the chance to do so. The merits of democracy are manifestly of another order.

88. Francis Haskell, *Rediscoveries in Art: Some Aspects of Taste, Fashion and Collecting in England and France* (Oxford: Phaidon Press, 1980), p. 4.

89. "Time, whose critical perspicacity I have always made the necessary adjustments for," as Borges once wrote, with his customary and arrogant modesty, about the (as he said) excessive fuss that "posterity," in this instance precocious, had made of two of his tales (Jorge Luis Borges, *Nueva antología personal* [Buenos Aires, 1968], p. 7). However, it goes without

THE SECOND PART OF THIS ARGUMENT (THE ARGUMENT ABOUT "maturity") might be regarded as a transposition of the first from the level of collective history to that of individual development. As such, it has a more "modern" cast; it also functions, it seems to me, as a way of dealing with the problems, rather obvious today, that the first butts up against. It asserts that individual taste always evolves in the same "unidirectional" and irreversible way, and is marked by steady progress in the quality of aesthetic appreciation; thus an individual progresses from, for example, a facile taste for Tchaikovsky, Graham Greene, or Norman Rockwell (announced above) to a more sophisticated taste for Haydn, Shakespeare, or Cézanne.[90] Like all empirical arguments, this one too would stand to gain if it could cite studies of some rigor in support of what it says, but, as far as I know, it never has. One thinks of the way in which Nietzsche came to prefer *Carmen* (and the zarzuela) to *Tristan*, a fact that may perhaps be allowed to stand over against this dearth of statistics as a counterexample.[91] Through this thick fog of received ideas and alleged facts, we can make out two relatively plausible determinants of "unidirectionality," namely, biological aging and the cumulative increase in artistic "competence." The first is all too certain, but its beneficial effects are a bit less so. The second appears to have a certain plausibility: we can at least take it for granted that there is a quantitative increase in an individual's aesthetic experience (at sixty, I have seen more paintings than I had at fifty), and express the wish (although it is much less self-evident that it will be fulfilled) that this experience will not lose on the one hand what it gains on the other, but will in fact bring about an increase in competence. The implicit assumption (this is beginning to make quite a few *ifs*) behind this line of reasoning is that biological aging and increasing competence conspire to the same end,

saying that the critical perspicacity of any author—and any reader—inevitably requires the same kind of "adjustment."

90. These examples are taken from Beardsley, *Aesthetics*, pp. 520, 532, and (by way of a reference to Michael Slote, who proposes the term "unidirectional") p. lv. (See Michael A. Slote, "The Rationality of Aesthetic Value Judgments," *Journal of Philosophy* 68 [1971]: 821–839.) Frank Sibley prefers to counterpose Bach to "Bruckner or Tchaikovski" ("Objectivity and Aesthetics," p. 47). Cultivated Americans make Tchaikovsky pay a rather heavy price for his abiding popularity.

91. Assuming that *Carmen* is "easier" than *Tristan*, an "obvious proposition" that is itself rather difficult to demonstrate with precision. In a sardonic passage of *The Captive*, Proust speaks of "those who, like Nietzsche, are bidden by a sense of duty to shun in art as in life the beauty that tempts them, and who, tearing themselves from *Tristan* as from *Parsifal*, and, in their spiritual asceticism, progressing from one mortification to another, succeed, by following the most painful of *viae Crucis*, in exalting themselves to the pure cognition and perfect adoration of *Le postillon de Longjumeau*." Proust, *La prisonnière*, p. 665 [*The Captive*, p. 156].

a *maturation* of taste, so that crude, naive, or sentimental effects are increasingly shunned in favor of more sober, complex ones, accessible only to an aesthetic sensibility refined by the passage of time and long-standing familiarity with works of art. Assuming that all the hypotheses we have here piled up are correct, we obtain a sort of tendential law of the following kind: "Biological and cultural maturation generally lead from appreciation of easier works toward appreciation of more difficult ones"—the degree of difficulty of a work being, apparently, the only even minimally objective and measurable property that can be brought into correlation with an individual receiver's level of maturity. It is assumed, of course, that due allowance has been made for the historically conditioned cultural variations which render Picasso or Stravinksy, for example, relatively more accessible today, even for a novice receiver, than they were yesterday for the cultivated public. But let me recall that this phenomenon of development, which is treated as if it were an established fact, is indirectly taken to prove the objective superiority of certain works over others. However, it cannot play this role by itself, for nothing ensures, a priori, that the effect of increasing age and experience will be positive here; after all, they could bring with them as many negative circumstances (senility, an attachment to old habits, obstinacy, closed-mindedness, various forms of regression) as positive ones. The presumed aesthetic progress of a subject can, then, be established only with reference to the *superiority* of the ("difficult") works he appreciates in his mature years (which age is that?) over the ("easy") works he appreciated when he was an adolescent; the supposed proof thus clearly depends on the very circumstances it is supposed to prove. It may well be that difficult works are "superior" to easy ones, and it may also be that experienced receivers are "better judges," in Hume's sense, than novices, but neither of these two propositions is self-evident, and it is rather obvious that each depends on the other: my taste is superior to that of others because I prefer, today, works whose superiority is proven by the fact that I like them better today than yesterday. This makes a nice little circle. It seems to me that this whole line of reasoning merely *illustrates* the system of values of the people who invoke such arguments, even while claiming to *justify* it. That seasoned critics exercise superior judgment is, for understandable reasons, an article of faith of seasoned critics, who, taking advantage of their age, themselves establish the hierarchy in which they have a prominent place. It is never very sound practice, however, and it is even less convincing than it is sound, for the same person to be both judge and judged. The same holds for claims about "posterity." As Schaeffer points out, whenever one says that "good taste has won out over

bad," it is always "good taste that calls the other bad,"[92] and which thus pronounces itself "good."

Let me add that this ostensible argument is predicated on an unduly simplistic and reductive conception of the aesthetic field. The first reduction will have been obvious for several pages now: considerations of this kind deliberately and explicitly take into account only works of art; given the role that cultural and technical factors play here, one would be hard pressed to extend them to the aesthetic relation in general. A second reduction has to do with the homogenous, gradualist vision of the artistic field that they imply. It might seem plausible (at best) that an art lover (in general) should pass, in the course of his life, from Rockwell to Cézanne and, in a parallel movement, from the *Pathétique* Symphony to the *Art of Fugue*, but a sentence I find in Beardsley[93] makes me very uneasy: it cites, as examples of objects that are, as it were, transitory for early* musical tastes—doubtless while they wait to accede, late in the day, to the well-earned delights of Beethoven's last quartets—Johann Strauss and Duke Ellington. I do not feel "the call," as the expression goes, to defend the Viennese waltz tooth and nail, but I think it is a little silly to regard it as a "stage" in an itinerary, no matter where the itinerary is supposed to lead. I doubt that concertgoers in Vienna, charmed by the annual New Year's concert, are all temporarily incapable, because of their age or for some other reason, of appreciating more austere music: we have to do here with two distinct kinds of appreciation which nothing encourages us to arrange in one order or the other on a "scale" of values. I would say the same, with a more personal motivation this time, about the relationship (intimated in Beardsley) between jazz and so-called classical music. I am not unaware that certain fans of the former, like, in his day, Boris Vian, profess to scorn the latter, and vice versa (which does not show either group to best advantage, but that's their affair). On the other hand, no one can be ignorant of the fact that there are music lovers who appreciate Ellington (because Ellington undeniably *exists*, whatever some might suppose) as much as Mozart, or Webern as much as Coltrane. And as I number among this latter group, I may add, on the basis of very reliable introspective sources, that these two tastes are exercised in fields perceived as being largely heterogeneous, fields which, in some respects, do not communicate with one another at all. To like jazz and classical music *at the same time* is not always to want to close the distance between them at all costs, and does not nec-

92. Schaeffer, *Les célibataires de l'art*, p. 198.
93. Beardsley, *Aesthetics*, p. 520.

essarily incline one to favor some sort of "fusion" or "third way" between them. To like the one "as much as" the other (if this adverb of quantity means anything here) is not to like them *in the same way*, or to ask which of the two rises above the other on the much-vaunted scale. Each of them operates, and may excel, *in its own order*. To put it frankly, it seems to me that aesthetic maturity, if there is such a thing, begins with the recognition of pluralities of this kind. To appreciate Racine and also Shakespeare, do we have to seek out the same kind of "merit" in the work of both? Do we always have to choose between portraits and landscapes? *Parsifal* and *Die Meistersinger*? *Othello* and *Falstaff*? *The Misanthrope* and *That Scoundrel Scapin*, as Boileau (strongly) suggests? I am well aware that, at least since Collingwood, "art proper*" is often counterposed to what is regarded as nothing more than activities (production and consumption) of amusement*,[94] and I am not blind to the relevance of this distinction, which we will, perhaps, meet again. I would point out, however, that it is sometimes used, with perfect irrelevance, to devalue one art in favor of another, or, within the limits of "the same art," to deprecate one genre in favor of another, leading to arbitrary "hierarchies" whose objective foundation is by no means assured. Even Kant and Hegel feel compelled to set up hierarchies of this sort.[95]

IT SEEMS TO ME, THEN, THAT THE "DEMONSTRATION" WHICH Beardsley felt objectivism needed to make has yet to be produced, and that, until this indefinitely postponed demonstration can be had, the subjectivist position remains the most accurate. But let me spell out that this position is not merely a theory "by default," resting entirely on—or, rather, consisting entirely in—the absence of proof for the "antithetical" theory. If it were to be proven that there are objective criteria of beauty and ugliness, that is, necessary and universally determinant causes for aesthetic appreciation, these criteria would not simply provide an objective explanation for appreciations hitherto unaware of their cause, as is the case when someone points out to me the unconscious reason for my liking one or another painting, poem, or sonata. They would also have to convince

94. R. G. Collingwood, "Art as Amusement," chap. 5 of *The Principles of Art* (Oxford: Oxford University Press, 1958), pp. 78–104.

95. Hegel's (complex and ambiguous) hierarchy is an integral part of his dialectical portrayal of artistic development, from the symbolic (architecture) through the classical (sculpture) to the romantic (painting, music, poetry). Kant's (*Critique of Judgement*, §53, pp. 191–196) is much less closely tied in with his general system; it gives the impression that he is doing an intellectual chore, and sometimes borders on the ridiculous—for example, when he deprecates music because "it plays merely with the sensations," and "lacks urbanity" because it can disturb others in the listener's vicinity (ibid., pp. 195–196).

(really and authentically) those who do not share this taste that they are in "error." Or, rather, they would perhaps have to teach them, in a revelation à la Plato, that they had always shared this taste without knowing it, since an objective criterion cannot fail to make one and the same appreciation necessary and inevitable for everyone; any exception could only be illusory. There is no need to add that a hypothesis of this sort seems to me highly improbable, not to say fantastic.

Value and Definition

Subjectivism, and the relativism that I believe follows from it, are sometimes accused of making any definition of art impossible.[96] If this were shown to be a consequence of subjectivism, there would indeed be cause for concern; but it has *not* been shown, for an objective definition of "beauty" and "ugliness" is by no means indispensable to the definition of art—no more, for that matter, than it is indispensable to the definition of any aesthetic relation whatever. In order for an aesthetic relation with an object to come about, it is necessary and sufficient for a certain (aspectual) type of attention to determine, in one or more subjects, aesthetic appreciation of that object, constituted from the vantage point such attention defines. The presence or absence of an objective criterion capable of legitimating this appreciation plainly has no bearing on the validity of the definition. In order for there to be a work of art, it is necessary and sufficient for an object (or, more literally, a producer, by way of this object) to seek to elicit, exclusively or among other things, such aesthetic appreciation, favorable if possible. If the appreciation obtained is not favorable, or (as often happens) is not as favorable as the creator of the work would like, his bid for aesthetic appreciation will have entirely or partially failed, but it is enough for it (for the artistic intention) to have been recognized, or even merely presupposed, for a work to function as such. If this bid for appreciation is itself not recognized, the work will not function as a work; but something that does not so function here and now may very well function that way somewhere else, or later. Of course, certain cases can remain undecidable (it is not known whether or not the producer of a particular utilitarian object also meant to elicit the aesthetic appreciation the object

96. The notion that it is impossible to define art is based on other arguments as well; I have mentioned them in Gérard Genette, *L'œuvre de l'art*, vol. 1: *Immanence et transcendance* (Paris: Seuil, 1994), pp. 8–9 [tr. *The Work of Art: Immanence and Transcendence*, trans. G. M. Goshgarian (Ithaca: Cornell University Press, 1997), pp. 2–4].

calls forth), or are obviously not the result of an artistic intention (everyone knows that this or that natural object, for example a rock which functions aesthetically, does not do so in virtue of an authorial intention). However, in all these cases, the subjective character of the appreciation elicited, whether it is obtained or not, or even if it is obtained without being elicited, by no means invalidates the definition. An object is "aesthetic" insofar as it is something that elicits, and to the extent that it elicits, aesthetic appreciation; it is artistic insofar as it is an obvious "candidate" (Dickie), and to the extent that it is an obvious candidate, for such appreciation (in this case positive); neither the success nor the failure of this candidacy determines whether it is a work of art. "Most works of art," says Goodman, "are bad."[97] Evidently, I cannot, in the name of a subjectivist theory for which "good," "bad," and other evaluative predicates arise from illusory and unwarranted objectifications, endorse this proposition in that literal form; but I endorse it every day in my objectifying practice, and I can, moreover, relativize it in the form "there are many works I don't like, or that leave me cold." I do not, for all that, deny them the status of works, which in no way depends on my approbation. Illusory or not, the "merit" of a work does not enter into its definition, and the uncertainty of aesthetic appreciations has no more effect on the definition of the work than it does on that of any other kind of object: I do not have to like an object aesthetically for it to be a work of art any more than I have to like it for it to be a tool—which does not mean no (other) condition has to be met for it to be a work of art. As I see it, then, the fact that it is impossible to define beauty does not in any way imply that it is impossible to define art. I shall come back to this point.

From this state of affairs, Goodman draws, in the last chapter of *Languages of Art*, a conclusion that seems to me excessive, one I mentioned at the end of the previous chapter. I mean the fact that he excludes from the province of what he, in addition, refuses to call "aesthetics," any consideration of appreciation, because he rejects all such considerations as "hedonistic," emotive, passive, etc. This rejection operates in favor of a conception of the aesthetic relation in general and the artistic relation in particular that is at once cognitive and voluntarist (or activist). In fact, Goodman's choices bear on the definition of attention and, at the same time, of judgment. I have already said that this dynamic conception of aes-

97. "We must distinguish very sharply . . . between the question 'What is art?' and the question 'What is good art?' . . . And if we start defining 'what is a work of art' in terms of what is good art, I think we are hopelessly confused. For unfortunately, most works of art are bad." Nelson Goodman, *Of Mind and Other Matters* (Cambridge: Harvard University Press, 1984), p. 199.

thetic attention seemed to me very much to the point. The notion of contemplation, and even more that of attention, do not necessarily exclude the notion of activity—physical activity included: a serious tour of a cathedral is not exactly a rest cure. In any case, it seems to me that attention implies activity more than it excludes it; and we saw in the last chapter that whether the Goodmanian "symptoms" are present and operative depends at least as much on the receiver's perceptive activity as on the nature of the object. This amounts, in sum, to according more to this activity than Goodman himself does. I likewise find no cause for alarm—quite the contrary—in the emphasis Goodman puts on the cognitive aspect of the aesthetic relation, the role that "curiosity"[98] plays in it, and the kinship, closer than is generally admitted, between the "disinterested" nature of intellectual inquiry and aesthetic experience,[99] though I am not certain that the same kind of "disinterestedness" is involved in both cases: I readily grant that the two activities are equally disinterested (as far as "practical objectives" go), but it seems to me, as it did to Santayana, that the feature of formal intransitivity (or, as Goodman himself shows, the fact that attention is shifted to exemplificational values) characteristic of the second is enough to distinguish the two kinds of "disinterestedness." Above all, however, I do not believe that we can exclude from the aesthetic relation the emotional component defined by the positive or negative appraisal of an object, which is what Goodman does, obviously carried away by his desire to set the stage for his thesis by presenting as incompatible two features that seem to me to be, rather, complementary. "Intransitive" attention is a necessary condition for the aesthetic relation, but it is not its sufficient condition. For as long as the subject does not respond emotionally to the object, by showing pleasure or displeasure, the relation remains a purely cognitive one: it resembles the attitude that an expert might (I say might) adopt toward a painting as he prepared to make an attribution, or that a historian of language might adopt toward a poem. Goodman has nothing but sarcasm for the notions of pleasure, satisfaction, or emotion. He goes so far as to confound, in rather sophistic fashion, the emotion that a work can elicit with that which it expresses, and he adduces the examples of Mondrian vs. Rembrandt and Webern vs. Brahms in support of his rejection of all emotionality, as if a work devoid (by hypothesis) of emotional content were not capable of provoking an emotional reaction from the viewer—even if only a reaction of rejection, as when Boileau judges the conceit articulated in a pair of famous lines by Théophile to be

98. Goodman, *Languages of Art*, p. 258.

99. "Disinterested inquiry embraces both scientific and aesthetic experience" (ibid., p. 242).

colder "than all the icebergs of the North taken together" because of its artificiality. The (putative) coldness of a Mondrian can elicit a very lively reaction from a viewer, of the following kind—"How can they put such a stiff, cold painting on exhibit?"—or of some other kind. They say that after finding a copy of Descartes's *Treatise on Man* in a bookshop on the rue Saint-Jacques, Malebranche "read it with such eagerness and enthusiasm that it made his heart flutter, so that he was obliged, from time to time, to lay down the book."[100] I do not know what type of emotion was involved here, but I doubt that it was of the same order as the coldly "mechanistic" discourse of the work that provoked it. Conversely, the intense emotion a work expresses may very well call up only indifference or disgust on the part of its receiver. In short, the emotional coloration of the object, if it has one, does not necessarily ensure that its reception will be tinged by the same emotion, so that we cannot infer, from the fact that there supposedly exist works devoid of emotion, that emotion is absent from the aesthetic relation: a work, like any object, pleases or displeases us to a greater or lesser extent, or leaves us more or less indifferent. This effect is inevitable, and its affective character incontestable, because, quite simply, the effect consists in the way the object *affects* us.

In *Languages of Art*, Goodman argues that "the drive is curiosity and the aim enlightenment. . . . The primary purpose is cognition in and for itself; the practicality, pleasure, compulsion, and communicative utility all depend upon this. . . . works of art are not race-horses, and picking a winner is not the primary goal. Rather than judgments of particular characteristics being mere means toward an ultimate appraisal, judgments of aesthetic value are often means toward discovering such characteristics."[101]

As I have already said, I do not think it is possible to assign a motivation or goal to the aesthetic relation: it is, in Schaeffer's words, a "causal," nonintentional relation (in the ordinary sense of the word).[102] While one can seek out this relation, it does not itself serve any purpose other than its own perpetuation or renewal, and I do not think that it is possible to distinguish ends (whether cognitive or emotional) and means (whether emotional or cognitive) in it. We can, however, distinguish causes and effects in it, and it seems to me that, in these terms, the cause tends to be of a cognitive, and the effect of an emotional kind, even if both can operate si-

100. Bernard de Fontenelle, "Éloge du père Malebranche," ed. Alain Niderst, *Œuvres complètes*, vol. 6: *Histoire de l'Académie des Sciences*, Corpus des œuvres de philosophie en langue française (Paris: Fayard, 1994), pp. 337–360.

101. Goodman, *Languages of Art*, pp. 258, 262. Or again: "In aesthetic experience the *emotions function cognitively*" (ibid., p. 248).

102. Schaeffer, *Les célibataires de l'art*, pp. 167–177.

multaneously. I do not look at a painting *in order to* like it, I do not like it (as Goodman appears to suggest) *in order to* see it, I like it because, when I see it, a rapport comes into being between the painting and myself. My appreciative judgment is not the "purpose" but, plainly, the *consequence* of my seeing it—even if, after and in consequence of my appreciation of it, I make an effort to look at it more attentively. I have not distributed the verbs "see" and "look" haphazardly here (obviously, it would be possible to counterpose "hear" and "listen to" in the same way, though this nuance is wanting in other modes of reception): "seeing" is merely an attentional *fact*, whereas "looking" is an intentional mode of behavior with a definite end purpose. I see an object *because* it is in front of me, I look at it *in order to* see it (better). Now, it seems to me that the aesthetic relation (attention and appreciation) is, in each instance, *initially* of a circumstantial order [*de l'ordre du fait*] (it is attentional and appreciative), and *only thereafter*, if at all, of the order of activity [*conduite*]: I perceive an object, consider it on an aesthetic level, appraise it, and, depending on the result of this appraisal, I decide to contemplate it more attentively, or to turn away from it.[103] I do not believe that it is possible, within this complex set of circumstances [*faits*] and activities, to distribute the notions of means and ends as one likes. However, if it were possible to use this expression in a noninstrumental sense, I would be inclined to say that, in the aesthetic relation, if appreciation can ultimately be "at the service of" attention, it is initially attention (the spontaneous or deliberate adoption of an aesthetic viewpoint) that conditions appreciation.[104]

I will nevertheless concede one point to the critique of aesthetic "hedonism" (whether Goodmanian or of some other stripe): namely, that the idea of pleasure (or displeasure)—which I have constantly taken as basic here, after Kant and Santayana—doubtless does not go to the heart of the aesthetic relation, but rather bears on what is certainly its most direct, in-

103. This is not to say that a negative appreciation inevitably leads one to turn away from the object; such an appreciation can very well serve as the point of departure for a more attentive consideration that is, if not pleasurable, at least "interesting." It is just as interesting (I will come back to this) to try to discover why one does not like an object as to ask why one likes it; but I do not think that an "interesting" activity can be entirely devoid of a certain pleasure, even if it is not exactly of an aesthetic kind.

104. In a move that may or may not be a concession, Goodman mentions "our [?] conviction that aesthetic experience is *somehow* emotive rather than cognitive" (*Languages of Art*, p. 247), only to add straightaway that theories cast in affective terms fail to explain *how* or *why* aesthetic experience appears more emotive. It seems to me that his own description of the "symptoms" of the aesthetic, like the Kantian analysis of the judgment of taste, helps us see, at least, *on what* (attentional) *ground* the act of appreciation occurs. This is not very far from the required explanation. What is still lacking doubtless pertains, in each instance, to the individual response.

dissociable, and obvious effect. The positive or negative appraisal of an object plainly *results* in pleasure or displeasure when one is exposed to that object; it is a sure sign of approval or disapproval, at least as far as the subject who feels the pleasure or displeasure is concerned. But it is doubtless inexact to say that one's appraisal *consists* in this resultant state; it consists, rather, in another feeling, less self-centered, if I may put it that way, and certainly more attentional—quite simply, in *liking* the object. When an object pleases me, this doubtless means that it gives me pleasure, but it gives me this pleasure only because it "pleases" me in the ordinary sense, which first of all designates a positive *affect*, even if this affect manifests itself in the pleasure it causes. We are hardly likely to say, in speaking of an object we appreciate aesthetically, "This object *gives me pleasure*," and are even less likely to say, "This object *causes me pain*"; we say, rather, "It pleases me," or "It displeases me," not in the "thymic" sense,[105] but rather in the affective sense of "I like it" or "I don't like it." And, *in this sense*, the (most spontaneous) objectifying expression, "It is beautiful," which means that we *find* it beautiful, is the most faithful reflection of the aesthetic feeling, which is a feeling relative to the object, not the effect it has—whence the irresistible tendency toward objectification. A very commonplace word expresses the feeling in question rather well (as long as one specifies the aesthetic ground*, for it obviously applies to many other domains as well, ethical or intellectual, for instance): I mean "admiration."[106] Yet it seems to me that it carries a connotation which makes applying it to natural objects somewhat problematic: what one admires, strictly speaking, is, rather, the creator of an object, an object which can therefore only be a human product that one "admires," in fine, by metonymy. I admire the *St. Matthew Passion* with reference to its creator, and because it is a work that has been created by someone. I would be less likely to say, spontaneously, that I admire the falls at Iguaçu, because I do not refer them to any producer and do not find the least trace of human activity in them. I know perfectly well that one sometimes says, without losing much thought over these nuances (especially when one does not perceive them), that one admires a landscape; from there, passing from trope to trope, this broad sense of the

105. For lack of a more familiar word, I have borrowed the name of this category from Greimas's semiotics (Algirdas Julien Greimas and Joseph Courtès, *Sémiotique: Dictionnaire raisonné de la théorie du langage* [Paris: Hachette, 1979] [tr. *Semiotics and Language: An Analytical Dictionary*, trans. Larry Cristo et al. (Bloomington: Indiana University Press, 1983)]). The category is there broken down into states of *euphoria* or *dysphoria*, experienced without necessarily being accompanied by an assessment of their possible cause; the aim is to differentiate as sharply as possible between what pertains to the inward state of pleasure or displeasure and what pertains to the *affective relation** of attraction or repulsion.

106. "The feeling authentically called up by beauty is admiration." Souriau, *La beauté rationnelle*, p. 120.

term "admire" could be adopted, by convention, to designate any positive aesthetic appreciation. But the antonym "detest," which applies mainly to ethical matters, seems to me most ill-suited to designate the opposite, except as far as the appreciation of works of art is concerned: I can "detest" a novel, not a landscape. Let us say no more of the matter: our languages are sometimes defective, we can do very little about it, and practical usage here is not too severely hampered by this defect, because, to repeat, appreciation is in any case most frequently expressed by way of objectifying predicates: not, "I admire the *St. Matthew Passion*," for example, but "The *St. Matthew Passion* is sublime." "Most frequently," and most accurately as well, because it is when I express myself that way that I say exactly, not what *is* (the *St. Matthew Passion* is not sublime *in itself*), but what I *think*. Of course, the fact remains that my concession to anti-hedonism concedes nothing to anti-emotionalism [*anti-affectivisme*]: that aesthetic pleasure or displeasure is merely the effect of the positive or negative feeling an object inspires does not prevent this feeling from being . . . a feeling.

I AM AWARE THAT I AM HERE PROPOSING A THEORY OF THE AES-thetic relation that I would describe, in all modesty, as *hyper-Kantian*, since I draw, from the subjectivism assumed and defended by Kant himself, a conclusion that Kant, as we have seen, warded off with all the means he could muster. Such a position is not very highly regarded today by the philosophical tradition I feel closest to in other respects, that of analytic philosophy; analytic philosophers see in relativism (which they associate, not entirely without reason, with the "Continental" philosophy of the last half-century) a danger for thought, which relativism robs of objective criteria, stable values, and rational procedures. While I will not here take sides in this debate as far as morals or the theory of knowledge is concerned, it seems to me that there is no a priori reason to extend the subjective, relative nature that I ascribe to aesthetic appreciation to other domains of the life of the mind: that there exist no objective, universal criteria for determining what is "beautiful" by no means implies, in my opinion, that there exist no such criteria for distinguishing—let us say, in order to simplify matters (a great deal)—truth and falsehood. Nor does this imply that the requirements of our social life, among others, do not mandate that human behavior be subjected to certain rules.[107] Thus I do

107. Be it recalled that in a 1770 addition ("Questions sur *l'Encyclopédie*") to the article "Beautiful, beauty," which I mentioned earlier in connection with Hume, Voltaire—before reaffirming his determination, thoroughly Kantian *avant la lettre*, not "to compose a long treatise on beauty"—declares that the assessment (moral assessment, in fact) of human actions has nothing of the "uncertainty" proper to aesthetic judgment. "The beauty which

not have the impression that I am contributing to any kind of nihilistic subversion in recognizing that a feeling—because what is involved here is definitely a feeling—possesses the properties that all affectivity does, with the privileges and restrictions those properties imply. Nor do I believe that the largely irrational character the aesthetic relation seems to me to have means that the study of aesthetics is condemned to the same irrationality, any more than all eye doctors are condemned to be near-sighted or far-sighted, or all astrophysicists to travel at the speed of light. "Aesthetic rationality,"[108] as I see matters, can only be the rationality of aesthetics considered as a body of knowledge [*une connaissance*]—as the study, which is by definition as rational as possible, of a practice that is itself not rational, and has no reason to be. And the first rational, or simply lucid, act of a science [*science*] is to refrain from unduly attributing to its object the character it legitimately imposes upon itself.

However, I do not make this restrained relativity (restrained to the sphere of aesthetics)[109] an a priori and, if I may be permitted the term, absolute principle: as I have already acknowledged once or twice, the subjective nature of aesthetic appreciation does not systematically rule out empirical agreement among those who appreciate something, which can sometimes be gratifying. Indeed, the hypothesis that it should exclude such agreement is plainly contradicted by experience, since it very frequently happens that *several* subjects—and since it is therefore *possible* that *all* subjects, chance willing—concur in their appreciation of an object, at least as far as essentials are concerned, and to the extent that they can communicate their appreciation to one another. To put it differently, the subjectivity of appreciation does not necessarily imply its variety, but merely the possibility of such variety as a purely empirical phenomenon— which is, in contrast, and as such, quite definitely empirically observable. The only a priori principle, to my mind, is the subjectivity of appreciation. This subjectivity implies, by definition, the relative nature of appreciation

strikes the senses merely, the imagination, and that which is called 'intelligence,' is often uncertain therefore. The beauty which speaks to the heart is not." Voltaire, *Dictionnaire philosophique*, ed. Étiemble (Paris: Classiques Garnier, 1967), p. 470 [*Philosophical Dictionary*, volbeaut.htm].

108. See Rainer Rochlitz: "Dans le flou artistique: Éléments d'une théorie de la 'rationalité esthétique,'" in Rainer Rochlitz and Christian Bouchindromme, eds., *L'art sans compas* (Paris: Cerf, 1992), pp. 203–238, and *Subversion et subvention* (Paris: Gallimard, 1994). The second of these two works goes over some of the same ground as the first.

109. Or, more precisely, the sphere of judgments that are "aesthetic" in the sense Kant gives the word in the first paragraph of the *Critique of Judgement;* this sphere thus includes judgments of feelings of pleasure. For me, of course, such judgments are quite as relative as judgments "of taste" (for Kant, they are apparently still more relative).

(in fact, the two terms are here synonymous: every appreciation of an object is *relative to* the subjectivity of the individual who appreciates it), but not its diversity (actual disagreement among different individuals), which is merely a possible, not a necessary, consequence of the subjectivity of appreciation. However, this diversity, whenever it is manifested, provides a sure index of subjectivity, as a footprint is an index that someone has passed by. And, conversely, if real unanimity should happen to obtain in a particular case—say, universal admiration for the heavenly vault or the Dome of St. Peter's—this would in no wise contradict that subjectivity: the absence of a footprint does not prove that no one has passed by. If, carrying out an inquiry à la (the early) Hume, I note a certain variety in the appreciation of an object, I can infer that this appreciation is not based on the object alone, since, if that were its sole basis, all variation would be ruled out. In short, the greater or lesser diversity of appreciations proves only its own possibility, but this possibility itself suffices to prove, on my view, the subjectivity of appreciations. Aesthetic relativism consists solely in taking note of an empirical, a posteriori, unsystematic datum (the plurality of appreciations) and in recognizing its cause (the subjective, or relative, nature of these appreciations)—a cause which is, for its part, a priori, since it is rooted in the very definition of appreciation, and could, when all is said and done, dispense with an index or confirmation of this sort. After all, Kant's analysis, an a priori analysis if ever there was one, in no way depends on Hume's (initial) empirical inquiry, which it obviously prefers to ignore.

OUT OF METHODOLOGICAL NECESSITY, I HAVE, TO THIS POINT, restricted myself to considering the aesthetic relation in as general a sense as possible. I have not taken much account of anything that might have to do with the specific nature of our relation to works of art, and I have even tried to resist the slippage from genus to species that can be seen in, or that is encouraged by, modern aestheticians, who are generally objectivist and oriented, by choice, toward a theory of works of art (or, by an even narrower choice, toward a theory of the criticism of art). The course of the first two chapters of this book has been set by my discussion of such theories. It is now time to return to the realm of art proper, so as to look more specifically at the particular turn the aesthetic relation takes when it involves a work of art—or rather, no doubt (we will come upon this nuance again), when it involves what the subject of the aesthetic relation *takes to be* a work of art.

CHAPTER 3

The Artistic Function

The bird's song tells of joyousness and contentment with its existence. At least so we interpret nature—whether such be its purpose or not. But it is the indispensable requisite of the interest which we here take in beauty, that the beauty should be that of nature, and it vanishes completely as soon as we are conscious of having been deceived, and that it is only the work of art—so completely that even taste can then no longer find in it anything beautiful nor sight anything attractive. What do poets set more store on than the nightingale's bewitching and beautiful note, in a lonely thicket on a still summer evening by the soft light of the moon? And yet we have instances of how, where no such songster was to be found, a jovial host has played a trick on the guests with him on a visit to enjoy the country air, and has done so to their huge satisfaction, by hiding in a thicket a rogue of a youth who (with a reed or a rush in his mouth) knew how to reproduce this note so as to hit off nature to perfection. But the instant one realizes that it is all a fraud no one will long endure listening to this song that before was regarded as so attractive. And it is just the same with the song of any other bird. It must be nature, or be mistaken by us for nature, to enable us to take an immediate *interest* in the beautiful as such; and this is all the more so if we may even call upon others to take a similar interest.[1]

1. Immanuel Kant, *The Critique of Judgement,* § 1–60, in *Kant's Critique of Aesthetic Judgement,* trans. James C. Meredith (Oxford: Clarendon, 1911), pp. 161–162. Cf. ibid., p. 89: the song of a bird imitated by man "would strike our ear as wholly destitute of taste."

One would be hard pressed to find a passage in Kant that more clearly reveals his well-known preference for the "beauty of nature": the phrase "only . . . art" (*nur Kunst*) is typical to the point of caricature. That the imitation of the nightingale's song by "a rogue of a youth" loses all attraction and interest for "taste," once we have seen through the trick, is plainly an exaggeration.[2] Everyone knows that Aristotle maintained just the opposite, identifying pleasure in imitation as a characteristic feature of human sensibility and the basis or model for any aesthetic experience (or any experience we *call* aesthetic). Arthur Danto today endorses this proposition, evoking, for his part, the imitation of a somewhat less frequently invoked, and less agreeable, song: "The pleasure we take in imitation is, as noted, dependent upon the knowledge that it is an imitation and not the real thing. We take a (minor) pleasure in the crow calls made by a man imitating crows which we do not ordinarily take in crow-calls themselves, not even when one crow repeats the same calls made by another."[3]

To my mind, the theoretical interest of this substitution is that it clearly shows that the pleasure we take in an imitation is, as Pascal complained in vain about painting, independent of the pleasure we take (or fail to) in the original. The song of Kant's imitator, which, once he has been found out, is supposed to displease us, would in fact please us *differently* than the nightingale's song. The song of Danto's imitator pleases us even when that of his model, by hypothesis, does not please us at all.

Kant's analysis nevertheless seems to me to provide an appropriate starting point for an examination of our new subject, the specificity of our aesthetic relation to artworks, which I will call, for the sake of brevity, the *artistic relation*—though our relation to works of art is often not aesthetic but, for example, scholarly or scientific (historical), as when we are trying to determine a work's author or date, or else practical, as when a believer goes into the Chartres cathedral simply to follow the mass, or when Duchamp or Goodman, deliberately neglecting the artistic nature of the

2. Kant's analysis at the beginning of the same paragraph, §42, where he cites the example of artificial flowers and carved birds perched on the branches of trees in order to fool a "lover of the beautiful," is hardly more nuanced: once the artifice is discovered, "the immediate interest which these things previously had for him would at once vanish—though, perhaps, a different interest might intervene in its stead, that, namely, of vanity in decorating his room with them for the eyes of others" (ibid., p. 158). Here Kant does not deny that this "different interest" exists; but he plainly deprecates it as inauthentic and unaesthetic. I will come back to the ambivalence of *Interesse* in Kant.

3. Arthur C. Danto, *The Transfiguration of the Commonplace: A Philosophy of Art* (Cambridge: Harvard University Press, 1981), p. 26. Cf. Jean-Marie Schaeffer, *Les célibataires de l'art: Pour une esthétique sans mythes* (Paris: Gallimard, 1996), pp. 149–150.

object, imagines using a painting by Rembrandt as an ironing board, blanket, or shutter.[4] What Kant opportunely points out is that here the *same* object (auditory, in the present instance) can take on at least *two* different aesthetic values simply because a piece of accessory information happens to be given (or a hypothesis made) about its origins or the way it was produced, although its *Beschaffenheit* has in no way changed.[5] I say "two different values," whereas Kant makes a wholesale distinction between value and the absence of value, but this is a minor difference—at least for the time being. The same auditory event is first appreciated as a natural object (a nightingale's song), and then (says Kant) dismissed with disgust or annoyance, or (as I would say) appreciated *differently*, as a product of the art of the imitator—whom we shall make, so as to have a pretty example, a bird-catcher like Papageno in *The Magic Flute*.[6] The imitator's song elicits a different type of appreciation simply by virtue of the fact that it is an artificial object—more precisely, a human artifact produced by an expert for a specific purpose—if only because this appreciation will inevitably include the predicate "skillful," which the "natural" song of the nightingale does not necessarily suggest, or, if it does, then with a different slant, or applied to a different object. Thus the skillfulness of the nightingale is, if you like, the instinctive skillfulness of a marvelous singer, whereas Papageno's is the marvelous, and doubtless acquired, skillfulness of a marvelous imitator; it is clear that we are not dealing with the same kind of talent in both cases. That is by itself sufficient to make two distinct works of the same "song," and it is perfectly legitimate to prefer the second, as the Emperor of China

4. Marcel Duchamp, *Duchamp du signe: Écrits*, ed. Michel Sanouillet (Paris: Flammarion, 1975), p. 49; Nelson Goodman, "When Is Art?" in Goodman, *Ways of Worldmaking* (Indianapolis: Hackett, 1978), p. 67. These suggestions are obviously meant to be facetious (though in different ways), but the story goes that an eighteenth-century merchant one day discovered, in the house of an antique collector, "that the main table . . . was made up of one of Annibale Carracci's masterpieces which had been attached to a base solid enough to resist the ravages of time for a few years more" (cited in Francis Haskell, *Rediscoveries in Art: Some Aspects of Taste, Fashion and Collecting in England and France* [Oxford: Phaidon, 1980], p. 30). I have read somewhere that someone once used paintings by Toulouse-Lautrec to patch up the holes in his ceiling; I recall reading somewhere else that during the Franco-Prussian War, Prussian soldiers in Louveciennes made butcher's aprons out of paintings by Monet and Pissarro. The ways of everyday vandalism are inscrutable, and occasionally more inventive than the iconoclastic provocations of the most daring of avant-gardes.

5. Adorno aptly observes, in a discussion of the same passage, that knowing whether or not a work is authentic "does colour aesthetic experience. (For instance, you will look at a picture with different eyes if you know the name of the painter.)" (Theodor W. Adorno, *Aesthetic Theory*, trans. C. Lenhardt, ed. Gretel Adorno and Rolf Tiedemann [London: Routledge and Kegan Paul, 1984], p. 257).

6. And also because the bird-catcher has to know how to imitate the bird so as to fool not only a naive "guest," but the nightingale herself, a feat that presumably deserves higher praise.

does for a while in Anderson's tale. Danto formulates this distinction in the simplest possible way when he says that "there are two orders of aesthetic response, depending upon whether the response is to an artwork or to a mere real thing that cannot be told apart from it."[7] Of course, the difference at issue has yet to be *defined;* coming up with this definition is, in sum, the objective of the present chapter. It must, however, be understood from now on that, contrary to what might be suggested by our initial example, which counterposes a song and an imitation of it, the specificity of the artwork does not *necessarily* reside, as Aristotle implies,[8] in the fact that it is an imitation or representation. Our "same object" judged in two different ways might be, for example, a block of stone perceived either as a boulder whose shape is accidental or a sculpture whose form is intentional, but not, in this instance, figurative; it does not follow that the second should be considered an imitation of the first—nor, for that matter, that the first should be considered an imitation of the second, as Hegel would have it. A boulder can call forth an aesthetic response without resembling a sculpture, and a sculpture can (today) bear witness to its creator's talent without resembling anything at all. Papageno could produce an admirable melody, which we would plainly ascribe to the art of whistling or flute playing, without imitating any bird whatever; Mozart's art itself, here as elsewhere, does not exactly proceed by way of imitation. In short, technical skill, which we shall soon identify as a property specific to artworks as opposed to natural (aesthetic) objects, is not only put to work to produce imitations.

This theme (two works for one object), which we discussed earlier in connection with the transcendence of works,[9] will reappear here in another light, after we have made a new detour—a detour dictated by the fact, which we have already noticed and which is in any case obvious, that natural objects and works of art are not the only two possible kinds of ob-

7. Danto, *The Transfiguration of the Commonplace*, p. 94. Be it recalled that, these cases of indiscernibility aside, Danto's opinion, based on the familiar method of extrapolating from the acts of Duchamp and Warhol, is rather that the "aesthetic response" does not have much to do with the function of artworks. Danto also holds that, if the indiscernibility of the Brillo boxes is, like the bird-catcher's song, the result of scrupulously exact imitation, that of a (simple) "ready-made" stems from the fact that there exists an industrial series of which it is, physically, one interchangeable element.

8. As does Kant himself, if only in passing: "A beauty of nature is a *beautiful thing;* beauty of art is a *beautiful representation* of a thing." Kant, *Critique of Judgement*, p. 172. Note, however, that Kant does not say, as classical authors often do, "the representation of a beautiful thing."

9. Gérard Genette, *L'œuvre de l'art*, vol. 1: *Immanence et transcendance* (Paris: Seuil, 1994), chap. 13, "L'œuvre plurielle," pp. 259–288 [tr. *The Work of Art: Immanence and Transcendence*, trans. G. M. Goshgarian (Ithaca: Cornell University Press, 1997), chap. 13, "The Plural Work," pp. 230–257].

jects of aesthetic attention, so that we need to consider the status of inter-
mediate cases at least once. But I do not want to quit Kant's nightingale
without first noting that the two hypotheses the philosopher considers are
not the only possible ones in this instance: I can hear and appreciate a song
without knowing if it is being sung by a nightingale or a roguish bird-
catcher—which brings us back to Courbet painting an unidentified ob-
ject—or even without knowing that there are such things as birds and
bird-catchers in the world. Such situations [*dispositifs*], in which one is ig-
norant of (or indifferent to) the cause, can come about for any number of
different reasons. Some—like Kant's example itself, in its "roguish" ver-
sion—presuppose a certain mise-en-scène and a degree of manipulation:
what professor, running the experiment advocated (and carried out) by
I. A. Richards,[10] has not had his students read a poem without telling them
the author's name, simply in order to avoid interpretations that might be
determined in advance by their knowing who he was? And, after all, we all
very frequently have the experience of tuning in to the radio in the middle
of a piece of music that is, as a result, temporarily unidentified—whence
an artificially "innocent" reception, or else various attempts to identify, by
the style ("if that isn't Bartok . . ."), historical sleuthing, or pure guess-
work, a piece that has not been identified by accessory information.[11] Sit-
uations of this sort arose less readily before Marconi, or Charles Cros,
since it was hardly possible to go to a concert without knowing the pro-
gram, but they were not absolutely impossible, with or without the con-
nivance of a "jovial host." This was apparently "M. de Stendhal's" situa-
tion in Florence and Rome,[12] or Swann's in Mme de Saint-Euverte's salon,
where, unexpectedly hearing the sonata by Vinteuil, he was immediately

10. Ivor A. Richards, *Practical Criticism: A Study of Literary Judgement* (London: Rout-
ledge and Kegan Paul, 1929).

11. Incidentally, this kind of attempt to guess the identity of a piece is at least as para-
sitical on the aesthetic relation as supplying the information beforehand—as is proven by all
the devotees of the "blind" commentary, or blindfold test*, dear to jazz lovers, a test that all
too often becomes a mere guessing game.

12. "The overture began [at the Cocomero in Florence], and, to my delight, I found
myself yet again in the society of that charming old friend of mine, Rossini. By the end of
the third bar, I had recognized his presence. To confirm my suspicion, I went down to the
pit and enquired; and indeed, as I had surmised, the Barbiere di Siviglia which stood on the
programme *was* his. . . . On the program that evening [in a Roman theater that Stendhal
does not name] were a number of songs that were wildly applauded; I asked what the com-
poser's name was—nobody knew." We are here in the semi-fiction of *Rome, Naples et Flo-
rence en 1817*, but this passage obviously bears witness to the practices of a period. (See
Stendhal, *Rome, Naples et Florence en 1817*, in *Voyages en Italie* [Paris: Pléiade, Gallimard,
1973], pp. 16, 25 [tr. *Rome, Naples and Florence*, trans. Richard N. Coe (London: John Calder,
1959), p. 308]).

touched to the quick;[13] and it is, basically, the situation of every expert in front of an (as yet) unidentified painting or sculpture awaiting attribution. From which it appears that uncertainty cannot be reduced to the simple alternative between a bird and an artist, but also haunts that between an artist and . . . an artist.

Between Nature and Art

The antithesis between nightingale and roguish imitator creates a situation [*dispositif*] that has been simplified by the absence of other elements (making it a simple confrontation between nature and art). However, on at least one occasion, as we have already briefly seen, Kant alludes to the existence of intermediate objects, human products presumably devoid of artistic purpose, and raises the question of their aesthetic status. I have in mind the note at the end of the "third moment" of the "Analytic of the Beautiful." Kant has given his third definition: "*Beauty* is the form of *finality* in an object, so far as perceived in it *apart from the representation of an end.*" The footnote to this passage is worth citing in full:

> As telling against this explanation, the instance may be adduced, that there are things in which we see a form suggesting adaptation to an end, without any end being cognized in them—as, for example, the stone implements frequently obtained from sepulchral tumuli and supplied with a hole, as if for [inserting] a handle; and although these by their shape manifestly indicate a finality, the end of which is unknown, they are not on that account described as beautiful. But the very fact of their being regarded as art-products [the German word is *Kunstwerk,* which does not here mean "work of art," but simply "artifact"] involves an immediate recognition that their shape is attributed to some purpose or other and to a definite end. For this reason there is no immediate delight whatever in their contemplation. A flower, on the other hand, such as a tulip, is regarded as beautiful, because we meet with a certain finality in its perception, which, in our estimate of it, is not referred to any end whatever.[14]

The reason for this distinction is plainly the difference between an end that is merely unknown (although it is assumed that there was a determi-

13. Marcel Proust, *Du côté de chez Swann,* in *A la recherche du temps perdu* (Paris: Pléiade, Gallimard, 1987), vol. 1, p. 339 [tr. *Swann's Way,* in *Remembrance of Things Past,* trans. C. K. Scott Moncrieff and Terence Kilmartin (New York: Random House, 1981), vol. 1, p. 375].

14. Kant, *Critique of Judgement,* p. 80.

nate end: I don't know what this object was used for, but I know that it had a specific use) and an end that is indeterminate in the full sense, like, says Kant, the one we perceive, or rather do not perceive, in an object we assume to be natural. (Let us note in passing that, in the case of a tulip, this is a hypothesis that simplifies matters to an extreme.) What interests us here is not this distinction, but its consequence, namely, the rather abrupt elimination of "implements" from the realm of aesthetic contemplation ("for this reason there is no immediate delight whatever in their contemplation"). This footnote explicitly confirms the earlier, implicit rejection of utilitarian objects—or else, perhaps, their assimilation pure and simple to the status of artworks, which in the present instance is hardly more gratifying. Where we perceive three categories, each with its own distinct status (natural objects, utilitarian artifacts, works of art), Kant, all indications are, perceives only two, because he reduces the second to the third. Moreover, an adjective that occurs in both texts, "immediate," is worth pausing over. Kant says that only natural objects can elicit immediate interest or satisfaction ("delight"). I am not sure that my interpretation of this point respects Kant's intentions (in any event, we know—I will come back to this—that he does not mean to say art has *no* aesthetic function at all). For the moment, I note only that human artifacts *may* produce aesthetic satisfaction, but that this satisfaction is not, in any event, immediate, or (I continue to draw inferences) is *less immediate*—we shall see in what sense—than that produced by natural objects.

We can imagine the whole set of objects capable of eliciting aesthetic attention (this is, in fact, the set of all objects, material or ideal) as forming a continuous gradation extending, in one direction or the other, from the most evidently natural objects to the "purest"—in the sense in which we used to speak of "pure" poetry—or least functional works of art: as a provisional (because rather naive) illustration, let us imagine a scale running from, say, wild flowers, if they still exist, to a painting by Mondrian or variation by Webern. This supposed continuum doubtless includes a few qualitative leaps or thresholds, between, for example, natural objects that come about by chance or necessity and are devoid of "definite end" (barring theological hypotheses), and human products that proceed from a purely practical intention; or between those products and works that have a manifestly aesthetic purpose; or, again, between two types of works, of which one (a church, a dress, a speech) also has a manifestly practical function, which the other (a sonata) apparently lacks. But these distinctions are in fact less stable than they seem at first, and I am not sure that any of them is beyond the reach of healthy doubt. As everyone knows, man's mark on this planet (until something better, or worse, comes along)

is such that the notion of a purely natural object is becoming increasingly academic—if only because certain objects, which earlier were inaccessible to our perception, like those creatures of the abyss whose supposed magnificence intrigued Kant,[15] have practically become our familiars, thanks to deep-sea photography and film, and have thus acquired the status of *objects* (of attention) which they lacked for a long time: they were certainly natural, and apparently still are, but only became objects as the result of technical procedures. The technical processes that modify countless animal and plant species through training and/or genetic selection are, so to speak, more active, so active, indeed, that it takes considerable naiveté to regard such-and-such a variety of tulip or breed of horse as a "natural object," to say nothing of precious stones; and it is well known how much any number of "natural landscapes" (a notion Borges once bluntly dismissed as an "imposture")[16] owe to purposeful human activity, whether utilitarian or decorative. All these objects with "hybrid causal status,"[17] the results of collaboration between man and nature, have become so many semi-artifacts (at a minimum) through rectification. Conversely, the special kind of objects known collectively as driftwood*[18] that certain contemporary aestheticians have taken an interest in are very often wooden artifacts, initially man-made, but subsequently converted, or rather brought back, to the state of natural objects by historical accident and the corrosive effect of exposure to the sea. After all, "human products," including works of art, are, without exception, material objects that have been momentarily "extracted," as Dürer puts it,[19] and then transformed by man. Time gradually works a transformation in the opposite sense; it has the effect of returning them, if not to their original form, then at least to their initial state, even if the agents which modify them through corrosion or the effect of accumulated layers of dirt are today, in the majority of cases, themselves "human products."

In a context I will come back to, Panofsky has very opportunely highlighted the fact, obvious but often ignored, that the complex, many-

15. Ibid., p. 131. This remark finds an echo in G. W. F. Hegel, *Aesthetics: Lectures on Fine Art*, trans. T. M. Knox (Oxford: Clarendon, 1975), vol. 1, p. 171, where it is extended to virgin forests "which . . . rot and decay . . . unenjoyed."

16. Jorge Luis Borges, "Crítica del Paisaje," *Cosmópolis* 34 (1921): 196.

17. Schaeffer, *Les célibataires de l'art*, p. 259.

18. See, inter alia, Morris Weitz, "The Role of Theory in Aesthetics," *Journal of Aesthetics and Art Criticism* 15 (1956): 34.

19. "In reality, art is in nature; it belongs to those who know how to extract it" (I do not know the original source of this citation, which I have taken from Friedrich Piel, *Albrecht Dürer: Aquarelles et dessins* [Paris: Adam Biro, 1990], page facing Plate 17).

faceted aging process which affects even works of art is in part a process of return to the state of a natural object:

> When abandoning ourselves to the impression of the weathered sculptures of Chartres, we cannot help enjoying their lovely mellowness and patina as an aesthetic value; but this value, which implies both the sensual pleasure in a peculiar play of light and color and the more sentimental delight in "age" and "genuineness," has nothing to do with the objective, or artistic, value with which the sculptures were invested by their maker. From the point of view of the Gothic stone carvers the processes of aging were not merely irrelevant but positively undesirable: they tried to protect their statues by a coat of color which, had it been preserved in its original freshness, would probably spoil a good deal of our aesthetic enjoyment.[20]

In this sense, then, we have constantly to do with joint productions to which nature and human industry both contribute, in varying proportions. Indeed, human industry is itself, obviously, one specific derivative of nature, and its activity, always intentional in theory (human beings do not "produce," that is, do not transform or fashion anything without a purpose), often has undesired secondary effects as well: plainly, we do not burn fossil fuels in internal combustion engines *in order to* deteriorate historic buildings. I would add that the human species is not the only one to produce or fashion objects: birds build nests (and eggs), spiders spin webs, bees make honeycombs, molluscs make shells, beavers build dams, polyps make coral, termites construct strange pyramids with galleries—the list could be extended. When we pay aesthetic attention to one of these objects, it is hard for us not to see in them what Valéry called "a kind of intention and action that seem to have fashioned them rather as man might have done, but at the same time we find evidence of methods forbidden and inaccessible to us."[21] The case of drawings or paintings done by animals (usually apes) is somewhat different, for these productions come about only with considerable help from human beings, who provide at least the occasions and means, together with the whole technical and institutional context.[22] This is a fortiori the case, of course, whenever we put

20. Erwin Panofsky, "The History of Art as a Humanistic Discipline," in Panofsky, *Meaning in the Visual Arts: Papers in and on Art History* (Garden City, N.Y.: Doubleday, 1955), p. 15. The "objectivity" Panofsky ascribes to the "artistic value" sought by medieval sculptors is defined in opposition to the subjective character of "our" contemporary aesthetic appreciation: the producer's intention is "objective" only for the receiver.

21. Paul Valéry, "L'homme et la coquille," in *Œuvres*, vol. 1 (Paris: Gallimard, 1957), p. 887 [tr. "Man and the Sea Shell," in *Collected Works*, vol. 13, trans. Ralph Mannheim (New York: Pantheon, 1964), p. 7].

22. On this subject, as exciting as it is difficult, see, inter alia, George Dickie, "Defin-

the random acts of an animal to work: a donkey's tail or elephant's trunk dipped in a can of paint, for example, or, again, a monkey, cat, or some other animal allowed to wander across a piano, typewriter, or computer keyboard, or rummage around in a basket containing, all in a jumble, the elements of a surrealistic "exquisite corpse." "Art," Dickie says in conclusion to his discussion of this subject, "is a concept which necessarily implies human intentionality." The truth of the matter seems to be that "human" goes too far, in two senses. On the one hand, in the absence of more complete information on this score, it would seem that the *only* kind of intentionality there is is human, at least in this realm (whereas a dog that guides you, or leaps at your throat, gives every appearance of acting purposefully). On the other hand, *if* one discerned an aesthetic intention in Betsy's or Congo's action paintings*, it would become necessary to speak—and why not?—of genuine artistic productions by animals.

But I am not forgetting that Valéry, at the beginning of "Man and the Sea Shell," discusses objects—both mineral ("a crystal") and vegetable ("a flower")—which do not (necessarily) proceed from organized productive activity, and yet create a new, intermediate state between the two purely theoretical extremes constituted by the supposed object "in the raw" and the artwork created *ex nihilo*. Nor have I forgotten that, a bit later in the same essay, he asks himself the only apparently idle question—one that is in fact thornier than it seems—as to what makes it possible to

> recognize that a given object is or is not *made by a man*? It may seem somewhat absurd to pretend not to know that a wheel, a vase, a piece of cloth, or a table has been produced by someone's industry, since we know perfectly well that it has. But what I say is that we do not know this *just by examining these things*. If no one had ever told us, then by what marks, by what signs should we know? What is it that indicates the presence or absence of a human operation? When an anthropologist finds a piece of flint, does he not often hesitate as to whether man or chance fashioned it?[23]

Once again, then, the answer is that the distinction between "man" and "chance," between nature and culture, is not always a matter of simple, or even complex, observation, but rather depends on information from sources external to the object—sources not always available to us. We

ing Art II," in Matthew Lipman, *Contemporary Aesthetics* (Boston: Allyn and Bacon, 1973), pp. 118–131, and Schaeffer, *Les célibataires de l'art*, chap. 1, pp. 21–119. The haphazard, but often charming, scratchings of little children exemplify the same phenomenon—which tends to relativize the distinction between the human race and other species.

23. Valéry, "L'homme et la coquille," p. 892 [tr. "Man and the Sea Shell," p. 160].

will encounter the same problem in connection with the evaluation and interpretation of works, but it is not a matter of indifference that we should find it already cropping up while merely trying to establish the status of an artifact. Kant perhaps too hastily attributes this status to one or another object discovered in a burial mound, since it is not always unambiguous, nor always obvious and *index sui*, as his own little fable about the nightingale and the bird-catcher itself indicates: if the nightingale did not exist, Papageno's mimetic performance would not have an object; if it were not for its deceptive resemblance to this model, it would have nothing to recommend it.

Sharply delineated concepts like those designated, in Heidegger, by the simple terms *Ding* (thing), *Zeug* (utilitarian product), and *Werk* (work), cannot, then, be defined in terms of absolute essences, but only with reference to their dominant character: an object is more or less natural, more or less man-made, more or less artistic.[24] Moreover, I think that these notions (but Heidegger, it seems to me, would not agree) stand to one another in a relation of inclusion: "products" are, for me, a particular kind of "thing," while "works" are a particular kind of "product." The restriction of extension here obviously goes hand in hand with an enrichment of intension—and, in this particular case, of intention as well: a product is something created by men (with various, especially practical, ends in mind), whereas a work is a product whose end (one of whose ends) is aesthetic. One could accordingly consider the aesthetic relation to (the most) natural objects the simplest, treating it as purely aesthetic because it does not involve any practical and/or technical considerations; but it seems to me that it in fact often involves something else, on the order of what Kant called "charm," or the physical pleasure of agreeableness: our aesthetic appreciation of a flower is not always indifferent to its freshness or fragrance; that of a landscape sometimes takes into account the bracing purity of the air and the feeling of peacefulness which silence and solitude bring; that of a human body can be influenced by the *je ne sais quoi* we find so charming, and so on. Kant himself admits that our supposed preference for the song of a bird as opposed to its human imitation, "destitute of taste," may be due to confusion between the beauty of this song and "our sympathy with the mirth of a dear little creature"; more generally, he admits that "the charms in natural beauty [read, *more* than in art] are to be

24. Martin Heidegger, "The Origin of the Work of Art," trans. Albert Hofstadter, in David Farrell Krell, ed., *Basic Writings from* Being and Time *(1927) to* The Task of Thinking *(1964)* (New York: Harper and Row, 1977), pp. 143–187. [Hofstadter translates *Zeug* as "equipment."] But the distinction between work and product, with its strong positive and negative moral connotations, has frequently been drawn, for example by Balzac: "We have products, we no longer have works" (cited in the *Robert* [authoritative French dictionary by Paul Robert]).

found blended, as it were, so frequently with beauty of form."[25] Doubtless no relation whatsoever can be called purely aesthetic; that notion is itself an artifact generated by analysis. These various precautions should be borne in mind whenever we have recourse to overly simple terms like "natural object," "utilitarian object," or "artistic object,"[26] or argue that the first two have in common the fact that they do not include an unmistakable aesthetic intention,[27] while the latter two have in common the fact that they are human artifacts, produced and situated in History. I would add that all three have in common the fact that they are things, but we would have to extend the use of this term to cover events and actions (like dramatic performances) as well as ideal objects (like literary or musical texts);[28] "object," to repeat, seems to me the better term for all these objects of attention taken together.

Panofsky, in a chapter we have already cited, differentiates between two kinds of everyday artifacts that make no bid for aesthetic attention:

> Those man-made objects which do not demand to be experienced aesthetically are commonly called "practical," and may be divided into two classes: vehicles of communication, and tools or apparatuses. A tool or apparatus is "intended" to fulfill a function (which function, in turn, may be the production or transmission of communications, as is the case with a typewriter or with the previously mentioned traffic light).[29]

I am not sure that the "practical" functions of man-made objects should be limited to these two; for example, it seems to me that there is room for the function of "amusement*," to use Collingwood's word, and,

25. Kant, *Critique of Judgement*, pp. 161, 89.

26. This last term should not cause too much interference with the term *objet d'art*, used by museums and institutions. Curiously, the latter term seems to be restricted to products of the so-called minor arts (the work of goldsmiths, craftsmen in wrought iron, jewelmakers, cabinetworkers, ivory-carvers, etc.), in which the aesthetic intention is acknowledged to some extent: some of these objects serve practical purposes (furniture, hinges), others (jewels) are essentially decorative—which is not exactly an absence of function. We reject the hierarchy the terms implies, but the notion it designates (like "artistic craftsman") provides a rather good illustration of the fact that there exist intermediate cases, of interest to us here.

27. Natural objects do not include any such intention, unless we hypothesize a Divine Artist. The aesthetic intention informing utilitarian objects, unlike so-called *objets d'art* (which often have equally obvious practical functions and aesthetic objectives) is uncertain: I can have a very intense (conditional) aesthetic relation with an ancient *tribulum*, but I do not know if its producer had the least intention of eliciting it—to be honest, I very much doubt it. To treat it as a purely ("decorative") aesthetic object implies that one utterly ignore its original, practical function, assuming one knows what that was.

28. See Genette, *L'œuvre de l'art*, pp. 37–39 [*The Work of Art*, pp. 29–31].

29. Panofsky, "The History of Art as a Humanistic Discipline," p. 12.

doubtless, for that of sexual titillation as well: these two functions obviously have more to do with the practical sphere than with contemplative activity. The "demand to be experienced aesthetically," which is not ordinarily, or necessarily, associated with objects destined for practical functions, defines the work of art for Panofsky, as it does for Urmson or Vivas.[30] But Panofsky immediately adds:

> Most of the objects which do demand to be experienced aesthetically, that is to say, works of art, also belong in one of these two classes. A poem or an historical painting is, in a sense, a vehicle of communication; the Pantheon and the Milan candlesticks are, in a sense, apparatuses; and Michelangelo's tombs of Lorenzo and Giuliano de' Medici are, in a sense, both. But I have to say "in a sense," because there is this difference: in the case of what might be called a "mere vehicle of communication" and a "mere apparatus," the intention is definitely fixed on the idea of the work, namely, on the meaning to be transmitted, or on the function to be fulfilled. In the case of a work of art, the interest in the idea is balanced, and may even be eclipsed, by an interest in form.
>
> However, the element of "form" is present in every object without exception, for every object consists of matter and form; and there is no way of determining with scientific precision to what extent, in a given case, this element of form bears the emphasis. Therefore one cannot, and should not, attempt to define the precise moment at which a vehicle of communication or an apparatus begins to be a work of art. If I write to a friend to ask him to dinner, my letter is primarily a communication. But the more I shift the emphasis to the form of my script, the more nearly does it become a work of calligraphy; and the more I emphasize the form of my language (I could even go so far as to invite him by a sonnet), the more nearly does it become a work of literature or poetry.
>
> Where the sphere of practical objects ends, and that of "art" begins, depends, then, on the "intention" of the creators. This "intention" cannot be absolutely determined. In the first place, "intentions" are, *per se*, inca-

30. "An artifact primarily intended for aesthetic consideration" (J. O. Urmson and David Pole, "What Makes a Situation Aesthetic?" *Proceedings of the Aristotelian Society*, supp. vol. 31 [1957]: 87); "an artifact made for the specific purpose of eliciting the aesthetic response" (Eliseo Vivas, "Contextualism Reconsidered," *Journal of Aesthetics and Art Criticism* 18 [1959]: 233). Dickie's definition, which introduces the term "candidacy for appreciation," a term I, for one, am happy to have to hand, is more complex than those already cited, because it almost immediately goes on to mention the "institutional settings" that validate works of art *as* works of art. I do not find this idea indispensable. On the other hand, the definition refrains from assigning appreciation an aesthetic character which, following Duchamp (and Danto), Dickie does not consider important. Thus a work of art is "an artifact upon which some society or some sub-group of a society has conferred the status of candidate for appreciation" (this formulation, which is not the first of its kind, may be found in Dickie, "Defining Art," *American Philosophical Quarterly* 6 [1969]: 254).

pable of being defined with scientific precision. In the second place, the "intentions" of those who produce objects are conditioned by the standards of their period and environment. Classical taste demanded that private letters, legal speeches and the shields of heroes should be "artistic" (with the possible result of what might be called fake beauty), while modern taste demands that architecture and ash trays should be "functional" (with the possible result of what might be called fake efficiency). Finally our estimate of those "intentions" is inevitably influenced by our own attitude, which in turn depends on our individual experiences as well as on our historical situation. We have all seen with our own eyes the transference of spoons and fetishes of African tribes from the museums of ethnology into art exhibitions.[31]

From this long (but, for me, crucially important) passage, let me single out, for the moment, the idea that works of art, defined by the presence of an aesthetic intention, can also have a "practical" function, which is not always—indeed, is rarely—negligible. It can be utilitarian (buildings, clothes, *objets d'art*), "communicational" (literature, painting, sculpture—the whole spectrum of the "representative" arts, according to Souriau), or of some other kind, if my amendments are adopted: arts like music and dance, popular film, cartoons, comic strips, and many others combine, to various degrees, the function of amusement with an aesthetic purpose.[32] Moreover, everyone knows what a delicate balance the various kinds of erotic art strike between sexual titillation and aesthetic appreciation. I would further underscore, in the passage quoted from Panofsky, the idea that the artistic status of these works, which varies with the conceptions of their creators and the standards of their time and culture, also varies with those of the time and culture of the receivers; it is, conse-

31. Panofsky, "The History of Art as a Humanistic Discipline," pp. 12–13. The summary in the headnote to the French translation of this chapter should also be cited: "The work of art is defined as a man-made object which solicits aesthetic perception. Thus it is distinguished from: 1) natural objects; 2) objects made by men for practical purposes (a category that is further subdivided into vehicles of information and tools or apparatuses). Every object can be perceived aesthetically, and most works of art can, from a certain vantage point, be perceived as practical objects. But what distinguishes the work of art from all other objects is that it 'intends' to be perceived aesthetically. The criterion of 'intention' manifests itself in the attention paid to the object's form, independently of all interest in the thought of the work it might perform. But, because every object includes a formal dimension, this criterion is itself thoroughly relative: the dividing line between artworks and practical objects depends on an 'intention' that cannot be determined absolutely" (Bernard Teyssèdre, headnote to Erwin Panofsky, "The History of Art is a Humanistic Discipline," in *L'œuvre d'art et ses significations* [Paris: Gallimard, 1969], p. 28).

32. The opposition suggested here between "function" and "purpose" is by no means absolute: I do not wish definitively to exclude the aesthetic relation from the set of "functions" vital to the human species. I simply want to leave the question open.

quently, as attentional as it is intentional. Here again, the *what* of essentialistic definitions must often yield to Goodman's *when*.[33] The only works whose artistic status is constitutive and relatively "pure" would be those that have neither a practical nor a denotational function, like works ("presentative," according to Souriau) of instrumental music or abstract painting or sculpture, but doubtless also those belonging to categories that have been firmly established as artistic in the eyes of creator, receiver, or both. Thus paintings, sculptures, poems, novels, palaces, and the creations of high fashion, whatever the relative importance of content and function in each instance, are usually received as works of art without it being necessary to inquire as to whether or not they arise from artistic intention, since that is held to be beyond doubt in productions of this kind. It must further be admitted that there exists no definitive list of these categories, which depend heavily on historical and cultural factors. For us, it goes without saying that an ode or tragedy is a work of art, since the ode and the tragedy are established "literary genres"; but what, precisely, was their status in the age of Pindar and Aeschylus? Since when, and for whom, are African masks works of art? That aesthetic intention (the fact of "demanding to be experienced aesthetically," as Panofsky puts it)[34] suffices to define the work of art in general does not make it any better adapted to defining a *particular* object as a work of art, because making that identification presupposes, on Panofsky's hypothesis (which I subscribe to), that we are certain the object includes such intentionality. A generic definition is not in itself a means of identifying individual instances: knowing that a square is a rectangular parallelogram with sides of equal length helps me identify a given figure as a square only if I see that it is a rectangular parallelogram with sides of equal length, or ascertain that it is by measuring it. Knowing that a mule is a hybrid, the offspring of a donkey and a mare, is not enough to identify an animal I encounter on my way as a he-mule; it may be a hinny. I indicated earlier why I thought that the Goodmanian (or other)

33. Defining his conception of "content" as distinct from "subject matter" a few lines further on, Panofsky speaks, in terms borrowed from Peirce, of "that which a work betrays but does not parade" (Panofsky, "The History of Art as a Humanistic Discipline," p. 14). This formulation anticipates my own discussion (see Chapter 1 of the present volume) of the objectivity (or nonobjectivity) of exemplificational values, regarded as values that are "exhibited" or merely "possessed."

34. This overall aesthetic intention ("candidacy" for aesthetic attention) should not be confused with the specific intention (symbolic, for example) of a work; we will discuss this point later, with (or *against*) Beardsley. One of these intentions can be certain, or probable, while the other remains doubtful or inaccessible. I can be simultaneously unsure as to what Kafka "means" in *The Castle*, and sure that his intention was literary; conversely, I can be sure of the function of a tool or ancient building, but unsure of its aesthetic intention, or what it is common practice to call, since Riegl, its *Kunstwollen*.

"symptoms" were capable of revealing the "aesthetic character" of my *relation* to an object, but not of the object itself, which cannot possess such a property in itself. An object can, on the other hand, objectively (historically) possess the property that consists in being a work of art, and therefore possess an "artistic" or operal[35] "character." However, the criterion which defines this artistic character (the criterion of intention) is not, generally speaking, empirically perceptible, and, consequently, cannot constitute a "symptom" (which is, by definition, a perceptible sign), and even less what Morris Weitz calls a "criterion of recognition."[36] "If it's to be seen, I saw it!" (and doubtless the other way around), says the Duke de Guermantes about the *View of Delft*;[37] but that general principle doesn't do him much good in the case at hand, because he no longer has any idea whether he has actually seen the picture at the Mauritshuis, although he prides himself on having visited that museum ("Ah! The Hague! What a gallery!"). Similarly, "if something is intentionally aesthetic, it's a work of art," and vice versa. Well and good; but how is one to know—to "see," as Wittgenstein would say[38]—that something is intentionally aesthetic? We will raise this question again later—less, perhaps, to answer than to eliminate it.

IF THERE CAN BE NO INDEX OF THE ARTISTIC NATURE OF AN OB-ject which is infallible, perceptible, and (this is the gist of what Valéry was telling us a moment ago) *immanent in the object*, there can, and, in my view, do exist symptoms of the artistic nature of, again, our *relation* to the object. In a charming study, "The Beauty of Old Towns,"[39] Gombrich alludes in

35. [Genette glosses this neologism in *L'œuvre de l'art*, p. 286 n (*The Work of Art*, p. 256 n).]

36. Weitz, "The Role of Theory in Aesthetics," p. 35. Weitz quite rightly denies that such empirical criteria exist, but he is wrong, on my view, to go on to assert, as a good Wittgensteinian, that criteria for establishing a conceptual definition do not exist either. To repeat, the difficulty we frequently have in *recognizing* an individual work of art as such by no means implies that it is impossible to *define* the work of art in general. A definitional criterion is not necessarily a criterion of recognition.

37. Marcel Proust, *Le côté de Guermantes*, Part II, in *A la recherche du temps perdu* (Paris: Pléiade, Gallimard, 1987), vol. 2, p. 813 [tr. *The Guermantes Way*, in *Remembrance of Things Past*, trans. C. K. Scott Moncrieff and Terence Kilmartin (New York: Random House, 1981), vol. 2, p. 544]. In *Contre Sainte-Beuve* (in *Contre Sainte-Beuve*, preceded by *Pastiches et mélanges* and followed by *Essais et articles* [Paris: Pléiade, Gallimard, 1971], p. 285 [tr. *On Art and Literature, 1896–1919*, trans. Sylvia Townsend Warner (New York: Meridian, 1958), p. 207]), Proust puts the same remark in the mouth of the "Countess of Guermantes."

38. "Don't think, but look!" Ludwig Wittgenstein, *Philosophical Investigations*, 3d ed., trans. B. E. M. Anscombe (Oxford: Basil Blackwell, 1968), p. 31e. As a rule, however, there is nothing to *look at*, and everything to *learn*.

39. Ernst Gombrich, *Reflections on the History of Art: View and Reviews* (Berkeley: University of California Press, 1987), pp. 195–204.

passing to something that might be taken for such an index of attentional artistry:[40] namely, the adoption, vis-à-vis the object, of what he describes as a *critical* attitude in the strong sense, that is, one which consists in finding in the object, alongside whatever aesthetic merits it may have, certain "defects" one would like to see eliminated. "A critical attitude I would call one where the tourist on the Gornergrat would say 'magnificent, except that I wish the Southern slope of the Matterhorn were a bit steeper and the snowpatch on the peak of Mount Rosa were swept away.' " According to Gombrich, such remarks would be out of place, or even ridiculous: "We do not criticize mountains, trees or flowers." He does not state the reason we do not; it is, obviously, that one can only "criticize," in this precise sense, something one ascribes to the intentional productive activity of a subject to whom one could give advice ("you should put a splotch of red in this corner"), or, at least, express regret ("you should have put a splotch of red in this corner"). To be sure, one can have *reasons* for liking or not liking an object assumed to be purely natural,[41] but one's account of these reasons, no matter how well argued, cannot be described as a "criticism" in the strong sense of the word, for that presupposes reference, even if only retrospective, to an intention. We might therefore take the existence (or, at least, the pertinence) of such an attitude as an index of the artistic relation, and, *a contrario*, its absence (or, at least, manifest inappropriateness) as an index of the simple aesthetic relation. I do not, however, think that this index is reliable as far as the nature of the object itself is concerned, since the subject can mistake it in perfect good faith, as when I take a pebble for a head by Brancusi, or vice versa. The "critical" attitude Gombrich speaks of does indeed provide a likely "symptom" of the artistic relation, as distinguished from what Goodman's symptoms point to in the aesthetic relation, and it is, accordingly, a feature that is very useful for describing the psychology of

40. In Genette, *L'œuvre de l'art*, p. 10, I used *artisticité*, a properly derived, but rather cumbersome neologism. In a review of the book (*Le Monde des livres*, 6 January 1995), Michel Contat prophesied that the word was not likely to catch on; but, doubtless unconsciously motivated by this (justified) expression of disapproval, he cited the word in the emended form (emended by haplology) *articité*, which I am happy to adopt—if only to fulfill his prophecy as soon as possible. [The English translation of *L'œuvre de l'art* renders *artisticité* as "artistry" (*The Work of Art*, p. 4); for lack of a better, that term will be retained in the present volume.]

41. One can further object to Gombrich that certain "natural" objects, already mentioned, have been extensively transformed by man, so that it is in every sense pertinent to "criticize" a tree or flower obtained by genetic selection. We do not therefore have to go as far as Viollet-le-Duc, who once drew up a project—fortunately never carried out—to "restore" Mont Blanc (if Danto is to be believed; see *The Transfiguration of the Commonplace*, p. 90).

the artistic relation. However, it obviously does not enable us to identify an object, objectively and with certainty, as an artwork, because this attitude assumes (even if only implicitly, and even if mistakenly) the existence of precisely the distinguishing feature (aesthetic intention) that is here to be established.

I have left the rest of Gombrich's analysis aside in order to discuss a remark that merely serves as its point of departure. The balance of Gombrich's commentary introduces a new element of uncertainty into the determination, already quite relative, or, at least, graduated, of the artistic nature of a given aesthetic object. The critical attitude, Gombrich observes, comes into full play in discussions of recent buildings—and a fortiori, of course, of architectural or urban projects we might well have a say in and whose future we might help determine. No one, for example (it is not Gombrich who is speaking here), denies himself the pleasure of "criticizing" the Opéra-Bastille or even Sacré-Cœur,[42] and some go so far as mentally to demolish them so as to make way for an imaginary building spectators would find more satisfying. Ancient monuments, however, are as a rule not subject to this attitude; their age seems to assure them a kind of aesthetic immunity, as if they were

> gradually receding into [a] past which is beyond recall and beyond reproach. . . . Who would criticize Stonehenge and wish that one of the sarsens were a little broader or taller? It is part of the landscape. . . . The same, surely, is true of all the great landmarks of the past. They are seen and admired as landmarks, not criticized as human artefacts that are the products of decision. The Palazzo Ducale at Venice must be one of the most photographed and gazed-at buildings in the world. One wonders how many of the visitors to Venice even noticed that two of its windows are not aligned with the others, or asked themselves whether they would prefer the building, if it were more symmetrical or less. Imagine a modern designer coming up with such a solution and having to defend his decision! Needless to say we meet with such irregularities in nearly all old buildings. We accept them as tokens of their slow growth just as we accept the signs of weathering and decay as tokens of age.[43]

42. [Completed in 1989 and 1875, respectively.]

43. Gombrich, *Reflections on the History of Art*, p. 197. Gombrich obviously means the two windows facing the lagoon on the right of the great façade of the Doge's Palace; they give us some idea of how the present building must have looked before it was finished. John Ruskin, at any rate, did not fail to remark (favorably) on this odd feature of the palace, which is hard to miss: "the whole pile rather gains than loses in effect by the variation thus obtained in the spaces of wall above and below the windows" (John Ruskin, *The Stones of Venice*, 3 vols., ed. Ernest Rhys [London: Dent, Everyman, 1907], 2:263).

This spirited plea does not merely constitute an analysis of the charm of "old towns" (and doubtless, accessorily, a warning against the excesses that might be committed in restoring them). It also illustrates, like the previously cited passage by Panofsky on patina and the effects of weathering, the relative nature of the distinction between the aesthetic attention "demanded" by works of art and the attention we give natural objects, which can only metaphorically be said to make demands on us. Art is not only "extracted" from nature, as Michelangelo's statues were extracted from the marble slabs of Carrara; in a sense, it never stops returning to it, or melting back into it—and who would make this matter for complaint? This gradual naturalization is not, moreover, the sole reason for what I have termed the (relative) aesthetic "immunity" of works of the past. The other, which we will encounter again, is the always historical nature of our relation to them (ignorance aside), which leads us to accept, or even to confer a high value upon, features we would not like in a more recent work: "Steeped as we are in historical relativism the very idea of improving a work of the past must strike us as bizarre."[44]

Genetic Fallacy?

The manifestly "conditional" nature of these criteria does not, in my view, prevent us from using them in a theory of the artistic relation. Even if *nothing* is a work of art *in itself*, it is still possible, and necessary, to understand what the individual or collective reception of an object as a work of art contributes to, or takes away from, or changes in, its aesthetic consideration. But we must also take into account the, as it were, logical or categorical factor arising from the phenomena (which are, when all is said and done, numerous in all the arts, though not all equally decisive in this regard) of generic affiliation, on which the status of *constitutive*—that is, in the main, institutional—artistry depends.[45] To be sure, it is not very helpful to note that a painting is a landscape or still life, or that a musical composition is a sonata or symphony, in order then to conclude that it is a work of art, since it is plain (at least for me) that a painting or musical composition is a work of art by definition; but in other domains, for example, that of verbal objects, whose artistic nature is not guaranteed a pri-

44. Gombrich, *Reflections on the History of Art*, p. 130.
45. See Gérard Genette, *Fiction et diction* (Paris: Seuil, 1991), chap. 1, pp. 11–40 [tr. *Fiction and Diction*, trans. Catherine Porter (Ithaca: Cornell University Press, 1993), chap. 1, pp. 1–29].

ori, such generic specifications are decisive[46] for institutional reasons, since, if it is true that every text is not necessarily (constitutively) a work of art, every poem, play, and narrative fiction undoubtedly *is*, regardless of its aesthetic "merit." This generic criterion is obviously a characteristic feature of the literary realm, but I do not think that it is entirely absent from other artistic domains, even if it does not play a decisive role in them. Certain types of buildings (palaces, cathedrals, ancient temples) are, so to speak, automatically viewed as works of art, while others (office buildings, apartment buildings, factories, highway interchanges) must "earn" that status by way of a candidacy and acceptance that are accorded individually—except for the case in which a whole class of objects is promoted to the rank of artwork. I refer the reader to Panofsky's remark about the "spoons and fetishes of Africa" transferred en masse from one museum to another;[47] the same obviously applies to designer* typewriters and toasters.

Whether an object attains the status of a work basically depends, then, on whether its receiver considers the possibility that an aesthetic intention is present within it. But I say "considers the possibility," rather than "perceives," because the aesthetic intention is not always certain (*"Is there* an intention?"), and, even less, determinate (*"What* is the intention?"), and because the specific attention which confers the status of artwork on the object consists precisely in the *ascription* of an aesthetic intention to the object's producer. Just as, *for me*, an object is an aesthetic object *when* I enter into a relation of an aesthetic type with it, so it is a work of art *for me* when, rightly or wrongly, I decide that this relation can be traced to an authorial intention. A boulder can be a "beautiful" object for me; if I learn (or suppose) that it is not a boulder but a sculpture, the status of this object changes in my eyes, inasmuch as I now refer its aspect, which I first at-

46. On condition, of course, that they are themselves assured: if I do not know whether a given text is fictional or documentary, I may hesitate to say that it is constitutively literary, and let my aesthetic appraisal of it determine whether I confer attentional literariness upon it, or treat it as a simple aesthetic object and so attribute conditional literariness to it. It also sometimes happens that a text is "unclassifiable" because we hesitate between two classifications that are both manifestly literary (for example, *short story* and *prose poem*). In this case, generic uncertainty does not entail any uncertainty as to artistic status. Doubt at the level of one class does not necessarily imply, contrary to what the Wittgensteinians pretend to believe, doubt at the level of the next highest class: not being sure what kind of animal a creature is means being sure it is an animal.

47. Schaeffer, *Les célibataires de l'art*, p. 52, cites the example of the scroll paintings that were brought to France from China and initially parceled out between the Louvre (as works of art) and the Guimet Museum (as historical documents), then all brought to the Guimet, which had in the interim become an art museum. It is well known that various ongoing projects involving the "primitive arts" [*arts premiers*] have run up against similar problems of classification, among others.

tributed to the "hazard" of erosion, to the intentional activity of a sculptor, and inasmuch as this act of referral, which assigns the object the status of a work, almost inevitably modifies my appreciation of it—even if it does so only by tempering my enthusiasm, as Kant would perhaps assume ("If it is *merely art* . . .").[48] But, to repeat, the choice between the status "aesthetic object" or "artistic object" is based, not on unimpeachable information, but on a simple attentional hypothesis of the type "A form like that cannot be the result of pure chance"; and if I err with assurance (if, without the slightest doubt, I take for a sculpture what is in fact only a boulder), the erroneous nature of my hypothesis will obviously not in any way alter the "artistic" nature of my relation to the object I have so ineptly identified.

I therefore define as artistic any relation of this kind, whether the identification it rests on is correct or mistaken—or, as Kant said with regard to Nature, "whether or not our interpretation is in conformity with her purpose." The decisive role here played by the recognition or ascription of an aesthetic intention again brings us face to face with an antiintentionalist theory that has been very influential in this century, on both sides of the Atlantic; again, Monroe Beardsley offers us an emblematic illustration of it, if only by virtue of the title of his most famous contribution to it: "The Intentional Fallacy."[49]

BEARDSLEY'S AESTHETIC PRESENTS US WITH A PARADOX THAT may be summed up as follows. On the one hand, as is appropriate for a "philosophy of criticism," that aesthetic is clearly focused on works of art, regarded as aesthetic objects par excellence by virtue of their "specialized function"; yet, on the other hand, it refuses to take into account that which defines this function as an *intentional* effect—a refusal tantamount

48. But it should be recalled that others, like Hegel, or Beardsley, maintain for their part that the status of artwork *increases* the aesthetic value of an object, recognized as something "born of the spirit" (Hegel, *Aesthetics,* vol. 1, p. 2) or invested with a "specialized [aesthetic] function" (Monroe C. Beardsley, *Aesthetics: Problems in the Philosophy of Criticism,* 2d ed. [Indianapolis: Hackett, 1981], p. xx). My own opinion, as will appear, is rather that this status modifies the attentional context by bringing to our attention specific references not associated with the simple aesthetic object. For Mikel Dufrenne, "Esthétique et philosophie," in the *Encyclopædia Universalis* (Paris: Encyclopædia Universalis, 1990), vol. 8, p. 812, "the place where beauty manifests itself [*se produit*], where it is produced [*est produite*], is principally art." The adverb relativizes art's privileged position, and it is a fact that only artistic beauty (or ugliness) "is produced"—whereas Nature, in some sort, "manifests itself" by itself.

49. Monroe C. Beardsley and William K. Wimsatt, "The Affective Fallacy," in Beardsley and Wimsatt, *The Verbal Icon: Studies in the Meaning of Poetry* (Lexington: University of Kentucky Press, 1954), p. 21.

to treating works of art as pure "aesthetic objects,"[50] and, further, as if they were natural objects whose aspectual properties we considered without reference to any aesthetic intention (here, of course, Beardsley's formalism is sharply at odds with the entire Hegelian tradition). The way Beardsley deals with a hypothetical list of seven statements about a work of art (which happens to be Renoir's *Three Bathers*) illustrates this exclusion of aesthetic intention rather well:

1. It is an oil painting.
2. It contains some lovely flesh tones.
3. It was painted in 1892.
4. It is full of flowing movement.
5. It is painted on canvas.
6. It is on a wall in the Cleveland Museum of Art.
7. It is worth a great deal of money.[51]

Setting aside statements 3, 6, and 7 for later consideration, Beardsley begins by counterposing 2 and 4, which he says involve "perceptual" properties, to 1 and 5, which have to do with "physical" properties. The latter can only be ascertained, according to Beardsley, by scientific analyses using specialized instruments capable of detecting properties that elude ordinary perception. I am not sure that the two examples he gives are well chosen, for it seems to me that, in many cases, a minimally competent art lover can, at first (or second) glance, distinguish an oil painting from a water-color or pastel, or a picture painted on canvas from one painted on wood; but we shall later have occasion to discuss a critique of this matter of the relative nature of distinctions, which is, precisely, what is implied by "competence." To illustrate Beardsley's "physical" properties, one could, doubtless, substitute other features that are more to the point, such as the weight of a painting or the kind of fabric the canvas is made of. The main contention of this first chapter is that physical properties, being inaccessible under the normal conditions of the artistic relation, do not constitute aesthetic properties, and that the only properties that can be called aesthetic are perceptual properties: for instance, visual features in the case of painting, or audible features in that of music. A fortiori, statements 3, 6, and 7 are excluded from the aesthetic realm as being extrinsic to the object itself. I do not believe that 6 and 7, though they obviously depend in part on external factors, are completely independent of a work's intrinsic prop-

50. This is the title of the first chapter of Beardsley, *Aesthetics*.
51. Ibid., pp. 29–30.

erties (another of Renoir's paintings might not have made it to Cleveland, or be worth as much), and I believe even less that they have no influence on the public's appraisal of the work. But the most significant statement in this latter group is obviously 3, which situates the work in the painter's career and the history of painting. A statement like "It's a Renoir" or "It was painted in three hours" would have similar status. It is statements of this kind and the realities they refer to which Beardsley aptly describes as "genetic," inasmuch as they have to do with the circumstances that surrounded, and possibly presided over, the production of works—in this sense, considerations of an author's intentions are obviously genetic. The Intentional Fallacy is for Beardsley a special case of the Genetic Fallacy, which consists in believing that knowing what led to the production of an object, and the processes used to produce it, is relevant to the interpretation and appraisal of phenomena in general, and works in particular:[52] a special and indeed aggravated case, because, Beardsley and Wimsatt argue, the author's intentions are often unknown, or even unknowable. However, even the most objectively attested external circumstances are "extrinsic" to the work *qua* perceptible object, at least when the receiver can arrive at a knowledge of them only indirectly, even if they are beyond doubt. There is no visible record of the date when *The Three Bathers* was painted in the painting, and even if, as sometimes happens, it were visibly (and truthfully) recorded there by the artist, this paratextual indication, as one says in literature, would be no less peripheral to the essence of the painting, according to Beardsley.

Beardsley's central thesis concerns (contests) the *validity* of receptions based on such (more or less) accessory knowledge, and especially on the question, "Is conformity to an author's intention the touchstone for a correct interpretation?" I must confess that I do not have a categorical opinion on this point, a typical subject of controversy in the 1950s and 1960s.[53] The one thing that does seem clear to me is that certain factual data historically invalidate certain hypotheses (for example, the hypothesis that *The Imitation of Christ* is a satirical work by Louis-Ferdinand Céline), and that no factual datum unquestionably dictates any interpretation. My question is a more modest one; it concerns, not the validity, but the actual

52. "The Intentional Fallacy is a confusion between the poem and its origins, a special case of what is known to philosophers as the Genetic Fallacy." Beardsley and Wimsatt, "The Affective Fallacy," p. 21. For the moment, I retain the capital letters, to which these authors attach some importance.

53. See, inter alia, E. D. Hirsch, *Validity in Interpretation* (New Haven: Yale University Press, 1967), which takes a view poles apart from that of Beardsley and Wimsatt.

influence of such data on the reception and, especially, appreciation of works. My response to this question about influence is quite simply affirmative: yes, as long as the receiver knows, or thinks he knows, the "genetic" circumstances of the production of a work, they influence, for better or worse, the reception and, especially, appreciation of that work. The disagreement, formulated in this way, might seem susceptible of the following simple solution: everyone (Beardsley included) would admit that such an influence exists; Beardsley (and other "formalists") would deplore it as tending to lead us astray; others (like Hirsch) would approve of it as salutary; and some (I am one of them) would abstain from making a judgment, contenting themselves with observing that this influence is a distinctive feature of the artistic relation. This is doubtless a pretty accurate picture of the situation, but Beardsley, in his polemical fervor, seems to me to come close to denying the *very existence* of these phenomena of influence, in that he denies not only their validity but even their *relevance*: for him, a judgment based on genetic information in fact bears, not on the work as object, but, rather, on its author. If someone tells me that such-and-such a painting, which I admired as a Vermeer, is a fake, I think that I change my mind about the painting, when, in fact, I change my mind about its author, whom I no longer consider to be a seventeenth-century painter of genius, but simply a skillful imitator—and the other way around, of course, if the painting is once again attributed to Vermeer. It would follow that the *genetic fallacy* [*illusion*] is also an illusion as to the nature of a judgment by the very individual who makes that judgment; he is mistaken, in our example, about the effect of the genetic information he has just taken into account. As can be seen, Beardsley's position here is both more extreme and more subtle than appears at first sight. For Beardsley, the genetic information has no real influence on one's appreciation of the work, but it does give rise to a mistaken belief that such influence exists, and profoundly perverts the relation to the work, which is not what one believes it to be: I think what I like is a Vermeer, but what I really like is the fact that it is a Vermeer. I am not sure that I am not distorting Beardsley's thinking somewhat, but, if so, I am distorting it to bring it into line with my own view: our aesthetic relation to works of art is, in fact, always a bit (more or less) "perverted" by the accessory information of all sorts that accompanies our perception, and is almost never an "innocent," "purely aesthetic" relation—if there is such a thing. Yet nothing requires us to valorize such innocence or such purity, nor, conversely, to devalue the impurity or perversity of the artistic relation, which is, without any doubt, generally—and, except under artificial conditions, paradox-

ically[54] — a relation that is "less immediate," as Kant put it, than the aesthetic relation to natural objects. Again, the disagreement would seem to be, in the end, basically axiological.

I have ignored the category of "physical" properties, which Beardsley too excludes from aesthetic consideration. It is nevertheless clear that these properties have in common with "genetic" properties the fact that they cannot, in principle, be immediately perceived, and can usually be made accessible only with the help of accessory information: as a general rule, I *perceive* that a painting is rectangular, but I have to *learn* that it weighs twenty-two pounds (a physical property),[55] or that it was painted on a Sunday (genetic property). The fact that both physical and genetic properties are not immediately perceptible invites us to combine these two types of properties in a larger class that I shall very provisionally call *cognizable*. To the fact that both kinds of properties belong to this common category, we may, moreover, add the fact that many nonperceptible properties can (according to Beardsley) be assigned, indifferently, to one class (physical) or the other (genetic): for example, that a painting is in oils or pastels, on canvas or wood, painted with a brush or a knife. Beardsley himself provides a (twofold) example from architecture,[56] which seems to me highly indicative of this ambiguity — that is (as I see it), of the fact that the distinction between physical and genetic properties is generally pointless. The famous Guarantee Building in Buffalo, built in 1895 by Louis Sullivan, is a twelve-story building in the Florentine style; it rests on piers, every other one of which contains a steel column. The steel columns are of course necessary to support the weight of the proto-skyscraper, but they are invisible, and Sullivan has been reproached for hiding them away, as Beardsley notes. Again, various skyscrapers of more recent vintage, like Cass Gilbert's Woolworth Building in New York (1915, sixty stories), look like Gothic buildings from the outside.[57] Beardsley imagines two architecture lovers observing one such building, a library. One says he finds it "sturdy-looking and yet graceful." The other responds that, to him, it looks "cheap, vulgar, insincere, and earth-bound. I know something that

54. "Paradoxically," because a situation likely to block out the genetic information that "naturally" surrounds the reception of works (for example, a blindfold* test) has to be created artificially.

55. But an expert could doubtless evaluate this property with a fair degree of accuracy without using any instruments, that is, in a directly perceptual manner.

56. Beardsley, *Aesthetics*, p. 50.

57. Beardsley's second example is not the Woolworth Building, but rather an unidentified university library built to resemble a Gothic tower. Yale's very handsome Harkness Memorial Library (built around 1920) has an additional deceptive feature: it was artificially eroded to make it look old.

you do not know," he adds; whereas Gothic buildings "supported themselves by the weight of their own stone" [I would add that they are also supported by visible flying-buttresses], "this one is secretly built around a steel framework, so that though it may look to the uninitiated as though the stone were holding it up, actually the steel is. The building therefore appears phony to me."[58] In his commentary on this imaginary, but by no means improbable, conversation, Beardsley evokes his distinction between physical and perceptual qualities; he adds that the second of his two architecture lovers "objects to the way the library is built." This, says Beardsley, is an "engineering matter," and the criticism is obviously based on genetic considerations. Beardsley imagines another example, involving sculpture this time: a statue which one might possibly evaluate differently once one learns that it was carved out of soap, without any commendable effort. "The question here," he concludes, "is not whether this does happen, but whether it ought to happen." He answers, of course, that it ought not to:

> I propose to count as characteristics of an aesthetic object *no* characteristics of its presentation that depend upon knowledge of their causal conditions, whether physical or psychological. Thus I will say that the dishonesty seen in the library by [the second speaker] in the dialogue . . . is not in the library as aesthetic object, and that to see the object in its true nature, [he] must either forget what he knows about its physical conditions, or learn to abstract from that knowledge.[59]

As can be seen, the criticism directed at all physical or genetic considerations here comes down to extracting from the object under consideration a purely "aesthetic object," which is wholly and, as it were, by definition, identified with the perceptible object (be it recalled that Beardsley, unlike Sibley, does not differentiate between perceptible "aesthetic" and "nonaesthetic" facts; for him, only that which is perceptible, and everything that is perceptible, is aesthetic). It likewise comes down to positing that the only legitimate relation to a work of art consists in treating it as a purely aesthetic object—that is (to my mind), as if it were not a work of art, even if one knows full well that it is, with, for example, its particular technical and historical features, which one may need to know about in another context and from another standpoint. Beardsley does not deny that a more "informed" relation can exist, and he even implicitly acknowledges

58. If I am not mistaken, Soufflot resorted to a similar artifice to construct the dome of Sainte-Geneviève (today the Panthéon).

59. Beardsley, *Aesthetics*, pp. 50–52.

that, in many cases, we have to make a very special kind of mental effort (which calls for forgetting or abstracting from what we know) in order to put all accessory information out of our minds, but he postulates, simply, that such an informed relation is not purely aesthetic, and that its intellectual flaw (the *fallacy*) consists in believing that it is—in believing, for instance, that we can *perceive* the "dishonesty" of a Gothic skyscraper, when we merely know of it by hearsay, or have inferred or guessed its existence. He also notes the practical disadvantage attendant upon making our judgment of an object depend on factual data extrinsic to the object itself, when, for example, we change our minds about a building after acquiring a piece of simple technical information about it, although the building itself has in no way changed before our eyes. I will come back to this key point, but, for the moment, let me stress that the two or three examples just mentioned show that the *physical/genetic* distinction is secondary and negligible in comparison with the more relevant *perceptible/cognizable* distinction. We now need to examine the latter distinction in its turn.

By using the two adjectives "perceptible" and "cognizable," the first of which is not too unfaithful a translation of Beardsley's "perceptual," to which the second stands in a relation of analogy and symmetry, I have to this point effectively admitted that certain properties are accessible to simple perception in objective, "dispositional" fashion, while others are only accessible by way of accessory information. But this way of dividing up properties is valid only at the two ends of a spectrum that extends, if you like, from a property such as "being rectangular" to another such as "having been painted on an odd day of the month."[60] In a large number of intermediate cases, what pertains to the category of the "perceptible" for some belongs in that of the "cognizable" for others. To limit myself to a matter I have already mentioned, "in oil or pastels" is of the order of the cognizable for the untutored, and of the most manifestly perceptible for an expert or, simply, an art lover with a basic knowledge of art. "In G minor" is a property that is easily perceptible for a musician with "perfect pitch," while "in a minor key" is perceptible even for a music lover with the rudiments of a musical education; but even these two features must be *learned about* by an untutored or novice listener. Certain properties are "perceptible" on condition that one has a few basic instruments at one's

60. Here, I refrain from saying "on a Sunday," because a feature of that kind can, in certain cases, be surmised from perceptible features of the painting, such as what the people represented are wearing or the place settings on a table. "Sunday-afternoon painter" is, moreover, almost a generic category, and, indeed, every day of the week has something resembling its own tonality (". . . like a Monday"), which a sensibility such as Proust's would be capable of perceiving. Dates are decidedly more conceptual.

disposal; one thinks here of Nelson Goodman's comments, as sensible as they are sarcastic, on the idea of "merely looking":

> We are looking at the pictures, but presumably not "merely looking" at them, when we examine them under a microscope or fluoroscope. Does merely looking, then, mean looking without the use of any instrument? This seems a little unfair to the man who needs glasses to tell a painting from a hippopotamus. But if glasses are permitted at all, how strong may they be, and can we consistently exclude the magnifying glass and the microscope? Again, if incandescent light is permitted, can violet-ray light be ruled out? And even with incandescent light, must it be of medium intensity and from a normal angle, or is a strong raking light permitted?[61]

I omit the rest, which insensibly leads us to the most sophisticated equipment of the laboratories of the present and future,[62] which, for example, make it possible to detect a layer of Prussian blue, a pigment discovered in 1704, in a painting hitherto attributed to an artist of the Quattrocento. . . . This healthy warning indicates that the dividing line between perception and knowledge is not a function of the object but of the subject, and even that it does not separate one subject from another, but runs through each subject: what I *know* in one particular set of circumstances, I *perceive* in another. My objectivist ("dispositional") terms "perceptible" and "cognizable" are, then, inaccurate: the de facto, not de jure, dividing line runs in each instance between *something perceived* and *something known*, and the "something known" of one instance can be the *something perceived* of another. Let me add that if aesthetics must be defined in terms of the perceived—as Beardsley, thus amended, would suggest—the extension of the term must be broad enough for it to be applicable to what we "perceive" mentally of a literary text, if only in the most immediate fashion: for example, the fact that *Père Grandet* is a miser or that *The Charterhouse of Parma* is set in Italy, which presupposes, after all, that we *know* what miserliness and Italy are. But because, as Goodman says after Poussin,[63] not only are texts not made to be simply looked at, but even paintings are made to be *read*, the term "perception" must be so defined that we can

61. Nelson Goodman, *Languages of Art: An Approach to a Theory of Symbols* (Indianapolis: Bobbs-Merrill, 1968), pp. 100–101. See Genette, *L'œuvre de l'art*, pp. 77–78 [*The Work of Art*, pp. 66–67].

62. See, inter alia, Magdeleine Hours, *Les secrets des chefs-d'œuvre*, 2d ed. (Paris: Robert Laffont, 1988).

63. Or Marcel Proust: "A cathedral is not only a beauty you feel. Even if you do not regard it as a course of instruction you should take, it remains, at least, a book you should try to understand." Preface to Ruskin, *The Stones of Venice*, in *Contre Sainte-Beuve*, preceded by *Pastiches et mélanges* and followed by *Essais et articles* (Paris: Pléiade, Gallimard, 1971).

"perceive," that is, *understand*, that this man nailed to a cross is Jesus—a perception of a "secondary" kind, as Panofsky puts it, presupposing a good deal of accessory information. And, in any case, there must also be agreement as to the degree of awareness that we assume accompanies the fact of perceiving something: one can perceive a feature without identifying it, as an incompetent but attentive listener will unfailingly "hear" a tritone or augmented fourth (for example, C / F ♯), without knowing *that it is* a chord of that kind (or even what a chord of that kind is); or, again, as an attentive but incompetent viewer unfailingly "sees" intersecting ribs without knowing that he is looking at intersecting ribs (or knowing what intersecting ribs are). I shall come back to this.

Our dividing line is decidedly turning out to be ever fuzzier—even if we do not accept Goodman's suggestion that every known (learned) feature becomes, from the moment we have learned about it, ipso facto perceptual:[64] I am not sure that knowing that a painting is only a perfect copy necessarily means that I can perceive its difference from the original—differences which, by definition, are imperceptible on the present hypothesis. I think, rather, that that information could induce me, owing to influence and the power of suggestion, *to believe that I perceive* these nonexisting differences; and I am, once again, sure that it would modify my appreciation of the picture, which would, for its part, not have changed in the interim—or only changed ever so slightly. . . .

Beardsley himself offers an analysis of cases of this sort. Though it does not represent a departure from the formalist position we have already recognized, it does seem to me to pave the way for a solution:

> Suppose we have two paintings, X and Y, and someone says that X is better than Y. Now suppose he also said there is no difference between X and Y, either in their internal characteristics or in the way they were produced, or their relation to other things. This would amount to saying that he can give no reason for his judgment, for there is nothing he can say about one that could not be said about the other. Now suppose, instead of saying that X and Y do not differ in any way, he says that there *is* a difference in their origin—one is a "fake"—but no difference in their internal characteristics, so that no one could tell them apart just by looking at them. Then, I suggest, this amounts to saying that there is no *aesthetic* reason for the judgment, though there may be another kind of reason; and the critic's word "good" no longer can refer to aesthetic value, but only to some other species of value.[65]

64. Goodman, *Languages of Art*, pp. 103–104.
65. Beardsley, *Aesthetics*, pp. 502–503.

Let us observe, in passing, that here the notion of "fake" goes beyond that of a fraudulent *copy*, because it also takes in that of a fraudulent *imitation* (like Van Meegeren's "fake Vermeers," but also forgeries in literature and music, two allographic arts in which, by definition, it is not possible to produce copies, but certainly possible to produce imitations). Nevertheless, it seems to me that this nuance is of small importance in the case at hand. Between two paintings, one of which is a perfect copy of the other, there is by definition no perceptual[66] difference. Between two paintings, one of which perfectly imitates the other's style, but treats another subject, there is obviously a perceptual difference in the strict sense of that term, but there is no *stylistic* difference, and the stylistic identity of the two paintings may be regarded, from our standpoint, as perceptual in the broad sense, because, extreme obtuseness aside, this identity emerges from a simple visual examination requiring no accessory information—information which would, conversely, become necessary to substitute a correct attribution ("it's a very good imitation of a Vermeer") for a plausible but mistaken one that identified it as the genuine article. Thus we may assume that the case of a copy and that of an imitation, or forgery, are, with respect to what interests us here, equivalent.

Ignoring this nuance, then, I return to Beardsley's formulation, which I will sum up as follows: when I judge differently two works that are for me perceptually indiscernible (or, I would add, more simply, when I modify my appraisal of the same work), invoking accessory information of a genetic kind, such as "this one is a fake," the criterion this appraisal is based on is not aesthetic, but of another order. That formulation seems acceptable to me, on condition that we recognize that "aesthetic" is here being used in a restricted sense. Thus it appears that the difference between the formalist position illustrated by Beardsley (among others, but Beardsley illustrates it rather better than others) and the one I am defending here boils down to the logical difference between a narrow and a broad definition of the adjective "aesthetic." Beardsley's formalism may consequently also be described as *aestheticism*, if we take this term to designate the viewpoint according to which nothing differentiates works of art as a specific class from "aesthetic objects" in general, or, more precisely, according to which extraperceptual (for example, genetic) data are irrelevant in the case of works of art, despite the fact—which Beardsley himself admits, only to deplore it—that, in actual practice, we continue to take

66. Henceforth, I shall use this adjective to mean "pertaining to perception"; I am taking it for granted that, in line with what has already been suggested, "perceptible" will automatically be taken to mean "perceived."

these data into account in our relation to works of art. My position, which is in conformity with usage, is that works of art—for reasons that we will, naturally, examine—require, on the contrary, that we broaden the meaning of the predicate "aesthetic," or—but this comes to the same thing—that we take certain extraperceptual data into consideration as relevant to aesthetic appreciation as soon as they become known. It is this relevance, or, at least, the possibility of such relevance, which defines the specificity of the artistic relation, even if it is still always possible, under certain conditions (for instance, ignorance of the artistic nature of an object), to treat a work of art as a simple "aesthetic object," without regard for its "origin"—although it is true that not all extraperceptual data are of equal aesthetic relevance. Everyone knows that literary history and the history of art are teeming with insignificant details ("painted on an odd day of the month") whose aesthetic relevance is often small and sometimes nil. However, on the one hand, the object of these disciplines is not to guarantee such relevance, but merely to establish the facts, significant or not; and, on the other, it is not always easy to know in advance whether a detail is or is not aesthetically relevant—what is irrelevant for X can be relevant for Y, or what is irrelevant today can become relevant tomorrow, or the next day. And, after all, the aesthetic relevance of the perceptual data themselves is not always much more solidly established: the exact number of times the letter *e* occurs in *The Charterhouse of Parma*, or E natural in the *Jupiter* Symphony, are "intrinsic" facts, perfectly perceptible for anyone who cares to go to the trouble of remarking them, but I am not sure that they have much more bearing on my appreciation of these works than does the number of cups of coffee imbibed by Stendhal or Mozart while these works were being composed. Yet I am also not sure of the opposite. In any event, I do know that, under certain circumstances, the fact that the letter *e* does not occur in *A Void* does have a bearing on my appreciation of it.

Aesthetics and Technique

The (shifting) frontier between the pertinent and the contingent is not, then, identical to the one (no less mobile) between the perceptual and the extraperceptual, which we should, perhaps, agree to give a less negative name. Symmetry suggests *conceptual*, and doubtless some principle of the excluded middle as well: in the cognitive realm, everything that is not perceived is conceived. I perceive that the Woolworth Building is in the Gothic style, I conceive that this means it has a metal framework. But that opposition is oriented rather too exclusively toward reception for it to be

applicable to a work's properties. If I want to describe these two classes of properties objectively, the clearest way to do so would perhaps be to counterpose them as *aesthetic* and *technical*, in accordance with ordinary usage—while specifying that technical properties can, in certain cases and under certain circumstances, be relevant to aesthetics: the frequency with which the letter *e* occurs is a technical matter in the *Charterhouse*[67] as well as *A Void;* it is aesthetically relevant (for anyone who knows its frequency of occurrence) in *A Void,* but not in the *Charterhouse.* An artwork is an object that is simultaneously (and intentionally) aesthetic and technical; its technical properties are aesthetically relevant to the extent that they shape our appreciation of this work—let me add "for better or for worse," to appease Beardsley's ghost. That he spent only "a quarter-hour writing" his sonnet is plainly, for Oronte, an argument in its favor; but Alceste, for his part, has a right to his opinion that "the time's irrelevant."[68] This technical datum ("genetic," if ever anything was) is aesthetically (evaluatively) relevant for Oronte, but not for Alceste. However, it seems to me that when a technical fact is regarded by a receiver as aesthetically relevant, it becomes for him, ipso facto—I will not say, like Goodman, a perceptible fact, but, at least, an aesthetic fact.

This new disagreement with Beardsley may seem unrelated to the first, which had to do, as we saw in the last chapter, with the objective or subjective nature of appreciation. But it is not. A passage from Beardsley's *Aesthetics* seems to me to indicate the relationship between these two points quite clearly:

> Anyone who attributes to aesthetic objects all the phenomenal characteristics induced by the knowledge of the personalities of artists and their techniques is faced with an uncomfortable dilemma. He may say that the characteristics of the object change as historical knowledge changes; which is an odd way of speaking. Or he may say that the "true" object is the one that contains all the phenomenal characteristics that would be seen it its presentations by anyone who knew all the facts about its causal conditions. This would seem to imply that we can actually know little of the "true" nature of all ancient and medieval, and most modern, works of fine art, even works that we can study for years in a good state of preservation.[69]

67. It may seem inappropriate to describe an obviously involuntary matter as technical. Stendhal does not choose his *letters* (which is why it is not relevant to know how many there are); but this involuntary matter stems from another that is voluntary, and relevant, namely, his choice of *words.*

68. Molière, *The Misanthrope,* trans. Richard Wilbur (1954; New York: Harcourt Brace and World, 1965), p. 35.

69. Beardsley, *Aesthetics,* p. 53.

I do not much know what to make of the second horn of this cruel dilemma, but the first suits me perfectly. Consenting to this proposition is, of course, what is known as relativism. We have already seen why Beardsley should find it "bizarre"; this shows that a certain formalism and a certain objectivism can go hand in glove. I say "can" because there exist other configurations. In France, we only recently experienced a resolutely subjectivist (and relativist) formalism, at least in literary criticism, and this in the period in which people defended, with one hand, the "closure of the text," "immanent readings," and "the death of the author," while, with the other, they took up the cudgels for the absolute freedom of the reader's interpretive activity. Together, these two positions were opposed to the "biographism" and historicism of the Lansonian tradition, which took the life of the author in its historical context as the touchstone for the veritable meaning of a work. For objectivist formalism, it is the idea that a work's "properties" can change as a function of the cognitive conditions of its reception that is, in the proper sense of the word, unbearable. This position consists, in essence, in denying that a work has any transcendence—in the sense I give this word, that is, in the sense (among others) in which the reception of a work, and its (variable) impact on the receiver, are an integral part of the work—and, consequently, in wholly identifying the work with its object of immanence. From this vantage point, Beardsley's formalist objectivism coincides with Goodmanian nominalism in a common stance that we can, ultimately, identify as *immanentist*. It is illustrated by, for example, the fact that Goodman refuses to distinguish Cervantes' *Don Quixote* from Pierre Ménard's, because—this is a sufficient reason, according to Goodman—their *texts* are identical.[70] For me, in contrast, the functional plurality of a work is so obvious as to be self-evident, on condition that the work is not reduced to its object of immanence. To cite Malraux once again, "Metamorphosis is not an accident, it is the very life of the work of art."[71]

I recently mentioned, in connection, precisely, with the "operal plurality" that arises from changing conditions of reception, a few examples of how such genetic or intentional data could be relevant (*Momo*, the *Letters of a Portuguese Nun*, *The Fall of Icarus*, and inevitably, because of its emblematic ambivalence, Ménard's *Don Quixote*). I will not discuss those examples again here,[72] but I will mention two further typical instances from

70. See Genette, *L'œuvre de l'art*, pp. 272–279 [*The Work of Art*, pp. 242–249].

71. André Malraux, *Le musée imaginaire* (Paris: Idées-Art, Gallimard, 1965), p. 224 [tr. *Museum without Walls*, trans. Stuart Gilbert and Francis Price (Garden City, N.Y.: Doubleday, 1967), p. 224].

72. Genette, *L'œuvre de l'art*, pp. 266–288 [*The Work of Art*, pp. 237–257].

the realm of architecture, which Beardsley himself chooses to discuss. Frank Lloyd Wright's nineteen-story Price Company Tower[73] seems (to semicompetent students of architecture) as if it must be constructed around a "classical" metal framework, with curtain-walls, like most skyscrapers. In fact, it rests on a central axis sunk deeply into the ground; at each story the floors, which are out of plumb, radiate from this axis like the branches of a tree. Let me mention as well that most illustrious of constructions, the dome of Santa Maria del Fiore, built by Brunelleschi between 1418 and 1434. Faced with the problem posed by the width of the drum, which seemed to make it impossible to erect the trusswork required to support the dome, the architect had the idea (which I am here simplifying in the extreme) of superimposing one dome upon another. The first, which is pyramidal, is corbeled and has no arch; the second, with a Gothic arch, rests atop it, held up by invisible supports. In both case, a primary aesthetic judgment based solely on perceptual data is, in a sense, sufficient and perfectly legitimate: I do not need any accessory information to admire the elegance of Price Tower or, from atop San Miniato hill, the audacity of the dome in Florence. But, quite obviously, knowing about a building procedure, a tour de force, or the solution of a problem, enriches my relation to an edifice with a technical datum that contributes, in a positive or negative sense ("that's based on a trick"), to my experience of the work as artistic object. By the same token, knowing (or assuming) that Vermeer worked in a darkroom enables me to explain certain of the distinctive, perceptible traits characteristic of most of his paintings, like their nearly square formats, their optical perspective, or the luminous globules of paint in the "circles of confusion"; it also sheds light on Kenneth Clark's curious impression of the *View of Delft* as a "coloured photograph."[74] I have spoken of "accessory" information that contributes to the artistic (operal) experience without being indispensable to the aesthetic experience; but what are we to say of instances of hyperoperality, where the identification of another, underlying work is an integral part of the act of reception, as is the case with musical or pictorial "variations"? (What do we see of Picasso's *Las Meninas* or *The Women of Algiers* if we miss the ref-

73. Bartlesville, Oklahoma, 1952. This building was deformed somewhat when it was built. It had been anticipated in many respects by a 1929 project for a St. Mark Tower to be constructed in New York. Generally speaking, Wright likes buildings which are out of plumb: this is a persistent feature of his work.

74. See Svetlana Alpers, *The Art of Describing: Dutch Art in the Seventeenth Century* (Chicago: University of Chicago Press, 1983), pp. 26–33, and the earlier studies cited there. Clark's view may be compared with Proust's or Claudel's (see Genette, *L'œuvre de l'art*, p. 283 [*The Work of Art*, pp. 252–253]). "The most beautiful painting in the world" certainly does seem to accommodate many different ways of looking.

erence to Velasquez or Delacroix? What do we hear in the first movement of *Petrushka* if we are not aware that its theme has its origins in the music halls and popular theater?) The same holds for literary parodies—can we truly *receive* Paris's line in *Tiger at the Gates*, "By losing one person your life has become entirely re-peopled," if we fail to perceive the ironic Lamartinian echo?[75] Such "aesthetic experiences" seem to me almost as sharply truncated as that of the person evoked by Goodman who contemplates a poem without knowing how to read—or, to refer yet again to this inexhaustible example, as that of someone who looks at Jastrow's drawing without wondering if it is a rabbit or a duck. But "truncated" does not exactly mean "invalid" here (everyone appreciates what he perceives in accordance with his own taste, and nothing can "invalidate" a feeling); it does, however, certainly mean *incomplete* in comparison with what the objects considered offer, as when I appreciate (in a reproduction) a "detail" without knowing that it comes from a larger picture—which, moreover, might well disappoint me if I were to see it in its entirety. Learning that Paris's declaration contains an allusion adds to my understanding of the text, not necessarily to my pleasure (or displeasure). "It is only a parody," Kant might say here. More enlightened appreciation is not necessarily keener; but it is inevitably different, because the attentional object it is brought to bear on is modified by it.

It might be objected that all these instances are, in their various ways, peripheral to the way works usually function: not all works are variations, or ambiguous, or allusive, or imitative, or of uncertain attribution, and not all dissimulate the technical procedures that went into their making. I would reply, to begin with, that even if such cases are peripheral, a theory of the artistic relation that did not account for them would be, at a minimum, insufficient; and, above all, that "technical" data are by no means significant only in works of this kind. We shall see, somewhat further on, the logical necessity that the universality of such "technical" significance is based on.

Works of art exhibit, then, a twofold feature that only apparently involves a contradiction. On the one hand, by virtue of their specific intentionality (their "candidacy"), they solicit, exclusively or over and above whatever practical function they may have, a more constitutive aesthetic attention than that which may arbitrarily be brought to bear on purely attentional "aesthetic objects" (natural objects, utilitarian artifacts). On the

75. Jean Giraudoux, *La guerre de Troie n'aura pas lieu* (Paris: Larousse, 1987), p. 48 [tr. *Tiger at the Gates*, trans. Christopher Fry (London: Methuen, 1955), p. 12. The line in the play reads, *Un seul être vous manque, et tout est repeuplé*. The line from Lamartine's poem "L'isolement" is identical except for the last word, *dépeuplé*.]

other hand, however, by virtue of this very intentionality, they mobilize technical means in its service, which, if they come to our attention, have an incidence on the works' aesthetic function, when, and insofar as, they influence our appreciation of them. Indeed, it seems to me that this aesthetic relevance of technical data constitutes the essential feature of the special status of artworks. Let us note in passing that it is also what justifies the importance a Nelson Goodman attaches to the cognitive activity (in the strong sense) of the artistic relation: natural objects, being fundamentally nonintentional products of chance and necessity, do not display features one could describe, in the strong sense, as "technical." Utilitarian objects, for their part, in the very variable measure in which one regards them as nonintentional, certainly do display technical features, but the aesthetic impact of these features is subject to doubt, or is even, in some cases, patently nil: an automobile is doubtless streamlined to increase its aerodynamic efficiency, but the choice of one or another light metal alloy to bring down its weight generally has no impact on its "styling." In design*, architecture, and elsewhere, the functionalist credo, according to which "an object has its own beauty whenever its form is the manifest expression of its function,"[76] seems to me to sum up one aesthetic among others, which owes more to a principle that is essentially moral or ideological (the "honesty" or "sincerity" of form) than to any obvious aesthetic reality. We see clear evidence of this in Alfred Loos's charge that ornament is a "crime."[77] "Expression of function" is *one* of the paths aesthetic effect can take, not the only one: witness, for example, the charm many find in old automobiles, which showed small concern for streamlining, but took their inspiration from the forms of the horse-drawn coaches that preceded them, in line with an abiding tendency in technological development. The same holds today for the neo-Gothic skyscrapers of the early twentieth century: the formal and decorative stratagems used to hide the building techniques they are based on does not usually detract from their aesthetic effect. Moreover, this effect can perfectly well invest the very attempt to conceal something, so true is it that aesthetic appreciation can invest any object whatsoever, and thus any aspect, perceptual or conceptual, of an object. The artistic function is, par excellence, the locus of interaction be-

76. Paul Souriau, *La beauté rationnelle* (Paris: Félix Alcan, 1904), as cited in Pierre Francastel, *Art et technique aux 19ème et 20ème siècles* (Paris: Minuit, 1956). I do not find precisely these words in Souriau's text, but I do find a number of different sentences to the same effect. For example: "in theory, the most aesthetic form that a man-made object can have is that which most simply and directly corresponds to its purpose" (ibid., p. 364). Of course, Souriau is one of a great many partisans of functionalist aesthetics, which is not, be it said in passing, without merit.

77. Adolf Loos, "Ornament und Verbrechen," in *Trotzdem* (Innsbruck: Brenner, 1931).

tween the aesthetic and the technical. The same thing can, of course, be said the other way around. *There exists* an artistic function *whenever* the technical and the aesthetic are conjoined: whenever an activity, and therefore a technical factor, produce an aesthetic effect by influencing aesthetic appreciation. Obviously, this does not always happen, and I suppose that many "secrets of production," once they are revealed, remain aesthetically inert; the same may be said of certain technical factors that are entirely "perceptible," at least for specialists. Michael Riffaterre clearly showed some time ago, *pace* Jakobson and Lévi-Strauss, that certain phonological and grammatical features of Baudelaire's famous poem "Les Chats" (the number of "liquid consonants" like *l* or *r*, "masculine" rhymes in pairs of grammatically feminine words like *volupté* and *fierté*) depend on technical categories that have nothing to do with the "poetic structure" of this sonnet, that is, with the way it works aesthetically.[78]

In his critique of "Genetic Reasons," Beardsley makes short shrift of two themes that are effectively, and eminently, characteristic of artistic appreciation: *skillfulness* and *originality*. On the one hand, Beardsley says, these two predicates pertain, despite what they claim, not to the work, but to its author; thus they unduly ascribe to the former a merit that redounds only to the latter. On the other hand, both predicates refer to a genetic situation (and, in particular, an intention) that is not always known; an error here would invalidate our aesthetic judgment: "When we speak of a 'skillful work,' this is a judgment about the producer, and is logically irrelevant to the question whether the product is good or bad."[79] To be able to say, for example, that a work is "a success" or "a failure," we need to know the author's intention, for the notion of success or failure can be defined only as measured against that intention. That a figure in a painting is manifestly "distorted" can be deprecated as a sign of "bungling" only if we are sure that the artist did not intend to distort the figure—and, conversely, this can be evaluated positively, as a stylistic mark of "success," only if we are sure that the artist *did* intend to. In the countless instances in which there is room for doubt (including those in which we have an unambiguous, yet suspect, declaration on the part of the author—suspect because he can always lie *ex post facto* about what he meant to do), such judgments are baseless. Moreover, in the rare cases that are beyond doubt, the fact that the author attained his goal, or fell short of it, has no bearing on the positive or negative aesthetic value of the result: knowing that the artist was dissatisfied with a sketch or satisfied with the final painting should not,

78. Michael Riffaterre, "Describing Poetic Structures: Two Approaches to Baudelaire's 'Les Chats,' " *Yale French Studies* 36–37 (1966): 200–242.

79. Beardsley, *Aesthetics*, pp. 459–460.

Beardsley says, influence my evaluation of it,[80] for this historical (bio-graphical) fact, which I may be ignorant of today and learn tomorrow, is not such as to modify the perceptual properties of the sketch or painting.

In an essay whose sole object is to rebut the "anti-geneticist" position, Jerome Stolnitz asserts that the status of judgments to the effect that a work of art is "skillful" is not as easily determined as Beardsley claims: judgments of value such as (in the case of a piece of classical music in the sonata form) "the transition, at the recapitulation, from the second subject to the first subject is skillfully managed" can be based exclusively on con-siderations internal to the work, without reference to the composer's in-tentions. Thus one can affirm that the second subject, harmoniously far re-moved from the first, gets back to the tonic in a few steps; or that the second subject, while exploiting its own potentialities, at the same time be-gins to intimate the first; or again, that a transitional episode, not identi-cal with either of the two subjects, but harmoniously related to both, di-verges from the second while anticipating the first. Such technical effects can be deemed "skillful" in and of themselves, without reference to an in-tention—unless one should rather say, as I am inclined to, that they them-selves are marked by the intentionality informing them, so that, for once, no external evidence of this intentionality is required. Thus, from the mo-ment we discover the technical procedures Brunelleschi used to build Santa Maria del Fiore, or those Wright used to construct the Price Tower, there can be no doubting the fact that these works are intentional; nor can we question the intentional nature of Ronsard's sonnet "Comme on voit sur la branche," in which he repeats, in the tercets, the rhymes on *-ose* and *-eur* that occur in the quatrain. Stolnitz's conclusion, which I, needless to say, agree with, is that "judgements of artistic value are therefore a sub-class of aesthetic judgements."[81] Yet the fact remains that the predicate "skillful" is used to describe artistic achievement alone, and that it applies to a technical procedure, generally human (we would hardly say of a cloud that it "skillfully manages the transition between its light and dark hues").

Tellingly, Stolnitz does not take up the second of the artistic predicates Beardsley invokes—originality—which it is somewhat harder to defend against the accusation of transcendence (if accusation it be: it plainly is for Beardsley, and perhaps remains a bit of one for Stolnitz as well; for me it is nothing of the sort), since it is quite evident that we cannot evaluate this

80. In any case, it is a fact (one I will come back to) that we often find we have made an evaluation of a work which is at odds with what we know of the intention, realized or not, of its author, an intention that is by no means binding on our taste.

81. Jerome Stolnitz, "The Artistic Values in Aesthetic Experience," *Journal of Aesthetics and Art Criticism* 32 (1973): 5–15.

"merit" without moving beyond the closure of the object of immanence—what Croce calls the "insularity of the work." Nothing in the pure contemplation of a work reduced to this object can tell me if the work is original or ho-hum, and even less if it was innovative, traditional, or archaistic in its day. This comparative aspect typically depends on a historical context that we have to know, because, in the absence of accessory information, we can hardly arrive at a knowledge of it by guesswork. To buttress his dismissal of considerations of this sort, Beardsley asks us to imagine we have two very similar symphonies by Haydn, and cannot tell which antedates the other. "Are we going to say that *A* becomes better when we decide that it was the earlier, but reverse our judgment when newly discovered band parts give priority to *B*?" This is obviously an example made up ad hoc, but we cannot say that it is absolutely impossible and irrelevant. "Judgments of artistic value" based, even if only in part, on the criterion of originality or innovativeness indisputably depend on historical information that someone may or may not have, that some may have and others not, that do or do not make up part of "general culture" or the common knowledge* that we have a right (?) to expect every receiver to possess, and so on. Beardsley's question is clearly rhetorical: it implicitly rejects as ridiculous, because illegitimate, every response in the affirmative. The question of legitimacy is not easy to decide, but it seems to me legitimate to dismiss it: once again, the question (meta-)aesthetic theory has to answer is not whether it is or is not legitimate for such factors to determine people's judgment, but whether they in fact do. Here, the answer is plainly yes. We can perfectly well maintain that such determining factors are illegitimate, as Beardsley does; but nothing justifies invoking this illegitimacy to deny that they exist. My opinion is that they obviously do exist (we are "always," as the expression goes, changing our minds about works on the basis of accessory information), that they are doubtless "illegitimate" at the strictly aesthetic level, for reasons which, as Kant shows, define the subjective autonomy of the judgment of taste, but that they cease to be illegitimate at the artistic level, the characteristics and determining causes of which are *not* purely and exclusively aesthetic: they are also, as we have seen—to describe them, again, a bit summarily—*technical*.

Artistic Predicates

I will discuss this point again soon at leisure, but first, because the aesthetic effect is a matter of judgment, or, at least, *issues* in a judgment, it is

perhaps not superfluous to ask how this conjunction of the aesthetic and the technical operates in aesthetic judgments of works of art—to ask, in a word, what the specific logic of "judgments of artistic value," and consequently of *artistic predicates*, consists in. I will begin my discussion of the question by considering a passage from Mark Sagoff's essay "The Aesthetic Status of Forgeries."[82] What is in question in this essay goes well beyond its avowed object, which we have already seen in Goodman and Beardsley: the recurrent question as to whether there is an aesthetic difference between (for example) a painting and a copy of it that is perceptually indiscernible from the original, but that has been identified as a copy by other means. The answer, says Sagoff (this is what adds to the interest of his discussion), is to be sought in the logical nature of the predicates under consideration. He bases his argument on a study by Samuel Wheeler[83] showing that certain adjectives, which Wheeler describes as "attributives," have a surface grammar that makes them look like "monadic" or one-place predicates, though they in fact work like two-place relational predicates.[84] This calls for a bit of explanation. In the statement "Claudia Schiffer is a top model*" (I have updated Sagoff's examples a bit,[85] and rung a few changes on his general theme), "top model" is a monadic predicate, which merely assigns the individual in question to one particular membership-class. In "Claudia Schiffer is beautiful," the predicate "beautiful" (aesthetic if ever predicate was, although there is doubtless a dash of physical "attraction" involved here) implies a reference-class that specifies it, which is, obviously, "top model," or, more generally, "member of the fair sex": Claudia is, on a widely held view of the matter, beautiful as a *woman*. Used of a woman, the adjective does not have the same meaning as it would if used of a cathedral: a cathedral that looked like Claudia Schiffer would perhaps not be beautiful, or at any rate would not be a beautiful cathedral, and vice versa. "Beautiful," like aesthetic predicates in general, is in this sense a *two*-place predicate; how it applies will depend, in each instance, on the reference-class, which is generally implicit because it is assumed to be obvious, that is, assigned in advance to the object of

82. Mark Sagoff, "The Aesthetic Status of Forgeries," *Journal of Aesthetics and Art Criticism* 35 (1976): 169–180. See also Sagoff, "Historical Authenticity," *Erkenntnis* 12 (1978): 83–94. These two texts date from 1973 and 1975.

83. Samuel C. Wheeler III, "Attributives and Their Modifiers," *Noûs* 6 (1972): 310–334.

84. The terminology in this field is a bit confused, but it seems to me that the opposition between one-place and two-place predicates covers the same ground as that between "statements of inherence" and "statements of relation," proposed quite some time ago by Jules Lachelier, *Études sur le syllogisme* (Paris: Félix Alcan, 1907), pp. 41–44.

85. Without making any special attempt to be original, and with no regard for posterity; but, barring accident, the radiance the person alluded to is widely recognized to possess will easily last as long as the attention accorded this page.

which it is predicated: Claudia is a beautiful woman, Notre-Dame de Chartres is a beautiful cathedral. The relationship between the two predicates rests on the extensionality accorded each of them: in *"The Rowers' Lunch* is dazzling," the implicit reference-class is "painting," or "impressionist painting," or "painting by Renoir." One could, however, imagine a situation in which it would be the predicate "dazzling" that was implied, and the predicate "Renoir" foregrounded—if, for example, I had asked to see a dazzling painting and was given a choice between *The Rowers' Lunch* and *The Marriage at Cana.* In theory, and from a purely logical point of view, an object to which one attaches an aesthetic predicate is situated at the intersection of two classes, one of which is the category (historical, generic, authorial, etc.) the object is assumed to belong to, and the other a class of aesthetic judgments: a "beautiful Renoir" is indifferently, in all logic, beautiful-among-Renoirs and, if I may put it this way, Renoir-among-the-beautiful. Practical usage and its intentional orientation are what usually lead us to privilege the first type of relation as more pertinent, and therefore to specify that the beautiful Renoirs are a subclass of the class of Renoirs, not of the class of beautiful paintings. This practical specification (it is doubtless even more clear-cut in the case of "Claudia is a beautiful woman," which obviously has to be construed as "beautiful-among-women" rather than "beautiful-among-beautiful-things") is of the same order as those which lead semanticists like Uriel Weinrich to differentiate *oriented* semic "configurations" from simple "semic clusters" (a boy is indifferently "young + masculine" or "masculine + young"): a dwarf "is not simultaneously a man and short, but short as men go." This might be translated by the formula "man → short."[86] Thus Claudia is here, according to what I will call, for lack of a more appropriate term, ordinary predicative logic, rather "woman → beautiful" than "beautiful → woman," and the dazzling Renoir is "Renoir → dazzling" rather than "dazzling → Renoir." Aesthetic predicates, and, especially, artistic predicates (or aesthetic predicates applied to works of art), which, as we shall see, are as a rule the most strongly marked categorically, constantly confront us with such oriented configurations—oriented, it is understood, from the reference-class, often complex, toward the predicate of appreciation.

Sagoff's specific concern, as I have said, is with the relationship between a "forgery" and the original: he maintains that forgery and original, even if they are perceptually indiscernible, do not belong to the same implicit reference-class as long as we know that the forgery is a forgery

86. Oswald Ducrot, in Oswald Ducrot and Jean-Marie Schaeffer, *Nouveau Dictionnaire encyclopédique des sciences du langage* (Paris: Seuil, 1995), p. 447.

(Sagoff calls this implicit class that of "who-when-where sortal predicates"—by which he means, in essence, predicates that assign something to a genetic category). For example, "skillfulness" in the case of a copy is not the same thing as "skillfulness" in the case of the original. A modern copy of a Trecento fresco may well be a skillful copy of an original that would be considered rather clumsy if measured by our contemporary technical standards. Again, our Papageno's imitation (Sagoff too alludes to Kant's fable) is a matter of talent, whereas the nightingale's song is a matter of instinct. In neither case does the receiver's aesthetic appreciation of the original have the same content as his appreciation of the forgery—as long, again, as he has been apprised of the difference, which we may choose to call genetic, technical, historical, or conceptual. In the course of his discussion, Sagoff adopts Goodman's idea (discussed above) that this difference never fails to become perceptible once we have become aware of it. This is undoubtedly true in the majority of real-life situations, for no real copy (or stylistic imitation) is perfect, with the result that genetic information leads us to examine matters more closely and thus to perceive differences that had earlier escaped our notice. But this does not hold for the hypothetical case in which we are confronted with two strictly indiscernible objects, or, a fortiori, for the case (admittedly fictitious) of Cervantes-Ménard's *Don Quixote*. (We already know the problems this poses for Goodman.) And it is difficult to apply to the many different cases of de-attribution and re-attribution strewn through the history of the arts, literature included. Once I can no longer attribute the *Letters of a Portuguese Nun* to Mariana Alcoforado, or *Claudine at School* to Willy, the very least that can be said is that the stylistic (or other kinds of) indices of the fact that they are forgeries or ghost writings*, indices I "perceive" as evident after the forgeries have been revealed, are rather suspect of being products of suggestion-by-accessory-information. It therefore seems to me wise to drop this point and turn to something more certain that Sagoff demonstrates very clearly: namely, that artistic appreciation generally refers to (and depends on) certain categories or preexisting "conceptual frameworks" which specify its meaning and scope. As Gombrich had already observed, *Broadway Boogie-Woogie* gives the impression (if you like) of "gay abandon" *for a Mondrian;* attributed to a Severini (or a Rubens), it would probably seem austere.[87] On the crucial role of these "conceptual frameworks" in the formation of artistic judgments, I can do no better than to cite Jean-Marie Schaeffer:

87. Ernst Gombrich, *Art and Illusion: A Study in the Psychology of Pictorial Representations*, 2d ed. (Princeton: Princeton University Press, 1969), p. 456, cited in Sagoff, "The Aesthetic Status of Forgeries," p. 173.

The propositional structure Kant chooses, i.e., "*a* is beautiful," oversimplifies the actual structure of aesthetic judgements, especially when they are brought to bear on works of art. In fact, this structure takes the form "*a* is an *x* such that *beautiful*." In other words, an object is rarely described as beautiful in an absolute way: rather, it is so described with respect to the field delimited by a given category or context.[88]

Doubtless the implications of the clause "*especially* when they are brought to bear on works of art" need to be further clarified, for there can be no doubt about the fact that *even* aesthetic judgments of (for example) natural objects are in large measure specified by contextual or categorical factors: Babar is graceful *for an elephant*, and I doubtless do not regard a bush the same way before and after establishing that it was in reality a gigantic bonsai.[89] But I too am of the opinion that these factors, for reasons having to do with the phenomenon of operality as such, exercise *greater* influence on our appreciation of works. We shall encounter these reasons again.

THE CONDITIONS UNDER WHICH THESE FACTORS COME INTO PLAY have been analyzed with some precision by Kendall Walton in an essay that explicitly, and very effectively, contests the immanentist position defended by Beardsley.[90] Summarily and provisionally, we can say that Walton broadens the categories put forward by Beardsley (only perceptual features are aesthetically relevant, as opposed to physical or genetic properties, which are aesthetically inert) and refined by Sibley (nonaesthetic perceptual properties help determine aesthetic properties). He does so by including among the properties that play this accessorily determinant role (and are therefore to be counted as nonaesthetic perceptual properties) the genetic factors which Beardsley rejects and Sibley neglects; he proceeds, however, by analyzing these genetic factors as, rather, generic factors.[91] For Walton, in other words, nonaesthetic properties plainly help

88. Jean-Marie Schaeffer, *L'art de l'âge moderne: L'esthétique et la philosophie de l'art du XVIII^e siècle à nos jours* (Paris: Gallimard, 1992), p. 81.

89. It goes without saying that a bonsai, "gigantic" or not, is not exactly a simple "natural object"—no more, of course, than Claudia Schiffer is (as for Babar . . .). I could doubtless pick another example, but it is not such a bad thing to come upon the relative nature of the opposition between natural objects and artifacts again.

90. Kendall Walton, "Categories of Art," *Philosophical Review* 79 (1970): 334–367.

91. Here as elsewhere, I use this adjective in a broad sense, which does not refer specifically to the existence of "genres" (literary, musical, pictorial), but to that of *classes* in general, the problem being that French does not allow us to create an adjective clearly derived from the word "class" [*classe*]. A second advantage of "generic" is that it can be paired off with "ge-

determine aesthetic "properties," but in relation with, and in virtue of, generic categories that specify them, and thus also help determine them, in a way that Sagoff (later) clarifies in his analysis of aesthetic predicates as two-place "attributives." To develop, in this spirit, the example we borrowed earlier from Sibley, a *flowing* line (this is a nonaesthetic perceptual property that helps determine aesthetic properties) can be judged *graceful* (an aesthetic predicate) when it occurs in a *classical drawing*. It would perhaps be graceful in a different way if we assigned it to another category—for example, that of the results of action painting* à la Pollock. This would be to give its flowing quality a different origin and intention and put it in a different stylistic category; it would also be to give a different flavor to the evaluative predicate, which might become, for example (I am happy to confine myself to run-of-the-mill interpretations), "furious." Thus, artistic appreciation no longer involves *two*, but, rather commonly, at least *three* terms: a perceptual condition (here, a flowing quality), a generic assignation[92] (classic drawing or dripping*), and a judgment, in this instance positive. Underlying this judgment is the double—and thus rather narrowly circumscribed—determination by the other two intersecting terms: because it is flowing, I like this line, which I regard as graceful when it occurs in a classical drawing, and furious in a dripping. If I didn't like it, it might seem to me mawkish in the drawing and chaotic in the dripping. Each of these evaluative predicates (graceful, mawkish, furious, chaotic, etc.) thus implicitly, or even unconsciously, evokes a perceptual condition and, at the same time, a generic reference—and is therefore obviously conceptual: *Rio Bravo* is classical *for a Western*.[93]

But I do not wish to push Sibley's elementary example further than it can be made to go, the more so as what Walton affirms is more complicated than I have so far indicated. The exact wording of Walton's formulation is as follows: "a work's aesthetic properties depend not only on its nonaesthetic ones, but also on which of its nonaesthetic properties are 'standard,' which 'variable,' and which 'contra-standard,' in senses to be explained." But it is already clear that the three features introduced here

netic," to which it is, obviously, very similar. Assigning a work to a "genre" in the broad sense ("dripping*," for example), often comes down to assigning it an origin (in the present instance, Pollock).

92. I am more inclined to use this term than "membership," which Walton often uses, because I think, needless to say, that these relations arise from attentional decisions at least as much as from factual states of affairs or authorial intention.

93. I do not use "classical" here to mean what we shall, in line with Walton's usage, call "standard." *Rio Bravo* is by no means a "classic Western," but rather (to my mind), a Western "of classical rigor"—and one atypical of its genre. To cite a work in another genre (which it is somewhat harder to find a name for), *Golden Marie* [*Casque d'or*] is, in the same sense, a "classical" film.

(standard, variable, and contra-standard) can only be understood with respect to a generic assignation. In sculpture or architecture, the (nonaesthetic) perceptual property "having three dimensions" is plainly standard (it "goes without saying," as Wölfflin remarks of the stylistic traits common to artists of the same period), but it is not standard in painting; "having three movements" is standard for a classical symphony, but not for a baroque prelude; "being cut off at the chest" is standard for a bust, but not for a portrait; "being in verse" is standard in a sonnet, but not in a novel. (I include this last example despite the fact that Walton hesitates to speak of "perception" in connection with literary texts, which are not perceptual objects in the ordinary sense, because it seems to me essential to extend Walton's idea to cover all the regimes of artistic immanence. To do so, it is enough to broaden the notion of "perception," as I have already suggested: I "perceive" that a text is in verse, or in French, if I meet certain conditions of competence. But, after all, I must also meet such conditions in order to "perceive" that a picture is oval or that a piece of music is being played on the piano: there is no perception that does not require a certain minimal competence.) Whence this addendum to the formula: the properties in question are "standard, variable, or contra-standard relative to perceptually distinguishable categories of works of art." I will come back to the phrase "perceptually distinguishable," which does not seem to me indispensable; for the moment, I would like to sum up what Walton puts forward in synoptical but, I hope, accurate form: *a work's aesthetic properties depend not only on its nonaesthetic properties, but also on whether these nonaesthetic properties are standard, variable, or contra-standard in the generic category assigned to the work.*

It remains, of course, to define the three features in question. Walton defines as standard all those properties which are simply taken for granted in the generic category assigned to a work (for reasons inherent in a given medium, like the fact that paintings are two-dimensional, or arising from generic conventions, like the fact that a sonnet has fourteen lines). A feature that is not standard can for its part be defined, depending on the particular case, as either variable or contra-standard. "A feature is *variable* with respect to a category just in case it has nothing to do with works' belonging to that category—the possession or lack of the feature is irrelevant to whether a work qualifies for the category."[94] Representations of a human being, landscape, or fruit bowl are variable features in the generic category "painting"; being in C major or G minor, in the category "musical composition"; being in hexameter or pentameter verse, in the category

94. Walton, "Categories of Art," p. 339.

"poem." Finally, "a *contra-standard* feature with respect to a category is the absence of a standard feature with respect to that category—that is, a feature whose presence tends to *disqualify* works as members of the category." Being two-dimensional is contra-standard in sculpture, as is consisting in an entirely solid volume in architecture, or, in literature, not including any verbal statements (it will soon become clear why I am limiting myself to such inelegant examples for the nonce). Taken literally, Walton's definition implies that standard and contra-standard properties are, in the strict sense, antithetical and contradictory, since the presence of one of the latter is equivalent to the absence of one of the former. Moreover, since the presence of one of the latter or—but this is the same thing—the absence of one of the former suffices to exclude a work, or, at least, contributes to excluding it, from a given category, it clearly follows that standard features are *necessary* conditions relative to that category. I therefore come back to a proposition I left in abeyance a moment ago: "a feature of a work of art is standard . . . just in case it is among those in virtue of which works in that category belong to that category—that is, just in case the lack of that feature would disqualify, or tend to disqualify, a work form that category." A standard feature is thus not only a feature that is taken for granted in the category: it is *required* in that category—its absence is disqualifying and its presence is at least a necessary condition for generic assignation. It is a necessary but not a sufficient condition, doubtless because each of these features is merely *one* "among those in virtue of which . . ."; only a cluster of such features is determinant with respect to generic assignation. In poetry, "being in a language" is a standard feature which is necessary but not sufficient, if (I say *if*) one considers other features that are just as standard, for example, "being in verse," to be necessary as well. Two-dimensionality is a standard feature, necessary but doubtless not sufficient, in painting, in which it is better to exhibit the feature "colored surface." In virtue of these various modalities, which we will encounter again, a standard feature, which is in principle aesthetically inert *in* a category (where it is taken for granted), is not inert generically speaking, since it is determinant with respect, at least, to membership in a genre. Indeed, Walton even denies that such features are aesthetically inert, inasmuch as the perception of a genre and of the fact that a given work illustrates its norms (as a sonata, for instance, illustrates the exposition-development-recapitulation scheme, or a comedy the happy end*) is part of one's aesthetic relation to the work. Walton is clearly right about this.[95] What is "aesthetically inert" in a standard feature is its predictability rela-

95. Ibid., pp. 348–349.

tive to the category assigned to a work. In a typical Western, I can evaluate aesthetically (and positively) the way the film respects and illustrates the "laws of the genre," but however agreeable this conformity to the rules may be, it is obviously not relevant to what determines that particular Western's specificity, except, perhaps, by way of a paradox: if we suppose that most Westerns in a certain period "deviate" in one way or another from the "laws of the genre," a Western (of this period) in perfect conformity with these "laws" would be original for that very reason. However, I imagine that this would in fact lead to redefinition of the norm (I will come back to this), or to a distinction between norm and practice, as when Corneille ascribes to Aristotle a distinction between ordinary and "perfect" tragedies, claiming, without excessive modesty, that *The Cid* qualifies as one of the latter.[96]

We may therefore say that generic categories do not arise from purely arbitrary or random choices on the part of receivers, since they are determined by, among other things, relatively clear perceptual indices that are standard in those categories. If a given work is written in a language, it is doubtless a literary work; if instrumental sounds can be heard in it, it must be music; if it is two-dimensional, it is a painting rather than a sculpture; if it is solid, it is a sculpture rather than a building,[97] etc. A contra-standard feature, in contrast, tends (and with good reason) to exclude a work from its category. Strictly construed, however, a formulation of that sort is contradictory: logically, one cannot affirm that an object is excluded from "its" category, because, if it is excluded from a category, that category cannot be "its"; the contra-standard feature should simply be regarded as a standard feature of *a different* category, to which it belongs in the full sense. To treat it as contra-standard in the first category merely amounts to discovering and correcting an error of classification that it would have been better to avoid altogether: if I find that a "painting" has the property, which is *very* contra-standard indeed, of being in B minor, I have doubtless made a (big) error in taking it for a bizarre painting, when it is in fact a humdrum sonata. The logic behind this line of reasoning would obviously lead us to reject as absurd the very notion of the contra-standard property, but that logic errs by its excessive rigidity—by, I mean, forget-

96. See the 1648 "Avertissement" and the 1650 "Examen" and "Discours de la Tragédie." I will return to this complex case in a moment.

97. It is by no means obvious that this last "index" is "perceptual," for one can only establish that it is by exploring the object. It is, rather, of a definitional, that is, conditional, type. If I am told that a pyramid is solid, I would conclude that it is likely to be a (big) sculpture; if I am told that one can enter it, and even reside in it, dead or alive, then it is likely to be a building. But it is easy to find more doubtful cases than these, like Dubuffet's towering totems, or the Statue of Liberty.

ting or failing to recognize the dynamic, that is, historical, nature of generic categories. If contra-standard features exist, it is thanks to the development of artistic forms: it seems to me that a culture whose forms did not evolve at all would, by the same token, not know what contra-standard features were. Such a culture would have only standard features, determining various categories that were perfectly clear-cut because perfectly stable. Within these categories, one would find only the play of "variable" features, which are for their part factors that by no means favor development, but merely provide an occasion for exercising options internal to the range authorized by each category. If I wrote poetry in that type of culture, I would have the choice between formal variables like the ode, sonnet, or elegy, thematic variables like love, war, or death, and metric variables like six-foot, eight-foot, or ten-foot lines. If I composed music, I would here have the choice between formal variables such as the sonata, symphony, or quartet, keys such as C major, G minor, and so on. I would never encounter features that counted as "contra-standard in a category"; they would in fact be standard features of another category.

As these examples doubtless suggest, stable situations of this kind have prevailed to one extent or another in certain arts in certain periods, generally described as "classical," even if these situations have not all lasted as long as the ones that furnish our canonical instances (although this may merely be a matter of ethnocentric or retrospective illusion): namely, Egyptian or Chinese art. But from the very outset of a period that is at all conflictual, or caught up in a process of change, there appear nonstandard features which deviate sufficiently from the norm to qualify as "variable," and must therefore be regarded as contra-standard relative to the category *in* which they appear, although, as soon as they do, they start to undermine that category. The use of intersecting ribs, with all its many structural consequences (if one is to believe Viollet-le-Duc), deviates too sharply from the norms of Romanesque style to be considered as a mere variable for long; hence it paves the way for a new stylistic category, called (after the fact) "Gothic." Schoenberg's resolute rejection of the tonal system made it necessary to create the new category of "atonal music"; Kandinsky's rejection of figurative painting led to the creation of the category of "abstract painting." The categories called into question will vary in their scope: the transition from Romanesque to Gothic, besides the fact that it takes place over a rather long and often complex transitional period, obviously jeopardizes, not the generic category "architecture," but only a stylistic category; the same holds for the transition from Gothic to Renaissance, or Renaissance to baroque. The concepts "atonal music" or "abstract painting," which in Haydn's or Poussin's day would doubtless have

been regarded as quite simply contradictory, obviously have greater destructive potential—to the point that people were in doubt, at least for a time, as to how to deal with these new forms, even wondering whether they counted as "music" and "painting." "Concrete" music caused even greater hesitation, as did Frank Stella's "formed" paintings in "2.7 dimensions," which could just as easily have been assigned to the category sculpture, or to a new, intermediate category, along, perhaps, with the "shallow reliefs" of Hans Arp. The hesitation was prolonged in the case of "collages" and "assemblages"—which today, almost a century after coming into existence, have still not completely lost their generic autonomy—or in that of Calder's "mobiles" and Tinguely's "machines," which, it seems, are going to have to remain in categories of their own, or at least in the special (common) category of "kinetic sculpture"—special enough so that opposition between mobile and immobile sculpture is not considered an ordinary "variable": we have mobile sculpture and sculpture tout court (a marked and an unmarked term). On the other hand, the opposition between representational and nonrepresentational painting, or tonal and atonal music, today displays a somewhat greater tendency toward the equivalence of the opposed terms; the features that distinguish them are in the process of becoming simple variables. Conversely, the particularity of Calder's work is still so sharply marked that those of his productions which are not suspended from iron wires at the mercy of the slightest current of air have been baptized "stabiles," without people either classifying them as simple sculptures or dividing all the sculpture in the world into mobiles and stabiles,[98] assigning the latter category to the *Venus of Milo* or the *Winged Victory of Samothrace*, for example.

Contra-standard features are thus in reality *innovative* features capable of calling an existing generic paradigm[99] into question, and of provoking a break leading to the creation of a new category or the extension of an older category.[100] The initial assignation of the genre "tragicomedy" to *The Cid* seems to me, paradoxically, an instance of the first possibility: the catastrophe at the end was too essential an element of the definition of tragedy for it to be possible, in 1637, to treat the play's (relatively) happy

98. We are indebted to Duchamp for the first term, to Arp for the second. Calder has, however, also produced mixed works, which are, naturally, known as "mobile-stabiles."

99. Here as elsewhere, I use this term in the sense, today current, of a generally, temporarily accepted model, whatever the field the paradigm operates in. This expansion of the meaning of the term has been authorized in advance by Kuhn, who acknowledges that he himself borrowed the concept of "periods punctuated by . . . revolutionary breaks" from the realm of the arts in order to apply it to science (Thomas Kuhn, *The Structure of Scientific Revolutions*, 2d ed. [Chicago: University of Chicago Press, 1970], p. 109).

100. Walton, "Categories of Art," p. 353.

ending as a simple "variable" in this genre. This explains why Corneille fell back on the then common generic designation of tragicomedy for his play, while endowing the word with a new meaning, that of tragedy with a happy ending, or "happy tragedy,"[101] as he would put it more boldly in his *Discours du poème dramatique*. But this solution was merely temporary: in 1648, Corneille went back to the traditional designation. Time had done its work, so that the category "tragedy" was now capable of accommodating this originally contra-standard feature as a variable.[102] But the innovation which, in 1650, was to justify creating the genre "heroic comedy" for *Don Sanche d'Aragon* (a nontragic plot set in an aristocratic milieu; this assignation was taken up again for *Pulchérie* in 1671 and for *Tite et Bérénice* in 1672) was apparently never considered fully "assimilated," to judge by the titles Corneille gave these works. Moreover, everyone knows that, in the eighteenth century, a dissociation operating in the opposite sense (tragic plot, nonaristocratic milieu) would create the category "bourgeois drama"—tragedy as a genre being reserved for the high and mighty of this world—and that, as late as the nineteenth century, romantic drama, which doubtless deviates even more sharply from tragedy, preferred to strike out for full autonomy rather than consider extending a category that had in the meantime lost much of its prestige. These developments were then followed by the general dissolution of generic categories that characterizes the theater of our day, in which, as a general rule, a play is a play, period. The complicated history of notions like prose poem and free verse, down to their absorption by a broader conception of poetry, is, it seems to me, fairly analogous, or parallel, *mutatis mutandis*.

THE OTHER TYPE OF RESTRUCTURING CONSISTS, THEN, IN EX-tending an existing generic category by eliminating one of its defining criteria. This is illustrated by the acceptance, widespread today, of subcategories like abstract painting and sculpture, atonal and concrete music, the *nouveau roman*, and the nonfiction novel, which, logically, evince (as

101. Pierre Corneille, *Discours de l'utilité et des parties du poème dramatique*, in Alain Niderst, ed., *Théâtre complet*, vol. 1 (Rouen: Université de Rouen, 1984), p. 56. The innovative effect would have been even more obvious if he had made this oxymoron a generic indication, as, in our period (1932), Vishnievski entitled one of his plays *Optimistic Tragedy*. The earlier sense of the word "tragicomedy," introduced in France by Garnier for his *Bradamante* (1582), and illustrated as late as 1632 by, again, Corneille, who applied it to his *Clitandre*, was rather more confused: it designated a genre that was in fact a mixture of tragedy, adventure story, and comedy.

102. It is in the 1648 *Avertissement* that Corneille begins to defend the idea that this play respects the two rules concerning themes which Aristotle had laid down for tragedy: the hero should have a mixed character (neither purely good nor purely evil) and the tragic deed should be done within the family.

"prose poems" already did) the capacity of the generic categories in question to accommodate (ultimately) the modifications these adjectives reflect, which are, generally speaking, negative or subtractive.[103] Abstract painting and sculpture give up the previously required feature of representativeness; atonal music, that of tonality; concrete music, that of using only sounds of a determinate pitch; prose poems, that of versification; the *nouveau roman*, if I remember correctly and may be allowed a considerable simplification, that of narrativity; the nonfiction novel, that of fictionality (as the name indicates). Every time a feature is deleted in this fashion, the categorical field is widened, so that the state of affairs that existed previously simply appears as a special case of the new state of affairs—as is sometimes said of scientific theories, Newtonian physics having been not so much refuted as engulfed (relativized) by Einstein's, much as Euclidian geometry was engulfed by the geometries of Riemann or Lobachevski. Moreover, we could make a similar analysis, at the theoretical level, of the transition from a classical aesthetic based on certain objective criteria—unity in diversity, balance, proportion, and so on—to a subjectivist aesthetic which discovers that aesthetic satisfaction (and artistic achievement) can dispense with such conditions. This would bring us back to the close link between objectivism and classical doctrine. It would seem, I note in passing, that this paring down of internal criteria (which Harold Rosenberg describes as the "de-definition" of art)[104] goes a long way toward explaining the emergence, characteristic of the contemporary period, of the external, "institutional" and sociocultural criteria certain recent theories make so much of. When painting gives up the criterion of representativeness, poetry, that of formal rhythm, music, that of tonality (or modality), and so on, the upshot is that the public is deprived of a simple guiding feature that once allowed it to (or gave it the illusion that it could) identify an object, unaided and unerringly, as belonging to such-and-such an art specified in that way, and, consequently, as belonging to the arts in gen-

103. See Arthur C. Danto, "Introduction" to *Beyond the Brillo Box: The Visual Arts in Post-Historical Perspective* (New York: Farrar, Strauss & Giroux, 1992), pp. 15–27. However, when features of a definition are abandoned, the subtractive nature of the process is not always reflected in explicit generic designations. Thus, the addition of the feature "with chorus," introduced by Beethoven's Ninth Symphony, was tantamount to the elimination of an earlier, implicit criterion, according to which a symphony was, by definition, a purely instrumental work. In the titles of Mahler's works, the use of the human voice, having become a "variable" feature since Beethoven's day, is no longer mentioned.

104. Harold Rosenberg, *The De-definition of Art: Action Art to Pop to Earthworks* (New York: Horizon, 1972). Rosenberg also speaks, in connection with Rothko and his friends from the "the theological section of Abstract Expressionism" (Still, Newman, Reinhardt, Gottlieb), of "a kind of marathon of deletions—one of them got rid of color, another of texture, a third of drawing, and so on" (ibid., pp. 100–101).

eral. Faced with the resulting categorical uncertainty, the public has had small choice but to look elsewhere than to the object—for example, to supposedly competent "specialists" (critics, owners of art galleries, directors of museums, organizers of exhibitions or concerts, publishers, television and radio producers, etc.) for assurances that the object itself no longer provides. A meticulously painted and framed canvas representing a cheerful landscape or the Virgin and Child was received as a work of art on the authority of generic criteria of identification, which were, to be sure, culturally determined, but which had long since been internalized and become virtually instinctive. An unframed, monochromatic canvas does not automatically identify itself as a work of art: it could be a simple panel for hiding a safe or electricity meter (this holds a fortiori for the safe and the meter exhibited as ready-mades). For the purpose of orienting the novice viewer's attention in the direction the artist would like, a place in a gallery, with a label indicating the artist's name, a title, and a date, and the flattering or furious comments of a reputable critic, are not unwelcome. In its diverse variants, the "institutional theory of art" ("art is whatever the world of art decrees is art") is, plainly enough, the spontaneous theory of an art that has arrived at this (not necessarily terminal) stage of extreme asceticism in the utilization of the internal criteria of artistry. Such a description is not, from my point of view, in any way pejorative; the flaw in this theory, if it has one, consists in extrapolating well beyond the sphere to which it applies (much as classical "mimetic" theory extrapolated from an almost exclusive consideration of representative arts like literature or figurative painting), without being overly concerned to make the necessary—and doubtless sufficient—allowances and adjustments. For, in a word, it is true enough that the criteria "Virgin and Child," "sculpted in marble," "a love story," or "in G minor" were just as institutional in their own way; but *their own way* is no longer ours, in particular because the role of whatever institution might have been involved was integrated into, and thus concealed behind, generic affiliations that seemed to announce themselves for what they were—without visible interference by mediators (Aristotle, Vasari, Boileau, Diderot, Hegel, or Baudelaire, for example) whose teachings had long been assimilated.

This second type of adjustment or restructuring seems to me more frequent than the first, for a historical reason it is not hard to see. Rigid categories—which, because they resist extension through negative innovation, force innovators to make frank and open breaks with past practice—are characteristic of "classical" periods, in which artists themselves have little inclination to innovate (Corneille, the last great "baroque" artist in France, was not at all typical in this respect). The consequence is that the

question of contra-standard features does not, in general, arise in such periods. Conversely, the modern and contemporary periods, which look much more favorably upon innovation, are at the same time more flexible, thanks to their open-ended categories. Hence they are more inclined to integrate contra-standard features by extending generic limits. In this period, radically new categories, such as photography and cinema, arise, rather, on the basis of technological innovations so radical that the question of their generic relation to previous practice hardly comes up, "pictorial" photos and "filmed plays" notwithstanding. And even conceptual works, informed by an aesthetic principle that is, in my opinion, quite specific to them, are frequently classified on the basis of the ordinary categories comprising the objects that serve as their supports: they are divided up into plastic and visual arts (Duchamp, Warhol, Barry), music (Cage), paratheatrical happenings (Oldenburg, Burden), literature—but, after all, *A Void* is clearly a novel too, and I am the one who has assigned it to the category of conceptual art, one it never claimed to belong to, as far as I know. The only relatively autonomous categories I can think of are those of Earth Art*, Land Art*, and Cristo's monumental wrappings, whose constitutively ephemeral nature makes it difficult to annex them to architecture or the art of garden design; Mail Art* also belongs in this class, because On Kawara's postcards and telegraphic health reports can with difficulty be assimilated to the literary realm, if only because of the nature of their support. Again, the relatively gradual, continuous development of art over the past century and more makes it possible to accept as variable features properties which, if they had made a more abrupt appearance a few decades earlier, would have been rejected as contra-standard, or even as utterly absurd. In order to recognize, almost without hesitation, the monochromes of a Reinhardt or a Ryman as *paintings*, we doubtless had to pass by way of Monet, Gauguin, Matisse, Rothko, Newman, and others, as we did in the space of a few generations. And "concrete" music is, after Webern and Stravinsky, a bit less surprising than it would have been after Haydn and Mozart.

The history of jazz provides a rather nice illustration of the simultaneous existence of contra-standard properties and the varying tolerance of categories. Features like the rhythmic emancipation of the percussion section, or the diminished fifth, were initially received, it seems to me, as contra-standard, to the point of inspiring the creation, in the 1940s, of a new genre (or "style") known as bebop. Many musicians and critics attached to the tradition were quite simply of the opinion that the new genre "was no longer jazz." Then, in a few years' time, this new style consolidated itself in a typical idiom. The same thing nearly happened to "free jazz," which,

however, ultimately played itself out instead of becoming the new main-stream*—whence a return to (revival*) of bop, which today (but for how long?) seems indestructible. In the meantime, however, a new metamorphosis had come about with the emergence, *alongside* jazz "properly speaking," of the new music (which is not so new after all, because it derives, in its way, from the common source, the *blues**) known as *rhythm and blues** or (to simplify) *rock and roll**; it is characterized by, among other features, simpler harmonic language and pronounced binary rhythms. The first reaction of hard-core jazz musicians tended, once again, to be one of rejection, as is illustrated by an episode, authentic or not, of Clint Eastwood's *Bird*, in which we see a horrified Charlie Parker listening to one of his ex-companions playing trash of this sort. The scene takes place toward the end of Parker's life, in 1954 or 1955. But it would not be much more than a decade before there appeared—especially under the lead of Miles Davis, who had once played trumpet for Bird—the hybrid genre "jazz-rock," that is, precisely the kind of "fusion" Parker apparently would have considered unnatural. Yet today this hybrid takes its rightful place as a fully recognized "variable" on the spectrum of the various legitimate species of an art become, all in all, a rather eclectic or "catch-all" form: in some fifty years, it has sighted and captured any number of other kinds of music, including Afro-Cuban, samba and bossa nova, salsa, modal scales, three-beat or five-beat measures, and so on.

I have just examined the possibility of choosing between the terms "variable" and "contra-standard" to describe a more or less deviant feature. This is doubtless to reshuffle, to some extent, Walton's classificatory system, which I have already taken a few liberties with. Indeed, it seems to me that his tripartite scheme can be boiled down to the opposition between *generically determinant* and *generically determined* features. Generically determinant features are standard features, which, as we have seen, determine the assignation of a work to a category in which these standard features become aesthetically contingent, as if they went without saying in that category (in the case of a classical poem, being in verse; in the case of a painting, having colors). But generically contra-standard features also count as determinant features whenever they give rise to the creation of a new genre, a new category in which they promptly become standard—for example, in the case of a prose poem, being in prose. The contra-standard features of one category are, here, the standard features of another (new) category. As to the generically determined features, they are obviously Walton's variable features, which are optional, and therefore aesthetically relevant and active in the genre that accepts them: in the case of music, being in one or another key; in the case of a painting, being a portrait or

a landscape; in the case of a sonnet, consisting of six-foot, ten-foot, or eight-foot lines, etc. Charles Rosen cites a very eloquent example of the varying degrees of relevance, and even perceptibility, of one and the same feature, depending on the genre the work appears in: classical composers, he reminds us, were very well aware that certain effects, involving, for example, tonal relations, could only be appreciated by connoisseurs, and would necessarily be lost on the average listener. But in chamber music as it was *practiced* among musicians in this period, the listeners were, in principle, performers as well, and were necessarily more competent and attentive than ordinary listeners. "It is for this reason that subtle effects based on tonal relations are much more likely to occur in a string quartet or a sonata, written as much for the performers as for the listeners, than in an opera or a symphony, more coarsely if more elaborately designed. Haydn's last sonatas play with distant tonal relations, for example, in a way that he never attempts in the *London* Symphonies."[105]

I will come back to this (variable) distinction between levels of reception that vary with the receivers' degree of competence; but the example just cited seems to me both to illustrate and also to explain, on the basis of reasons that are, when all is said and done, empirical, the fact that aesthetic effects depend on genre, since here the difference in genre rests on a difference in practice. It would doubtless be easy to find parallel distinctions in other arts. Frescoes or wall paintings meant to adorn corridors and other often poorly lit passageways do not aim to produce the same effects as easel paintings; the metric and stanzaic subtleties of poems that are meant to be read would be wasted in classic tragedies, which prefer the relative transparency of rhymed hexameter couplets so as not to divert attention from what is, after all, the essential component of a tragedy—the dramatic plot.[106]

As we have seen, whenever a contra-standard feature extends an existing category instead of creating a new one, even if only temporarily, it becomes, not standard, but variable in this category, and therefore aesthetically active. Thus, once the categories "music" or "painting" have been definitively extended, "tonal" or "atonal," "figurative" or "nonfigurative" become aesthetic predicates applicable to a given work in these classes, just

105. Charles Rosen, *The Classical Style: Haydn, Mozart, Beethoven* (New York: Viking, 1971), pp. 299–300.

106. Until the advent of the "romanticist" demand for prose tragedy. "One of the things most opposed to these moments of illusion is admiration—however well-founded it may be—for the beautiful poetic lines of a tragedy." Stendhal, *Racine et Shakespeare* (Paris: Garnier-Flammarion, 1970), p. 60 [tr. *Racine and Shakespeare*, trans. Guy Daniels (New York: Crowell-Collier, 1962), p. 25].

as "having a happy ending" can be predicated of *The Cid* once it has been reintegrated into the genre "tragedy," which can henceforth be broken down into the more specific classes of tragedies with happy or unhappy endings. Contra-standard features thus seem to me, by definition, *transitory* characteristics, which are eventually reduced to the status either of variable features, with the extension of a generic category, or standard features, with a restructuring of the system. And, of course, the standard or variable nature of a feature depends on the scope of the category in which it is considered. Being figurative or nonfigurative, tonal or atonal, are (today) variable features in the general categories "music" or "painting," but they are (today) standard features, by definition, in the narrower categories of "tonal music," "atonal music," "figurative painting," or "nonfigurative painting." The distinction itself, then, is determined categorically, and a feature that is variable in a genre is always standard in one of its species — the species, precisely, which that feature determines. Indeed, Walton reminds us that a work may be "perceived" in several categories at once (I would say, rather, that it must be) when these categories are contained one within the other, or when they overlap: thus "a Brahms sonata might be heard simultaneously as a piece of music, a sonata, a romantic work, and a Brahmsian work."[107] The only cases of incompatibility have to do, of course, with logical exclusion: it is impossible, says Walton, to see the same image simultaneously as a photograph and a still from a film. It is likewise impossible, I would add, to classify the same work, even at different moments, as a sonata and an oratorio, and a fortiori as a sonata and a still life.

EARLIER, I INDICATED THAT I HAD RESERVATIONS ABOUT A phrase of Walton's which said that the categories in which works are "perceived" must themselves be "perceptually distinguishable," that is, accessible to perceptual differentiation.[108] My reservation is a matter of principle, because I do not think that things are perceptual or nonperceptual in themselves; I think they are such relative to the diversity of receivers and the occurrences or circumstances of reception. It is also an empirical reservation, for it seems to me that a large number of generically determinant properties have their source, as far as most receivers are concerned, in accessory information that no "perception," no matter how attentive, could ever yield. Whether *Momo* belongs to the category "promising first novel"

107. Walton, "Categories of Art," p. 341.
108. Ibid., pp. 339–340. But Walton himself seems to me to hesitate over this idea, which, he says in a note, it is hard to define precisely.

or "imposture by an old hand," whether one of Monet's *Rouen Cathedrals* belongs to a series that was originally meant to be considered as a whole,[109] whether such-and-such a measure in an indeterminate key occurs in a symphony by Haydn, where it has a humorous function, or in of one of Schoenberg's *Five Orchestral Pieces*, op. 16, where it does not provoke the slightest smile—these are not assignations that can be described as "perceptually distinguishable." Walton himself admits that these "perceptions" depend on culturally determined conditions, like previous knowledge, direct or indirect,[110] of other works in the assigned category and of the generic characteristics of this category, or like the context in which a work is presented. It seems to me self-evident that such conditions go well beyond simple "perceptual discernment."

This cultural dimension, which, inevitably, varies with individuals and historical periods, makes Walton's final recantation—I will, inevitably, call it Humean—unconvincing in my eyes. Here Walton goes to great lengths to avoid the categorical relativism that seems to me to follow from his analysis; he does so by looking for criteria capable of sorting into "true" and "false," correct and incorrect, the generic assignations that never cease to govern our interpretations and judgments of works of art. According to Walton, four kinds of criteria can be used to identify correct assignations. The first consists in assigning to a work the category in which it has the largest number of standard features; the second, in assigning to it the one that gives it the greatest aesthetic value; the third, in making the assignation which most closely reflects the artist's intentions; and the fourth, in making the one that most closely matches the classificatory norms of the period the work dates from. Walton is well aware that his first criterion is not very meaningful; it does not, he admits, "get us very far." He also clearly sees the risk that the third and fourth criteria will diverge in those typically contemporary cases in which an artist's innovative intentions and the settled habits of his contemporaries clash: Schoenberg conceived his first twelve-tone works as dodecaphonic, the majority of his contemporaries received them as, quite simply, cacaphonic. Doubtless it is necessary, in such cases, to choose the third criterion over the fourth. But there remains the second, whose subjective character is unmistakable; it threatens seriously to clash with the following two, taken separately or conjointly, and even with the first. Seeing Cézanne in the (retroactive) light of cub-

109. See Arthur C. Danto, *Embodied Meanings: Critical Essays and Aesthetic Meditations* (New York: Farrar, Straus & Giroux, 1994), p. 83.

110. "What we have heard critics and others say about works we have experienced, how they have categorized them, and what resemblances they have pointed out to us" (Walton, "Categories of Art," p. 341).

ism, reading Saint-Simon, Michelet, or Flaubert in the light of Proust, or, as Proust himself wished, reading Madame de Sévigné under the influence of Dostoyevsky, listening to Bach or Pergolesi under the influence of Stravinsky, or Debussy under the influence of Berlioz, are doubtless tendential modes of "rediscovering" or "rereading" that diverge from the intentions of the artists, the categories of their period, and even the statistically optimal distribution of their standard features—and yet these modes are such as aesthetically to "optimize," for those who apply them, the works in question. Let me add, all value judgments aside, that this is also, and doubtless always has been, the dominant mode of our relation to artworks: our classical authors frequently read the *Iliad* as a crude rough draft of the *Aeneid*. Walton's second "criterion" is certainly not, as he would wish, a criterion for the validity or "correctness" of assignations, which would, once established, count as actual generic affiliations; it is, at the individual and/or collective level, a reason for receiving a work in a certain way, one which is not particularly concerned with historical "truth," but itself belongs to what we today call the history of taste and reception, among other things. That the first criterion tends not to converge with the last two is doubtless a matter for historians of artistic production; the general convergence of all four criteria seems to me highly improbable, even if it happens that the knowledge of some people influences the judgment of others. One judgment of taste can be better informed or more enlightened than another; but that, to repeat, does not make it more "valid" or "correct."

Moreover, Walton concedes that there exist cases which are "undecidable" because they lie between established categories, if only in periods of transition, like the period between baroque and classical music, or impressionism and cubism.[111] But it is not only these limit cases which are affected by categorical ambiguity; such ambiguity may manifest itself every time two receivers, "mobilizing" different properties of the same work, assign these properties to different categories (stylistic or expressive, for instance), like Proust and Claudel in front of the *View of Delft*,[112] or, if Arthur Danto is to be believed, Alfred Barr and Leo Steinberg in front of the *Demoiselles d'Avignon*: Barr saw the *Demoiselles* as "a purely formal composition," Steinberg, as "a tidal wave of female aggression," a divergence that led Steinberg to wonder, not unreasonably, "Can we be looking at the same picture?"[113] The truth of the matter is that this "same picture" contains several features or clusters of features capable of eliciting several dif-

111. Ibid., p. 361.
112. See Chapter 1 above at note 77.
113. Danto, *Embodied Meanings*, p. 18.

ferent assignations, and therefore several different interpretations that are, not uncertain, but equally plausible, based as they are on "perceptions" that are equally correct, though doubtless incompatible at a given moment, like our perceptions of Jastrow's duck-rabbit. If the picture is on the stiff side for a bordello, it is a bit too orgiastic for a (pre-)cubist painting. It is, moreover, well known that the history of works, and of the arts, is a series of conflicting receptions, none of which may be regarded as the only "correct" one, since the same work "belongs" to several classes simultaneously: Caravaggio, naturalist and "Luminist"; Céline, populist and inventor of a "little style all his own" [*une petite musique*]; Stravinsky, cosmopolitan and so Russian. The function of aesthetics is not, here any more than elsewhere, to sort interpretations or judgments, or even generic (or other) assignations, into the "aesthetically correct" and aesthetically incorrect. Empirically, they can reflect one or another historical reality more or less faithfully, and thus be, to put it summarily, more or less *historically correct;* sometimes this can even be demonstrated. They are always, as it were, more or less influenced by (among other things) historical information that is itself more or less correct: the theoretical study of the conditions under which this influence is exercised seems to me to be (for once) the business of aesthetics, as the empirical study of those conditions is the business of the history of taste.[114] But the gulf between fact and value seems to me unbridgeable here too. Very obviously, judgments of taste are physiologically, psychologically, sociologically, culturally, and historically determined, and their determination by these factors merits study by aesthetics, among other disciplines; but what it is impossible to determine, and consequently to study, is their "aesthetic validity"—an expression I continue to consider contradictory. It would appear, then, that Walton is right to maintain, against Beardsley, that "genetic" data, whether technical or conceptual, influence artistic appreciation; he seems to me to analyze particularly well the generic conditions of this influence. But it also seems to me that he is, like Beardsley, wrong to set out in search of wholly objective criteria for these conditions. Or, if one prefers, he is right as far as his critique of formalist immanentism goes, but wrong to reject relativism. In sum, I do not believe that bringing out the fact that our interpretations and appreciations are historically and genetically relative in any way lessens their subjectively relative nature. Quite the contrary: everybody appreciates every single work in accordance with his own sensibility and, at the same time, his own way of structuring the field, and, therefore,

114. To illustrate this discipline, I can only again cite Haskell, *Rediscoveries in Art;* the book sheds a great deal of light on the (extremely variable) conditions of "rediscovery" in art, and the incessant fluctuations of attention, interpretation, and appreciation.

in accordance with his own place, as well as the place he assigns the work, in this field. Far from canceling each other out, these two relativizing factors, it seems to me, are cumulative and reinforce one another through reciprocal determination, converging in what might be called an artistic *disposition*. The incontestable fact that such dispositions are, to a large extent, historically and socially conditioned does not make them any less subjective. As Durkheim pointed out long ago, in a passage we have already cited, a collective subject is still a subject.

THUS WE ESTABLISH, WITH A PARTICULAR OBJECT, A RELATION that goes beyond—sometimes well beyond—its particularity, investing it with a transcendence that seems to me fairly specific to artistic productions or productions regarded as artistic. A whimsical gloss on the "style" ascribable to a sunrise notwithstanding, Goodman happily acknowledges that we do well to restrict the utilization of the notion of style, as a general rule, to works of art or performances of them,[115] where this notion is most relevant. The aesthetic relation to a natural object is certainly, as I have said, categorized on the basis of the object's generic affiliation (one usually appreciates a tulip as a tulip and a butterfly as a butterfly, not the other way around), but, by definition, it is not subject to the special type of categorization that depends on the historical nature of works, or their status as artifacts, and thus on their relation to other works by the same author, in the same genre, or from the same period or culture. This relation is always relevant, if to varying degrees, in that it presupposes an intentional community—individual or collective, conscious or unconscious— from which it is assumed to proceed. These thematic and/or formal constants and the variants they admit of in time and space authorize us to consider style (in the broad sense) as the set of "feature[s] . . . exemplified by the work . . . that contribute to the placing of the work among certain significant bodies of work."[116] The sets involved here are multiple, since a work always belongs to several intentional classes at once (Picasso's style, Picasso's Blue Period style, French style, twentieth-century style, Western style, etc.).[117] As everyone knows, the study of these sets, of these constants and variations, holds an important place in the history, criticism, and theory of the different arts and their synchronic as well as diachronic interrelations; at least since Riegl and Wölfflin, it has provided matter for untold

115. Nelson Goodman, "The Status of Style," in *Ways of Worldmaking* (Indianapolis: Hackett, 1978), p. 36.
116. Nelson Goodman, "Routes of Reference," in *Of Mind and Other Matters* (Cambridge: Harvard University Press, 1984), p. 131.
117. Ibid.

descriptive tables, explanatory hypotheses, cyclical or developmental principles, comparisons between antithetical tendencies, methodological controversies, and so on.[118] The details of this discipline obviously do not concern us here, but the fact that it exists provides a good illustration of one characteristic feature of the artistic realm, the endless, multiform relations that connect works with one another—a network whose presence and powerful effects the most naive student of the arts cannot fail to sense, however dimly. The world of art is not a collection of autonomous objects, but a magnetic field of reciprocal influences and activations.

Levels of Reception

The relativization of appreciations through reference to all kinds of genetic, generic, and stylistic categories is far from always being a conscious, thought out process. When I admire a cubist painting, a Beethoven sonata, a Western, or a detective novel, I do not necessarily internalize and thematize the fact that I appreciate this object *as* a cubist painting, *as* a Beethoven sonata, *as* a Western or detective novel, even if that is generally the case. The features which, standard in various ways (and restrictive in various ways), orient me toward these categories are, precisely, standard enough to guide me without my becoming conscious of the fact: they guide me, as it were, "automatically," in the sense in which one speaks of an "automatic pilot." The assignations which involve the greatest amount of reflection are doubtless those based on accessory information, such as that provided by paratextual (generic, thematic, or historical) indications,[119] and, conversely, those bearing on the most doubtful cases—which sometimes remain, for that very reason, "undecidable," refractory to all assignation. Here as elsewhere, it is the effort we make to overcome a difficulty that makes us conscious of things, and allows us to recognize that

118. For a lucid treatment of this question, see Meyer Schapiro, "Style," in *Theory and Philosophy of Art: Style, Artist, and Society* (New York: George Braziller, 1994), pp. 51–102. Schapiro's discussion is of course restricted to the sphere of the visual and plastic arts, but Rosen's *The Classical Style* provides a perfect illustration of the same kind of study in musicology.

119. Here I am obviously extending the concept of paratext (*Seuils* [Paris: Seuil, 1987] [tr. *Paratexts: The Thresholds of Textuality*, trans. Jane E. Lewin (Cambridge: Cambridge University Press, 1992)]) to all the arts, in which many different kinds of indications, provided by titles, prefaces, and other official or semiofficial commentaries, come into play to one degree or another.

difficulty in the first place. In principle, nothing is more intense than the attention aroused by a test we take "blind," but the kind of attention such a test calls for is typically selective. Someone asks me who wrote a given poem, so I try to identify its author; someone asks me what key a piece is in, so I try to identify the key, etc.—whence, as I have already noted, the often disappointing nature of these tests, which diminish the artistic relation by focusing our attention too narrowly. But the degree of consciousness is not the most relevant aspect of this phenomenon: the important thing is the impact, perceived or not, that these conceptual references have on our appreciation of works. It may be described in the logical terms of Sagoff's analysis, which must itself be expanded beyond the notion of "two-place predicates": if aesthetic predicates imply, in general, an appreciation that is simultaneously descriptive and evaluative, of the type "flowing + agreeable = gracious," and if artistic predicates add to this elementary relation a conceptual reference, of the type "in such-and-such a generic, historical, etc. context," it goes without saying that the great diversity of contexts entails a great diversity of references, making the content of every act of artistic appraisal a predicate (implicit or explicit) that has *many more than two* places. For me, and not my neighbor, a given painting is warm, not frigid, a still life, not a portrait, analytical cubism, not impressionism, a Picasso, not a Braque, and so forth. I spoke in Chapter 1 of "attention without identification," indicating that it was characteristic of an aesthetic attitude innocent, as it were, of any extraperceptual consideration (or else constrained to make do without any kind of extraperceptual information). I added that such a situation (Courbet contemplating an unidentified object) was quite rare and could only be prolonged rather artificially. It is not often that we have "no idea" of the sort of object we are dealing with (Courbet perceived, at a minimum, the form and color of the object at the other end of the field, and must have been fairly sure that it was neither a ship nor a cathedral). Moreover, we only rarely refrain from trying to find out more very soon. I call attention of this type "primary," and define it as the minimal degree, or even the degree zero (which suggests that it is more a hypothetical than a real limit) of identification; the type of judgment it can give rise to ("I don't know what that is, but it is very beautiful," or "very ugly") I call "primary appreciation." *A contrario* (if I may put it that way), I use "secondary" to describe the types of attention and appreciation that are in part based—consciously or not, spontaneously or not, as a result either of individual initiative or of cultural influence or immersion—on indices or information capable of assigning the "perceived" object a genetic or generic context, and thus of as-

signing appreciation one or another frame of reference. I use these adjectives, of course, on the authority of the example of Panofsky's that I have already cited.[120] I have, however, simplified his terminology (and watered it down somewhat), in that I use, more or less indifferently, "primary" or "aspectual" to refer to what he merely designates as "formal," and summarily call "secondary" everything he subdivides into "primary (or natural) meaning, secondary (or conventional) meaning, and intrinsic meaning (or content)." What justifies this simplification is the fact that we do not here need to enter into the details of iconic signification, which are of course not relevant to all the arts. Yet it would doubtless be possible to find approximate equivalents on the verbal and, consequently, literary level: for example, primary attention would there consist (this is surely the bare minimum, and does not yet involve *reading*) in perceiving the outward aspect of a word (*flame*); secondary attention, in identifying its literal meaning ("a flame") and, beyond that, its figurative meaning ("love"), followed by its generic connotation (poetry). Similarly, in music, primary attention would consist in hearing a diminished fifth; secondary attention, in identifying it as a diminished fifth and then, possibly, in assigning it the (stylistic) value of modern jazz, etc. We could, while we are at it, enrich (or overburden) this terminology by utilizing the adjectives *tertiary*, and so on, but the level of analysis required here does not seem to me to necessitate these subdivisions.

I noted earlier, in expressing my approval of a phrase of Jean-Marie Schaeffer's, that these genetic or generic references seem to play a more active role in the appreciation of artworks than in that of natural objects. Here, however, it is necessary to spell out the nature of this distinction. The graduated differentiation of primary and secondary receptions (attention and appreciation) may help us to do so by allowing for a significant, albeit supple, relation between types of object and types of reception. If primary reception is more "innocent," while the various kinds of secondary reception are more "informed," in the twofold sense suggested earlier, by a consideration of the referential context, it seems clear that the aesthetic relation to natural objects is usually more primary than the relation to works of art—though these correspondences are not absolutely

120. Erwin Panofsky, "Zum Problem der Beschreibung und Inhaltsdeutung von Werken der bildenden Kunst," *Logos* 21 (1932): 103–119, and *Studies in Iconology* (New York: Harper and Row, 1967). On this complex semiotics, see Robert Klein, "Considérations sur les fondements de l'iconographie," chap. 16 of *La forme et l'intelligible* (Paris: Gallimard, 1970) [tr. "Thoughts on Iconography," chap. 8 of *Form and Meaning: Essays in the Renaissance and Modern Art*, trans. Madeleine Jay and Leon Wieseltier (New York: Viking, 1979), pp. 143–169]. Klein rightly adds another stylistic determination to this system—the case in which "the style indicates how the significant terms must be read" (ibid., p. 369 [tr. p. 156]).

rigid. Here we are still in the realm of "symptoms" and contributing factors, rather than that of necessary and sufficient conditions: if Babar is graceful *for an elephant*, the Matterhorn graceful *as a mountain*, and the song of Kant's nightingale charming *on condition that it is authentic*, then such two-place predicates are not those of an appreciation that is primary in the full sense. Nature is thus not a mine of unidentified aesthetic objects which we never can identify. Yet it seems to me indisputable that works of art, as artifacts with an (intentionally) aesthetic function, raise in a more urgent, because more relevant way, the question of their generic affiliation and genetic provenance—and, in particular, their historical provenance, since a human product is always, by definition, a historical object, whose intentionality is historically situated and defined. This last feature is one that artworks obviously have in common with all other artifacts, but, in the case of (presumed) artifacts devoid of aesthetic intention (the ancient *tribulum* that I hang on my wall because of the beauty of its form and the material it is made of), such historicity is not necessarily taken into account by aesthetic appraisal, since that appraisal treats the artifact as if it were a natural object, or, more precisely perhaps, *as it would treat a natural object*. I doubtless have a purely attentional aesthetic relation to this *tribulum*, of the same type as the one I would have to a rock or gypsum flower; it is without reference to an aesthetic intention, about which I know nothing, or a practical function, which I ignore. If I treated my *tribulum* differently, it would mean that I (rightly or wrongly) regarded it, to some extent, as a work of art, that is, as an artifact with an intention at once functional and aesthetic—as one of those mixed objects that Panofsky mentions, as we saw earlier.

A human artifact is not merely an object; it is also an *act*, and is therefore intentional, like any act. I mean by this not only that such an object is the result of creative or transformational activity (that is self-evident), but also that it is the site and means of an action. In the case of functional artifacts, this action bears mainly on the physical world, and is of a practical kind. In the case of artworks, it bears on a "public" of receivers, local or distant, known or unknown, real or hypothetical (in any event, the artist himself is one of them; he is, as is often and rightly said, his first and sometimes only "judge"); and it is of an "aesthetic" kind—in the sense, here, that it elicits, or at any rate solicits, an aesthetic reaction, if possible favorable. Undoubtedly the receiver can, to repeat, treat this work as a simple "aesthetic object" (especially when he does not notice its artistic character); a response of that sort is very close to what I call a primary relation. But he can also take into account, to one degree or another, the presence of an aesthetic intention; as soon as he does, he finds himself entering the

infinite spectrum of secondary relations, defined by, among other things, the "categories of art" Walton identifies. What I might know about botany, geology, or astronomy does not matter as much, or at least for the same reasons, in my aesthetic appreciation of a flower, landscape, or the heavenly "vault," because I know that the long, intertwining chains of causes that have issued in the *Beschaffenheit* these objects confront me with did not have my contemplation and appreciation as their final objective.[121] In contrast, the history of art, in the broad sense, together with everything this notion implies or symbolizes, does matter in my appreciation of a work, as long as I consider the work to be, and treat it as, an artwork. Renan's dictum—I have lost the reference—powerfully condenses this idea: "True admiration is historical."[122] "Historical," I would add, in a twofold sense: by virtue of the situation of the receiver himself, but also by virtue of the situation he ascribes to the work he admires—or detests. A single example (yet another) may be cited to illustrate this fact: my evaluation of an impressionist painting that depicts a bank of the Seine will differ radically, depending on whether I am told that it dates from 1874 or last year. Given my attitude toward painting, which I approach with the history of painting in mind, a figurative work of this kind cannot satisfy me unless it originates in a more or less distant past: on the one hand, I like paintings of landscapes and the impressionist style, but, on the other, I believe that impressionism has seen its day, and that it is of no artistic interest to produce impressionist pictures today. (If I were told that the painting dated from the eighteenth century, my reaction would be a mixture of incredulity and "admiration" in a very different sense of the word.) Moreover, my attitude here holds for all human productions considered with respect to their artistry: from a purely practical standpoint, but from a "purely aesthetic" one as well, I take very little interest in, for example, the age of a Louis XIV commode obligingly placed in an elegant guest room; the date it was made begins to matter to me (an original piece, perhaps signed by Boulle, or a good Second Empire copy?) only if I come to consider it as a work (as an "objet d'art"), taking into account the intentional meaning (among others) of the act that produced it. This contra-

121. On the aesthetic relevance of "geographical explanations" and their positive contribution to Julien Gracq's appreciation of landscapes, see Gracq, "Entretien avec Jean-Louis Tissier," in *Œuvres complètes*, vol. 2 (Paris: Pléiade, Gallimard, 1978), pp. 1193–1210. Gracq notes, however, that the geography he practiced as a specialist was still in its empirical, qualitative stages, and, as such, closer to the common relation. For him, as he spells out elsewhere (ibid., p. 1232), what was involved was a kind of "morphology: the study of the forms of a terrain." We are not very far here from Wölfflin's conception of the history of art.

122. The word "admiration," which, as I said earlier, applies in the full sense only to human productions, is altogether relevant here.

diction between a "naive" primary appreciation and a profoundly histori-
cal appreciation may seem to have a certain absurdity about it, but it is a
fact, and anyone who has business with an art as such has occasion to
experience the same sort of thing. Robert Klein has given a good descrip-
tion of

> this "historicization" of the value incarnated in works, this "descent" of
> formerly absolute artistic value to a "value of historical position," [which
> locates] the exemplary value of an artist [or of a group or period] in what
> is known as his contribution, and sometime merely in the trajectory of his
> development, rather than in the aesthetic quality of his works considered
> in isolation. [This makes] it difficult, if not impossible, to judge a work
> without knowing "where it comes from." What would Brancusi's egg be
> without all of its history, without all of Brancusi? . . . We have almost un-
> consciously acquired the habit of historicizing every new object [and every
> old one as well], and of always taking in the developments leading up to it
> with a quick, comprehensive glance, judging it according to its richness,
> synthetic power, and innovativeness, according to the difficulty of the
> problems it attacks, and the accuracy and audacity of the solutions it offers.
> Without any doubt, these are aesthetic criteria in such a context; by the
> same token, purely historical considerations of date and priority become
> artistically relevant.[123]

Once again, however, we must relativize this relativism. As everybody
knows, this view of historical perspective is of fairly recent date; it does not
go back much further than the nineteenth century. In large measure, the
aesthetic of classicism presented itself as ahistorical. It accepted, of the
past, only that which harmonized with its present, conceived as atempo-
ral: thus it accepted antiquity as revived and reinterpreted by the Renais-
sance, but not the Middle Ages ("Gothic"), nor the recent baroque, which
was speedily repudiated, at least in literature—and in architecture: one has
only to think of the reception given Bernini's projects for the eastern fa-
cade of the Louvre. The romantic aesthetic, which was in principle more
historicist, but no less partial as far as values were concerned, tended rather
to hark back to the Middle Ages, ignoring classicism, which had been re-
pudiated in its turn. We are doubtless poorly placed to see, today, our own
biases and the distortions they give rise to—but we should, at least, admit

123. Klein, "Considérations sur les fondements de l'iconographie," pp. 408–409. In this
context, we would do well to recall Wölfflin's famous remark to the effect that, in art, "not
everything is possible at all times." See Heinrich Wölfflin, *Principles of Art History: The Prob-
lem of the Development of Style in Later Art*, trans. M. D. Hottinger (New York: Dover, 1952),
p. 11. See also Wölfflin, *Gedanken zur Kunstgeschichte: Gedrucktes und Ungedrucktes*, 4th ed.
(Basel: Benno Schwabe, 1946).

that they exist in theory. Because history, individual or collective, is any-thing but a homogeneous, continuous temporal flow, every period has a specific vision of the past, which is often auto-teleological (consider Vasari, or, in more complex, "dialectical" fashion, to be sure, Hegel), and depends on its own paradigms as much as on its objective place in time. In a study of the relations between the Renaissance and its medieval precursors, Panofsky strikingly describes a characteristic difference between the me-dieval and the Renaissance relationship to antiquity:

> The Middle Ages had left antiquity unburied and alternately galvanized and exorcised its corpse. The Renaissance stood weeping at its grave and tried to resurrect its soul. And in one fatally auspicious moment it suc-ceeded. This is why the mediaeval concept of the Antique was so concrete and at the same time so incomplete and distorted; whereas the modern one, gradually developed during the last three or four hundred years, is comprehensive and consistent but, if I may say so, abstract. And this is why the mediaeval renascences were transitory whereas the Renaissance was permanent. Resurrected souls are intangible but have the advantage of immortality and omnipresence. Therefore the role of classical antiquity after the Renaissance is somewhat elusive but, on the other hand, perva-sive—and changeable only with a change in our civilization as such.[124]

Thus, in the Middle Ages, the inhabitants of Rome lived amidst the ruins of ancient Rome in an obscure, yet familiar and everyday, relation of closeness to and continuity with the past of which these ruins were the trace. Sartre has a description of them somewhere, "wandering about in a town which was too big for them and which was full of departed splen-dor, of wonderful and mysterious monuments which they could neither understand nor remake and which seemed to them to be evidence of the existence of ancestors who had been wiser and more able than they."[125]

124. Erwin Panofsky, *Renaissance and Renascences in Western Art* (New York: Icon Edi-tions, Harper and Row, 1972), p. 113. One of many literary illustrations of what Panofsky de-scribes as a distorted "concept" is provided by the culminating twelfth-century avatar, in the guise of Benoît de Sainte-Maure's *Roman de Troie*, of the Homeric epic, which was then un-known in its original form, but had been handed down over the centuries through a succes-sion of (serious) parodies. Again, pre-Romanesque and Romanesque architecture testify, in their fashion, to a living continuity with the heritage of antiquity; they did not have to "re-discover" it in order to derive from it in the empirical sense.

125. Jean-Paul Sartre, *Baudelaire* (Paris: Gallimard, 1947), p. 193 [tr. *Baudelaire*, trans. Martin Turnell (New York: New Directions, 1950), pp. 167–168]. Sartre casually attributes this description to "Gebhart, I believe." He may be thinking of Émile Gebhart, *Les origines de la Renaissance en Italie* (Paris: Hachette, 1879), the fourth chapter of which fleetingly evokes scenes like those Sartre depicts—even if they appear rather less tragic in Gebhart. Sismondi has a strikingly similar lament over the cities of the Renaissance, fallen into ruins in their turn at the beginning of the nineteenth century, deserted or else haunted by a poverty-stricken population incapable of recognizing them for what they once were. "One feels . . . that [such

This situation must have lasted, all in all, until the Quattrocento, when the heirs of the medieval Romans[126] abruptly broke with this blind familiarity in order to "understand and reconstruct," to repossess at a distance and reproduce in their own fashion what they took to be the essence of antiquity, an essence they in many respects defined themselves in line with their own preferences—even if their image of this antiquity has hardly been modified since by a (gradually globalized) Western civilization which has remained overwhelmingly faithful to their choices. The ruins of antiquity have become archeological remains, artistic models classified and protected by an "intangible" cultural showcase which is, moreover, being progressively enlarged to take in the entire historical heritage—a heritage that tends to be withdrawn from actual use to the extent that it is assimilated to the sacrosanct "cultural legacy." Thus we are today witness to the fact that, on a smaller scale and at a brisker tempo, the decades (the fifties*, sixties*, seventies*) are one by one peeling away from the evolutionary continuity of a tradition in order to constitute themselves as items that can be picked out of a repertory *ad libitum*, as, perhaps, the years, etc., soon will be; in a repertory so constituted, the "values of position" identified by Klein once again become, paradoxically, atemporal, absolute values. Thus, by means of alternating revivals*, historicism transforms itself into eclecticism, perhaps negating itself in the process, a movement already clearly manifested in the styles of late nineteenth-century architecture (neo-Gothic for a library, neo-Tudor for a country house, neo-Renaissance for a town hall, neoclassical for a museum, and so on), and also evinced, in a certain way, by the nostalgic [*rétro*] taste known as postmodernism, from the architect Philip Johnson to the musician Wynton Marsalis. But, fortunately, it is probably too early to declare with confidence that this "posthistorical" neo-eclecticism is in the process of furnishing the centuries to come with an aesthetic à la carte, as Arthur Danto often suggests

cities were] the work of a great people, and that this great people is no longer to be found anywhere" (J. C. L. Simonde de Sismondi, *Histoire des républiques italiennes du Moyen Age*, 16 vols. [Paris: Treuttel et Würtz, 1826] [tr. *A History of the Italian Republics* (Magnolia, Mass.: Peter Smith, 1990)], cited in Francis Haskell, *History and Its Images: Art and the Interpretation of the Past* [New Haven: Yale University Press, 1993], p. 215).

126. Who were, moreover, mainly Florentines, as if the cultural shock of a "voyage to Rome" were required to call up this "nostalgic vision born of estrangement as well as a sense of affinity—which is the very essence of the Renaissance" (Panofsky, *Renaissance and Renascences in Western Art*, p. 212). To be sure, these summary formulations tend to simplify an analysis that is more nuanced in its details. Panofsky is not blind, for example, to the influence "pre-Gothic Tuscan buildings like San Miniato and the Badia at Fiesole [had] on Brunelleschi" (ibid., p. 175). Robert Klein goes further, affirming that Brunelleschi was "closer to early Christian or even Romanesque architecture than to Antiquity" (Klein, "Considérations sur les fondements de l'iconographie," p. 215). The two relations to antiquity, though distinct, are not absolutely exclusive of one another.

with a satisfaction tinged with sadism—"the end of art" for "an end of history" in "the form of a kind of philosophical Club méditerranée [or Disneyland?]" writ large . . .[127]

OBVIOUSLY, THEN, OUR RELATION TO WORKS OF ART INCLUDES what I call (for what the term is worth) *levels of reception*, levels which nothing obliges us to arrange on a scale of values, but which are doubtless quantitatively distinguished by the degree of consideration each gives to the perceptual data (primary attention) and conceptual data (secondary attention) characteristic of each work. As I have already said, and as everyone knows from his own experience, we can appreciate an object on the basis of more or less intense perceptual attention, even if the emotional intensity of our appreciation is not necessarily proportional to the intensity of our attention, which is, for its part, *cognitive*. Variations in the intensity of our attention can, however, cause variations in our emotional response: I do not appreciate the same object in a constant, uniform manner, and the autonomy of aesthetic appreciation is by no means a guarantee of stability. If appreciation is conceived as the resultant of an interaction between subject and object, this resultant is necessarily variable, since, on the one hand, the subject never ceases to change, while, on the other, quantitative and qualitative variations in his attention entail as many variations in the object *qua*, precisely, attentional object: I never consider the same thing the same way twice, nor, in this thing, the same aspect—the same object. This is, to be sure, a very rough description of the relation, but it seems to me that a more refined description would only confirm my observation. Despite the shifting nature of these phenomena, one can doubtless affirm that certain forms of perceptual attention are more complex than others, in the sense that they take a greater number of aspects into account.[128] Again, it seems to me that considering extraperceptual information, generic or genetic, introduces a new series of factors into our relation to a work; they tend to complicate that relation by multiplying the number of features to be considered, and also by situating and naming those features with reference to the range of technical specifications the work is situated in. Thus, E. T. A. Hoffman offers the following analysis of an effect pro-

127. Arthur C. Danto, *The Philosophical Disenfranchisement of Art* (New York: Columbia University Press, 1986), p. 113.

128. When Schaeffer says that our appreciation of Richard Strauss's *Zarathustra* will not be "optimal" if we do not take its thematic program into account, I believe it is in this sense that he should be understood. The same could certainly be said of a contemplation of *The Last Supper* which failed to consider its iconographic program. Receptions of this sort are artistically incomplete, though they cannot be called artistically inferior—an affirmation that would be simply meaningless.

duced by a modulation in act 2, scene 3 of *Don Giovanni*: "When . . . the statue of the Commendatore sounds his terrible 'Sì' ['Yes, I am coming'] on the tonic E, but the composer now takes this E as the third of C and thus modulates to C major . . . no layman in musical matters will be able to understand the technical structure of the transition, but in the depths of his being he will tremble with Leporello."[129]

Hoffman adds that the trained musician will pay no more attention than the layman to this "technical structure," which for him is obvious, and, consequently, transparent: "he will thus find himself in the layman's position." Perhaps because I do not have the required level of competence, I do not find that last phrase very convincing. It seems to me rather that, in this situation, the layman (I am assuming he is attentive) "hears" the same chord as the musician, together with the abrupt shift in key that it precipitates, but that the musician has simply to pay attention in order to "perceive," in addition, the kind of harmonic phenomenon involved, while the layman only perceives the dramatic effect. Both listeners hear an abrupt modulation toward C major, but only the musician identifies it as such, since he brings to bear on it a range of technical specifications that the layman is by definition ignorant of. In short, both hear the modulation, but only the musician knows that it is one, which one it is, and what it represents in the range of technical options available to the composer.

In my opinion, this example illustrates the difference in level that can separate two receptions (primary and secondary) of the same piece of music. Its artistic content is not identical for the two listeners, inasmuch as one identifies the cause of that whose effect alone is experienced by the other. If we assume that Mozart introduced the modulation primarily in order to produce this dramatic effect, as is highly likely, we can assuredly regard the layman's reception as "sufficient," and therefore by no means inferior to the musician's; but the fact remains that the musician's reception takes in more features of the artistic phenomenon in question (assuming that attention to technical matters does not curtail one's ability to interpret the drama), thus taking the phenomenon more fully into consideration. The relation to musical works in general provides one long illustration of this extreme diversity of receptions varying as a function of the receiver's degree of competence: one can perfectly well appreciate a fugue without following the movement of, and the relations between, its parts; a sonata, without perceiving the succession of themes, changes in key, or the whole apparatus of developments and recapitulations; a piece of serial music without identifying the series; a jazz chorus without recog-

129. Cited in Rosen, *The Classical Style*, pp. 309–310.

nizing the chord changes of the theme in it, and so on. This kind of primary appreciation is not a whit inferior to the appreciation which results from secondary reception based, to some extent, on technical competence: every act of appreciation is, as it were, plenary, taking up all the emotional space that a relation to the attentional object offers. If I perceive a learned, complex work "naively," or even if I have a partial perception of a work because certain of its aspects remain concealed from me (without my knowledge),[130] my appreciation is still brought fully to bear on my attentional object, and is not marked by any emotional lack. I appreciate what I receive, and the fact that others perceive and/or know more of it, perhaps in closer conformity with all of the author's intentions or the realities of his cultural context, in no way detracts from the relation obtaining between my attentional object and my emotional response: everyone appreciates his own attentional object according to his own taste, and the intensity of his appreciation is in no way proportional to the number of features, perceptual or conceptual, entering into the definition of that attentional object. If we assert, somewhat summarily (but with a high degree of probability), that the attentional object of a relation of the secondary type (for example, the *Hammerklavier* Sonata as heard and analyzed by a professional like Charles Rosen) is more complex, and probably in closer conformity with the composer's artistic intention, than is the attentional object of a lay listener, we must nevertheless beware of treating Rosen's appreciation as qualitatively "superior" to the layman's, and so declaring the first, à la Hume, to be a "better judge" than the second. We must do so for the simple reason that, to put it in a nutshell, these two listeners do not "judge," and, to begin with, do not receive—or rather (as Danto puts it)[131] do not *constitute*—the same attentional object, that is, the same work, from the same object of immanence. Such is the meaning we can attach to Duchamp's bon mot: "Paintings are painted by those who look at them."[132]

Of course, that remark applies equally well to developments of the

130. I say "without my knowledge," because awareness of the partial nature of a reception, whatever the reasons for it, never fails to affect our appreciation of the fragment we do perceive. I appreciate the *Venus of Milo* for what it has become, and, at the same time, I wonder about what is missing from it (and what I am missing); my appreciation is in some sort deranged by my awareness of this lack. If I am not aware that there is something missing, or if I manage to forget the matter altogether, my relation to the fragment becomes as full as my relation to an intact (or, like the busts of antiquity, constitutively partial) work.

131. "Until one has constituted the work, as the phenomenologists use that expression, to what is one responding aesthetically?" Danto, *The Transfiguration of the Commonplace*, p. 104. Of course, this obviously does not always prevent one from responding, without knowing what one is responding to.

132. Duchamp, *Duchamp du signe*, p. 247.

kind that can change the relation one and the same receiver has to a work over his lifetime, or even in the course of a single encounter with the work, as long as that encounter provides the occasion for an increase in the quantity of perceptual and/or conceptual data. A prolonged relation to a work as vast and complex as a Gothic cathedral, for example, consists, in most cases, in a series of relations to the whole and its details; every attentional moment in this process is added to the sum of all the previous ones, completing and, possibly, modifying them, and giving rise, at each stage of the process, to a partial appreciation whose ultimate synthesis, if such a synthesis is made, will doubtless diverge considerably from the "first impression"—even if only to confirm it. Very obviously, after an hour's exploration, the attentional object that I have gradually constructed concerning the Amiens cathedral, or with the Amiens cathedral as my point of departure—an attentional object that is the object of my appreciation at that point—is not identical with the object of my initial contact and appreciation. If I make the "same" Ruskinian pilgrimage every year, each of these occurrences will be the occasion for a new perceptual construction, perhaps enriched by new information and accessory commentary—technical, historical, stylistic, ideological, etc.—like, precisely, that which a reading of Ruskin, among others, makes available.[133]

The example may seem too pat, since a work like the Amiens cathedral, its relative historical homogeneity notwithstanding, consists in a particularly complex set of partial works integrated into the whole to very different degrees. In fact, the same remark applies to objects that are, in principle, simpler—although this kind of difference is easier to talk about than to gauge—like a painting or a single movement of a sonata. What I perceive of the *View of Delft* after looking at it for a few minutes, or after reading a page of Proust, Claudel, or Kenneth Clark, like what I perceive of the first movement of the *Hammerklavier* Sonata after a few attentive listenings, informed, perhaps, by my reading of an analysis such as that of Romain Rolland or Charles Rosen, is not, of course, what I initially perceived of the painting or the movement. Nor will my appreciation be the same, even if I can express it, summarily, in the same "judgment," simply by virtue of the fact that it will no longer bear on the same attentional object. I do not believe it is still necessary, at this point, to defend the adjectives (however approximate they may be) "primary" and "secondary," which I am applying to these two levels of the aesthetic relation; the lat-

133. John Ruskin, *The Amiens Bible*, in E. T. Cook and Alexander Wedderburn, ed., *The Works of John Ruskin*, vol. 33 (London: George Allen, 1908), pp. 3–187. It should be noted that this text concentrates on the sculptures of the portal rather than the architecture of the cathedral.

ter, undoubtedly, includes more features, perceptual and conceptual, than the former. To come back to a case I have already alluded to[134] in discussing the transcendence of works, it is perfectly possible for our aesthetic relation to a single version of a work with plural immanence, such as *Saying Grace* or *The Temptation of Saint Anthony*, to be "plenary" and "sufficient," since that relation—primary, in this special sense—generally limits itself to the object (a painting, a text) it invests. However, the artistic relation to these plural works is plainly not complete until all of their versions have been taken into account.[135] Aesthetically, one *Saying Grace* may be enough to provide me pleasure (and it suffices for the majority of art lovers); artistically, this relation is insufficiently informed, and almost[136] as incomplete as my contemplation of only one panel of *The Battle of San Romano*. A version, like a fragment or a "detail," can be regarded as sufficient *qua* aesthetic object, but not as an *artistic* object. Moreover, given the inextricably tangled web of relations that go to make up the world of art, no work is sufficient unto itself in this regard, and no work contains itself in itself: the transcendence of works knows no limits.

THE RELEVANCE AND MEANINGFULNESS, FOR THE ARTISTIC RELATION, of "secondary" information of whatever sort (conventional meanings, technical procedures, etc.) introduces into this relation an element that is at once cognitive and emotional, which we can designate with a term bequeathed us by the *Critique of Judgement*, though not without considerable ambivalence: the term "interest." I do not need to recall that Kant declares aesthetic satisfaction to be "independent of all interest," even if, as we saw at the beginning of this chapter, the aesthetic relation to a natural object (a flower, a nightingale's song) is constantly described, in the *Critique*, as involving interest. In both cases, the German word is *Interesse*, a word that, in fact, provides the key to the whole of §42, entitled, precisely, "The intellectual interest in the beautiful." The adjective "intellectual," together with "immediate," which we have already come upon here and there, suffices to distinguish this kind of interest from the kind (more practical and sometimes, as we have seen, of the order of social vanity) from which Kant, at the very beginning of the *Critique*, exempts aes-

134. See Genette, *L'œuvre de l'art*, chap. 11, pp. 187–238 [*The Work of Art*, pp. 163–210].

135. The following empirical test illustrates this incompleteness: if I declare that I have read the *Temptation* (a work that exists in more than one version), I will very likely be asked, *which one?*, a question I am probably less likely to be asked if I declare that I have seen Rodin's *The Thinker*, an autographic work with multiple exemplars.

136. "Almost as much," because the mode of integration of the scattered versions of a plural work into a whole is obviously not the same as the mode of integration of the scattered elements of a composite work, such as a triptych.

thetic relations. As the fable about the nightingale makes clear, it is only possible to show interest of this kind in natural objects, on Kant's view; moreover, the "intellectuality" of such interest has a strong moral connotation, given the moral nuance which, in Kant, the relation to "natural beauty" alone carries. It is precisely this relation to "natural beauty" which is the subject of §42. To put it more simply, the "intellectual interest" that natural beauty, and natural beauty alone, is said to awaken, is in fact a *moral* interest, for reasons inherent in Kant's general philosophy that are none of my concern. Thus it is merely the *word* I borrow here,[137] in order to designate a feeling that is entirely different in nature, and an object that is perhaps still more so, since, unlike Kant, I apply it more specifically to our relation to works of art than to our relation to natural objects. The distinguishing feature of artworks, the fact that they are at once aesthetic objects and technical objects produced in the course of human history, general awakens curiosity about them; even in the case of the simple art lover, this curiosity is obviously of a cognitive, or even scholarly-scientific,[138] kind. Beyond pure appreciation, and owing, precisely, *to* this appreciation, one feels a desire to "know more" about works, sometimes more than is aesthetically necessary or relevant—about their details, the processes of their production, the circumstances and stages of their creation, their historical context, their generic "affiliation," and so on. The satisfaction, or even the mere existence, of this desire, yields, in its turn, an incontestable *cognitive pleasure* which Goodman gives a good account of—and which leads him to say in so many words, rightly and wrongly at the same time, that aesthetic emotion is at the service of cognition. In order to appreciate the nave of a cathedral aesthetically, I do not first of all have to ask whether it is two, three, or four stories high, or if it has a barrel vault, groins, intersecting ribs, pointed arches, cupolas, etc.; indeed, many art lovers content themselves with an emotional relation which may be quite intense (and, within its limits, perfectly legitimate), albeit based on a perception that manages without any technical information of that kind—or any other. Such information, and the "competence" it eventually gives rise to,

137. The reference to Kant can, for this reason, seem altogether superfluous, since I could simply use the word "interest," in the most ordinary sense, to refer to the relation I have in mind here. However, the fact that I (in the wake of others) have indicated that I subscribe to Kant's thesis about the "disinterested character" of the aesthetic relation makes it necessary to take certain precautions in my later use of the term—even if Kant does not care a fig whether I do or not.

138. It sometimes takes the form of fanatical historical erudition, as can often be seen in jazz lovers, for example. Obviously, that kind of "cognition" should not be confused with the no less cognitive, even if extremely "primary," activity that any perception of the object implies.

certainly leads to an increase in the number of aspects perceived, and thus the occasions for positive or negative evaluation (more objects to consider and, possibly, to appreciate), but, to repeat, this quantitative increase does not necessarily bring about qualitative "progress" in the act of appreciation. On the other hand, such information does add another kind of pleasure to the properly aesthetic kind, with which it becomes closely intermingled. What I am here calling "interest" is just that combination of pleasure and knowledge. For the reasons mentioned earlier, and in a very relative sense, it seems to me to be more a part of our relation to works of art than of our aesthetic relation to natural objects. I would add, moreover, that the appreciation which generally gives rise to this interest is not necessarily positive: to seek, in and around a work, the reason you do not like it, or are indifferent to it, is, as I noted earlier, often quite as "interesting," if not more so, than wondering why you like some other work—even if, in both cases, the reason would also have to be attentively sought in the individual looking for it. In other words, a work which is not "pleasing" aesthetically can be as, or even more, interesting than a work which is. For this reason (and in this sense), unlike the relation of judgment, the relation of interest—which is decidedly cognitive and emotional at once, since the interest one takes in knowing something is itself an emotion—has the immense advantage of always being positive. To paraphrase Goodman yet again, even if most works are "bad," all are interesting. But, however closely bound up with one another these two relations are, we must take care not to confuse them—although it is a fact that this confusion never fails to affect the artistic relation as actually experienced, since it is not always easy to sort out what pertains to aesthetic appreciation and what must be chalked up to simple curiosity.[139] I would tend to regard that curiosity as a fairly (more or less, depending on the individuals involved) constant consequence of the artistic relation, one capable of influencing, in its turn, aesthetic appreciation itself, just as physical "charm" is often a component or additional stimulant in the aesthetic relation to natural objects. As such, it seems to me that this curiosity should count among what I shall later be calling, to round out Goodman's scheme, the symptoms of the artistic.

Another feature characteristic of this relation, and doubtless even more closely related to aesthetic appreciation, is the presence of what we

139. "The interesting is not the good, nor the beautiful, nor the real, nor the agreeable, nor the useful, nor the indispensable, nor even the important; or, rather, when it is the one or the other, when it is good or beautiful, that is not what makes it interesting. In a word, the interesting is *disinterested*" (Paul Veyne, *Le quotidien et l'intéressant* [Paris: Les Belles Lettres, 1995], p. 67).

have already encountered under the name of "skillfulness," in Beardsley and Stolnitz; Jean-Marie Schaeffer calls it the judgment of "operal success."[140] This feature is "more closely related" precisely in that what is involved here is a judgment, and a judgment of appreciation, or, nearer to the mark perhaps, of relatively objective evaluation. If I assume (without much risk of error) that the purpose of the architect who built the Sainte-Chapelle was to erect a building that was as luminous and transparent as the technical means of his day permitted, or if I grant that Balzac's aim in writing *The Human Comedy* was to "compete with the registrar of births and deaths," then I can judge the "success" of these undertakings, that is, the conformity of the result to the intention, and I can do so independently of my taste, or distaste, for effects of this kind. What is involved is plainly an objective evaluation, a measurable relationship between a manifest intention and an observable result. Nothing, however, necessarily associates that evaluation with the feeling of pleasure or displeasure this result, as such, calls up in me: I can perfectly well regret that the architect or novelist set out to produce, and succeeded in obtaining, the effect he did, and I am very often glad that an artistic intention was not realized, making way for another that the author did not intend to produce, but that pleases me more than the planned "success" would have. We may find the narrative nonchalance of *The Sentimental Education* charming, but this would probably not console Flaubert for having so thoroughly failed to achieve the "pyramidal" effect, the effect of dramatic construction, which he would have liked this work to have. Similarly, our taste for ancient and medieval statues that have become white (or black) flouts the intentions of their authors, who overlaid them with polychrome surfaces that have, fortunately, been reduced to naught by the ravages of time. Thus Schaeffer is right to say that "aesthetic judgements are not reducible to judgements of operal success, and vice versa."[141] But "not reducible to" does not mean, of course, "incompatible with"; it does not even always mean separable in actual practice. Here again, the subject of the artistic relation is rarely capable of making this distinction, and often confusedly ascribes to the intention what in fact accrues to the result—if only by attributing to a work an intention after the fact, somewhat illusorily or sophistically. Thus when I say, even in perfect good faith, "I like this work because the author has fully accomplished his intention in it," what I generally like is what he has accomplished, which leads me to approve of his supposed intention. If I did not like what the artist has accomplished, I would not be inclined to

140. Schaeffer, *Les célibataires de l'art*, pp. 232–247.
141. Ibid., p. 240.

"like" the work, but, at most, to admire the artist's mastery, which is not quite the same thing. Yet we constantly find ourselves confounding these two feelings, and taking the second for the first—and also, sometimes, the first for the second, when we credit the artist with what we like in his work despite his manifest or declared intentions.

In sum, the relation of technical or historical interest, which is intellectually gratifying in its own right, is not exactly a relation of appreciation, and judgments of operal success or failure are for their part, while plainly judgments (of evaluation), distinct, in principle if not in practice, from judgments of aesthetic appreciation. Technical or historical interest is symptomatic of the "secondary" attention that marks the artistic relation, but its (considerable) impact on the aesthetic appreciation of a work very often involves confusion or amalgam. "It is extremely easy to drift insensibly from valorizing a work because of its operal success," as Schaeffer rightly says, "to a valorization that is aesthetic in the proper sense of the word."[142] It is also easy, and just as common, to drift insensibly in the opposite direction. We know very well that purely aesthetic relations, free of all confusion or amalgam, do not exist; the situation under consideration offers one more illustration of this. If every object can be received as "aesthetic," cognitive interest and technical achievement can, just as well as any other, and, as a matter of fact, sometimes are. The reception of a work is an attentional complex in which relations of all kinds converge in an appreciation that is experienced as ultimately and globally aesthetic. Such aesthetic appreciation is brought to bear on everything that happens along, and it seizes on anything that comes to hand to attain its ends.

THIS CIRCUMSTANCE SEEMS TO ME TO RESOLVE THE CONTRADIC-tion that might be supposed to exist between the Kantian principle of subjectivity, and therefore the autonomy of the judgment of taste, and the obvious fact that our appreciations of works of art are complex or even heterogeneous, and often evolve through time. The secondary relation does not modify primary appreciation by evoking "criteria" and general rules or by bringing forward "demonstrative arguments." It does not invalidate the initial judgment; even less does it *refute* it. Indeed, that notion makes no sense, as I see it: the secondary relation does not modify the judgment but, rather, *its object.* When I (sincerely) "change my mind" and (authentically) "revise my judgment" of a work, it is not because my appreciation has been "brought round" by an external argument of an axiological kind, but, among other reasons, and in a sense more radically, be-

142. Ibid., p. 243.

cause *the attentional object* of my appreciation has changed, just as the guest who is informed that he has been tricked no longer "hears" a nightingale's song but a skillful imitation; or, again, just as the viewer who has been informed, rightly or wrongly, that this landscape overlooking the seashore is entitled *The Fall of Icarus* no longer "sees" it as a rustic scene, but rather as a mythological episode. "To look," says Gombrich, "is to interpret,"[143] which implies the opposite as well. Even if this principle applies to "representative" works in particular, like works of painting and sculpture, it can be applied to works of literature as well. Someone who reads Éluard's famous poem "Liberté" without knowing in advance that the poet directly addresses "freedom" in the last stanza, revealing that it is the "you" of the poem, would doubtless first read it as a love poem rather than as political verse (if I am not mistaken, it was originally meant to be a love poem); the final apostrophe would all at once, retroactively, change the meaning of each line for him. The same does not, perhaps, quite hold true in the case of "presentational" arts like music, architecture, or abstract painting, whose reception remains essentially aspectual, since their whole aesthetic essence is contained in their appearance, and since no modification can endow them with a denotative function which they lack by definition. However, the transition from primary to secondary reception is not less strongly marked in these arts simply because it proceeds along different lines: for example, by way of the discovery of an imperceptible technical process like the inclusion of a steel framework in a neo-Gothic skyscraper, as we have seen, or the identification, after the fact, of a melodic or instrumental harmonic feature—the structure of a chord, reversal of a theme, or passage of that theme from the clarinet to the bassoon.

I took pains to say "sincerely" and "authentically" a moment ago, because it also sometimes happens, as Kant remarks,[144] that when various factors—conformism, snobbism, ideological interferences—induce us to feign a judgment that is not our own, our judgment can then be affected by what we say, since it is never easy to differentiate between what we feel and what we think we feel, or wish to feel. Consider, once again, the narrator of *Remembrance of Things Past*, who is reassured about the value of Berma's art by the audience's enthusiasm: "The more I applauded, the better, it seemed to me, did Berma act."[145] Does Reynolds not advise us,

143. Gombrich, *Reflections on the History of Art,* p. 86.
144. Kant, *Critique of Judgement,* p. 138.
145. Marcel Proust, *A l'ombre des jeunes filles en fleurs,* in *A la recherche du temps perdu* (Paris: Pléiade, Gallimard, 1987) vol. 1, p. 442 [tr. *Within a Budding Grove,* in *Remembrance of Things Past,* trans. C. K. Scott Moncrieff and Terence Kilmartin (New York: Random House, 1981), vol. 1, p. 486].

in the same vein, to approach certain works by "feign[ing] a relish, till we find a relish comes; and feel, that what began in fiction terminates in reality"?[146] (This is obviously the aesthetic equivalent of Pascal's recipe for acquiring religious faith.) I also took pains to say "rightly or wrongly," because the titular indication "Fall of Icarus" would assuredly be just as persuasive if it were apocryphal and whimsical: whether or not Brueghel actually set out to produce this effect, the idea that the person plunging into the water, with his leg sticking up out of it, is Icarus abruptly changes the whole meaning of the picture, and, as a result, its entire structure. In the museum on the campus of Duke University is a picture by Pier Francesco Mola in which we see a noble old man showing an attentive young boy a page from a book they are examining closely; the book has a seventeenth-century binding and is, I believe, richly illustrated. So far, there is nothing unsettling about the painting, even if the subject is, after all, not a very common one, especially in the period in which it was painted (seventeenth century). However, the cartouche, which I looked at only afterwards, offers an additional piece of information that is, for its part, most unsettling: the painting represents, as the title informs us, *Plato Teaching Aristotle to Read*. We thus have, once again, a figurative detail that changes everything: this is not just any reading lesson, and, along with the rest, the *bound* book is a delightful anachronism, though it is no more flagrant than any number of others—involving clothing, architecture, etc.—to be found in "modern" painting from its origins onward. I will certainly never again be able to "look at" this solemn (albeit familiar) pedagogical scene without recalling the references (and paying my reverences) to the two illustrious individuals engaged in it—to say nothing of the incongruous ideological connotations of a reading lesson given by someone so avowedly contemptuous of the written word. But, then again, this iconographic identification is worth no more and no less than any other identification of the sort, and, even if the title is historically attested (to the extent that the title of a painting can be), nothing tells me that it was not "forged" after the fact by an artist in the mood to give viewers a jocular wink. The "validity" of an interpretation, as measured by the yardstick of its faithfulness to the specific and *serious* intentions of the author, is not in any sense the necessary (or, for that matter, sufficient) condition of its effectiveness. After all, if Jastrow's duck-rabbit happened to have been taken from Leonardo's famous stained wall, in which one "sees" what one wishes to, it would continue to function in the same either-or way: on a primary reception, an unidentified, wiggly figure, sufficient unto itself; on a secondary (interpretive) reception, now a rabbit,

146. Cited in Gombrich, *Reflections on the History of Art*, pp. 100, 164.

now a duck. What the story of this drawing teaches me is that its back-and-forth ambiguity owes nothing to chance, and this piece of technical information reinforces my perceptual hesitation, if I may put it that way, without really modifying it: if the story was that the author had only set out to draw a rabbit, I would still be hard pressed to forget my duck—and wrong to try. In a word, although, in front of a work, perceiving means interpreting by classifying (to expand Gombrich's idea without betraying it), and although the history of art, like history tout court, rightly calls for correct interpretation (assignation), it seems to me that the correctness of an interpretation is of no concern whatever to a (meta-aesthetic) study of the aesthetic relation. Every interpretation, including, of course, the most "mistaken," has a bearing on that relation and the way we analyze it.

But there is assuredly something else which can (authentically) modify that relation, an agent of change that does not, this time, exercise a direct effect on its objectal pole, but rather on the subject himself: in the relation between an aesthetic subject and an attentional object, it is not only the latter that can evolve. To return to the simplistic formula I employed a moment ago, when I "change my mind" about a work (or, in the present instance at any event, about any "aesthetic object" whatsoever), the reason can also obviously be that I myself have "changed," at least in the sense that, as a result of physical, mental, or cultural "maturation" (the word is used here without any valorizing connotation), my aesthetic sensibility has actually been modified in some way, as, for example, when one remarks, with or without a touch of nostalgia, "I no longer love Van Gogh the way I did when I was fifteen"; or, again, when a work one has been overexposed to ends up suffering from this overexposure, which blunts the work's effects by entirely eliminating the factor of surprise: a feature that no longer surprises us at all can hardly have an impact on us, and is no longer, so to speak, perceived. Inevitably, a modification in the individual subject is enough to modify his or her attention, and therefore, indirectly, the attentional object too.

IN A SUBSECTION OF THE *CRITIQUE OF JUDGEMENT* THAT IS IN other respects highly abstract, Kant suddenly observes that, in the aesthetic relation to natural objects, "it is we who receive nature with favour, and not nature that does us a favour."[147] This is a way of insisting yet again on the subjective, autonomous nature of primary aesthetic appreciation, brought to bear on an object that, for its part, offers nothing but its immanence, and asks for nothing in return: nature has no aesthetic other

147. Kant, *Critique of Judgement*, p. 220.

than the one we assign it. "Impassive theater," as Vigny says, "she does not feel how we adore her," for she has by no means solicited our adoration, and manages quite well without it when she displays the splendors we assume are hers in those inaccessible places where, Kant presumes, no human eye will see them.[148] I have already mentioned Hegel's echo of this remark; but that echo is immediately accompanied by a powerful antithesis counterposing nature's indifference to the anxiety characteristic of artistic candidacy: "But the work of art is not so naïvely self-centered; it is essentially a question, an address to the responsive breast, a call to the mind and spirit."[149] These words describe, in their fashion, the intentional character of the artwork, which is not content to be regarded as pure immanence, because its intentionality, once perceived, compels us to recognize it as a feature of transcendence. This intentionality did not suit Kant, since it introduced a factor of objective finality that ran counter to his definition of aesthetic judgment. Whence his well-known discomfiture with the artistic relation, dispelled only by the rather providential intervention of the notion of *genius*—an unexpected resurgence of Plato's *enthusiasm*, here assigned positive value. Thanks to genius, the work of art is no longer subject to any conscious finality on the part of the artist, thus regaining the innocence of a natural object. By way of genius, a gift of nature, it is in fact nature itself that produces the work, through the simple agency of an artist unconscious of his means and ends, and incapable of accounting for, or a fortiori of transmitting, them. The happy consequence of this supposed state of affairs is that any work of art worthy of the name, that is, any work of genius, is "clothed with the aspect of nature"[150] and thus offers itself to our reception like a natural object, to which one can ascribe no determinate end, not even that of soliciting aesthetic appreciation.

I hardly need say that this miraculous expedient seems to me highly problematic, and ill suited to providing a coherent explanation for our aesthetic relation to artworks—or the conditions under which they are produced. However, it does seem to me to contain a kernel of truth, which is perhaps easier to discern if we consider the Kantian formula in all its studied ambiguity: "Hence the finality in the product of art, intentional though it be, must not have the appearance of being intention; i.e. fine art *must be clothed with* the aspect of nature, *although we recognize it to be art*."[151] The work of art is not, then, says Kant, simply received as a natural object:

148. Ibid., p. 133.
149. Hegel, *Aesthetics*, p. 70.
150. Kant, *Critique of Judgement*, pp. 166–182. On this idea, which I have summarized rather cavalierly here, see Schaeffer, *L'art de l'âge moderne*, pp. 55–65. The high value Kant places on the "natural" in art obviously also makes itself felt in his rejection, which we have already mentioned, of the ideal of perfection and regularity.
151. Kant, *Critique of Judgement*, p. 167; the emphasis on the concessive clause is mine.

it is received as an object which we know to have been produced by art, but which at the same time seems to be a natural object. Interpreted in the decidedly too specific light of our opening fable, this formula would seem to hold out as an artistic ideal the merry imitation of the bird-catcher, whenever one simultaneously perceives its mimetic origin and perfect resemblance to the nightingale's song. On this hypothesis, the two analyses would be flatly contradictory, since Kant earlier assumed that the imitation, once revealed for what it was ("only art"), could no longer elicit the slightest positive appreciation. The paradox of an object that is perceived simultaneously as artwork and natural phenomenon does not, then, find its (assuredly difficult) resolution in the overly restrictive register of imitation, but rather, on my view, in the fact that we plainly perceive the work of art as animated by an aesthetic intention, while the realization of this intention (aesthetic reception) in some sort effaces the intention as such, so that only its effect remains visible—as, according to Valéry, a message effaces itself in its signification, that is, the realization of its purpose. I by no means guarantee that this interpretation is faithful to Kant's thinking, but I do maintain, more confidently, that it is in line with the facts of the matter. Accessorily, it seems to me to justify the normative turn of the sentence I quoted a moment ago: the finality *must not* appear intentional, art *must* be clothed with the aspect of nature. If I may be allowed an expression that introduces into Kant's analysis an idea very foreign to it, then I would say that "candidacy" for appreciation cancels itself out in the appreciation it obtains. Everyone knows, after all, that once a candidate is elected, he is, ipso facto, no longer a candidate. The wisdom of the ages tells us that "art conceals art"—at the moment, in sum, when the technical appreciation of an "operal success" is converted into a judgment of taste. In the complex and constantly renewed relation between aesthetic attention and judgment, it is quite as if the positive appraisal of a work of art momentarily conferred upon it the innocence and gratuitousness of a natural object. I am inclined to call this its *grace* or *charm*, in the sense in which Freud assumes that the seductive power that radiates from children or certain animals is rooted in their narcissistic indifference to the effect they apparently produce without trying.[152] The functionalist position, already mentioned, according to which the beauty of a form derives from its manifestly expressing its function, paradoxically underwrites this valorization of an apparently unintentional beauty, since it assumes the producer has a (purely practical) goal which is anything but aesthetic, so that he

152. Sigmund Freud, "On Narcissism: An Introduction," ed. and tr. James Strachey et al., *Standard Edition of the Complete Psychological Works of Sigmund Freud*, vol. 14 (London: Hogarth Press, 1954), p. 89. Be it recalled that among those leading this parade of narcissistic seduction, we also find certain types of women, "great criminals," and . . . "humorists."

achieves an aesthetic effect indirectly and, so to speak, as a bonus: "The beauty of the engineer [*sic*] results from the fact that he is not conscious of seeking beauty."[153] Can we not say the same, after all, of the productions of animals—for example, our nightingale's emblematic song?

The opposite thesis, which finds an eminent illustration in Hegel, states not only that artistic beauty, as a production of spirit, is superior to natural beauty, but also that natural beauty is, as it were, merely an illusion, an effect produced retroactively by works of art; we see a kind of reflection of them in the spectacle offered by nature, which pleases us only insofar as it recalls certain artworks. Evoking Kant's parable, Hegel inverts its moral: a bird's song, he says, "interests us only when, as is the case with the nightingale's warbling, it gushes forth purposeless from the bird's own life, like the voice of human feeling."[154] As is well known, this way of standing Kant's idea on its head finds an echo in the paradox, a commonplace since Oscar Wilde, that nature imitates art: there were no fogs on the Thames before Turner,[155] and so forth. Proust elaborated on this theme, explaining that the world "has not been created only once, but as many times as an original artist has emerged"; the original artist teaches us to see everything through his eyes ("look now"), and to perceive beauty where no one perceived it before: "Women pass in the street, different from those we formerly saw, because they are Renoirs, those Renoirs we persistently refused to see as women. The carriages, too, are Renoirs, and the water, and the sky. . . . Such is the new and perishable universe which has just been created. It will last until the next geological catastrophe is precipitated by a new painter or writer of original talent."[156]

There is a great deal of truth in this description of what Goodman will call artistic worldmaking*: doubtless Turner has helped us, at the very

153. Henri Van de Velde, cited in Francastel, *Art et technique*, p. 101. This "unconscious quest," if there is such a thing, is apparently not quite the absence of a quest, but the effect is doubtless the same.

154. Hegel, *Aesthetics*, p. 43. [Unlike this English translation of Hegel's remark, the French translation Genette cites, based on a different version of the *Aesthetics*, contains a verbal echo of Van de Velde's idea that the engineer is not conscious of seeking beauty: here Hegel says that the nightingale produces her song "unconsciously."]

155. I cite this last remark as handed down by a plausible, but perhaps apocryphal tradition. According to Proust, *Contre Sainte-Beuve*, in *Contre Sainte-Beuve*, p. 273 [*On Art and Literature,* p. 180], what Wilde said was that "before the Lake poets there were no fogs on the Thames." Chronologically speaking, this amounts to the same thing.

156. Proust, *Le côté de Guermantes*, p. 623 [*The Guermantes Way*, pp. 338–339]. (Cf. Proust, Preface to *Tendres Stocks*, by Paul Morand, in *Contre Sainte-Beuve*, p. 615 [tr. Preface to *Green Shoots*, by Paul Morand, trans. C. K. Scott Moncrieff (London: Chapman and Dodd, 1923)]). This passage extends Proust's remarks about the "new writer," cited above (Chapter 2 at note 85). It confirms the relativist tendency of the earlier passage: every artist creates a "new" but "perishable" world, which lasts until a new artist comes along to create

least, better appreciate foggy landscapes, and Renoir, women who are on the plump side, etc., thus helping restructure our vision of the world. But I do not believe that the retroactive effect art has on nature makes every aesthetic relation depend on art: the dependency involved is reciprocal, and the adoption of new art forms is not necessarily the unilateral cause of our appreciation of certain natural forms. It is Proust himself who affirms that "if all this ['vapid' kitchen scenes become 'sumptuous' through the magic of painting] now strikes you as beautiful to the eye, it is because Chardin found it beautiful to paint"[157]—even if that which was "beautiful to paint" was perhaps not exactly the same thing, in his case, as what was simply beautiful to the eye. It seems more likely to me, then (if less piquant), that the two phenomena proceed from one and the same movement, a more general "worldmaking*"[158] which typifies the sensibility of an age, for example, and which the artist is caught up in quite as much as he actively contributes to it. Thus nothing in these ongoing interactions contradicts Kant's view that a positively appraised work becomes, by virtue of that very appraisal, a kind of new natural object, treated, in Gombrich's phrase, as if it were part of the landscape—a landscape that it first helped disturb, and then helped modify. *Homo additus naturae*: this can also mean that man, who is part of nature, adds, through culture, a bit of nature to nature.

The What and the When

I said earlier that the artistic relation, that is, the ascription of the status of artwork to an aesthetic object, rests on a twofold hypothesis, justified or not, to the effect that the object is an artifact and that its producer had an aesthetic intention. That is doubtless an extremely liberal definition, since it has the character of the relation depending on nothing other than the receiver's opinion. But it must be added that this opinion is neither arbitrary nor purely subjective, like judgments of appreciation, for a hypothesis necessarily rests in its turn on objective indices, whether well or poorly perceived and interpreted: I suppose that such-and-such an object is an arti-

the next new world, and so on. Proust wonders if the resulting movement is not, contrary to prevailing opinion, analogous to the "continuous progress" of science (Proust, *Le côté de Guermantes*, p. 624 [*The Guermantes Way*, p. 339]).

157. Proust, *Contre Sainte-Beuve*, p. 373 [*On Art and Literature*, pp. 324–325].

158. However, it is well known that, for Goodman, art is one way of worldmaking* among many; science is another.

fact because I believe that I can discern in it the deliberate result of a productive or transformative activity; I suppose that it proceeds from an aesthetic intention because I doubt that the aspect by means of which it elicits a positive appreciation on my part can be accidental, or because it seems to me to belong to a class of objects which are generally considered artistic, etc., and the artistic nature of my relation to this object is entirely dependent, not, perhaps, on the truth of my conjectures, but, at a minimum, on my belief in this truth—a belief that may later be shattered by information that contradicts it. The status of the artistic relation is not, then, identical to that of the simple aesthetic relation: an appreciation cannot be refuted, whereas a hypothesis can be. If someone clearly demonstrates to me that an object I like is not a work of art, there is no reason to suppose that the demonstration will spoil my aesthetic relation to that object, but it will definitely spoil the artistic nature of this relation, and nothing can justify my stubbornly maintaining my opinion in the manner in which the aesthetic subject, according to Kant, legitimately stands his ground in the face of all the "demonstrations" that would have him change his mind about his "judgement as to beauty."[159] Contrary, then, to purely aesthetic appreciation, specifically artistic appreciation is neither purely subjective nor fully autonomous. Even less does artistic appreciation suffice objectively to establish the artistic nature of its object, as it suffices (with good reason) to establish the aesthetic "value" of its object, a "value" that is in fact nothing more nor less than an objectification of such appreciation.

Arthur Danto rightly insists on this point:

> If knowledge that something is an artwork makes a difference in the mode of aesthetic response to an object—if there are differential aesthetic responses to indiscernible objects when one is an artwork and the other a natural thing—then there would be a threat of circularity in any definition of art in which some reference to aesthetic response was intended to play a defining role. For it would not be just aesthetic response that belonged to works of art in contrast with the kind that belongs to natural things or blasé artifacts like Brillo boxes (when not works of art)—and we should have to be able to distinguish works of art from natural things or mere artifacts in order to define the appropriate kind of response. Hence we could not use that kind of response to define the concept of the artwork.

159. "I stop my ears; I do not want to hear any reasons or arguments about the matter. I would prefer to suppose that those rules of the critics were at fault, or at least have no application, than to allow my judgement to be determined by a priori proofs. I take my stand on the ground that my judgement is to be one of taste, and not one of understanding or reason" (Kant, *Critique of Judgement*, p. 140).

And, a bit further on: "There are two orders of aesthetic response, depending upon whether the response is to an artwork or to a mere real thing that cannot be told apart from it. Hence we cannot appeal to aesthetic considerations in order to get our definition of art, inasmuch as we need the definition of art in order to identify the sorts of aesthetic responses appropriate to works of art in contrast with mere real things."[160]

The allusion to Warhol's Brillo boxes and other ready-mades shows that Danto poses the question—which is *our* main question—from a particular standpoint that is *not* ours. Obviously, the difference in aesthetic response to two indiscernible objects, Duchamp's bottle rack and an identical bottle rack on sale at the BHV,[161] will not establish which is a work of art, since that difference cannot come into play before the difference in status between the two objects (which is institutional, or, as Danto prefers to say, "theoretical," and, in any case, not aesthetic at all) has been established from the outside. For reasons I have already stated,[162] I reject this analysis, for I hold that in cases like these the work of art, despite the authorial declarations, which are not to be taken at face value precisely because they are part of the provocation, does not inhere in *either* of the two (or any of the three, etc.) objects, but rather in the act of provocation that consists in putting one of them forward as a work even while denying that it, like the other members of the series it belongs to, has any aesthetic properties—or, rather, in denying that the aesthetic properties it may well possess have any relevance in this regard. Thus I situate Danto's aporia, or his diagnosis to the effect that a circular definition is at work here, in a wider or more everyday perspective, which counterposes—let us begin with as stark a contrast as possible—the reception of a work of art like the *View of Delft* to that of a natural object like the Matterhorn. My thesis, from the beginning of this chapter, has been that my "aesthetic response" to the first is of a different kind than my response to the second, for the essential reason (though there are other reasons as well) that my reception of the first includes a consideration of aesthetic intention (or candidacy for attention) that my reception of the second does not. Once shifted onto this terrain, Danto's objection consists in saying that my consideration of an intention cannot serve as a criterion for identifying the *View of Delft* as an artwork,

160. Danto, *The Transfiguration of the Commonplace*, pp. 91, 92–93. I have already cited the latter passage.

161. [The Bazar de l'Hôtel de Ville, a department store located near Paris City Hall (l'Hôtel de Ville) with a hardware department in the basement. Duchamp bought the bottle rack that became *Bottle Rack* there.]

162. Genette, "L'état conceptuel," chap. 9 in *L'œuvre de l'art*, pp. 154–176 ["The Conceptual State," in *The Work of Art*, pp. 135–155].

since this consideration is itself determined by my awareness of its status as artwork: if I take an aesthetic intention into account in looking at the *View of Delft*, the reason is that I know in advance—or that I immediately infer from the fact that what I have before me is plainly a painting—that it is a work of art. It is the fact that it obviously has the status of a work of art that determines the specificity of my response, not the other way around. In a more doubtful case ("sculpture or boulder?"), I would not know what kind of response was appropriate, so that the nature of this response, still indeterminate, could not determine the nature of the object for me. And if I made the wrong decision, naively taking what is just a boulder for an intentional sculpture, this determination would simply be mistaken, and hence could not serve as a criterion.

Thus reformulated, the objection seems to me to be indubitably valid as far as objective status is concerned, that is, whenever the task at hand is to determine historically whether an object "is" or "is not" an artwork. This is, of course, the question that Danto is asking when he wonders how to identify "the kind of response appropriate to works of art": the fact that I have a relation of an artistic type to an object by no means suffices to prove that that object really *is* a work of art, and that my response is therefore "appropriate" or legitimate; assuming the contrary inevitably traps us in a circle. That I *regard* an object as a work of art does not *make* this object a work of art—even if, be it said in passing, my name is Warhol, Duchamp . . . or Danto. Moreover, this difficulty is not of the same order as the one which simple aesthetic appreciation entails, for if it can be maintained, as, in the wake of Kant, I unreservedly do, that no object is *objectively* beautiful or ugly, and consequently that no aesthetic appreciation can be "correct" or "mistaken," it is rather more difficult to maintain that no object *is*, or *is not*, objectively, a work of art. The artistry of a work is, after all, a historical fact; it does not *depend* on my subjective appreciation as does its "beauty" or "ugliness," which is nothing more than an objectified expression of this appreciation. Therefore, if I regard an object as a work of art, and, consequently, bring an attention and appreciation of an artistic kind to bear on it, someone could legitimately convince me of my error in certain cases (only in *certain* cases, since others can remain temporarily or definitively undecidable, owing to our common ignorance); he can, consequently, bring me to change a mistaken attitude, something he could not, in principle, bring me to do when what is involved is an aesthetic appreciation—if it were not for the fact that ceasing to consider something as an artwork, or, conversely, considering it as such (or substituting one artistic consideration for another, as in those instances where I change an attribution) inevitably has an impact on aesthetic appreciation

itself, as we have seen. I said a moment ago that a revelation of the *nonartistic* nature of what I once regarded as an artwork could not spoil my *aesthetic* relation to this object; but I must now recall that, for Kant, a revelation of the opposite sort (a shift from nightingale to bird-catcher) inevitably does have this effect. This confirms, in passing, the difference between an argument that has directly to do with an object's "value" ("you have to find this object beautiful for such-and-such a reason"), which is, for reasons of principle, ineffective, and a demonstration that bears on its status ("you have to admit that this object is, or is not, a work of art"), which can be, legitimately and in actual fact, convincing, and can thus indirectly *modify* appreciation, since we do not judge the same object *in the same way* if we regard it as a work and if we do not.

Obviously, then, whether or not the receiver considers the object to be art is not an objective criterion for artistry. But it constitutes—even when it rests on a mistaken or unverifiable hypothesis—a subjective fact as certain as aesthetic attention and appreciation, and this fact is, in sum, the only one that matters to us here, i.e., that matters to an attempt to define the artistic relation: an artistic relation to an object exists whenever an aesthetic subject ascribes an aesthetic aim to that object—one can equally well say an *artistic* aim, since aesthetic intentions, on this definition, can only inform works of art. I can "err" in regarding (or not regarding) an object as an artwork, but I cannot err when I observe that I regard it as such (or not). Defining the artistic relation by no means requires that this relation be "appropriate," legitimate, and based on an objective criterion—which such a relation cannot, obviously, constitute.

But it so happens that in the vast majority of cases—if we refrain from treating as universal paradigms the uncertainties characteristic of one particular period (the contemporary period, or a period which is perhaps already behind us now) and one particular interpretation of its productions—the (historical) status of artistry that certain objects possess is not open to doubt, for reasons we have already noted: as far as most things in this world are concerned, no one has to make risky hypotheses in order to tell whether he is dealing with a natural object, an artifact devoid of aesthetic intention, or a (more or less) artistic work. As a general rule, the doubtful cases can be cleared up with the help of readily available accessory information. Those that remain permanently doubtful do not seem to me such as to compromise a theoretical definition: even if the "wolf of Larzac" turns out to be a dog, that will not, in my opinion, suffice to call the concept "wolf" into question, but will merely show that it has been incorrectly applied. I said earlier that a definition was not a criterion for making individual identifications; now it needs to be said, conversely, that

the uncertainty of an individual identification does not invalidate a definition. The most significant cases of uncertainty are, to my mind, those arising from cultural differences and historical drift [*dérive*]: we ("cultivated" Westerners with something of a tendency toward aestheticism) have, for a good hundred years now, been in the habit of treating certain objects (cave paintings, idols, masks, items of clothing, various implements) taken from a wide variety of distant or exotic cultures as works of art (by, for example, exhibiting them in art museums, or publishing reproductions of them in art books, or purchasing them at rather stiff prices and using them to decorate our homes). We are often ignorant of the function these objects originally had; in certain cases, we even suspect that their "native status," as Schaeffer puts it,[163] was *not* aesthetic. But this ignorance or suspicion does not dissuade us, and rightly so, from continuing to divert such objects to aesthetic ends, often proceeding on the basis of formal analogies with our own artistic productions (an idol resembles a sculpture; an amulet, a jewel; a ritual prayer, a poem, and so on), the existence of mixed states (an icon surely has something of a painting about it), or the ongoing adaptation, through expansion, of the concept of art (and its countless generic subconcepts), whose open-endedness and variability facilitate all these annexations.[164] In my opinion, these cases of what may well involve a distortion in function illustrate what I shall call the subjective (or attentional) legitimacy of artistries that are objectively (or constitutively) illegitimate. There is certainly nothing to make a federal case of here, for the important thing is the aesthetic relation to an object, whether or not what is in question is a work of art. Risky hypotheses (when they *are* risky) as to that object's original status, artistic or not, do no more than modulate this relation in a way that is, when all is said and done, secondary. The important thing, then, is to know whether an object pleases me or not, and, secondly, whether it pleases me as a work of art or not, since it can please me on condition that I do not regard it as a work of art (Kant's nightingale), or, on the contrary (according to Hegel), that I do regard it as a work of art, or, again, can please (or displease) me in different ways, depending on whether I receive it as a work or not. Whether or not my hypothesis is well founded is an empirical question, which an ethnologist or historian may be able to settle, and which it is assuredly, given his special competence, his responsibility to settle, but which, for as long as I do not

163. Schaeffer, *Les célibataires de l'art*, p. 28.
164. Schaeffer (ibid., pp. 112–119) offers us a diagrammatic representation of this open-endedness; though he says the diagram should not be taken "literally," it seems to me to be very suggestive. On the vexed question of the universality (or nonuniversality) of the aesthetic relation, see ibid., pp. 137–143.

ask it *myself*, has no influence on my aesthetic relation to the object. But the aesthetic relation, let us not forget, is what interests us here.

In a passage recently published by Jean Jamin, Michel Leiris raises the question of the artistic or nonartistic status of certain African objects, which he formulates in terms that seem to me very much to the point, even if his response to the question is somewhat ambiguous. Some people, he reminds us, believe that "there is no warrant for describing as a 'work of art' anything that is not recognized as a work of art by the people which produced it." But it is possible, he replies,

> that the problem propounded here is, all things considered, a false problem. To constitute an object as a work of art, is it not enough for an aesthetic emotion, no matter where it comes from, to be manifested toward that object? We do not, for example, know how the ancient Egyptians reacted to the statues of their gods or kings; but it would not occur to any Westerner with even a smattering of culture to evoke this ignorance in order to deny the legitimacy of attributing the status of *objet d'art* to these objects, even if we cannot say that they were in any sense produced to meet properly aesthetic needs.[165]

The first position is based on the excessive demand that, says Schaeffer,[166] underlies "the objection raised by the historian of cultures"—a typical victim of "the endemic historicism that so often stands in for methodological reflection in the human sciences." This demand is "excessive" because, to our aesthetic reception of objects of this kind, it applies a criterion that is appropriate only for establishing historical descriptions of them—a description it is often impossible to provide for lack of conclusive proof or personal testimony. Leiris's first response to his own question—to the effect that an "aesthetic emotion" is enough to justify calling an object a work of art—is, in contrast, too accommodating, since an aesthetic emotion can just as readily be called up by a natural object which no one would therefore seriously, or literally, describe as a "work of art." His second response, which I find more balanced (although Leiris does not seem to notice that there is a difference between the two), consists in recognizing that an object which did not have the status of an artwork in its original context—or, at any rate, whose original status we cannot determine—can acquire this status in a different cultural and historical context, if only by technical analogy with objects (here: sculptures) that are today held to be constitutively artistic. It is this criterion which Schaeffer repeatedly de-

165. Michel Leiris, *Miroir de l'Afrique* (Paris: Gallimard, 1996), p. 1086.
166. Schaeffer, *Les célibataires de l'art*, p. 138.

scribes as "generic." He adds that "this is precisely the case of the funerary statuette whose generic inscription evokes specific modes of production common to it and other works produced by the same techniques, their different functions notwithstanding. . . . This is because they can be ascribed to an operal genre that functions, *for us*, as an 'obvious' exemplification of the artistic—namely, sculpture."[167] Thus something that was perhaps not intentionally *produced* as a work of art, something that the "historian of cultures" can, invoking this doubt, legitimately refuse to *call* a work of art, can legitimately be *received* as such by the art-loving public and *function* as such in its eyes. In an analogous case, invested with an artistic authority that the ordinary art lover can of course not lay claim to, Picasso settled the question in sovereign fashion and without undue ethnological scruple: "I don't know where that comes from, I don't know what that's used for, but I understand very well what the artist was trying to do."[168]

THIS POINT BRINGS US BACK TO GOODMAN'S RECOMMENDATION, of course: the question we should try to answer is not, *What is art?* but rather, *When is art?* However, it so happens that Goodman himself, curiously enough, has not answered this question, or, more precisely, that the answer he has given is in fact the answer to another, which is, as it were, anterior to the one just mentioned: namely, *When is there an aesthetic object?*—that is, in my terms, *When is there an aesthetic relation?* I will not reconsider the substance of this response, which I have already analyzed. I would, however, briefly like to call attention to this shift, which Goodman would doubtless not regard as one, but which I do, and which, as such, merits consideration. Let me begin by recalling that the last chapter of *Languages of Art* includes a subsection, the fifth, very appropriately entitled "Symptoms of the Aesthetic"; we have interpreted it, inflecting it in a way its author would doubtless not approve of, as a table of symptoms indicative of the aesthetic character *of the attention brought to bear on an object.* This table is also included in the 1977 essay "When Is Art?" where it is offered as a response to the question posed in the title, as if a description of the aesthetic relation sufficed to describe an artistic relation, which implies that any aesthetic object, as such, were ipso facto a work of art. This latter affirmation, be it recalled, can itself be interpreted in two ways: either (the objectivist interpretation) "works of art *are* the only aesthetic objects in the world" or (the subjectivist interpretation) "any object need

167. Ibid., pp. 109, 117; cf. pp. 49–51.
168. Cited by Philippe Dagen in *Le Monde*, 18 November 1995.

only function aesthetically in order to *become* a work of art, at least to the extent that it so functions." Since Goodman does not make the equation *artistic* = *aesthetic* explicit, but rather contents himself with tacitly shifting from one to the other, he is obviously not required to say what meaning he assigns this shift. Certain of his formulations, however, seem to me to rule out the first interpretation; for example, his discussion of the stylistic properties of a sunrise. Others rather clearly imply the second, as when he remarks that "the stone is normally no work of art when in the driveway, but may be so when on display in an art museum. In the driveway, it usually performs no symbolic function. In the art museum, it exemplifies certain of its properties—e.g., properties of shape, color, texture."[169] The affirmation that a stone is, or "can be," a work of art when on display in an art museum (and not, of course, when exhibited in a collection of geological specimens) does not, however, mean that Goodman has rallied to the "institutional" theory of art, for the fact that the stone is on display in the museum is, here, as far as those who have decided to display it are concerned, merely a consequence of the aesthetic attention of certain (influential) receivers, even if this can induce others to adopt the same kind of attention. The effects of displaying the stone are thus not specially privileged; display is simply one of the practices Goodman calls "implementation," like musical performances, the publication of literary texts, and so on.

> Where an object is not an artifact but rather, say, a stone found on a beach, implementation may nevertheless occur: for example, as when the stone is mounted and displayed in an art museum. But I do not—as is sometimes supposed—subscribe to an "institutional" theory of art. *Institutionalization is only one, sometimes overemphasized and often ineffectual, means of implementation.* What counts is the [symbolic] functioning rather than any particular way of effecting it. The beach stone may be made to function as art merely through singling it out where it lies and perceiving it as a symbol exemplifying certain forms and other properties. Implementation, clearly, is not restricted to making a work of art work as such, but includes making anything work as art.[170]

169. Goodman, "When Is Art?" p. 67.
170. Goodman, *Of Mind and Other Matters*, p. 145. I refrain from translating "implementation"; I do not think there is any satisfactory French equivalent for this word. But the context, in this 1982 essay on the "Implementation of the Arts," tends to diminish the force of Goodman's statement: "A work must, indeed, be executed if it is to be implemented, but that is because we have a work at all only through execution—a work is something *made.*"

What "makes" an object a work of art, for a certain period, is not, accordingly, the fact that a reputable museum has selected it; it is rather, says Goodman (unlike the proponents of the institutional theory, whether in its Dantoesque or Dickian version), the aesthetic attention which provides the basis for this selection. Such attention can very well dispense with the museum's offices: a certain way of looking at the object is sufficient to make it art.

But, even after this potential misunderstanding has been cleared up, there remains a difficulty that has to do with what might be described as the conflict between the functional and "ontological" definitions of the work.[171] Although Goodman opts (as I do) for the functional definition, he is well aware of this difficulty:

> Perhaps to say that an object is art when and only when it so functions is to overstate the case or to speak elliptically. The Rembrandt painting remains a work of art, as it remains a painting, while functioning only as a blanket; and the stone from the driveway may not strictly become art by functioning as art. Similarly, a chair remains a chair even if never sat on, and a packing case remains a packing case even if never used except for sitting on. To say what art does is not to say what art is; but I submit that the former is the matter of primary and peculiar concern.[172]

The hesitant accent, rather unusual for this ordinarily more categorical author, is hard to miss here: the fate of the Rembrandt and that of the stone are not quite identical, because the painting, apparently, *remains* art even when not functioning as such, whereas the stone, when it functions *as* art, is not a work of art in the *strict* sense. Moreover, that "as" is ambiguous, since it can be construed to mean either "*qua*" or "in the manner of," which is not quite the same thing. It is evident that this awkwardness stems from the surreptitious shift, which we noticed earlier, from the symptoms of the aesthetic (of aesthetic attention) to what I for my part propose to call the symptoms of *artistic* attention—"the symptoms," or, perhaps, *the* symptom par excellence, which is, to repeat, the ascription of an aesthetic intention, with the many different consequences such ascription brings in its wake; the principle consequence being, as we have seen, what Robert Klein calls the *historicization of value*. Even if a natural object, like a simple rock, or the branch which Magnelli selected for display at the

171. Dominique Chateau has clearly perceived this difficulty. See Chateau, *La question de la question de l'art. Note sur l'esthétique analytique: Danto, Goodman et quelques autres* (Paris: Presses universitaires de Vincennes, 1995), pp. 112–113.

172. Goodman, "When Is Art?" pp. 69–70.

Musée National de l'Art Moderne not long ago, is put on exhibit in an art museum, it can only function "as" an aesthetic object; it functions as a work of art only if it is received, in this instance erroneously (but one can easily imagine a sculptor deliberately producing an object resembling a rock or branch), as proceeding from an intention to produce something aesthetic. "Erroneously," because the mere selection of an object is not an intention to produce something, in the sense in which I use the term.

In the foregoing commentary, there is at least one word that is definitely inadmissible from Goodman's point of view: the word "intention," which is irreconcilable with his philosophical position. Nevertheless, on at least one occasion, Goodman grants that the feature of artifactuality is one of the defining conditions (a condition that is at least necessary) of artistry: "a work is something *made*,"[173] which means, I take it, "produced by a human being." A feature of this sort is no longer entirely of the order of attentional functioning (perceiving an object as exemplifying certain properties), which can, as Goodman rightly says, "come and go."[174] It is, rather, of the order of objective historical conditions: in order to, not merely *function as* a work of art, but also *be* a work of art, an object must *in fact* have been produced by a human being. As this necessary condition is not sufficient, since a hammer is not (always) a work of art, another condition must be introduced, namely, what we have been calling aesthetic intention: a hammer can be, objectively, a work of art if it in fact contains an aesthetic intention, but it can *function as* a work of art (not as a simple, occasional "aesthetic object") only if its receiver ascribes to it, rightly or wrongly, an aesthetic intention.

It would seem, then, that we are turning in circles, and one might therefore wonder what the sense of this detour through the Goodmanian "symptoms" is, if they must be abandoned in favor of a return to a criterion external to them. The answer is that I do not, in fact, propose to abandon them, but rather to complete them so as to make possible a transition from the general case (the aesthetic relation, which these symptoms describe rather well, on condition, let me recall, that we add to them the emotional feature of *appreciation*) to the special case represented by the artistic relation. The new, complementary trait is, obviously, the ascription

173. Goodman, *Of Mind and Other Matters*, p. 145. However, the context, in this 1982 essay on "Implementation of the Arts," perhaps limits the scope of this sentence: "A work must, indeed, be executed if it is to be implemented, but that is because we have a *work* at all only through execution—a work is something *made*." (I cited the balance of this passage, which begins "Where an object is not an artifact," at note 170 above.) As can be seen, all the terms in this passage are fairly ambiguous.

174. Goodman, "When Is Art?" p. 70.

of an aesthetic intention. If one wishes to interpret the Goodmanian symptoms as symptoms, not merely of the aesthetic relation, but also of the special case of the aesthetic relation we call the artistic relation, then one must, on my view, add this final symptom of, not the aesthetic this time, but the *artistic*. The symptoms I mentioned earlier (cognitive interest, judgment of "operal success") could themselves be the consequences of this last symptom, since one symptom can always be the cause of another. If we take an interest in the technical procedures used to create an aesthetic object, and in their efficacy, the reason is doubtless that we regard the object, rightly or wrongly, as intentionally aesthetic; a purely natural object (if such a thing exists) does not depend on such conditions, while the conditions of production of a purely utilitarian artifact (same proviso) are not as closely bound up with its aesthetic effect(s), which the object did not set out to produce.

This subjectifying interpretation (subjectifying, because it treats the objective grounds for the ascription as secondary) is obviously not faithful to Goodman's position, but I believe that this interpretation alone lends his position a coherence it cannot otherwise attain: the goal, in a word, is to rid Goodman's theory of the objectivist aspects that render it, in my opinion, incoherent. In sum, the veritable question is not exactly, When is there art?—a question that is doubtless contradictory if taken literally, as Goodman's hesitations indicate—but rather, When is an object *received as* a work of art? We saw earlier that Kantian subjectivism trapped itself in an awkward position by refusing its own subjectivist consequences; we see now that Goodmanian (or any other kind of) relativism[175] is not coherent unless it accepts subjectivist premises: one cannot simultaneously employ the relativist *when* and the objectivist *there is*, at least not in the literal sense of those terms. The question *when?* (as opposed to the *what is?*) is germane only if it bears on a reception, that is to say, on a subjective phenomenon, which can come and go: "When do I *perceive* art?" If an object—like, say, the Rembrandt that Goodman or Duchamp occasionally divert to their own ends—*is* (objectively and permanently) a work of art, as Goodman ultimately concedes, not without reason, the question *when?* can only have to do with its reception, that is, the uses I put it to, or the idea I form of it, depending on whether or not I receive it as a work. If I formulate the

175. It should be remembered that Goodman is willing to be called a relativist, at least if "relativism" is amended to read "constructive relativism" or "constructionalism" (Nelson Goodman and Catherine Z. Elgin, *Reconceptions in Philosophy and Other Arts and Sciences* [Indianapolis: Hackett, 1988], pp. 45–48). However, he rejects "subjectivism," which, as he puts it, "threatens" (Nelson Goodman and Catherine Z. Elgin, "Changing the Subject," in Richard Shusterman, ed., *Analytic Aesthetics* [Oxford: Blackwell, 1989], p. 191).

question in objective terms, I have to give up the *when*, and return to the *what*: an object *is* a work if it has in fact been produced with an aesthetic intention; it *functions as* a work *when* we attribute such an intention to it, and these two conditions are to a large extent independent of one another. It sometimes happens that the aesthetic aim is not perceived, but that does not prevent it from having existed; it sometimes happens that that intention is wrongly ascribed to an object, but that does not prevent this ascription from having effects. In sum, the first question (*what?*) is just as legitimate as the second (*when?*); the response to it is not always unavailable, and does not depend on the response to the second. That *Bathsheba* is— that is, was created as—a work of art does not depend on me (on my subjective ascription). (That is why its status as a work is "objective," as Panofsky says in so many words.) What depends on me is only that it function as such for me. However, that functioning may depend, not on the objective artistry of this object, but on the idea I have of it—an idea which can, in its turn, depend on this fact: it is doubtless easier to convince me of *Bathsheba*'s artistry than of the Matterhorn's. Both questions are legitimate, but only the second directly concerns the artistic relation; the first concerns this relation only by way of the second, and it is in this sense— and, it seems to me, in no other—that the *what* depends on the *when*. To repeat one last time, and as clearly as possible: the question *when* by no means rules the question *what* out of court, and cannot always be substituted for it; moreover, a science like the history of art cannot seriously rely on it. Yet, as far as the analysis of the artistic *relation* is concerned, *when* is plainly, as Goodman says, "the most urgent and the most pertinent" question. For the artistic relation, in other words, the fact that an object functions as a work does not necessarily depend on the objective artistic status of that object.

It thus seems to me that the "provisional definition" of the work of art as an "intentional aesthetic object," or, indifferently, an "artifact with an aesthetic function," which I proposed not long ago[176] (a definition that is, moreover, rather commonplace, as we have since noted) must be treated as definitive, although it can be interpreted either in an objective, ontological way ("in order to *be* a work of art, an object must in fact proceed from an aesthetic intention"), or in a subjective, functional way ("in order to *function as* a work of art, an object must be received as proceeding from an aesthetic intention"). Artistries of the first type are evidently "constitutive artistries," whose intentional character is more or less

176. See Genette, *L'œuvre de l'art*, pp. 10–12 [*The Work of Art*, pp. 4–7].

objectively established, either on the basis of historical testimony or through manifest, determinate generic affiliation (a painting, poem, or symphony has small chance of being an object devoid of aesthetic intention). Artistries of the second type are occasional, or "conditional"[177] — today I would prefer to call them *attentional*, that is, in sum, artistries whose intentional nature is of the order of an attentional hypothesis, whether or not this hypothesis is warranted. This obviously implies that certain attentional artistries are also constitutive. If I naively regard the Matterhorn as a work of art, and accept the consequences that this belief has for my aesthetic relation to that mountain (those Gombrich points out, for example), then what is involved is a purely attentional artistry, which will reveal itself as such, and will therefore cease to exist once it has been factually refuted — an easy refutation to make, and therefore one that very likely will be made. If I regard all the Lascaux cave paintings taken together as a work of art, this conditional artistry is implicitly based on a hypothesis of aesthetic intention that is perhaps accurate, so that it is, simultaneously, certainly attentional and possibly constitutive: historical confirmation of my hypothesis would make it fully constitutive. But it is not very likely that I will ever have such confirmation, not only because the necessary "proofs" or testimony will doubtless never be forthcoming, but also, and above all, because it is highly improbable that the conceptual field of people in the Magdalenian period was so structured as to make room for a concept of artistic intention exactly identical with ours. Huizinga believes that even in the Middle Ages, much closer to our own time, "all art was more or less applied art. . . . the very notion of artistic beauty is still wanting."[178] Such a view, even if it can be sharply contested,[179] casts at least a degree of doubt on the permanence in time of this "concept." In fact, then, my implicit hypothesis here cannot be entirely true or entirely false, and the same doubtless holds for the artifacts produced in contemporary "primitive" societies: the testimony as to their "native status" that an ethnologist can still collect in such societies is probably

177. See Genette, *Fiction et diction* [*Fiction and Diction*], where this adjective was used to describe the special case of statuses of literariness. But, at the time, I had only taken into account — I realize this now, *a contrario* — the case of constitutive literary works, and that of texts received as simple attentional aesthetic objects. I had not considered the case, which is, in a sense, intermediate, of texts received as intentionally literary on the basis of a simple *attentional hypothesis*: if I appreciate the civil code aesthetically (second case), I can also ascribe an aesthetic intention to its author, and, from then on (third case), *regard it* (rightly or wrongly) *as* a literary work.

178. Johan Huizinga, *The Waning of the Middle Ages: A Study of the Forms of Life, Thought, and Art in France and the Netherlands in the XIVth and XVth Centuries*, trans. F. Hopman (Garden City, N.Y.: Doubleday, 1954), pp. 236, 255.

179. See Schaeffer, *Les célibataires de l'art*, pp. 141–142.

not susceptible of faithful term-by-term translation, which makes it impossible to establish a clear relation of identity or difference between this status (and the intention informing it) and that of our own "works of art." The shifting nature of these distinctions is obvious: it would doubtless be preferable to say that certain artistries are *more* constitutive than others — and to notice once again that this gradation is not of much importance at the aesthetic level, since a purely attentional or even wholly illusory artistry can have as sharp an impact on the aesthetic relation as a constitutive artistry (and, of course, sharper impact than a constitutive artistry which goes unperceived). A belief does not have to be articulated to be active, and a cave painting or African mask does not have to have been produced as a work of art in order to be received and to function as such today, for most people. Whether it can be resolved or not, the question of their original intention is a legitimate question for history, not for aesthetics.

ONE MIGHT BE TEMPTED TO LINK THIS GRADATION FROM THE conditional to the constitutive to another, that of the relative importance, in the production of the object, of the aesthetic intention as compared to its possible practical functions. It seems to me that the two are in fact unrelated, and, further, that the second, even if we assume it has been established and can be measured, cannot serve as a criterion for the degree of artistry of an object. I was recently moved to suggest, doubtless out of a desire to play it safe, that the legitimate definition of an object as a work of art turned on whether or not the aesthetic function was its end-purpose, and, therefore, *main* aim.[180] This unfortunate restrictive clause has caught the attention of Jean-Marie Schaeffer.[181] Elsewhere, Schaeffer cites a formulation of the same idea that he finds in Martin Seel, which shows well, as he puts it, the "hyperbolic" and thus imprudent character of such a requirement: "a work of art is an object . . . which draws us into, or invites us to have, an aesthetic experience—*and nothing else.*"[182] I emphasize the hyperbolic clause here; in its excessiveness, it reveals rather well the already exaggerated nature of my own phrase. If the aesthetic aim had to be

180. "The aesthetic function is the (main) purpose of a work of art" (Genette, *L'œuvre de l'art*, p. 12 [*The Work of Art*, p. 6]). The parenthetical phrase was intended to sound a note of caution, in that it meant to leave room for other purposes, practical, for instance. However, one has only to translate this sentence into the terms of a definition ("in order to be a work of art, an object must have the aesthetic function as its main purpose") in order to transform the concession into an excessive requirement.

181. Schaeffer, *Les célibataires de l'art*, p. 366.

182. Martin Seel, *Die Kunst der Entzweiung: Zum Begriff der ästhetischen Rationalität* (Frankfurt: Suhrkamp, 1985), cited in Schaeffer, *Les célibataires de l'art*, p. 42.

the "main" or, a fortiori, the exclusive aim of the whole work, architecture, for example, would very likely be excluded from the sphere of art, to say nothing of the African ritual masks or Egyptian funerary figurines which Schaeffer mentions in his objection—and, more generally, "all the Arts whose works serve a purpose, introducing an ambiguity between utility and beauty in our lives," as Valéry puts it.[183] The aesthetic end-purpose of a Greek temple or Gothic cathedral (to cite only genres whose artistry is recognized by everyone) is manifestly neither exclusive nor even dominant, and Schaeffer is plainly right to draw the following conclusion: "Can one at least maintain that *all* works of art, in the generic sense of the term, arise from an intention that is *primarily* aesthetic? Nothing is less certain." What might be "primarily" or even, if the adverb makes any sense here (which I doubt), "exclusively" aesthetic is the relation that I have to these objects, of whose pertinence I am, at this level, sole judge. It would, however, obviously be a mistake to project the nature of this relation onto the purpose that informed their production. We must clearly, then, allow for a certain play in the correspondence between artistic intention (which can be, and often is, aesthetic only *in addition to something else*) and aesthetic attention, which has the right to do as it sees fit, and thus the right to be (or to consider itself) as exclusive as it likes. But the reception of a work as such—"optimal" reception, in the sense Schaeffer attaches to this term—which seeks to take into account as many of the work's intentions as it can, certainly does not stand to gain by ignoring its possible (and almost inevitable) extra-aesthetic purposes. The "almost" is there to leave certain works, of music or abstract painting, for example, the right to a purely artistic aim, a possibility that should not be excluded in principle: it seems obvious to me that the relative importance of the aesthetic purpose can vary enormously from one work to the next, one genre to the next, one art to the next, and so on. It is, however, just as obvious that these degrees of importance by no means determine the degree of artistry possessed by a work, unless one were to maintain, in a caricature of formalism that modernist criticism has not always managed to avoid, that so-called "pure poetry" is constitutively more poetic than narrative or descriptive poetry, abstract painting constitutively more pictorial than figurative painting, or music (instrumental music, program music excepted) constitutively more artistic than architecture or literature.

I do not think, then, that this notion of degree of artistry is particularly relevant, and I am even less inclined to think that a certain degree of

183. Paul Valéry, "Variations sur la céramique illustrée," in *Œuvres*, vol. 2 (Paris: Pléiade, Gallimard, 1957), pp. 1352–1356.

artistic intention is necessary to the objective definition (or the subjective reception) of an object as an artwork. Despite appearances, it is more reasonable to say that even a scintilla of aesthetic intention suffices to meet this definition. For an object to be a work of art, it is necessary and sufficient for it to proceed from an aesthetic intention, however accessory that intention may be when measured against the object's practical function. For an object to function as a work of art, and figure as the object of an artistic relation, it is enough to impute some degree of such an intention to it—full stop. The problem, sometimes, is to be sure that such an intention obtains; that is the problem, but it is not the most important consideration, for the simple reason (among others) that no one can be entirely certain even of his own intentions. Accordingly, when I find a plow, streetlight, or fork aesthetically pleasing, it is not only true that I often do not know if its author meant it to be such; he himself may not have known. When in doubt, one could wager that the answer is yes (people rarely aim to displease, and one is just as rarely, if not more rarely, indifferent to whether one pleases or not).[184] This would make *every* artifact a work of art. That exaggeration—if it is one—does not unduly trouble me; in any event, it troubles me less than going to the opposite extreme would.

I DO NOT, HOWEVER, BELIEVE THAT ADOPTING SO SUBJECTIVE A criterion for determining the artistic function surreptitiously introduces into the definition of the work of art an axiological or evaluative dimension which would make "merit" a criterion of artistry. It is sometimes claimed that such a dimension is necessary; following Goodman,[185] I have explicitly rejected this idea. To repeat, the fact that the presence of a candidacy or "claim" for positive appreciation, or, in Panofsky's less exuberant formulation, the fact that the "demand to be experienced aesthetically" defines the work in general (by distinguishing it from the "simple" natural

184. Duchamp and Co. will be cited by way of objection; but I have already indicated why I doubt that this negative intention exists: Dada aims to please by displeasing, a rather common strategy of indirection.

185. In particular by Adorno, for whom "the concept of the work of art implies the notion of success. Botched art is no art at all" (Adorno, *Aesthetic Theory*, p. 269). See also p. 236, and p. 371: "The idea of a value-neutral aesthetics is nonsense." Rainer Rochlitz also treats "merit" as central to the definition of artistry. See Rochlitz, "Logique cognitive et logique esthétique," *Cahiers du Musée national de l'art moderne*, Fall 1992, pp. 55–71; "Dans le flou artistique: Éléments d'une théorie de la 'rationalité esthétique,' " in Rainer Rochlitz and Christian Bouchindromme, ed., *L'art sans compas* (Paris: Cerf, 1992), pp. 203–238; and *Subversion et subvention* (Paris: Gallimard, 1994). Adorno's formulation, which, to be sure, has the merit of clarity, seems to me logically untenable: one might equally well affirm that black (or white, etc.) cats are not cats. On this question, see Schaeffer, *Les célibataires de l'art*, pp. 186–199, 343–387.

or artifactual object which, for its part, claims nothing, and becomes the object of aesthetic attention by dint of an unconstrained choice), and, again, the fact that recognizing or assuming this candidacy is the grounds for identifying a particular object as a work, by no means implies that the *favorable reception* accorded this candidacy (in other words, its *success*) constitutes the necessary condition of a theoretical definition or practical identification. The "aesthetic function" that defines an artifact as a work of art is obviously intentional—otherwise it would be a mere *effect*—and, to repeat, it is very unlikely that this intention (the artist's wish) was to elicit a negative or neutral appraisal; but perceiving in an object, rightly or wrongly, the anguished "question" Hegel speaks of is entirely sufficient to identify it as a work, whether one's answer to the question be positive, negative, or neutral. The work asks for a (positive) appraisal, and it is this demand which identifies it as a work, not the evaluation as "aesthetically correct" that it does or does obtain. The demand is, in itself, an empirically verifiable matter; the recognition of it, or the assumption that it exists, is another; nothing in any of this requires including the axiological dimension of positive appraisal in the general definition or particular identification of the work. After all, being a question—and even managing to win recognition that one is a question—does not assure one of, and thus does not imply, an answer.

This metaphor evidently presupposes a certain analogy with the distinction, today standard in pragmatics, between the "illocutory" and the "perlocutory": as a speech act, a question aims to obtain a satisfactory answer (the perlocutory effect sought). To that end, however, it must, as a general rule, first be recognized as a question; that suffices to assure its illocutory "success." To the anguished question "What time is it?" the answer "I don't have a watch" is, to be sure, unsatisfactory, but it at least evinces sufficient consideration of the fact that the question is a question; silence would not provide evidence of such consideration, which is why it counts as impolite. To the candidacy put forward by the work of art, acknowledgment of the fact that it is a work (recognition of its artistic *act*), which ipso facto leads to aesthetic consideration of it, constitutes a sufficient illocutory response, even if this acknowledgment consists in a negative appraisal, and is consequently not very gratifying: "It's absolutely worthless" counts, here, as certification of artistry. This is probably not what the artist wished; he would perhaps even prefer that I admire his work without recognizing it as a work, as the man who asks what time it is would prefer that his interlocutor, entirely by chance and without having understood the question, accidentally show him his watch while pointing to the sky. But this disappointment itself clearly indicates what I

wished to establish: the difference, or even nonrelation, between the definition (and the identification) of the work as such and a positive appraisal of it. In order to push the convergence with speech act theory a bit further,[186] let us say, in Searlian terms, that recognition is *constitutive* of (categorical) status as a work, while positive appraisal is only *normative* (axiological) in this regard: just as it is not necessary to win even one little game in order really to play chess, although it is necessary to respect the rules governing the moves of the different chessmen, so it is not necessary, to acquire the status of a work of art, to "merit" positive appraisal, though it is necessary to show that one is soliciting it. To repeat, I too attach more importance (as I just said that I assume the artist does) to the first kind of "success" than to the second, since I prefer, on balance, to marvel at some miscellaneous object than to yawn before what is supposed to be a "masterpiece." But the fact of the matter is that one does not always have the choice.

186. But the analogy between the two spheres is doubtless due to the fact that both belong to the broader category of human acts. Oswald Ducrot (in Ducrot and Schaeffer, *Nouveau Dictionnaire encyclopédique des sciences du langage*, pp. 641–650) draws an apt parallel between, on the one hand, the Austinian distinction between illocutory and perlocutory and the Searlian distinction between constitutive and normative rules, and, on the other, the distinction previously proposed by Bühler between (linguistic) "acts" and "actions": the act is "inherent in the mere fact of speaking"; the action consists (I am interpreting Bühler somewhat) in the effect, successful or unsuccessful, of this act. This distinction seems to me to hold for all activities, and therefore for artistic activity as well. The production of a work, as of any artifact, is an act, which may or may not be recognized as such, and may or may not accomplish the action it sets out to. The two facts are relatively independent: the first does not presuppose the second, and vice versa.

Conclusion

LET US SUM UP, AT THE UNAVOIDABLE RISK OF REPEATING OUR-selves. The aesthetic relation in general consists in an emotional response (of appreciation) to an attentional object, whatever it might be, considered with regard to its aspect—or rather to an attentional object constituted by the aspect of an object, whatever it might be. This object can be natural or it can be "man-made," that is, the result of a human activity of assembly and/or transformation. Whenever the subject of this relation, rightly or wrongly and to whatever degree, takes this object for a human product and ascribes to the person who produced it an "aesthetic intention," that is, the aspiration to achieve an aesthetic effect, or "candidacy" for aesthetic reception, the object is received as a work of art, and the relation takes the more specific form of an artistic relation or function. The aesthetic relation to a work of art (a work usually solicits many other relations as well), whenever its artistic character, or "artistry," is not perceived, can be a simple aesthetic relation, like those that ordinary objects may elicit, whether they are natural or man-made. Conversely, this artistic character can be erroneously ascribed to a human product that did not proceed from an aesthetic intention at all, or even to a natural object, if it is mistaken for a human product. Again, it can be regarded as the result of a supernatural intention: if the whole of Nature is the work of a God, one can impute various intentions to this Creator, aesthetic intentions among them. The objective existence of an intention is not always certain, or verifiable (for example, I doubt that the question just mentioned will ever find an answer); the mere subjective (attentional) positing of such an inten-

tion, whether or not it has objective warrant, affects the aesthetic relation, sufficing to make it, more specifically, an artistic function. This special case of the artistic relation is defined through a consideration of technical and historical as well as genetic and generic facts, in conjunction with an operal character that has been recognized or surmised. This consideration can be more or less extensive, more or less intense, more or less complex, more or less relevant, more or less faithful to the producer's intention, if there was such an intention. It affects and modifies, to a greater or lesser extent, the attention brought to bear on the object and also the appreciation that results from it, which is always subjective in principle, but constantly being solicited by a "new" object—the same object, regarded in a different light [*sous un autre jour*]. It thus contributes, in that measure, to enriching and renewing the aesthetic relation in general, of which it is, nevertheless, merely an adjunct, one which is not, however, confined to this accessory role: the aesthetic experience and "knowledge of the arts" are two autonomous, self-sufficient activities; neither is altogether at the service of the other; and their conjunction, which is sometimes fertile and sometimes sterile, is by no means necessary a priori—it is not indispensable that one like a work in order to study it, and studying it is not indispensable to liking (or hating) it. Whatever meaning the illustrious promoter of the notion of "aesthetic curiosity" attached to this idea, it is a heterogeneous, highly unstable compound, in which cognitive interest and emotional reaction mesh less completely than one might think. If there is an aesthetic illusion (the objectification of "value"), there is also, over and above it, an artistic illusion; it consists in experiencing as aesthetic many aspects of the relation to a work which, though of another order, nevertheless surreptitiously contribute to one's overall appreciation of it.

The general nature of this function, thus defined, belongs, in my opinion, to the province of theoretical aesthetics—although it only makes up one of its subdistricts, since, to repeat one more time (the last), art is not the only (nor always the best) occasion for the aesthetic relation. The details of this function, for their part, should be the object of a joint investigation, already well underway outside France, combining anthropological inquiries of all kinds (psychological, sociological, ethnological, historical), which collectively constitute what might be called empirical aesthetics: the history of taste, for example, or, though it is to my mind something of a pleonasm, *reception aesthetics*. It is far beyond the scope of the present volume to examine, and a fortiori to engage in, this kind of research. The same holds for the study of the creative aspect of the work of art, which is the business of still other disciplines, both theoretical (the celebrated "philosophy of art") and empirical (including the history of the arts): I do not feel the call, nor do I

have the competence, to pursue them now. It will have been understood that this work has limited itself to considering the perspective of the receiver constituted by the "public," of which, as an art lover (enlightened or not), I am a member; and that its method has been, to a considerable degree, introspective—an introspection tempered by a dash of suspicion of the "beguiling powers" whose blandishments are a legitimate part of the game, but not of the description of it. I have tried to examine my own aesthetic experience here (even if it is commonplace), with the greatest and also the least possible naiveté; I have tried to do so both at the level of the mode of being of works, and of that of their mode of action as it is experienced by those of us who obviously do nothing more than receive them, however active and, occasionally, adventuresome "contemplation" of them can be. Clearly, this is only one aspect of matters, and I certainly do not claim that aesthetic experience suffices—as artistic *creation* doubtless does suffice, for the artist—to bring about what has rightly been called "self-accomplishment."[1] To imagine that this could be so (to believe, for example, that reading could do more than introduce one to "the life of the spirit")[2] would doubtless involve what Proust called, in opposition to Ruskin and a few others, *idolatry*—the typical pitfall of aestheticism. But it so happens that one cannot be on both sides of this divide at once, and it is better to know, in every case, and with as much lucidity as possible, which side one finds oneself on. It must also be acknowledged, as we have said about certain more or less recent efforts in this direction, that an evaluation of the aesthetic relation, of whatever kind, falls outside the province of aesthetics itself.

As the reader will have noticed, the present volume ends approximately where the previous one, *The Work of Art*, began; this is in keeping with the idea, put forward there, that nothing logically prescribes an order between the question of status, the subject of the first volume, and the question of function, the subject of the second. The study of the modes of existence, and, in particular, of the modes of transcendence of works, leads insensibly to the study of their modes of action; the latter, in its turn, seeks to define the object of the former. These two volumes thus stand in a circular relation; each seeks to shed light on the other, and to provide an introduction to it. This circular structure does not necessarily call for an infinite reading—though I shall make no effort to prevent anyone from attempting one.

1. Tzvetan Todorov, *La vie commune: Essai d'anthropologie générale* (Paris: Seuil, 1995), pp. 161–165.
2. Marcel Proust, "Journées de lecture," *Contre Sainte-Beuve*, preceded by *Pastiches et mélanges* and followed by *Essais et articles* (Paris: Pléiade, Gallimard, 1971), p. 178 [tr. "Days of Reading," trans. E. H. W. Meyerstein, in *Essays on Language and Literature*, ed. J. L. Hevesi (Port Washington, N.Y.: Kennikat Press, 1967), p. 46].

Bibliography

Adorno, Theodor W. *Aesthetic Theory* (1970). Trans. C. Lenhardt. Ed. Gretel Adorno and Rolf Tiedemann. London: Routledge and Kegan Paul, 1984.

Alpers, Svetlana. *The Art of Describing: Dutch Art in the Seventeenth Century*. Chicago: University of Chicago Press, 1983.

Aristotle. *De Poetica (Poetics)*. Trans. Ingram Bywater. In Richard McKeon, ed., *The Basic Works of Aristotle*. New York: Random House, 1941, pp. 1453–1487.

Baumgarten, Alexander Gottlieb. *Aesthetica* (vol. 1, 1750; vol. 2, 1758). Rpt. Hildesheim, Germany: Georg Olms, 1961.

Baxandall, Michael. *Patterns of Intention: On the Historical Explanation of Pictures*. New Haven: Yale University Press, 1985.

Beardsley, Monroe C. "Aesthetic Experience Regained." *Journal of Aesthetics and Art Criticism* 28 (1969): 3–11.

——. "The Aesthetic Point of View." In H. Kiefer and M. Munitz, eds., *Perspectives in Education, Religion, and the Arts*. Albany: State University of New York Press, 1970, pp. 219–237. Also in John W. Bender and H. Gene Blocker, eds., *Contemporary Philosophy of Art: Readings in Analytic Aesthetics*. Englewood Cliffs, N.J.: Prentice-Hall, 1993, pp. 384–396.

——. *Aesthetics: Problems in the Philosophy of Criticism* (1958). 2d ed. Indianapolis: Hackett, 1981.

——. *"Languages of Art* and Art Criticism." *Erkenntnis* 12 (1978): 95–118.

Beardsley, Monroe C., and William K. Wimsatt. "The Affective Fallacy" (1949). In *The Verbal Icon: Studies in the Meaning of Poetry*. Lexington: University of Kentucky Press, 1954, pp. 20–39.

——. "The Intentional Fallacy" (1946). In *The Verbal Icon: Studies in the Meaning of Poetry*. Lexington: University of Kentucky Press, 1954, pp. 1–18.

Bell, Clive. *Art* (1914). New York: Capricorn Books, 1958.

Binkley, Timothy. " 'Piece': Contra Aesthetics." *Journal of Aesthetics and Art Criticism* 35 (1977): 265–277.

Borges, Jorge Luis. "Crítica del Paisaje." *Cosmópolis* 34 (1921): 195–197.

——. *Nueva antología personal*. Buenos Aires: Emecé, 1968.

Bouveresse, Renée. Introduction to *Essais esthétiques: Art et psychologie*, by David Hume. Paris: Vrin, 1974, pp. 7–63.

Brunschvicg, Léon. *Introduction à la vie de l'esprit*. Paris: Félix Alcan, 1900.

Bullough, Edward. " 'Psychical Distance' as a Factor in Art and an Aesthetic Principle."

British Journal of Psychology 5 (1912): 87–98. Also in Elizabeth M. Wilkinson, ed., *Aesthetics: Lectures and Essays*. London: Bowes and Bowes, 1957, pp. 91–130. Also in Marvin Levich, ed., *Aesthetics and Philosophy of Criticism*. New York: Random House, 1963, pp. 233–254.

Cabanne, Pierre. *Le siècle de Picasso* (1975). Paris: Folio-Essais, Gallimard, 1992. [Partially translated as *Pablo Picasso: His Life and Times*, trans. Harold J. Salemson. New York: Morrow, 1977.]

Chateau, Dominique. *La question de la question de l'art. Note sur l'esthétique analytique: Danto, Goodman et quelques autres*. Paris: Presses universitaires de Vincennes, 1995.

Claudel, Paul. *Introduction à la peinture hollandaise* (1935). In *Œuvres en prose*. Paris: Pléiade, Gallimard, 1965, pp. 169–204.

Collingwood, R. G. *The Principles of Art* (1938). Oxford: Oxford University Press, 1958.

Corneille, Pierre. *Discours de l'utilité et des parties du poème dramatique* (1660). In Alain Niderst, ed., *Théâtre complet*, vol. 1. Rouen: Université de Rouen, 1984, pp. 51–65.

Danto, Arthur C. *Beyond the Brillo Box: The Visual Arts in Post-Historical Perspective*. New York: Farrar, Straus & Giroux, 1992.

——. *Embodied Meanings: Critical Essays and Aesthetic Meditations*. New York: Farrar, Straus & Giroux, 1994.

——. *Narration and Knowledge*. New York: Columbia University Press, 1985.

——. *The Philosophical Disenfranchisement of Art*. New York: Columbia University Press, 1986.

——. *The Transfiguration of the Commonplace: A Philosophy of Art*. Cambridge: Harvard University Press, 1981.

Dawson, Sheila. " 'Distancing' as an Aesthetic Principle." *Australasian Journal of Philosophy* 39 (1961): 155–174.

De Bruyne, Edgar. *Études d'esthétique médiévale*. Bruges: De Tempel, 1946.

Dickie, George. *Aesthetics: An Introduction*. Indianapolis: Bobbs-Merrill, 1971.

——. *Art and the Aesthetic: An Institutional Analysis*. Ithaca: Cornell University Press, 1974.

——. "Beardsley's Phantom Aesthetic Experience." *Journal of Philosophy* 52 (1965): 129–136.

——. "Defining Art." *American Philosophical Quarterly* 6 (1969): 253–256.

——. "Defining Art II." In Matthew Lipman, ed., *Contemporary Aesthetics*. Boston: Allyn and Bacon, 1973, pp. 118–131.

——. *Evaluating Art*. Philadelphia: Temple University Press, 1988.

——. "The Myth of the Aesthetic Attitude." *American Philosophical Quarterly* 1 (1964): 56–64.

Doran, P. M., ed. *Conversations avec Cézanne*. Paris: Macula, 1978.

Duchamp, Marcel. *Duchamp du signe: écrits*. Ed. Michel Sanouillet. Paris: Flammarion, 1975.

Ducrot, Oswald, and Jean-Marie Schaeffer. *Nouveau Dictionnaire encyclopédique des sciences du langage*. Paris: Seuil, 1995.

Dufrenne, Mikel. *Esthétique et philosophie*. Paris: Klincksieck, 1980.

——. "Esthétique et philosophie." In *Encyclopaedia Universalis*. Paris: Encyclopædia Universalis, 1990, vol. 8, pp. 812–816.

Durkheim, Émile. "Jugements de valeur et jugements de réalité." *Revue de métaphysique et de morale* 19 (1911): 437–453. [Tr. "Value Judgments and Judgments of Reality," trans. D. F. Pocock. In *Sociology and Philosophy*. Glencoe, Ill.: Free Press, 1953.]

Elgin, Catherine Z. "Understanding: Art and Science." *Midwest Studies in Philosophy* 16 (1991): 196–208.

Empson, William. *Seven Types of Ambiguity* (1930). Cleveland: Meridian, 1955.

Fish, Stanley. *Is There a Text in This Class?* Cambridge: Harvard University Press, 1980.

Flaubert, Gustave. *Madame Bovary* (1857). Ed. Jean Pommier and Gabrielle Leleu. Paris: José Corti, 1949.

Fontenelle, Bernard de. "Éloge du père Malebranche" (1716). In Alain Niderst, ed., *Œuvres complètes*, vol. 6: *Histoire de l'Académie des Sciences*. Corpus des œuvres de philosophie en langue française. Paris: Fayard, 1994, pp. 337–360.

Francastel, Pierre. *Art et technique aux 19ème et 20ème siècles*. Paris: Minuit, 1956.

Freud, Sigmund. "On Narcissism: An Introduction" (1914). In James Strachey et al., eds. and trans., *Standard Edition of the Complete Psychological Works of Sigmund Freud*, vol. 14. London: Hogarth Press, 1957, pp. 67–104.

Gebhart, Émile. *Les origines de la Renaissance en Italie*. Paris: Hachette, 1879.

Genette, Gérard. "La clé de Sancho." *Poétique* 101 (1995): 3–22.

——. *Fiction et Diction*. Paris: Seuil, 1991. [Tr. *Fiction and Diction*, trans. Catherine Porter. Ithaca: Cornell University Press, 1993.]

——. *Mimologiques*. Paris: Seuil, 1976. [Tr. *Mimologics*, trans. Thais E. Morgan. Lincoln: University of Nebraska Press, 1995.]

——. *L'œuvre de l'art*, vol. 1: *Immanence et transcendance*. Paris: Seuil, 1994. [Tr. *The Work of Art: Immanence and Transcendence*, trans. G. M. Goshgarian. Ithaca: Cornell University Press, 1997.]

——. *Seuils*. Paris: Seuil, 1987. [Tr. *Paratexts: The Thresholds of Textuality*, trans. Jane E. Lewin. Cambridge: Cambridge University Press, 1992.]

——, ed. *Esthétique et Poétique*. Paris: Seuil, 1992.

Gilson, Étienne. *Introduction aux arts du beau*. Paris: Vrin, 1963.

Giono, Jean. *Voyage en Italie* (1953). In *Journal, Poèmes, Essais*. Paris: Pléiade, Gallimard, 1995.

Gombrich, Ernst. *Art and Illusion: A Study in the Psychology of Pictorial Representations* (1959). 2d ed. Princeton: Princeton University Press, 1969.

——. *Reflections on the History of Art: Views and Reviews*. Berkeley: University of California Press, 1987.

Goodman, Nelson. *Languages of Art: An Approach to a Theory of Symbols*. Indianapolis: Bobbs-Merrill, 1968.

——. *Of Mind and Other Matters*. Cambridge: Harvard University Press, 1984.

——. "On Being in Style" (1981). In *Of Mind and Other Matters*. Cambridge: Harvard University Press, 1984, pp. 130–134.

——. "On Symptoms of the Aesthetic" (1981). In *Of Mind and Other Matters*. Cambridge: Harvard University Press, 1984, pp. 135–138.

——. "Reference in Art" (1978). In *Of Mind and Other Matters*. Cambridge: Harvard University Press, 1984, pp. 80–86.

——. "Routes of Reference" (1981). In *Of Mind and Other Matters*. Cambridge: Harvard University Press, 1984, pp. 55–71.

——. "The Status of Style" (1975). In *Ways of Worldmaking*. Indianapolis: Hackett, 1978, pp. 23–40.

——. "When Is Art?" (1977). In *Ways of Worldmaking*. Indianapolis: Hackett, 1978, pp. 57–70.

Goodman, Nelson, and Catherine Z. Elgin. "Changing the Subject." In R. Shusterman, ed., *Analytic Aesthetics*. Oxford: Blackwell, 1989, pp. 190–96.

——. *Reconceptions in Philosophy and Other Arts and Sciences*. Indianapolis: Hackett, 1988.

Gracq, Julien. "Entretien avec Jean-Louis Tissier." In *Œuvres complètes*. Paris: Pléiade, Gallimard, 1978, vol. 2, pp. 1193–1210.

Gracyk, Theodore A. "Rethinking Hume's Standard of Taste." *Journal of Aesthetics and Art Criticism* 52 (1994): 169–182.

Grazia, Margreta de, and Peter Stallybrass. "La matérialité du texte shakespearien." *Genesis* 7 (1995): 9–27.

Greimas, Algirdas Julien, and Joseph Courtès. *Sémiotique: Dictionnaire raisonné de la théorie du langage*. Paris: Hachette, 1979. [Tr. *Semiotics and Language: An Analytical Dictionary*, trans. Larry Cristo et al. Bloomington: Indiana University Press, 1983.]

Hancher, Michael. "Poems versus Trees: The Aesthetics of Monroe Beardsley." *Journal of Aesthetics and Art Criticism* 31 (1972): 181–191.

Haskell, Francis. *History and Its Images: Art and the Interpretation of the Past*. New Haven: Yale University Press, 1993.

——. *Rediscoveries in Art: Some Aspects of Taste, Fashion and Collecting in England and France*. Oxford: Phaidon Press, 1980.

Hegel, Georg Wilhelm Friedrich. *Aesthetics: Lectures on Fine Art* (1832). Trans. T. M. Knox. 2 vols. Oxford: Clarendon, 1975.

Heidegger, Martin. "The Origin of the Work of Art" (1935). Trans. Albert Hofstadter. In David Farrell Krell, ed., *Basic Writings from* Being and Time *(1927) to* The Task of Thinking *(1964)*. New York: Harper and Row, 1977, pp. 143–187.

Hirsch, E. D. *Validity in Interpretation*. New Haven: Yale University Press, 1967.

Hogarth, William. *The Analysis of Beauty* (1753). Rpt. London: Scolar Press, 1969.

Hours, Magdeleine. *Les secrets des chefs-d'oeuvre* (1964). 2d ed. Paris: Robert Laffont, 1988.

Huizinga, Johan. *The Waning of the Middle Ages: A Study of the Forms of Life, Thought, and Art in France and the Netherlands in the XIVth and XVth Centuries* (1919). Trans. F. Hopman. Garden City, N.Y.: Doubleday, 1954.

Hume, David. "On the Standard of Taste" (1757). In Ernest C. Mossner, ed., *An Enquiry Concerning Human Understanding and Other Essays*. New York: Washington Square Press, 1963, pp. 246–266.

Ingarden, Roman. *The Literary Work of Art: An Investigation on the Borderlines of Ontology, Logic, and Theory of Literature* (1930). Trans. George G. Grabowicz. Evanston: Northwestern University Press, 1973.

Irving, John. *The Cider House Rules*. London: Transworld Publishers, Black Swan Books, 1986.

Jakobson, Roman. "Linguistics and Poetics." In Richard DeGeorge and Fernande DeGeorge, eds., *The Structuralists from Marx to Lévi-Strauss*. Garden City, N.Y.: Doubleday, 1960, pp. 85–122.

Kant, Immanuel. *The Critique of Judgement* §1–60] (1790). In *Kant's Critique of Aesthetic Judgement*, trans. James C. Meredith. Oxford: Clarendon, 1911, pp. 3–311.

Klein, Robert. *La Forme et l'intelligible: Écrits sur la Renaissance et l'art moderne*. Paris: Gallimard, 1970. [Partially translated as *Form and Meaning: Essays in the Renaissance and Modern Art*, trans. Madeleine Jay and Leon Wieseltier. New York: Viking, 1979.]

Kuhn, Thomas. *The Structure of Scientific Revolutions* (1962). 2d ed. International Encyclopedia of Unified Science, vol. 2, no. 2. Chicago: University of Chicago Press, 1970.

Lachelier, Jules. *Études sur le syllogisme*. Paris: Félix Alcan, 1907.

Leiris, Michel. *Miroir de l'Afrique*. Paris: Gallimard, 1996.

Loos, Adolf. "Ornament und Verbrechen" (1908). In *Trotzdem*. Innsbruck: Brenner, 1931.

Lories, Danielle, ed. *Philosophie analytique et esthétique*. Paris: Méridiens-Klincksieck, 1988.

Macdonald, Margaret. "Some Distinctive Features of Arguments Used in Criticism of the Arts." *Proceedings of the Aristotelian Society*, supplementary vol. 23 (1949): 183–194.

Malraux, André. *Le Musée imaginaire* (1947). Paris: Idées-Art, Gallimard, 1965. [Tr. *Museum without Walls*, trans. Stuart Gilbert and Francis Price. Garden City, N.Y.: Doubleday, 1967.]

Margolis, Joseph. *Art and Philosophy: Conceptual Issues in Aesthetics*. New York: Harvester, 1978.

Moeschler, Jacques, and Anne Reboul. *Dictionnaire encyclopédique de pragmatique*. Paris: Seuil, 1994.

Morizot, Jacques. *La philosophie de l'art de Nelson Goodman*. Nîmes: Jacqueline Chambon, 1996. [This book was published too late for me to be able to consult it while writing the present volume.]

Nagel, Alan. "Or as a Blanket: Some Comments and Questions on Exemplification." *Journal of Aesthetics and Art Criticism* 39 (1981): 264–266.

Panofsky, Erwin. "The History of Art as a Humanistic Discipline" (1940). In *Meaning in the Visual Arts: Papers in and on Art History*. Garden City, N.Y.: Doubleday, 1955, pp. 1–25.

——. *Renaissance and Renascences in Western Art* (1960). New York: Harper and Row, Icon Editions, 1972.

——. *Studies in Iconology: Humanistic Themes in the Art of the Renaissance* (1939). New York: Harper and Row, 1967.

——. "Zum Problem der Beschreibung und Inhaltsdeutung von Werken der bildenden Kunst." *Logos* 21 (1932): 103–119.

Piel, Friedrich. *Albrecht Dürer: Aquarelle und Zeichnungen*. Cologne: DuMont, 1983.

Popper, Karl. *The Poverty of Historicism*. Boston: Beacon Press, 1957.

Pouivet, Roger, ed. *Lire Goodman: Les voies de la référence*. Combas: Éclat, 1992.

Proust, Marcel. *Contre Sainte-Beuve*. In *Contre Sainte-Beuve*, preceded by *Pastiches et mélanges* and followed by *Essais et articles*. Paris: Pléiade, Gallimard, 1971, pp. 211–312. [Tr. *Contre Sainte-Beuve*, in *On Art and Literature, 1896–1919*, trans. Sylvia Townsend Warner. New York: Meridian, 1958, pp. 17–276.]

——. *Le côté de Guermantes*. Part II (1921). In *A la recherche du temps perdu*. Paris: Pléiade, Gallimard, 1987, vol. 2, pp. 609–884. [Tr. *The Guermantes Way*. In *Remembrance of Things Past*, trans. C. K. Scott Moncrieff and Terence Kilmartin. New York: Random House, 1981, vol. 2, pp. 323–620.]

——. *Du côté de chez Swann* (1913). In *A la recherche du temps perdu*. Paris: Pléiade, Gallimard, 1987, vol. 1, pp. 1–420. [Tr. *Swann's Way*. In *Remembrance of Things Past*, trans. C. K. Scott Moncrieff and Terence Kilmartin. New York: Random House, 1981, vol. 1, pp. 1–462.]

——. "Journées de lecture" (1905). In *Contre Sainte-Beuve*, preceded by *Pastiches et mélanges* and followed by *Essais et articles*. Paris: Pléiade, Gallimard, 1971, pp. 527–533. [Tr. "Days of Reading," trans. E. H. W. Meyerstein. In J. L. Hevesi, ed., *Essays on Language and Literature*. Port Washington, N.Y.: Kennikat Press, 1967, pp. 21–68.]

——. *A l'ombre des jeunes filles en fleurs* (1919). In *A la recherche du temps perdu*. Paris: Pléiade, Gallimard, 1987, vol. 1, pp. 421–630; vol. 2, pp. 1–306. [Tr. *Within a Budding Grove*. In *Remembrance of Things Past*, trans. C. K. Scott Moncrieff and Terence Kilmartin. New York: Random House, 1981, vol. 1, pp. 465–1018.]

——. Preface (1904) to *The Bible of Amiens*, by John Ruskin. In *Contre Sainte-Beuve*, preceded by *Pastiches et mélanges* and followed by *Essais et articles*. Paris: Pléiade, Gallimard, 1971, pp. 520–523. [Tr. in Jean Autret et al., eds. and trans., *On Reading Ruskin: Preface to* La Bible d'Amiens *and* Sésame et les Lys. New Haven: Yale University Press, 1987.]

——. Preface (1906) to the French translation of John Ruskin, *The Stones of Venice* [*Les pierres de Venise*], trans. Mathilde Crémieux. In *Contre Sainte-Beuve*, preceded by *Pastiches et mélanges* and followed by *Essais et articles*. Paris: Pléiade, Gallimard, 1971, pp. 520–523.

——. Preface (1904) to *Tendres Stocks*, by Paul Morand. In *Contre Sainte-Beuve*, preceded by *Pastiches et mélanges* and followed by *Essais et articles*. Paris: Pléiade, Gallimard, 1971, pp. 606–616. [Tr. Preface to *Green Shoots*, by Paul Morand, trans. C. K. Scott Moncrieff. London: Chapman and Dodd, 1923.]

——. *La Prisonnière* (1923). In *À la recherche du temps perdu*. Paris: Pléiade, Gallimard, 1988, vol. 3, pp. 517–915. [Tr. *The Captive*. In *Remembrance of Things Past*, trans. C. K. Scott Moncrieff and Terence Kilmartin. New York: Random House, 1981, vol. 3, pp. 1–422.]

Réau, Louis. *Histoire du vandalisme: Les monuments détruits de l'art français*. 2d ed. Paris: Robert Laffont, 1994.

Richards, I. A. *Practical Criticism: A Study of Literary Judgement*. London: Routledge and Kegan Paul, 1929.

——. *Principles of Literary Criticism*. London: Routledge and Kegan Paul, 1924.

Riffaterre, Michael. "Describing Poetic Structures: Two Approaches to Baudelaire's 'Les Chats.'" *Yale French Studies* 36–37 (1966): 200–242.

Rochlitz, Rainer. "Dans le flou artistique: Éléments d'une théorie de la 'rationalité esthétique.'" In Rainer Rochlitz and Christian Bouchindromme, eds., *L'Art sans compas: Redéfinitions de l'esthétique*. Paris: Cerf, 1992, pp. 203–238.

——. "Logique cognitive et logique esthétique." *Cahiers du Musée national de l'art moderne*, Fall 1992, pp. 55–71.

——. *Subversion et subvention: L'art contemporain et l'argument esthétique*. Paris: Gallimard, 1994.

Rosen, Charles. *The Classical Style: Hayden, Mozart, Beethoven*. New York: Viking, 1971.

Rosenberg, Harold. *The De-definition of Art: Action Art to Pop to Earthworks*. New York: Horizon, 1972.

Ruskin, John. *The Bible of Amiens* (1885). In E. T. Cook and Alexander Wedderburn, eds., *The Works of John Ruskin*, vol. 33. London: George Allen, 1908, pp. 3–187.

——. *The Stones of Venice* (1851–1853). 3 vols. Ed. Ernest Rhys. London: Dent, Everyman, 1907.

Sagoff, Mark. "The Aesthetic Status of Forgeries." *Journal of Aesthetics and Art Criticism* 35 (1976): 169–180.

——. "Historical Authenticity." *Erkenntnis* 12 (1978): 83–94.

Santayana, George. *The Sense of Beauty: Being the Outline of Aesthetic Theory* (1896). New York: Dover Publications, 1955.

Sartre, Jean-Paul. *Baudelaire*. Paris: Gallimard, 1947. [Tr. *Baudelaire*, trans. Martin Turnell. New York: New Directions, 1950.]

———. *Saint Genet comédien et martyre*. Paris: Gallimard, 1952. [Tr. *Saint Genet: Actor and Martyr*, trans. Bernard Frechtman. New York: George Braziller, 1963.]

———. *Situations II*. Paris: Gallimard, 1948. [Tr. *"What Is Literature?" and Other Essays*, trans. Bernard Frechtman et al. Cambridge: Harvard University Press, 1988.]

Schaeffer, Jean-Marie. *L'art de l'âge moderne: L'esthétique et la philosophie de l'art du XVIIIᵉ siècle à nos jours*. Paris: Gallimard, 1992.

———. *Les célibataires de l'art: Pour une esthétique sans mythes*. Paris: Gallimard, 1996.

———. Preface to *La transfiguration du banal*, by Arthur Danto. Paris: Seuil, 1981, pp. 7–18.

Schapiro, Meyer. "Style" (1953). *Theory and Philosophy of Art: Style, Artist, and Society*. New York: George Braziller, 1994, pp. 51–102.

Schwyzer, H. R. G. "Sibley's 'Aesthetic Concepts.'" *Philosophical Review* 72 (1963): 72–88.

Searle, John. *Intentionality: An Essay in the Philosophy of Mind*. Cambridge: Cambridge University Press, 1983.

Seel, Martin. *Die Kunst der Entzweiung: Zum Begriff der ästhetischen Rationalität*. Frankfurt: Suhrkamp, 1985.

Shaftesbury, Anthony. *Characteristics of Men, Manners, Opinions, Times* (1711). Ed. J. M. Robertson. Indianapolis: Bobbs-Merrill, 1964.

Shusterman, Richard. *The Object of Literary Criticism*. Schriften zur Philosophie und ihrer Problemgeschichte 29. Amsterdam: Rodopi, 1984.

Sibley, Frank. "Aesthetic and Non-Aesthetic." *Philosophical Review* 74 (1965): 135–159.

———. "Aesthetic Concepts." *Philosophical Review* 68 (1959): 421–450.

———. "Aesthetic Concepts: A Rejoinder" [reply to H. R. G. Schwyzer, "Sibley's 'Aesthetic Concepts,'" *Philosophical Review* 72 (1963): 72–78]. *Philosophical Review* 72 (1963): 79–83.

———. "Objectivity and Aesthetics." *Proceedings of the Aristotelian Society*, supplementary vol. 42 (1968): 31–54.

Sismondi, Jean-Charles Léonard Simonde de. *Histoire des républiques italiennes du Moyen Âge* (1807). 16 vols. Paris: Treuttel et Würtz, 1826. [Tr. *A History of the Italian Republics*. Magnolia, Mass.: Peter Smith, 1970.]

Slote, Michael A. "The Rationality of Aesthetic Value Judgments." *Journal of Philosophy* 68 (1971): 821–839.

Souriau, Étienne. *La correspondance des arts: Éléments d'esthétique comparée*. Paris: Flammarion, 1947.

Souriau, Paul. *La beauté rationnelle*. Paris: Félix Alcan, 1904.

Stendhal. *Racine et Shakespeare* (1823). Paris: Garnier-Flammarion, 1970. [Tr. *Racine and Shakespeare*, trans. Guy Daniels. New York: Crowell-Collier, 1962.]

———. *Rome, Naples et Florence en 1817* (1817). *Voyages en Italie*. Paris: Pléiade, Gallimard, 1973, pp. 5–168. [Tr. *Rome, Naples and Florence*, trans. Richard N. Coe. London: John Calder, 1959.]

———. *Vie de Henry Brulard* (1836). In *Œuvres intimes*. Paris: Pléiade, Gallimard, 1982, vol. 2, pp. 523–963. [Tr. *The Life of Henry Brulard*, trans. Jean Stewart and B. C. J. G. Knight. Chicago: University of Chicago Press, 1986.]

———. *Vie de Rossini* (1824). Paris: Le Divan, 1929. [Tr. *Life of Rossini*, trans. Richard N. Coe. London: Calder and Boyars, 1970.]

Stevenson, Charles L. *Ethics and Language*. New Haven: Yale University Press, 1944.
——. "Interpretation and Evaluation in Aesthetics" (1950). In Max Black, ed., *Philosophical Analysis*. Englewood Cliffs, N.J.: Prentice-Hall, 1963, pp. 319–358.
——. "Persuasive Definitions." *Mind* 47 (1938): 331–350.
Stolnitz, Jerome. "The Aesthetic Attitude." In *Aesthetics and the Philosophy of Art Criticism*. Boston: Houghton Mifflin, 1960, pp. 32–42.
——. "The Artistic Values in Aesthetic Experience." *Journal of Aesthetics and Art Criticism* 32 (1973): 5–15.
——. "On the Origins of 'Aesthetic Disinterestedness.' " *Journal of Aesthetics and Art Criticism* 20 (1961): 131–143.
——. "On the Significance of Shaftesbury in Modern Aesthetic Theory." *Philosophical Quarterly* 11 (1961): 97–113.
Strawson, Peter F. "Aesthetic Appraisal and Works of Art." In *Freedom and Resentment and Other Essays*. London: Methuen, 1974, pp. 178–188.
Tanner, Michael. "Objectivity and Aesthetics." *Proceedings of the Aristotelian Society*, supplementary vol. 42 (1968): 55–72.
Teyssèdre, Bernard. Summary of "L'histoire de l'art est une discipline humaniste," by Erwin Panofsky. In *L'œuvre d'art et ses significations: Essais sur les "arts visuels."* Paris: Gallimard, 1969, pp. 27–29.
Thomas Aquinas. *Summa Theologica*. Trans. the Fathers of the English Dominican Province. Hypertext version: New Advent, 1996 (1947). Http://www.newadvent.org/summa.
Todorov, Tzvetan. *La vie commune: Essai d'anthropologie générale*. Paris: Seuil, 1995.
Tomas, Vincent. "Aesthetic Vision." *Philosophical Review* 68 (1959): 52–67.
Urmson, J. O., and David Pole. "What Makes a Situation Aesthetic?" *Proceedings of the Aristotelian Society*, supplementary vol. 31 (1957): 75–106. (Urmson's contribution also in Joseph Margolis, ed., *Philosophy Looks at the Arts: Contemporary Readings in Aesthetics*. New York: Scribner's, 1962, pp. 13–26.)
Valéry, Paul. "L'enseignement de la poétique au Collège de France" (1936). In *Œuvres*. Paris: Gallimard, 1957, vol. 1, pp. 1438–1443. [Tr. "On the Teaching of Poetics at the Collège de France." In *Collected Works*, vol. 13, trans. Ralph Mannheim. New York: Pantheon, 1964, pp. 83–88.]
——. "L'homme et la coquille" (1937). In *Œuvres*. Paris: Gallimard, 1957, vol. 1, pp. 886–907. [Tr. "Man and the Sea Shell." In *Collected Works*, vol. 13, trans. Ralph Mannheim. New York: Pantheon, 1964, pp. 3–30.]
——. "Poésie et pensée abstraite" (1933). In *Œuvres*. Paris: Gallimard, 1957, vol. 1, pp. 1314–1339. [Tr. "Poetry and Abstract Thought." In *Collected Works*, vol. 7, trans. Denise Folliot. New York: Pantheon, 1958, pp. 52–81.]
——. "Propos sur la poésie" (1927). In *Œuvres*. Paris: Gallimard, 1957, vol. 1, pp. 1361–1378. [Tr. "Remarks on Poetry." In *Collected Works*, vol. 7, trans. Denise Folliot. New York: Pantheon, 1958, pp. 196–215.]
——. "Variations sur la céramique illustrée" (1934). In *Œuvres*. Paris: Pléiade, Gallimard, 1957, vol. 2, pp. 1352–1356.
Veyne, Paul. *Le quotidien et l'intéressant: Entretiens avec Catherine Darbo-Peschanski*. Paris: Les Belles Lettres, 1995.
Vivas, Eliseo. "Contextualism Reconsidered." *Journal of Aesthetics and Art Criticism* 18 (1959): 222–240.

——. "A Definition of Aesthetic Experience." *Journal of Philosophy* 34 (1937): 628–634. Also in Vivas and Murray Krieger, eds., *The Problems of Aesthetics*. New York: Rinehart, 1953, pp. 406–411.

——. "A Natural History of the Aesthetic Transaction." In Yervant H. Krikorian, ed., *Naturalism and the Human Spirit*. New York: Columbia University Press, 1944, pp. 96–120.

Voltaire. *Dictionnaire philosophique* (1764). Ed. Raymond Naves and Julien Benda. Paris: Garnier, 1967. [Tr. *The Philosophical Dictionary*, ed. and trans. H. I. Wolf. New York: Knopf, 1924. Http://history.hanover.edu/texts/volindex.htm.]

Walton, Kendall. "Categories of Art." *Philosophical Review* 79 (1970): 334–367.

Weitz, Morris. "The Role of Theory in Aesthetics." *Journal of Aesthetics and Art Criticism* 15 (1956): 27–35.

Wellek, René, and Austin Warren. *Theory of Literature* (1942). 3d ed. New York: Harcourt, Brace and World, 1962.

Wey, Francis. "Notre maître peintre Gustave Courbet." In Pierre Courthion, ed., *Courbet raconté par lui-même et par ses amis: Ses écrits, ses contemporains, sa postérité*. Geneva: Pierre Cailler, 1950, vol. 2, pp. 183–198.

Wheeler, Samuel C., III. "Attributives and Their Modifiers." *Nous* 6 (1972): 310–334.

Wittgenstein, Ludwig. *Philosophical Investigations* (1953). 3d ed. Trans. B. E. M. Anscombe. Oxford: Basil Blackwell, 1968.

Wölfflin, Heinrich. *Gedanken zur Kunstgeschichte: Gedrucktes und Ungedrucktes* (1940). 4th ed. Basel: Benno Schwabe, 1946.

——. *Principles of Art History: The Problem of the Development of Style in Later Art* (1915). Trans. M. D. Hottinger. New York: Dover, 1952.

Index

absolutism, 106

accessory information, 124, 175; aesthetic value and, 122; Beardsley and, 143, 146, 148–149, 158; the conscious and, 180; forgery and, 161

admiration, 116; the historical and, 184

aesthetic aim, 207, 215

aesthetic appreciation, 11, 84–86, 93–95, 117, 184, 188, 196; versus artistic appreciation, 3, 204; definition of art and, 111–112; the extraperceptual and, 150; form and, 23–26; the instrumental and, 83; judgment of agreeableness and, 62; Kant and, 12–13; natural objects and, 130; the objective and, 70–71, 89, 206; the subjective and, 64–65, 206–207. *See also* appreciation; artistic appreciation

aesthetic attention, 11, 26–28; appearance and, 30; the art museum and, 211–212; artifacts and, 131; artistic intention and, 218; aspectual attention and, 41; exemplification and, 47; Goodman's symptoms and, 31; intentionality and, 154; judgment and, 201; Kant and, 12–13, 16; the poetic and, 52; productions by animals and, 128; secondary, 22; status of a work as art and, 220; weathering and, 138. *See also* attention

aesthetic attitude, 21, 30–31; attention without identification and, 181; Beardsley and, 79

aesthetic definitions, 134

aesthetic descripton, 93

aesthetic effect, 1–2

aesthetic experience, 7, 20; aesthetic relation and, 223; Beardsley and, 78–81; Goodman and, 115*n*104; Richards and, 26

aesthetic function, 1–2; generic affiliation and, 183; Goodman and, 35; intention and, 220; practical function and, 51. *See also* artistic function; function

aesthetic hedonism, 115

aesthetic intention, 183, 203–207; candidacy and, 222; critical attitude and, 137; Panofsky and, 134; practical functions and, 217; status of a work as art and, 139–141, 207, 214, 215. *See also* intention

aesthetic judgment, 12–13, 15, 59, 95; Beardsley and, 75–76, 156; *Beschaffenheit* and, 63; emotion and, 81; judgments of artistic value and, 157; Kant and, 61, 66–68; objectivist, 85; operal success and, 195; predicates and, 81; primary, 153; Schaeffer on, 162; Stolnitz and, 157; universality and, 101. *See also* judgment

aesthetic object, the, 11, 192; Beardsley and, 78; intention and, 82, 154; natural, 13, 48; primary relation and, 183; semi-opaque, 49; theater and, 18; thematic content and, 25; as work of art, 215. *See also* object, the

aesthetic perception: Panofsky on, 133*n*31

aesthetic pleasure, 13–14, 83; the beautiful and, 88; formal qualities and, 23. *See also* pleasure

aesthetic predicates, 160, 174; the conscious and, 181. *See also* artistic predicates; predicates

aesthetic properties, 162–164; Danto and, 205

aesthetic reception: the historical and, 209

aesthetic relation, 2–3, 7–8, 11, 14, 117–119; and artistic relation, 29; versus artistic relation, 204; Beardsley and, 143–144; critical attitude and, 136–137; exemplification and, 41–42, 47; fifth symptom and, 55; Goodman and, 112–115; Goodmanian symptoms and, 213–214; history of art and, 199; instrumentalization and, 82;